GUSTAV KLIMT

THE RONALD S. LAUDER AND SERGE SABARSKY COLLECTIONS

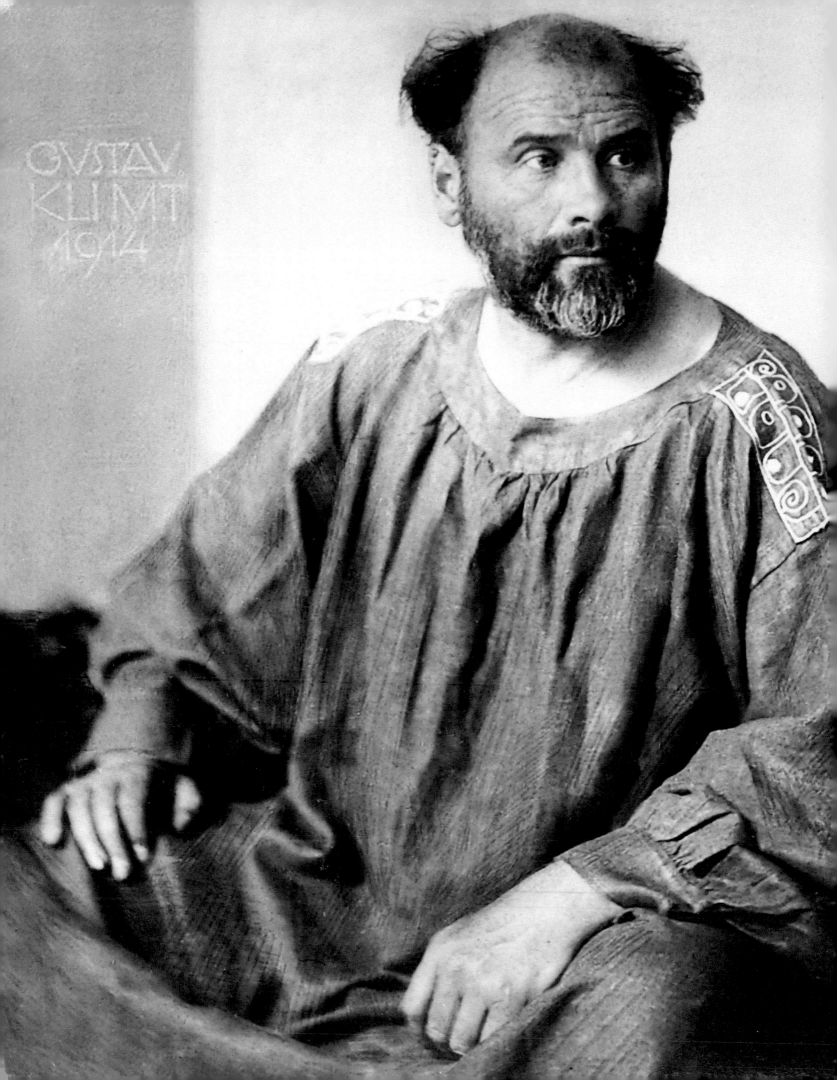

GVSTAV
KLIMT
1914

GUSTAV KLIMT

THE RONALD S. LAUDER AND SERGE SABARSKY COLLECTIONS

Editcd by Renée Price

With contributions by Ronald S. Laudcr,
Renée Price, Alessandra Comini, Sophie Lillie,
Maria Altmann, Ernst Ploil, Marian Bisanz-Prakken,
Tobias G. Natter, Emily Braun, Janis Staggs,
Manu von Miller, and Hansjörg Krug

NEUE GALERIE
MUSEUM FOR GERMAN
■ AND AUSTRIAN ART ■
NEW YORK

ACKNOWLEDGEMENTS

Maria Altmann, Los Angeles
Leah Ammon, New York
Bernhard Andergassen, Vienna
Paul and Stefan Asenbaum, Vienna
Hildegardt Bachert, New York
Christina Bachl-Hofmann, Vienna
Tamesh Bahadur, New York
Oliver Barker, London
Jonathan Becker, New York
Marian Bisanz-Prakken, Vienna
Tina Blondell, Minneapolis
Kaj Blunck, London
Emily Braun, New York
Ellie Bronson, New York
Chana Budgazad, New York
Jane A. Callahan, Cambridge
John Collins, Ottawa
Alessandra Comini, Dallas
Tara C. Craig, New York
Isabella Croy, Vienna
Joan Davidson, New York
Frank DeMars, Minneapolis
Ginnina D'Orazio, Los Angeles
Meta Duevell, New York
Franz Eder, Salzburg
John Elderfield, New York
Pate Eng, New York
Monica F. Eulitz, New York
Monika Faber, Vienna
Richard L. Feigen, New York
Jutta and Wolfgang G. Fischer, Vienna
Stefania Frezzotti, Rome
Georg Gaugusch, Vienna

Philipp Gutbrod, New York

Doede Hardeman, The Hague

Ellen Harvey, Brooklyn

Jean-Noël Herlin, New York

Paul Herring, New York

Stéphane Houy-Towner, New York

Laura Howell, New York

Michael Huey, Vienna

Agnes Husslein, Vienna

Charles Janoray, New York

Hans Janssen, The Hague

Michael Lesh, New York

Glenn Lowry, New York

Jane Kallir, New York

John Kallir, New York

Peter de Kimpe, Amsterdam

Wolfgang Kos, Vienna

Hansjörg Krug, Vienna

Elizabeth S. Kujawski, New York

Sophie Lillie, Vienna

Meg Malloy, New York

Pia Mayer, Vienna

Nancy McClelland, New York

Teresa Marchesani, Vienna

Sandy Markman, New York

Thomas Matyk, Vienna

Georg Mayer, Vienna

Katja Miksovsky, Vienna

Manu von Miller, Bremen

Ben Murphy, London

Dru Muskovin, Chicago

Tobias G. Natter, Bregenz

Françoise Newman, New York

Vlasta Odell, New York

Carlo Orsi, Milan

Olivia Paradine, Vienna

Margot Pignatelli, Litchfield

Ernst Ploil, Vienna

Lars Rachen, Venice

Paulus Rainer, Vienna

Gemma Rankine, London

Jerry Rivera, New York

Cora Rosevear, New York

Rebekka Rudin, New York

Thomas Ryun, New York

Varun Sawhney, New York

Daniel von Schacky, Berlin

E. Randol Schoenberg, Los Angeles

Elisabeth Schmuttermeier, Vienna

Suzanne Scherer, Boca Raton

Wolfgang Schermer, Zell am See

Kerstin Schmidt, Berlin

Patrick Seymour, New York

Fabienne Stephan, New York

Gerald Stiebel, New York

Barbra Streisand, Los Angeles

Sally Susman, New York

Jennifer Tonkovich, New York

Kathleen Tunney, New York

John Vinci, Chicago

Julia Wachs, New York

Alfred Weidinger, Vienna

Christian Witt-Dörring, Vienna

Agnieszka Wojdylo, New York

Christine Zehner, New York

Tom Zoufaly, New York

CONTENTS

Gustav Klimt, 1914. Photograph by Anton Josef Trčka, bromine silver print. Private Collection

Josef Hoffmann, Seal for Gustav Klimt, ca. 1907–09, executed by the Wiener Werkstätte in gold-plated silver and malachite. Private Collection

Rudolf Herrmann, *Caricature of Gustav Klimt, Oskar Kokoschka, and Karl Kraus, after Klimt's painting "Medicine,"* ca. 1910, black ink and gouache over graphite on paper. Neue Galerie New York

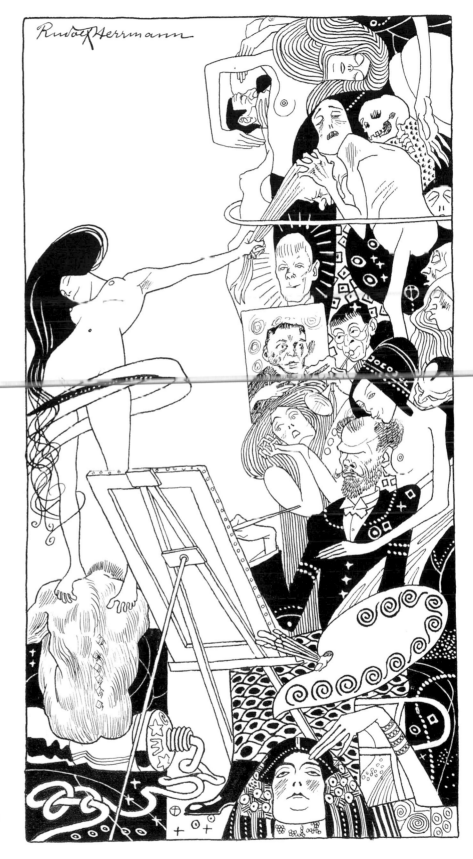

NOTE FROM THE EDITOR

The exhibition *Gustav Klimt: The Ronald S. Lauder and Serge Sabarsky Collections* presents a cross-section of Klimt paintings and drawings selected from the outstanding collections of the co-founders of the Neue Galerie New York. The exhibition catalogue, with fascinating essays by leading scholars, contains new art historical research on the artist's life and work. In keeping with the Neue Galerie's interest in the American reception history for German and Austrian artists, Klimt exhibitions and museum holdings in the United States are fully documented. We also present a mere glimpse of this artist's enormous impact on contemporary culture, from high to low.

It is extraordinary to see how the demand for Klimt has grown in this country. In the decades following his death, there was virtually no American interest in the artist. His reputation gradually began to grow in the 1960s, with Klimt eventually reaching cult status. He is now internationally recognized as a major figure of twentieth-century art. The Viennese master, who never ventured to our shores, would certainly have been proud.

I am grateful to our esteemed authors, whose essays bring fresh insights to their chosen subjects; and especially to our President, Ronald S. Lauder, who has consistently demonstrated the depth of his commitment to the art of Gustav Klimt, and who recently drew worldwide attention with his acquisition, on behalf of our museum, of Klimt's iconic painting, *Adele Bloch-Bauer I* (1907). As a result, the Neue Galerie has become the premiere destination outside Austria for admirers of the art created by this complex and very private man.

Renée Price
New York City
June 2007

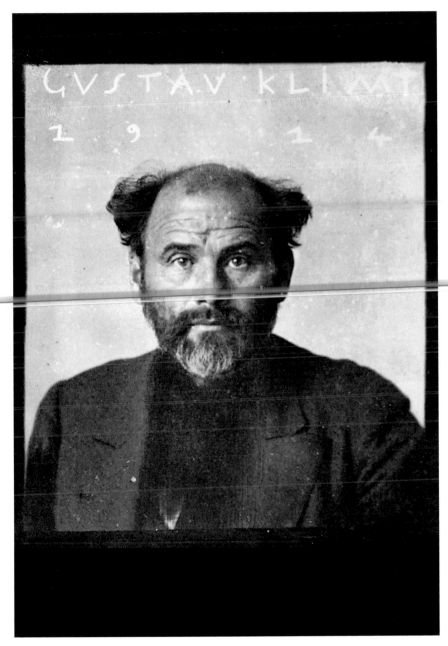

Gustav Klimt, 1914. Photograph by Anton Josef Trčka,
bromine silver print. Private Collection

DEDICATION

This publication is dedicated to Estée Lauder.

Estée understood the power of beauty to transform lives. She possessed an abiding love for the art of Gustav Klimt, seeing in it a perfect reflection of an elegant, bygone era. Her spirit continues to radiate, and her influence becomes more evident with every passing year. She is greatly missed.

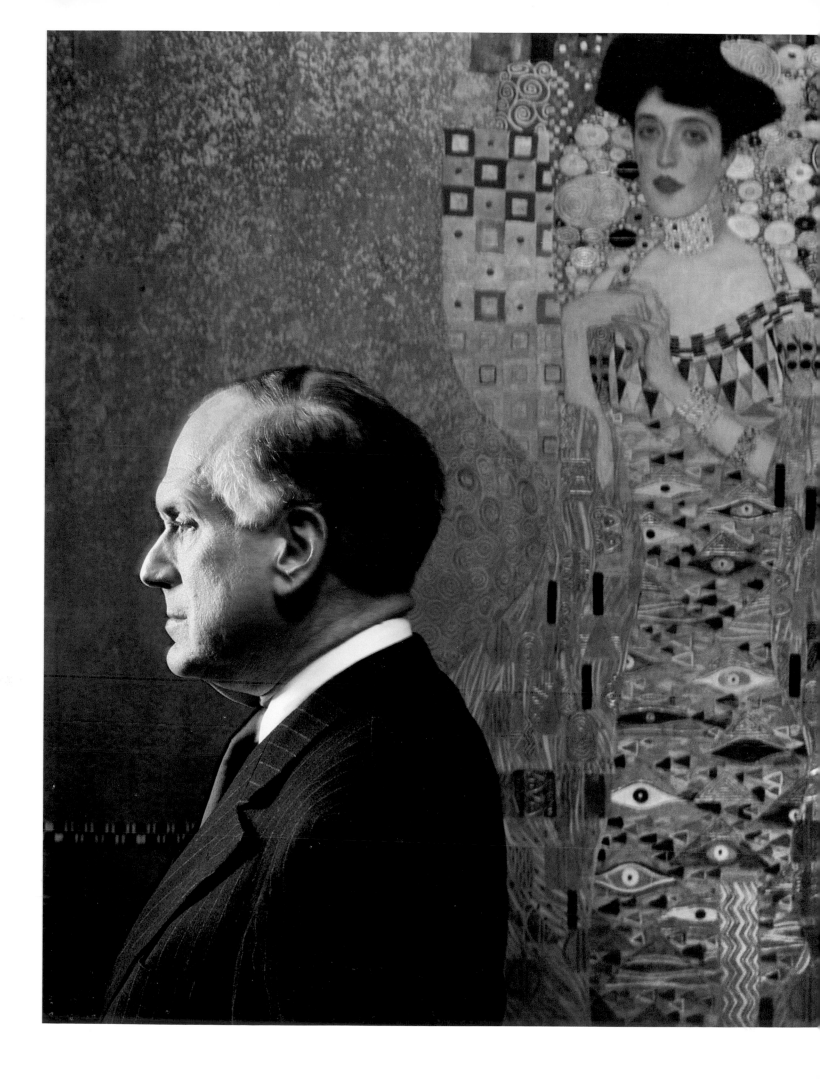

RONALD S. LAUDER

Discovering Klimt

I will never forget the sight of it: Gustav Klimt's 1907 masterpiece *Adele Bloch-Bauer I*, arriving at the Neue Galerie New York, the museum I co-founded with my good friend, the late Serge Sabarsky.

The painting arrived late at night, surrounded by a full security complement: police cars cordoning off 86th Street. My heart was racing as the enormous crate was trundled in by a team of art handlers. A day later, after the painting had had a chance to become acclimatized to its new surroundings, the crate was opened. And there she was: exquisite, regal, serene, the gold inlays that adorn her dress shining. As well as I knew this painting, I still felt a kind of ecstatic shock seeing it at the Neue Galerie for the first time.

This was an event I could not have predicted when I first laid eyes on Adele, some thirty-seven years ago. I was fifteen years old, and had taken a train from Paris to Vienna and checked into the Hotel Bristol. Art collecting had entered my life two years earlier, and was quickly becoming a consuming passion. I had already discovered the work of Egon Schiele, and had even acquired a drawing by the artist. Now I was determined to learn about the whole world of fin-de-siècle Vienna—of which, I knew, Klimt was a kind of patron saint.

I arrived in Vienna at 5:30 pm, too late to go the Österreichische Galerie Belvedere, the magnificent museum that housed the most important works by Klimt and Schiele. I was so eager to see the collection that I barely slept that night. First thing the next morning I walked from my hotel to the Belvedere, arriving before it opened. I was the first person to enter the museum that day.

I was entranced by the museum's extraordinary holdings, but when I walked into the room where the *Adele Bloch-Bauer I* was hanging, I was stopped in my tracks. She seemed to epitomize turn-of-the-century Vienna: its richness, its sensuality, and its capacity for innovation. I felt an intense personal connection to this woman, and with the man who had captured her so beautifully on canvas. This

Ronald S. Lauder standing with Gustav Klimt's 1907 *Adele Bloch-Bauer I*, January 2007. Photograph by Steve Pyke

was the beginning of a fascination—with Klimt and with this most famous muse of his—that has lasted through the years. As my collecting interests deepened, I urged my own family to acquire works by Klimt, which I felt were not being given their due admiration in the art world. My mother, Estée Lauder, eventually acquired several major Klimt paintings, including *Pale Face* (*Bleiches Gesicht,* 1903), *The Park of Schloss Kammer* (*Schlosspark Kammer*), ca. 1910, and *Forester House in Weissenbach on the Attersee* (*Forsthaus in Weissenbach am Attersee*, 1914). These were to become some of the key works in the collection of the Neue Galerie.

When I was appointed Ambassador to Austria in 1986, my interest in Klimt and his peers intensified. At the time, a groundbreaking exhibition, *Traum und Wirklichkeit*, had recently opened in Vienna, and interest in the artist and his world was becoming widespread. I was delighted to be able to help bring a version of this show to The Museum of Modern Art in New York, and to see others sharing my passion for the art and architecture of Vienna around 1900.

Around this time, I also became very involved in the issue of art restitution—specifically the return to the original owners of art plundered by the Nazis. My own efforts dovetailed with a larger movement to provide more information on this long-hidden subject, and culminated in the Mauerbach sale at Christie's in 1996, which was undertaken on behalf of the Federation of the Jewish Community of Austria, and which benefited the victims of this massive theft. In 1998, I spoke before the United States Congress as part of an effort to raise awareness of restitution in this country. Even then, I never dreamed that I would play a role in the return of the golden Adele and other Klimt paintings to the heirs of the Bloch-Bauer family—or that I would one day be standing beside them as Adele took her place at her new home in New York.

Now *Adele Bloch-Bauer I* is perhaps the most cherished painting in the collection of the Neue Galerie, and a source of fascination and delight for people from around the world. One hundred years after Klimt immortalized her, Adele has the ability to summon an entire world, along with all the faces and places of that extraordinary era. When I gaze at this picture, I seem to fall under the seductive spell it first cast on me so many years ago, and I am almost magically transported back to Vienna. I am very happy to be able to share this feeling with visitors to the Neue Galerie New York, and to know that future generations, long after my time, will be able to enjoy the creative spirit embodied by Gustav Klimt.

FEBRUARY 1900 TEN CENTS

THE LADIES' HOME JOURNAL

FROM A PAINTING BY GUSTAV KLIMT

THE CURTIS PUBLISHING COMPANY, PHILADELPHIA

LONDON: 10 NORFOLK STREET, STRAND, W. C. THE ENTIRE CONTENTS OF THIS MAGAZINE COPYRIGHTED IN GREAT BRITAIN AS WELL AS IN THE UNITED STATES. ALL RIGHTS RESERVED
THE CENTRAL NEWS COMPANY, PHILADELPHIA, GENERAL AGENTS

RENÉE PRICE

Gustav Klimt and America

In the summer of 2006 the Neue Galerie New York acquired the Gustav Klimt masterwork *Adele Bloch-Bauer I*. This monumental acquisition was reported on the front page of the *New York Times* on June 19, 2006. The ensuing wide media coverage—much of it focusing on the amount paid for the painting (thought to be the highest to date for a work of art)—brought Klimt's name new currency in the early twenty-first century. Klimt's 1907 portrait of a Viennese socialite was described as "half-queen, half–Las Vegas show girl. The perfect New Yorker" [Fig. 9]. This addition to the museum's collection brought Klimt to a new peak of recognition in the United States. But the artist was not always so popular in this country.

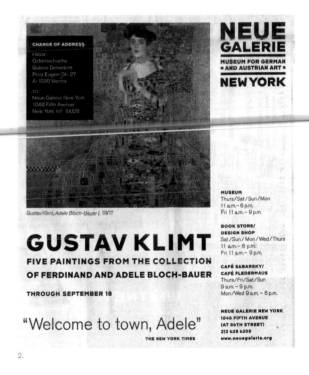

Gustav Klimt, *Adele Bloch-Bauer I*, 1907

GUSTAV KLIMT

FIVE PAINTINGS FROM THE COLLECTION OF FERDINAND AND ADELE BLOCH-BAUER

THROUGH SEPTEMBER 18

"Welcome to town, Adele"

THE NEW YORK TIMES

2.

BEGINNINGS

Despite his status as a revered son in his native Austria, Gustav Klimt was little known in the United States during the first half of the twentieth century (although his painting *Love* [*Liebe*, 1895] was used five years after it was created as a cover illustration for the *Ladies' Home Journal* in 1900) [Fig. 1]. Architect Josef Hoffmann's design for the Austrian pavilion of the 1904 St. Louis World's Fair was scheduled to feature the artist's work; unfortunately, what was to be Klimt's debut American showing was canceled for political reasons [Fig. 4].[2]

The only known notation Klimt himself ever made concerning America is in his last notebook, of 1917. There, on June 2, he entered in his usual abbreviated manner: "*männ*[licher] *Amerikane*[r]"[3]—"male American"—a cryptic message, perhaps referring to a male model who had either been in America or was of American descent. The possibility that Klimt was referring to an American collector in Vienna would seem unlikely, as the notebook dates from the time of World War I, when few Americans were venturing into Austria.[4] As far as we know, Klimt never aspired to visit America—indeed, he did not care for travel in general.

1. Cover of *Ladies Home Journal*, February 1900, commercial lithograph. Santa Barbara Museum of Art

2. "Welcome to Town, Adele," advertisement in the *New York Times*, July 2006

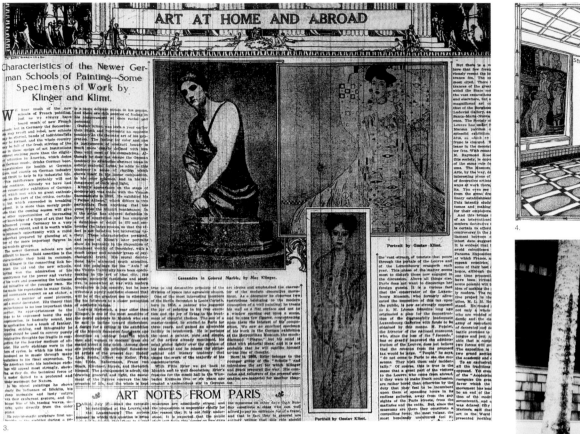

3.

4.

5.

3. "Art at Home and Abroad," *New York Times*, August 4, 1912

4. Josef Hoffmann, proposed design for the Klimt room at the Louisiana Purchase International Exposition, St. Louis, Missouri, 1904

5. Fritz Waerndorfer in Florida, 1914. MAK–Austrian Museum of Applied Arts/Contemporary Art, Vienna

In the early years of the twentieth century, despite Klimt's celebrity at home, his name was so little known on American shores that he was mistakenly lumped in with the "German School" with his first mention in the *New York Times*, in August 1912. There the golden *Adele Bloch-Bauer I* portrait was reproduced for the first time in an American newspaper [Fig. 3]. It was noted in the article that thus far Klimt's paintings had not attracted "more than the slightest attention in America."[5]

Indirectly, however, Klimt did enable a close friend and active participant in the Viennese avant-garde to emigrate to America. A few months before the outbreak of World War I, Fritz Waerndorfer [Fig. 5], a textile industrialist and the principal financial backer of the Wiener Werkstätte until 1914, sold seven Klimt paintings from his collection and bought a farm in Florida from the proceeds.[6] Waerndorfer in turn would play the part of strategist in the market for Klimt paintings in the United States.

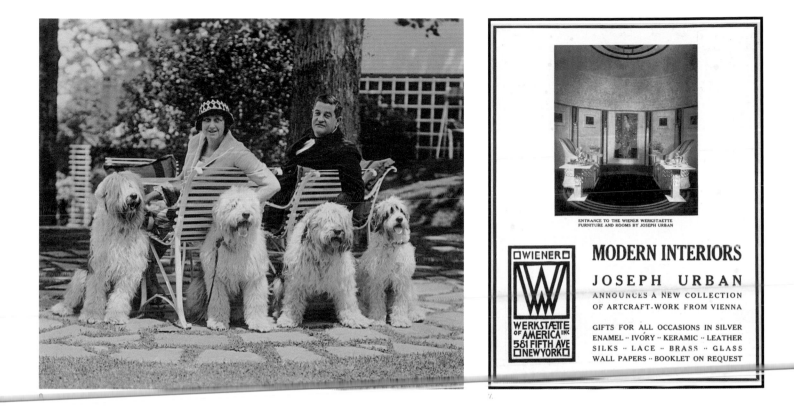

ENTRANCE TO THE WIENER WERKSTAETTE
FURNITURE AND ROOMS BY JOSEPH URBAN

☐WIENER☐
W
W
WERKSTÆTTE
ᴼᶠAMERICAᴵᴺᶜ
581 FIFTH AVE
☐NEWYORK☐

MODERN INTERIORS

JOSEPH URBAN
ANNOUNCES A NEW COLLECTION
OF ARTCRAFT-WORK FROM VIENNA

GIFTS FOR ALL OCCASIONS IN SILVER
ENAMEL ·· IVORY ·· KERAMIC ·· LEATHER
SILKS ·· LACE ·· BRASS ·· GLASS
WALL PAPERS ·· BOOKLET ON REQUEST

GROWING PRESENCE

Joseph Urban [Fig. 6], the Viennese architect and designer, initially introduced Klimt's art to New York when he opened his elegant Fifth Avenue showroom of the Wiener Werkstaette (so spelled in the United States) in June 1922—only four years after the painter's death. Urban owned the unfinished painting *The Dancer* (*Die Tänzerin*, 1916–18), which remained unsold at the showroom; he also had a set of twenty-four lithographic reproductions of Klimt's works (from a portfolio titled *Das Werk Gustav Klimt 1914–1918*), which were framed and hung around *The Dancer* in the showroom's reception area, and were not for sale[7] [Fig. 7].

A year prior to this earliest presentation of Klimt's work on U.S. soil, Urban had suggested to Philipp Häusler, the managing director of the Vienna headquarters of the Wiener Werkstätte, to publish monographs on Klimt, Josef Hoffmann, and Egon Schiele in the United States, in order to better acquaint Americans with these Viennese creative forces.[8] Urban's marketing idea was not realized, and Klimt remained largely unacknowledged, even once his work was offered for sale in New York. Urban's wife, Mary, initiated a special Klimt-Hoffmann Fund in yet another effort to spread the artist's name—this scheme, too, met with no success.[9]

In a 1924 letter to the designer Eduard Josef Wimmer-Wisgrill (an advocate of Klimt's work, then based in Chicago), Waerndorfer advised:

6. Joseph and Mary Urban with sheepdogs in the garden of their Yonkers home, mid-1920s. Columbia University Libraries, Rare Book and Manuscript Library, New York

7. Advertisement from *The News Picture of Society* showing Joseph Urban's original configuration of the reception room for the Wiener Werkstaette of America, 1922

LEIPZIGER KUNSTVEREIN
im Museum der bildenden Künste

LEIPZIGER KUNSTVEREIN
im Museum der bildenden Künste

Postscheck-Konto: Leipzig No. 33132
Fernsprech-Anschluß No. 20 186

LEIPZIG, den 21.Aug.1927.
Augustusplatz 6

An

Herrn Hugo Adolf B e r n a t z i k ,

W i e n , XIX,
Steinfeldgasse 2.

Sehr geehrter Herr Bernatzik,

Zurückgekehrt von meiner Reise finde ich Ihre Anfrage vom 28.Juli vor. Es ist natürlich ausserordentlich schwierig, unter den heutigen Verhältnissen einen K l i m t zu verkaufen, da das Interesse an seiner Kunst doch gegenwärtig nicht mehr so lebendig ist. Desgleichen ist es ausserordentlich schwer, einen bestimmten Preis für ein Bild festzulegen, da Klimt-Bilder fast nicht mehr gehandelt werden. Ich hatte mich kürzlich, wie ich Ihnen seinerzeit schon mitteilte, für den Verkauf eines Klimt-Portraits eingesetzt und habe an sämtliche grossen amerikanischen Sammlungen geschrieben, diese Angelegenheit hatte aber absolut keinen Erfolg. Vielleicht wenden Sie sich in Wien einmal an Herrn Gustav Nebehay, Hotel Bristol, der Ihnen über die Preisbildung, bezw. Marktlage

8A.

von Klimt-Bildern am besten Auskunft geben kann, da er meines Wissens als guter Freund Klimts früher sehr viel Klimt-Bilder gehandelt hat. Wenn Sie sich bei Herrn Nebehay auf mich berufen, bin ich überzeugt, dass er Ihnen die entsprechende Auskunft gibt.
Ich verbleibe mit den besten Empfehlungen

Ihr ganz ergebener

8B.

9.

8. Letter from the Leipziger Kunstverein to Hugo Adolf Bernatzik, August 21, 1927. Private Collection

9. Otto Kallir, ca. 1950s. Courtesy Galerie St. Etienne, New York

Undertake NOTHING regarding the sale of paintings by Klimt in Chicago. You will have endless troubles and inconvenience, and you will sell NO Klimts in Chicago, and then in Vienna they will say that you failed to sell anything by Klimt simply because you were unable to get enough money by this means. Whatever you do, wait until Chicago of its own accord declares that it dearly desires to have a picture by Klimt.[10]

Three years later, the situation had not improved. On July 5, 1927, Waerndorfer wrote to Wimmer-Wisgrill again:

Do you really believe that a Klimt can be sold in America? Of course, I know nothing about the N[ew] Y[ork] art market—who are the buyers, etc.—but then only the old classics command steadily rising prices.... Well, if there really should be an attempt to sell Klimts here, I'm afraid they are going to be disappointed.[11]

The Austrians were not the only ones having difficulty rousing interest for Klimt in the United States. A letter dated August 21, 1927, from Dr. Werner Teupser of the

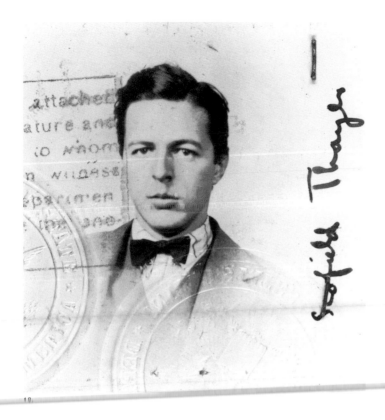

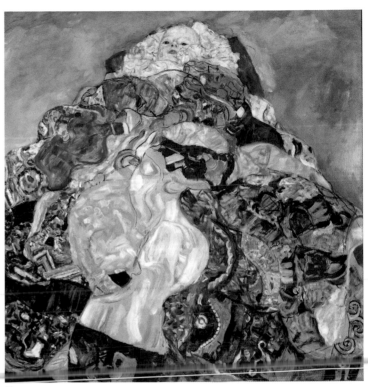

Leipziger Kunstverein to Hugo Adolf Bernatzik in Vienna, reports on the great challenge of selling Klimt paintings, and an unsuccessful attempt to place a Klimt portrait painting into an American collection [Fig. 8].[12]

American Klimt collectors in the 1920s were few and far between. Scofield Thayer, editor-in-chief of the influential Boston magazine *The Dial* (and a patient of Sigmund Freud's in Vienna during the 1920s), may well have been the first American to acquire his work on this side of the Atlantic [Fig. 10].[13]

Otto Kallir [Fig. 9], a Viennese immigrant who had operated a successful art gallery in Vienna, opened his Galerie St. Etienne in New York in 1939. Kallir was the first dealer who actively and systematically sought to create a market for Klimt in America.[14] Three Klimt paintings, listed as *Park in Upper Austria*, *Pear Tree*, and *The Attersee near Salzburg*, were shown as part of the group show *Saved from Europe*, presented in the summer of 1940 at the Galerie St. Etienne. The *New York Times* observed the influence of French artists Paul Signac and Claude Monet in Klimt's work.[15] The *New York World Telegram* continued the *New York Times*'s 1912 "German School" gaffe, describing Klimt as a "considerably less well-known contemporary German artist."[16]

Kallir cultivated the unreceptive American cultural terrain by shrewdly placing Klimt canvases in three important museum collections: in 1956, he donated the painting

10. Scofield Thayer, 1921. Passport photograph, courtesy Yale Collection of American Literature, Beinecke Rare Book and Manuscript Library

11. Gustav Klimt, *Baby (Cradle)*, 1917–18, oil and tempera on canvas. National Gallery of Art, Washington, D.C.

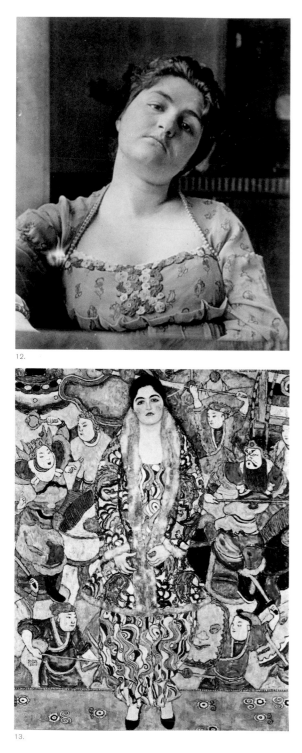

12.

13.

12. Friederike Maria Beer-Monti, 1910s.
Courtesy Wolfgang Georg Fischer Archive, Vienna

13. Gustav Klimt, *Friederike Maria Beer-Monti*, 1916, oil on canvas. The
Mizne-Blumental Collection, Museum of Art, Tel Aviv

Pear Tree (*Birnbaum*, 1903) to Harvard University's Fogg Art Museum in
Cambridge, Massachusetts; in 1957 Kallir sold *The Park* (ca. 1910), through
Gertrud A. Mellon, to The Museum of Modern Art in New York. (The two works were
then valued at less than five thousand dollars each.) And in 1960 the Carnegie
Museum of Art in Pittsburgh bought Klimt's painting *Orchard (Garden Landscape)*
(*Gartenlandschaft*), executed before 1910, also from Kallir. Almost twenty years
later, Kallir—steadfast and true to his mission to champion the works of Austrian
artists in the United States—would donate Klimt's 1917–18 painting *Baby (Cradle)*
(*Baby [Wiege]*, 1917–18) to the National Gallery of Art in Washington, D.C. [Fig. 11].

In 1959 the Galerie St. Etienne organized an exhibition of works by Klimt,
ushering in the market for the artist's work in America. The reason for the late
date of this first solo show was that few oil paintings by Klimt had made their way
over the Atlantic, and Kallir prudently felt that a show of drawings would not have
sufficient impact as an introductory event. Although he had included works by
Klimt in many shows prior to this, the first of the artist's drawings that Kallir
succeeded in selling was in 1957, to The Museum of Modern Art, for $120. At the
1959 St. Etienne exhibition, the prices of drawings were slightly higher, ranging
from $250 to $350. One landscape canvas sold for $8,000.

Not surprisingly, the lenders to this show were mostly immigrants from Vienna
who had come to America in the late 1930s. They included Kallir himself;
Friederike (Federica) Maria Beer-Monti [Fig. 12], who had brought her 1916 Klimt
portrait [Fig. 13] with her to New York;[17] Mary Urban (widow of Joseph, who died
in 1933); Mrs. Charles Black (sister of Mary Urban); Mrs. Adalbert Greiner; Alma
Mahler-Werfel [Fig. 15]; Mr. and Mrs. André Mertens [Fig. 17]; and Adolf Tersch.
For this solo exhibition, New York's Museum of Modern Art loaned their recently
acquired painting *The Park*.

American collectors who owned Klimts in the early 1960s included Lillian
Langseth Christensen [Fig. 16], Edith Neumann and Hannah Spitzer (the
daughters of Viennese lawyer and art collector Alfred Spitzer), Richard Murray,
Otto Fleischmann, Alice M. Kaplan, and Bruce Goff [Fig. 18]. The architect Frank
Lloyd Wright for a time owned the 1909 painting *Old Woman* (*Alte Frau*) [Fig. 14].
But Klimt was by no means universally appreciated; his drawings were tersely
described by one critic in 1960 as "feathery and nervous in line, influenced by
Toulouse-Lautrec."[18] Still, by 1964 his better drawings were selling for as much
as $1,200—a tenfold price increase in less than a decade. And when the Galerie
St. Etienne mounted an exhibition in 1971 focusing exclusively on the artist's
drawings, the prices ranged between $2,000 and $4,000.[19]

On the American museum front, Peter Selz [Fig. 19] curated the first Art Nouveau
survey at The Museum of Modern Art in New York in 1960.[20] Klimt was among

14.

15.

16.

17.

18.

14. Gustav Klimt, *Old Woman*, 1909, oil on canvas. Private Collection, courtesy Christie's, New York

15. Alma Mahler, ca. 1905. Photograph by Madame d'Ora Studio, Paris

16. Lillian Langseth Christensen, ca. 1930s

17. Mrs. André Mertens (center) at the dedication of the André Mertens Galleries for Musical Instruments at the Metropolitan Museum of Art, with Dr. Emanuel Winternitz, Curator of Musical Instruments, and Mrs. Loretta Hynes Howard, December 11, 1969. The Metropolitan Museum of Art, New York

18. Bruce Goff in Chicago, ca. 1930s. Bruce Goff Archives, Ryerson and Burnham Archives, The Art Institute of Chicago

many artists featured in this show, which included his 1909 painting *Judith II* (*Salome*). Thomas M. Messer [Fig. 20], the director of the Solomon R. Guggenheim Museum, organized the 1965 exhibition *Gustav Klimt and Egon Schiele*, the first large-scale presentation of Klimt's work in the United States.[21] Messer had previously shown Klimt's work in Boston, where he had served as director of the Institute of Contemporary Art.[22] The Guggenheim exhibition drew mostly favorable reviews for Klimt—but not all of the critics were impressed: Anthony West, in a March 1965 review in the *Washington Post*, lambasted the show as an attempt to "float two Viennese second-raters," and went so far as to characterize Klimt's 1907–08 painting *The Kiss (Der Kuss)* as revealing "the essence of the vulgar fraud that his 'art' truly was."[23]

But even such harsh condemnation could not slow the juggernaut of interest in Klimt's work. The Guggenheim exhibition incited a new dialogue among European and American scholars of German and Austrian modernism, and was a decisive moment for Klimt's reception on our continent. In the same year, Kallir sold the painting *The Dancer*, once owned by Joseph Urban, for $50,000. This was a record price for a major Klimt canvas, a number that would not be surpassed for several years.

Richard Davis [Fig. 21], director of the Minneapolis Institute of Art, was a great connoisseur of German and Austrian art, and had introduced the work of Oskar Kokoschka to the United States. Davis owned several Klimt drawings and added others to his museum's collection.[24]

Yet another Viennese immigrant, Serge Sabarsky [Fig. 22], the co-founder of the Neue Galerie and longtime associate of Ronald S. Lauder, entered the New York art scene in 1968. At his gallery at 987 Madison Avenue, Sabarsky presented Klimt's paintings and drawings on numerous occasions. He identified with the artist's love of women and his distaste for highbrow art historical interpretations, adhering to Klimt's mandate that the artist should be assessed on the virtue of his art alone—in Klimt's words, "the only thing that matters."[25]

In 1978 The Museum of Modern Art in New York, hoping to upgrade to a better Klimt, arranged to sell *The Park* to Sabarsky for $500,000. The museum had its sights on the 1907–08 canvas *Hope II* (*Die Hoffnung II*), which the museum and its advisers deemed a more important work historically. Lauder persuaded Sabarsky to return the landscape to the museum and agreed to cover the difference between the price of *The Park* and that of *Hope II*—but some of the trustees were reluctant to choose between the two works. Eventually, The Museum of Modern Art managed to raise the funds to retain both canvases.

19. Peter Selz, 1958

20. Thomas M. Messer, 1960s

21. Richard Davis, late 1950s

22. Serge Sabarsky, 1980s

23. Gustav Klimt, *Portrait of Elisabeth Bachofen-Echt*, 1914–16, oil on canvas. Private Collection, courtesy Neue Galerie New York

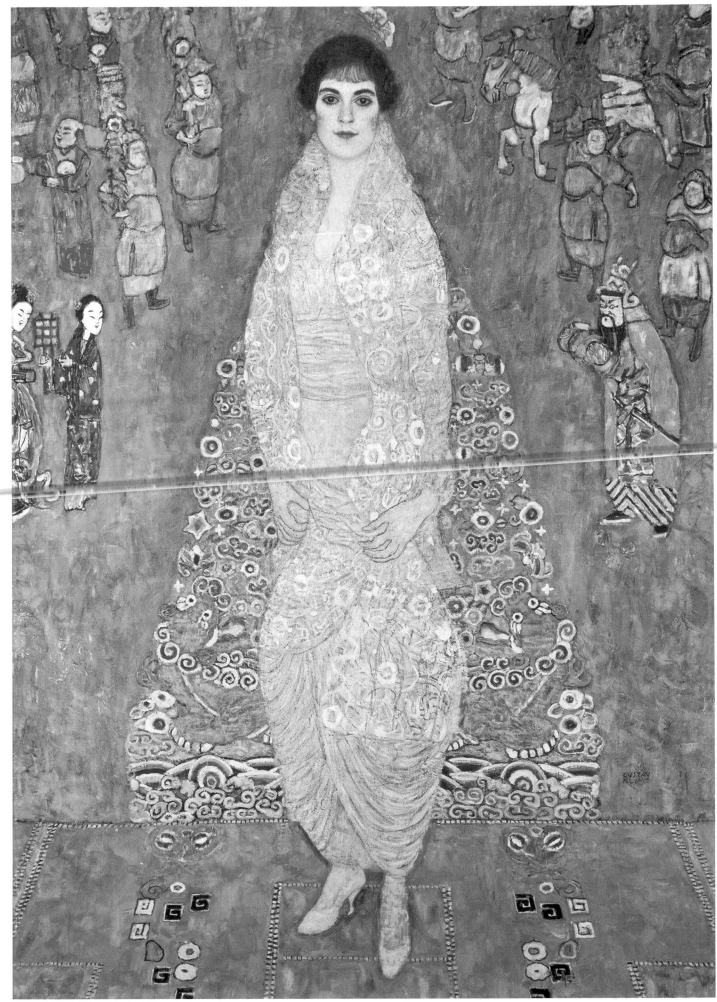

23.

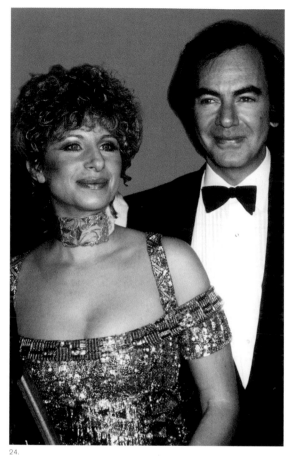

24.

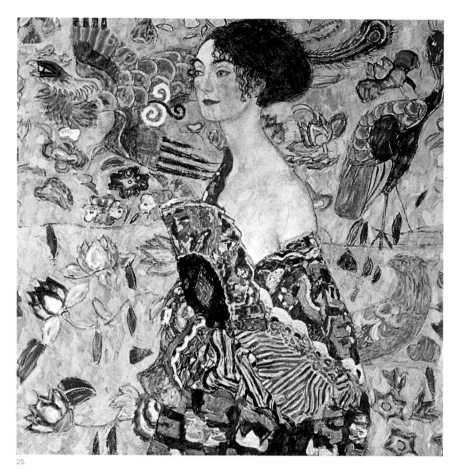

25.

26.

24. Barbra Streisand with Neil Diamond, 1984.
Steisand is wearing a dress designed by Ray Aghayan

25. Gustav Klimt, *Lady with a Fan*, 1917–18, oil on canvas.
Private Collection

26. Gustav Klimt, *Litzlbergkeller on the Attersee*, 1915–16,
oil on canvas. Private Collection

Later, Sabarsky, weary of the demands of a commercial gallery, devoted himself to organizing traveling museum shows. In 1981 he curated the first Klimt exhibition ever mounted in Japan, setting off a powerful wave of interest in fin-de-siècle Austrian art in the country.[26] Another Sabarsky production, *Gustav Klimt: 100 Drawings*, toured through Europe during the 1980s, and was presented at the Nassau County Museum on Long Island in June 1989.[27]

Sabarsky's passion for the work of Klimt never wavered, and his desire to obtain the artist's elusive paintings was intense. In the mid-1980s he placed the *Portrait of Elisabeth Bachofen-Echt* [Fig. 23] into a New York private collection. One of his greatest regrets was to have underbid at the 1994 sale of Klimt's *Lady with a Fan* (*Dame mit Fächer*, 1917–18) [Fig. 25], which brought $11,662,000. Sabarsky did own Klimt's 1915–16 oil painting *Litzlbergkeller on the Attersee* (*Litzlbergkeller am Attersee*) [Fig. 26], which was sold at the 1997 auction of his estate for about $14,742,000. Sabarsky once confessed that Klimt's works, along with those of Schiele and Kokoschka, were "without question the hardest…to let go of."

The well-known actress and singer Barbra Streisand [Fig. 24] became an important Klimt collector. In 1969, she and her then-husband, the actor Elliott

26

Gould, bought several Klimt drawings at the Galerie St. Etienne. Streisand also once owned the Klimt painting *Ria Munk on her Deathbed* (*Fräulein Ria Munk auf dem Totenbett*, 1911–12). Her admiration for the work of the artist spanned several decades. The glamorous gown (seen in Fig. 24) that Streisand had designed in 1984, and which she wore to an awards ceremony, was clearly inspired by the dress in Klimt's 1907 portrait of Adele Bloch-Bauer.

Over the years, American scholars, too, had been taking a keen interest in the literature, music, politics, psychoanalysis, architecture, fine arts, and applied arts of Vienna 1900. At the University of California's Berkeley campus, a center dedicated to the study of turn of-the century Austrian art was established in the early 1960s. Herschel B. Chipp organized the exhibition *Viennese Expressionism 1910–1924* at the University Art Gallery there in 1963—the first West Coast showing of the work of Klimt, Kokoschka, and Schiele. One of the University of California graduate students, art historian Alessandra Comini [Fig. 27], contributed significantly to Klimt scholarship. Her revelatory monograph *Gustav Klimt* (1975) was among the first publications about the artist to appear in English, and introduced the master of Vienna's Jugendstil to a large audience.[28] Carl E. Schorske, a historian and member of the Berkeley center [Fig. 28], contributed articles about Klimt to the *American Historical Review* starting in 1961; these texts were collected and published twenty years later in his seminal survey *Fin-de-siècle Vienna: Politics and Culture*.[29] And since 1978, the Galerie St. Etienne's co-directors Hildegard Bachert and Jane Kallir [Fig. 29],[30] have relentlessly carried on the work of Otto Kallir (Jane's grandfather), the founder of the gallery and a crucial advocate of the artist's work.[31]

Three figures based in the United Kingdom have played important roles in Klimt's American reception: British scholars Nicolas Powell[32] and Peter Vergo,[33] and the Viennese-born art historian, dealer, and writer Wolfgang Georg Fischer [Fig. 30]. Fischer worked in London at the Marlborough Gallery until establishing his own Fischer Fine Art gallery. He was well acquainted with American clients, dealers, and museums, and his publications and exhibitions have had a great impact on the Klimt market and general interest.[34]

By the early 1970s, Klimt had become practically a household name. Reproductions of his work—especially posters of *The Kiss* (*Der Kuss*, 1907–08)—decorated college dormitory rooms across the country (in this function, Klimt's biggest rival was probably Claude Monet). The Austrian's dreamy symbolism, psychedelic seas of ornamentation,[35] and intertwining themes of life, death, and sexuality struck a chord in the American zeitgeist. The great social upheavals of the 1960s—the era of counterculture, free love, LSD, "flower power," and disillusionment with the Vietnam War—gained momentum and eventually changed the social structures in the United States fundamentally. By the 1970s the

27. Alessandra Comini, 1975. Photograph by Raiberto Comini. Neue Galerie New York, Gift of Alessandra Comini

28. Carl E. Schorske, 1966

29. Jane Kallir, 1995. Photograph by Carol Rosegg

30. Wolfgang Georg Fischer, ca. 1990s. Courtesy Wolfgang Georg Fischer Archive, Vienna

31. Kirk Varnedoe, at the opening of the *Vienna 1900* exhibition at The Museum of Modern Art, June 30, 1986. Photograph by Jeanne Trudeau

32.

33.

34.

32. Colin B. Bailey, ca. 2004

33. Emily Braun, ca. 2000. Photograph by
Jeannette Montgomery Barron

34. "Klimt für Österreich" (Klimt for Austria) poster, 2006

American psyche was newly receptive to Klimt's overt and covert messages. The painter's influence was seen in every level of creative and commercial endeavor, from the work of artists and designers to the mass-productions of trinket-makers. His organic and geometric décor was translated into other media (see "Klimt and Contemporary Culture" in this volume), and a multimillion-dollar mass industry for kitsch was set in motion (see "Klimt in the Popular Sphere").

Another milestone in Klimt's U.S. presence was the blockbuster 1986 exhibition *Vienna 1900* at New York's Museum of Modern Art, an integrated overview of turn-of-the century Viennese culture, curated by the late Kirk Varnedoe [Fig. 31]. In an unprecedented act, the Austrian state permitted one of its most prized art treasures, Klimt's *The Kiss*, to travel across the Atlantic Ocean for this seminal exhibition, in acknowledgment of Klimt's significance and the importance of the American venue. The artworks and cultural artifacts exhibited in the show became all the rage in New York, and attracted many new collectors to the market.

Indeed, by the late 1980s that market had grown exponentially, and Klimt's work was a central feature of it. In the arena of the artist's drawings, those depicting his favorite subjects—beautiful women and erotic nudes—attracted the highest prices.[36] Klimt's oil paintings, considered by scholars and collectors to be his greatest artistic achievements, rarely appear on the market; when they do, their prices tend to reflect the low supply and accumulated demand. By 1987, Klimt's painting *Schloss Kammer on the Attersee II* (*Schloss Kammer am Attersee II*, 1909) brought more than five million dollars at auction. In an extraordinary jump, ten years later, the same painting was sold for a hammer price of more than twenty-three million dollars.

The 2001 exhibition *Gustav Klimt: Modernism in the Making* at the National Gallery of Canada in Ottawa was the first one-person show of the artist's work to be mounted at a museum in North America.[37] It was organized by Colin Bailey [Fig. 32] (now chief curator of New York's Frick Collection); the exhibition catalogue included contributions from Emily Braun [Fig. 33], professor of art history at Hunter College in New York City.[38] And in the summer of 2002, *Gustav Klimt: Landscapes* opened at the Clark Art Institute in Williamstown, Massachusetts. The record-breaking attendance for the show of only twelve canvases was evidence that Klimt's reputation was now sealed in the American mind.[39]

Yet—in all modesty—few events have had a greater impact on Klimt's reputation in the United States than the opening of the Neue Galerie New York in November 2001. The objective of our institution from the start has been to collect, preserve, study, and exhibit fine art and decorative arts of Germany and Austria from the first half of the twentieth century, and to trace the development of modernism in these and other European cultures. Naturally, Klimt has been absolutely central to

35.

35. *Amerika ich komme!* (America, here I come!), drawing by Viennese fifth-grader Laura I lof, 2006. Courtesy Bundesgymnasium und Bundesrealgymnasium Wien 3

this mission since the museum's beginnings. The cover of our inaugural exhibition catalogue was graced by Klimt's *The Dancer*—which had been the first painting by the artist ever shown in the United States, at Urban's Wiener Werkstaette of America. A rotating collection of works by Klimt has been permanently on view at the Neue Galerie, seen by close to one million people who have visited the museum in its first five years of existence.

Klimt's name has recently been linked to art restitution (see Sophie Lillie's essay on Gustav Klimt and his patrons in this volume). A landmark decision was reached in January 2006 by three Austrian judges to return five Klimt paintings, which had been on view at the Österreichische Galerie Belvedere for more than sixty years, to their rightful heirs. The art world was stunned by the news. The Austrian government refused to buy back the paintings, even though the heirs, descendants of the Bloch-Bauer family, offered them for a favorable amount. A private initiative was formed (recalling the valiant efforts of the Klimt-Hoffmann Fund of the 1920s): the Österreichische Kulturstiftung (Austrian cultural foundation), with the intention of collecting and preserving Austria's cultural heritage, and raising the necessary funds to keep at least two of the paintings in Austria [Fig. 34]. But their efforts were to no avail. Maria Altmann (Adele Bloch-Bauer's niece) and her family offered Klimt's portrait *Adele Bloch-Bauer I* to Ronald S. Lauder, president of the Neue Galerie New York. The other four paintings were sold at auction in New York in November 2006. It would seem that Klimt's well-deserved international fame is at long last firmly in place [Fig. 35].

I extend my thanks to Alessandra Comini, whose deep knowledge and encourage-ment have been invaluable; to Jane Kallir, for generously opening the archive of the Galerie St. Etienne and sharing her knowledge of the American Klimt art market; and to Paul Asenbaum, Ernst Ploil, and Christian Witt-Dörring for their ongoing support.

NOTES

1 Michael Kimmelman, "The Face that Set the Market Buzzing," *New York Times*, July 14, 2006, p. E1.

2 The Vereinigung bildender Künstler Österreichs (Association of fine artists) did not wish to show favoritism toward the Vienna Secession. See Christian M. Nebehay, *Gustav Klimt: Dokumentation* (Vienna: Galerie Christian M. Nebehay, 1969), p. 346. In Berta Zuckerkandl's interview with the artist (see Appendix I), Klimt states: "The same feelings of anxiety led to the abrupt rejection of the exhibition project I designed for the Secession in St. Louis."

3 For further information on Klimt's 1917 notebook, see Hansjörg Krug's essay in this volume.

4 Hansjörg Krug has confirmed this assumption in correspondence with the author.

5 "Characteristics of the Newer German School of Painting—Some Specimens of Work by Klinger and Klimt," *New York Times*, August 4, 1912.

6 See Peter Noever, ed., *Der Preis der Schönheit: Hundert Jahre Wiener Werkstätte* (Stuttgart: Hatje Cantz, 2003), p. 228. I am grateful to Christian Witt-Dörring for this reference.

7 Works by Klimt were offered in Vienna during the artist's lifetime, directly through Klimt; at exhibitions, in limited-edition publications, or (from 1904–17) through his dealer, the Galerie Miethke. After the artist's death in 1918, Gustav Nebehay became the successor to the Galerie Miethke. Recorded prices for drawings started in 1906 at 160 kronen; by 1910 that amount had doubled. Painting prices started at about five thousand kronen, a portrait would command ten thousand kronen. At the height of Klimt's career, painting prices had reached as high as 15,633 kronen. *Three Ages of Woman* (*Drei Lebensalter*, 1905) was sold to the Galleria Nazionale d'Arte, Rome (see Tobias G. Natter, ed., *Die Galerie Miethke*, exh. cat. [Vienna: Jüdisches Museum, 2003], pp. 248–56). Hansjörg Krug has kindly provided the rate of exchange: one krone in 1906 would be the equivalent of about ten U.S. dollars today.

8 Estate of Philipp Häusler, Wiener Stadt- und Landesbibliothek, card catalog no. ZPH833, 1(220/1–4), file WW Amerika WW Wien: letter from Joseph Urban to Häusler dated August 25, 1921. I am grateful to Paulus Rainer for this reference.

9 Noever, *Der Preis der Schönheit*, p. 322. The U.S.-sponsored Klimt-Hoffmann Fund was initiated to collect the recent work of Austrian artists.

10 Fritz Waerndorfer to Eduard Josef Wimmer-Wisgrill, October 24, 1924. Quoted in Renée Price, ed., *New Worlds: German and Austrian Art 1890–1940* (New York: Neue Galerie New York, 2001), p. 55, n. 43.

11 Printed with the permission of Fritz Waerndorfer's family, courtesy of John Kallir, who translated the correspondence. I thank Jane Kallir for bringing this to my attention.

12 Paul Asenbaum located this document from the Bernatzik family in Vienna, for which the author is most grateful.

13 The Dial Collection—containing forty-five examples of works on paper from the Viennese avant-garde, including nine Klimt drawings—was shown in May 1960 at New York's Galerie St. Etienne. These drawings were given to the Metropolitan Museum of Art, New York in 1982 as part of the Bequest of Scofield Thayer.

14 See Jane Kallir, "Otto Kallir and Egon Schiele," in Renée Price, ed., *Egon Schiele: The Ronald S. Lauder and Serge Sabarsky Collections* (New York: Neue Galerie New York, 2005), pp. 47–65.

15 "A Reviewer's Notebook," *New York Times*, June 30, 1940, section C, p. 7.

16 June 29, 1940, courtesy of the exhibition scrapbooks of the Galerie St. Etienne.

17 Friederika Maria Beer-Monti was the only subject to be painted in oil by both Egon Schiele and Gustav Klimt.

18 Dore Ashton, "Art: Austrian Draftsmen," *New York Times*, May 3, 1960, p. 79.

19 Jane Kallir generously provided this information from the Galerie St. Etienne's archive.

20 The exhibition *Art Nouveau* was presented at New York's Museum of Modern Art, June–September 1960, and subsequently traveled to the Carnegie Institute, Pittsburgh, the Los Angeles County Museum of Art, and the Baltimore Museum of Art, where it ended its tour on May 15, 1961.

21 This exhibition was inspired by Fritz Novotny at the Österreichische Galerie Belvedere in Vienna, and was supported by Otto Kallir.

22 See Thomas M. Messer, "Schiele's Earliest Museum Exhibitions in the United States," in Price, ed., *Egon Schiele*, pp. 69–71.

23 Anthony West, "Museums Hang 'Spring Line,'" *Washington Post*, March 28, 1965, p. G1.

24 Margot Pignatelli, Richard Davis's daughter, kindly provided this information and the photograph of her father.

25 Klimt's full quotation: "Whoever wants to know something about me as an artist—and that is the only thing that matters—must look attentively at my paintings…and glean from them who I am and what I want." Translated in Christian M. Nebehay, *Gustav Klimt: From Drawing to Painting* (New York: Abrams, 1994), p. 284.

26 *Gustav Klimt*, Isetan Museum of Art, Tokyo, January 29–February 24, 1981.

27 *Gustav Klimt: 125 Drawings,* Nassau County Museum of Fine Art, Roslyn, New York, June 2–October 14, 1989.

28 In recognition of her cultural contribution, Alessandra Comini received the Grand Decoration of Honor from the Republic of Austria in 1990.

29 Carl E. Schorske, *Fin-de-Siècle Vienna: Politics and Culture* (New York: Knopf, 1980).

30 Jane Kallir is a noted art historian in her own right, and author of numerous books about fin-de-siècle Austrian artists, among them *Gustav Klimt: 25 Masterworks* (New York: Abrams, 1995).

31 For details on the many presentations of Klimt's work at the Galerie St. Etienne over the years, see the listing of U.S. Klimt exhibitions in these pages.

32 Nicolas Powell is the author of *The Sacred Spring: The Arts in Vienna 1898–1918* (London: Studio Vista, 1974).

33 Peter Vergo is the author of *Art in Vienna 1898–1918: Klimt, Kokoschka, Schiele, and their Contemporaries* (London: Phaidon, 1975 [rev. ed. 1993]), and of "Gustav Klimts *Philosophie* und das Programm der Univsersitätsgemälde," in *Mitteilungen der Österreichischen Galerie, Klimt Studien*, vol. 22/23, nos. 66/77, 1978–79, pp. 69–100.

34 Wolfgang Georg Fischer is the author of *Gustav Klimt und Emilie Flöge: Genie und Talent, Freundschaft und Besessenheit* (Vienna: Brandstätter, 1987), published in English in 1992 as *Gustav Klimt und Emilie Flöge: An Artist and His Muse* (Woodstock, NY: Overlook Press).

35 Kirk Varnedoe was the first to point out Klimt's "affinities with psychedelic imagery of the 1960s." See Varnedoe's essay in *Vienna 1900: Art, Architecture and Design* (New York: Museum of Modern Art, 1986), p. 158.

36 More than four thousand of Klimt's drawings have been accounted for by Alice Strobl and her successor, Marian Bisanz-Prakken. Unlike Egon Schiele's drawings, however, Klimt's are almost exclusively studies for paintings, and therefore judged to be subordinate in the artist's oeuvre.

37 *Gustav Klimt. Modernism in the Making*, National Gallery of Canada, Ottawa, June 15–September 16, 2001.

38 Emily Braun has undertaken extensive research on Klimt through her study of the painter's influence on early twentieth-century Italian artists. She co-curated, with Emily D. Bilski, *The Power of Conversation: Jewish Women and their Salons* at the Jewish Museum, New York, March 4–July 10, 2005, and co-authored (with Bilski) an essay on Berta Zuckerkandl for that show's catalogue. Braun is also curator of the Leonard and Evelyn Lauder collection.

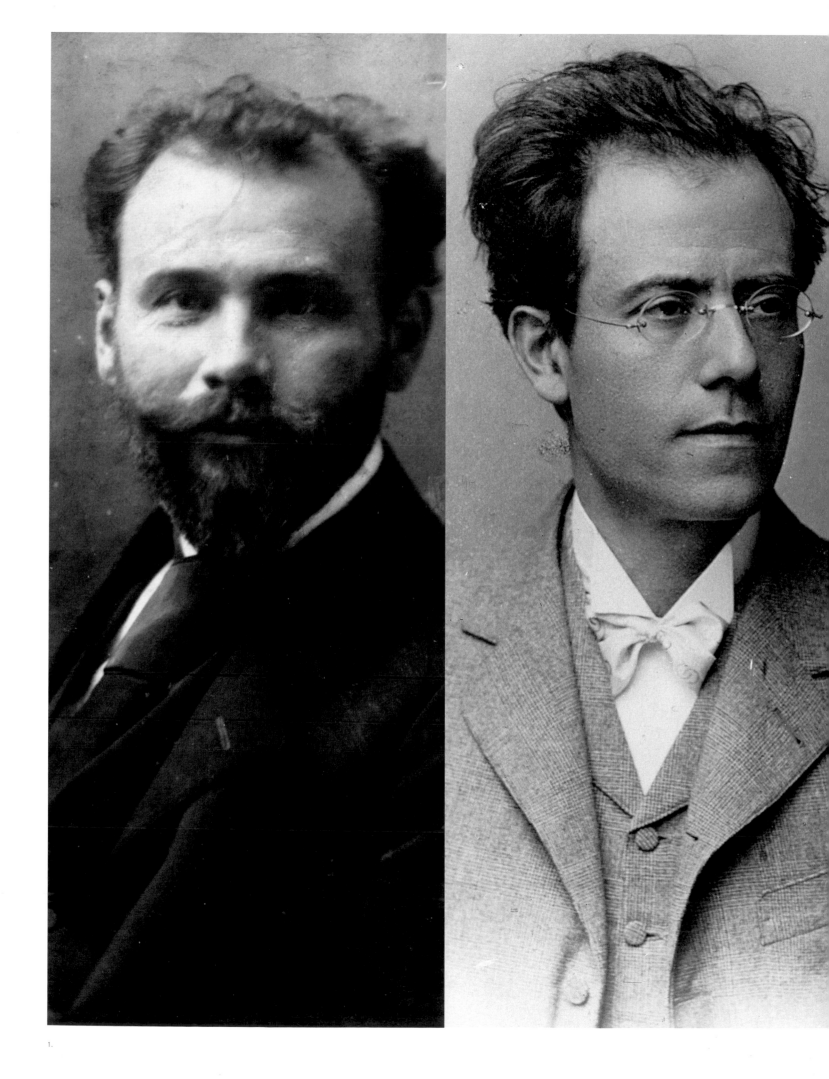

ALESSANDRA COMINI

The Two Gustavs

Klimt, Mahler, and Vienna's Golden Decade, 1897–1907

The ten years spanning 1897 to 1907 comprised in many respects Vienna's golden decade, as nineteenth-century Alt Wien metamorphosed (albeit sometimes with heels dragging) into twentieth-century Neu Wien. The decade commenced dramatically with the founding, on April 3, 1897, of the city's breakaway artists' association, the Secession, which had the thirty-four-year-old Gustav Klimt—Vienna's most renowned Art Nouveau painter—as its first president. Five days later, the thirty-six-year-old Gustav Mahler arrived in Vienna, his reputation as a formidable conductor preceding him, to take his post as the new director of the imperial Hofoperntheater (Court Opera Theater). That glittering decade of far-reaching change concluded with Klimt's defiant exhibition of his three controversial allegories, the faculty paintings for the University of Vienna, *Philosophy, Medicine,* and *Jurisprudence* (*Philosophie*, 1900–07; *Medizin*, 1901–07; and *Jurisprudenz*, 1903–07), at private galleries in Vienna and Berlin rather than at the Secession, from which he himself had seceded two years earlier. And in December 1907, plagued by nonstop intrigue and hostile (often anti-Semitic) press reviews, Mahler departed the Hofoper for New York's Metropolitan Opera. In the years between, a host of revelatory events illumined the cultural and political forces at work in Austria—influences that would ignite Expressionism in the arts and catch the Hapsburg Empire off-guard with the outbreak of World War I. The careers of Klimt and Mahler were touched by these forces in strikingly parallel ways, and both men were part of a stellar cast of characters—from Alma Schindler to Sigmund Freud—that moved inexorably across the revolving stage of Kaiser Franz Josef's imperial Vienna.

The painter was a self-indulgently sensual man (he fathered several children but never married); the musician was cerebrally emotional (he precipitously proposed marriage to a former inamorata of Klimt's, the ravishing young Alma Schindler)—still, the two Gustavs had much in common, although throughout their decade-long acquaintance they were never really close friends, due largely to the Alma factor. Both came from extremely humble backgrounds. Klimt, born second of seven children in a Vienna suburb in 1862, was the son of an artisan who eked

He is an attractive fellow—
one can have no idea what a free spirit he is.
—Alma Schindler on Gustav Klimt, June 1898

I knew him well by sight; he was a small,
fidgety man with a fine head.
—Alma Schindler on Gustav Mahler, November 1901

1. Opposite left, Gustav Klimt (1862–1918), ca. 1900.
Courtesy Asenbaum Photo Archive, Vienna
Opposite right, Gustav Mahler (1860–1911), ca. 1890, Bildarchiv der Österreichischen Nationalbibliothek, Vienna

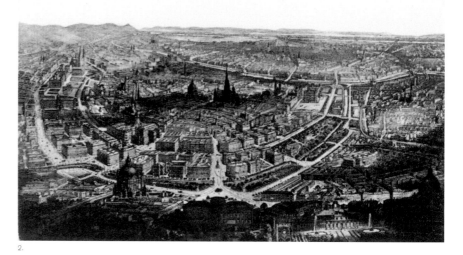

2.

2. Postcard showing a bird's-eye-view of Vienna's Ringstrasse shortly before 1900. Wiener Stadt- und Landesarchiv, Vienna

out a meager living as a gold engraver. Along with his younger brother Ernst, he attended not the traditional Akademie der Bildenden Künste (Academy of Fine Arts), but the recently founded Kunstgewerbeschule (School of Applied Arts), where his precocious talent for drawing was recognized and he was encouraged to specialize in mural decorations, thus giving him an early taste for allegory.

Mahler, born two years earlier in Bohemia—then a Slavic stronghold of Franz Josef's Austro-Hungarian Empire—was the second child of a Jewish peddler-turned-distillery-owner who would father fourteen children, seven of whom died in infancy. Such attrition was hardly unusual for the nineteenth century. But the early deaths of cherished siblings (Klimt's younger sister Anna at the age of five, his painting-partner brother Ernst at twenty eight; Mahler's younger brother Ernst at thirteen, the suicide of another, Otto, at twenty two) did incline both men's thoughts toward the riddle of life and death. Indeed, this would become an enduring thematic obsession in their work. Mahler's childhood was spent in Iglau, a center of Bohemia's German-speaking population, with a military garrison and ubiquitous band concerts. At the age of four, his acute musicality was already evident. Grimly determined to turn Gustav into a piano virtuoso, his father sent him to the demanding music conservatory in Vienna, where he was soon regarded by his fellow students as another Franz Schubert.

Arriving in the bustling capital at the impressionable age of fifteen, Mahler witnessed firsthand what Klimt and his fellow citizens were experiencing: completion of the broad horseshoe-shaped boulevard encompassing Vienna's inner city, the Ringstrasse [Fig. 2], with its great private palaces, opera house (the first significant structure to be completed, 1861–69), museums, theater, and university—some of which Klimt would soon be commissioned to decorate. The Ringstrasse became Vienna's most impressive self-portrait: a colossal,

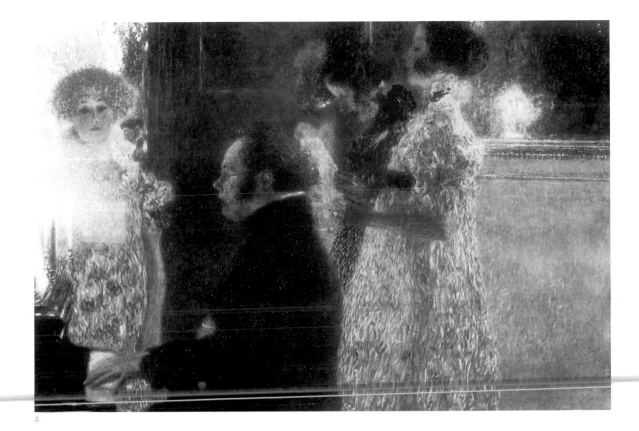

3.

continuous architectural façade proclaiming the ancient Hapsburg dynasty's historical preeminence and might.

Four years later, on Sunday, April 27, 1879, the national addiction to façade and spectacle climaxed in the painter Hans Makart's extravagant Festzug, a historical pageant along the Ringstrasse involving three thousand paraders and thirty floats in front of almost a million spectators. This five-hour event crowned the city's celebration of Kaiser Franz Josef's silver wedding anniversary. Klimt was entrusted with some of the painterly details, reinforcing his tendency toward the decorative. It is likely that Mahler, who had given a piano concert featuring Schubert's *Wanderer Fantasy* back home in Iglau a few days earlier, missed this collective national fantasy, but the gigantism of the Makart age could not but leave its grandiose imprint on his musical memory and emerge in his symphonic structures. When, after nearly a quarter of a century of *Wanderjahre*, he returned to the capital to assume his ten-year directorship of the Hofoper, in April of 1897, it was no longer Makart's Vienna—Alt Wien—that greeted him, but that of Klimt's avant-garde Secession—Neu Wien.

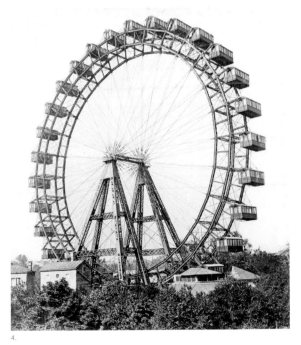

4.

From 1897 on, the most egregious symbol of that New Vienna was the Riesenrad (giant Ferris wheel) [Fig. 4] piercing the skyline from its perch in the Prater, the city's vast amusement park. Erected at the cost of one million kronen as part of

3. Gustav Klimt, *Schubert at the Piano*, oil on canvas, 1898–99. Destroyed by fire in 1945

4. The giant Ferris wheel in Vienna's Prater amusement park, ca. 1900

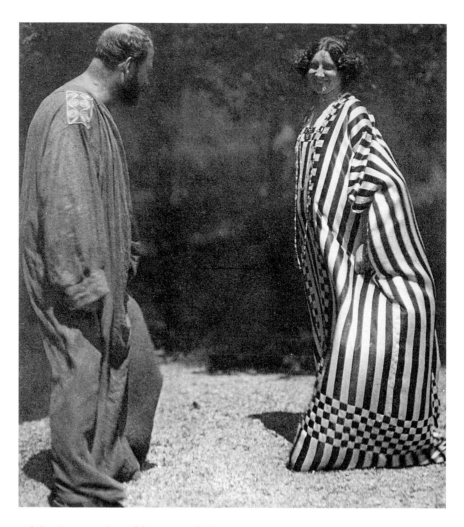

5. Gustav Klimt and Emilie Flöge in the garden of the
Villa Oleander on the Attersee, 1910. Photographer unknown.
Neue Galerie New York

celebrations marking fifty years of Franz Josef's reign, it became within months a magnet for dramatic statements. Wishing to draw public attention to the economic disparity between classes, a desperately poor woman, Marie Kindl, hanged herself from the window of one of the pendant cabins as the Riesenrad mindlessly repeated its majestic six-minute orbit before horrified onlookers below. Such poverty was the embarrassing underbelly of Franz Josef's Vienna, usually kept under wraps as the city concentrated on its exterior image of *Gemütlichkeit*, elegance, and well being.

Another anniversary—one somewhat less prone to drama—observed by Vienna in 1897 was the centennial of the birth of the city's native son, Schubert. This event had already engaged Mahler as conductor: just before returning to Vienna, he led Schubert's *Unfinished Symphony* in Hamburg. Klimt would be commissioned by the millionaire industrialist Nikolaus von Dumba, a collector of Schubert ephemera, to create an image of the composer as a *supraporte* [Fig. 3] for the music room of his palatial residence on the Ringstrasse, the study of which had already been decorated by the flamboyant Makart. Completed in 1899, the nearly 5-by-6½-foot

canvas (destroyed by fire in 1945) became an Austrian cult icon virtually overnight. It presented an appealing candlelit scene of quintessentially Viennese *Hausmusik.*[1] Klimt eschewed the traditional frontal portrait bust for a profile, waist-length view of the composer in a drawing-room setting. Bespectacled, earnest, and lit by the candelabra facing him, Schubert is shown seated at a piano on the left side of the canvas. Facing out from behind the piano keyboard, radiant and rigidly attentive, is a pretty female admirer (posed for by Marie ["Mizzi"] Zimmermann, one of the artist's models and mother of two of his children). Behind the concentrating, open-mouthed composer, sheathed in long, shimmering, decoration-flecked gowns suggesting both Biedermeier and Jugendstil fashion, stand two more young women in profile holding a sheet of music, ready to sing the lied being played. To their right can be seen an older man with prominent nose and jutting jaw, Klimt's recognizable homage to Schubert's stately Hofoper-singer friend Johann Michael Vogl. (Could the only other male presence, the miniscule profile of a young man with bowed head and long sideburns, behind Mizzi's shoulder, be Klimt's patron, Dumba, who in his youth was an outstanding interpreter of Schubert songs?) Local critics Hermann Bahr, Ludwig Hevesi, and Arthur Roessler enthusiastically lauded the pictorial Schubertiad as having captured a uniquely Austrian genius (seen as gentle and "feminine," as opposed to aggressive, "masculine" German genius). Color reproductions of this "ultimate" Austrian work by the nation's "new Makart" were soon published and eagerly bought by the public.

6. The nineteen-year-old Alma Schindler posing with bearskin, 1899. Österreichische Staatsbibliothek, Bildarchiv, Vienna

As for the identity of the two female singers, intriguing double-entendre readings could be inferred by those knowledgeable about the private lives of Schubert and Klimt (both demonstrated an almost maniacal fear of matrimony, and both lifelong bachelors seem to have contracted that dreaded disease of the nineteenth century, syphilis). Schubert's purported infatuation with one of Count Móric Esterházy's daughters may have inspired Klimt to present the two earnest singers behind Schubert as the Esterházy sisters, Carolina and Marie. But it is equally feasible to see in the two figures a ready allusion to Klimt's (probably) platonic love of twenty-seven years, the fashionable salon proprietor and dress designer Emilie Flöge, and her sister Helene; the latter had married the artist's brother Ernst eight years earlier. The loose gowns worn by the two singers in the painting suggest the non-binding *Reformkleider* ("reform clothing") that would be touted by the Flöge sisters' shop and enthusiastically adopted by Klimt, who designed for himself a blue, full-length smock—his proverbial "monk's robe." A telling photograph captures Gustav and Emilie facing each other outdoors and reveling in the freedom of their flowing "reform" garb [Fig. 5].

Yet another overlay comes into play when we note that Klimt was at work on this simpatico portrayal of Schubert surrounded by female admirers during the period of his own short-lived but ardent pursuit of the very intriguing nineteen-year-old Alma Schindler [Fig. 6].

Alma's parents were Emil Jakob Schindler, Austria's most prominent landscape painter, and his wife, Anna Sofie Bergen. Schindler died when his daughter was not quite thirteen, and six years after his death a life-size marble effigy of him was unveiled in Vienna's Stadtpark—an event attended by Klimt. Accustomed to being the child of someone important, Alma was shockingly outspoken, demandingly curious, widely if randomly read, trained in piano and composition, and possessed of a vibrant, willful personality that projected through intoxicating blue eyes. Anna was remarried, to Carl Moll, Klimt's close colleague and fellow founder of the Secession; Alma reluctantly put up with her mother's new husband. "The poor woman," she wrote, "there she went and married a pendulum, and my father had been the whole clock!"[2] She cast about for other prominent men who might compare with her father. "Klimpt," as she spelled his name in her first diary[3] references to him, was just the ticket—"already famous at thirty-five, and strikingly good-looking."[4] The attraction was mutual and the setting convenient—Moll's new house on the fashionable Hohe Warte in Vienna's nineteenth district on the edge of the Wienerwald, a regular meeting place of the rebel artists who had planned the Secession. Alma's mother, fully aware of Klimt's many relationships with women, observed the escalating flirtation with apprehension, making it her business never to leave her headstrong teenage daughter alone with the artist.

Schubert would provide the breakthrough. In the spring of 1899, at a private viewing the day before the opening of the Secession's fourth exhibition (March 18–May 31), now in its own handsome, golden "cabbage"-domed structure designed by Joseph Olbrich facing the Karlsplatz—Gustav managed to be alone with Alma. Offering to show her his latest work, he steered her past the life-size figure of his red-haired *Nuda Veritas* with its flamboyant puff of pubic hair and toward the innocuous *Schubert at the Piano* (*Schubert am Klavier*, 1898–99). Or was it so innocuous? "Klimt took me personally to look at his 'Schubert.' It's indisputably the best picture at the exhibition."[5] What was Gustav's motivation? Certainly when Alma looked at what (likely in response to their *Reformkleider* garb) she characterized as the "ultramodern young ladies" in this painting,[6] she was unaware that she was gazing at two of Klimt's "women"—Mizzi on the left and, in all probability, Emilie on the right. Was Gustav's intention to demonstrate the potentials of physical love? (Mizzi gave birth to her first son by him that August; another son had been born by yet another of Klimt's young models the month before.) Or the desirability of multiple loves? We can't know, as Alma's diary, usually so chatty, is silent on the issue. More likely, Gustav was simply eager to show that, despite the modest social standing of his family background as compared to Alma's, he was capable of appreciating and empathetically entering into her rarified world of culture, including classical music.

This seems to have worked. Alma confided to her diary that "our common, deeply vital musicality ... helped attune us to each other."[7] ... followed up a flattering

"Happy Easter" postcard that Klimt mailed to Alma while she was in Italy with her family during early April. It was a doctored commercial drawing of a slender young woman, hair swept up in a bun (like Alma's), surrounded by eleven admiring little toy sheep on wheels. The girl clasps her hands coquettishly below her chin. A single word printed on her long dress reads "Alma." The hat-adorned sheep are identified with the first and final initials of their surnames—all decipherable as regular visitors to the Moll household. One of them bears the meaningful designation "K—t."[8]

The K—t or "Klimt affair" (Alma's term) reached its climax when Gustav, as always, followed the call of his libido and accepted Moll's somewhat naïve invitation to join the family in Italy at the end of April. (Hence enacting in real life the title of one of Johann Strauss's most fetching waltzes, "My Life Course Is Love and Desire.") A surreptitious kiss was exchanged in Alma's hotel room in Genoa, then in Venice in early May Gustav asked for Alma's photograph of herself "with the bear" [Fig. 6]. She handed it over, the next day agitatedly demanded it back, then two days later remorsefully relented. Such erratic conduct could not fail to be noticed. A suddenly indignant Moll confronted them both separately and by May 4 the chastised Klimt was escorted to a train back to Vienna. The denouement came on May 19, when in a desperate bid to shed the bewitching "child" Alma and retain his "dearest" colleague's friendship, Klimt—usually a man of few words—wrote Moll an extraordinary thirteen-page letter of apology, self-recrimination, and excessive self-excuse. "Your intervention made us both fully conscious that one cannot live one's life as a dream."[9] From then on Klimt behaved himself with Alma, and soon was accepted back into the family circle, eventually even back into "betrayed" (again, her term) Fräulein Alma's good graces. She could afford to be forgiving: another Gustav had entered her life—Gustav Mahler.

In a moment of interconnections that could happen only in Vienna, Klimt was present at the fateful dinner party of November 9, 1901, given by salon hostess and art critic Berta Zuckerkandl ("In meinem Salon ist Österreich," she once wrote: "In my salon is Austria"), where Mahler—then forty-one and apparently the eternal bachelor despite a previous entanglement with one of his opera singers—met the twenty-two-year-old Alma. Her "piquant" air and bold candor provoked and attracted him; by the end of the evening, after a few arguments, he was smitten—with her and with the idea of settling down. He invited Alma to bring her music compositions to the opera house the very next day, and the day after that he sent her an "anonymous" poem littered with hints as to who the author might be: "It happened overnight—I never would have believed it, that counterpoint and the study of form would once more oppress my heart—It happened overnight—I spent it wide awake."[10] Two weeks later, Gustav invited Alma and her mother to attend a performance of Gluck's *Orpheus and Eurydice,* which he would be

conducting. He met them in the opera foyer during intermission, causing vast surprise and immediate gossip. By Mahler's fourth meeting with Alma, when he arrived unannounced at Moll's Hohe Warte house on November 27—just eighteen days after the Zuckerkandl dinner—he had decided they should marry. He blurted out something that was more of a caveat than a proposal: "It's not so simple to marry a person like me. I am free and must be free. I cannot be bound, or tied to one spot. My job at the Opera is simply from one day to the next."[11] Calmly Alma accepted: she had found her father substitute (as Freud would later gently explain to Mahler), and a genius of the highest caliber to boot. And so this marriage by fiat, so replete with contrasts—youth versus middle age, Catholic versus Jew—took place, speedily as Gustav had commanded, on March 9, 1902. The ascetic Gustav had succeeded where the licentious one had not; Alma was pregnant and would give birth to a daughter, Maria Anna ("Putzi"), at the beginning of November.

■ ■ ■ ■ ■

The turn of the new century greeted the work of both Klimt and Mahler with incomprehension and hostility. For the Secession's seventh exhibition, which ran from March 8 to June 6, 1900, Klimt, commissioned by the Ministry of Culture and Education, exhibited the first of three large rectangular ceiling allegories representing the faculties of Philosophy, Medicine, and Law for the assembly hall of Vienna's imposing new Italian Renaissance–style university building facing the Ringstrasse. Certainly there was nothing remotely Renaissance about Klimt's startling conception of *Philosophy* (*Philosophie*, 1900–07) [Fig. 7]. On the left a floating human tower fecundated by embracing nude couples spirals downward from expectant new life at the top to despairing old age at the bottom. This pessimistic interpretation of Nietzsche's eternal recurrence—to what end nature's perpetual procreation? to what end life?—is flanked on the cosmos-spangled right by the questioner of this endless puzzle, a large, sphinx-like, female presence with great unseeing eyes. A gasping infant floats off to the far right while, eerily lit from below on the bottom left rim of the picture, is Knowledge, personified by a disquietingly contemporary female face, eyes orbiting upward, mouth obscured by her dark undulating coiffure. She observes the futile cycle of life above her, unwilling or unable to shed light on its purpose. Hardly a Raphaelean *School of Athens* ensemble. Not only the general public but the university professors were outraged, their volcanic complaints gleefully reported in the daily press.

As soon as the scandal of the university pictures had begun, the press cartoonists went to work. Remigius Geyling, an artist who regularly joined Klimt for breakfast at Schönbrunn's Tivoli gardens, dashed off a good-natured and indeed telling caricature showing Klimt at work on *Philosophy* [Fig. 8]. The artist is suspended high up on a narrow plank and looks down appreciatively at the red-haired female

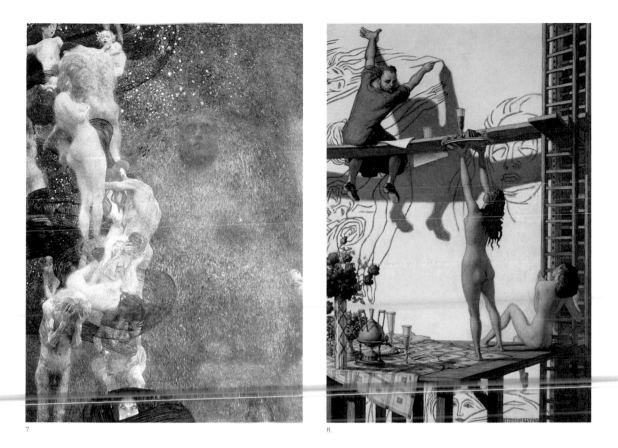

7. 8.

nude who energetically lifts up a platter of food and flute of wine to him—coincidentally inspiring the floating female nudes issuing from the artist's brush. A less sympathetic caricature by an anonymous artist of the painting itself, grossly exaggerating all the figures, appeared in the satirical magazine *Kikeriki* that same year. The fact that within a few weeks *Philosophy* received a gold medal at the 1900 Exposition Universelle in Paris did not assuage mounting indignation in Vienna. There was a parallel incongruity between the carping reception of Mahler's symphonies at home and the growing enthusiasm for his compositions abroad.

Undaunted, Klimt showed his second allegory, *Medicine* (*Medizin*, 1901–07) [Fig. 9], the following year, 1901, at the Secession's tenth exhibition (March 15–May 12). It was prominently displayed in the building's main room in a handsome, restrained setting created by the Secession artist Koloman Moser. Once again, on the right this time, a column of tangled nude humans of all ages and stages (one young woman is burstingly pregnant) writhes in somnambulistic unease. Death, a fully articulated skeleton, swirls companionably in their midst. Below, the three-quarter frontal figure of Hygeia, goddess of health, elegantly coiffed and gowned in gold and orange, holds up a small glass water bowl for the serpentine attribute coiling high on her arm. At the top of the empty left side of the panel, opposite the human knot of misery, one dreaming female drifts away, tethered to those in need

7. Gustav Klimt, *Philosophy* (final state), oil on canvas, 1900–07. Ceiling panel created for the Great Hall of the University of Vienna, destroyed by fire in 1945

8. Remigius Geyling, *Caricature of Klimt at Work on Philosophy*, watercolor, ca. 1900

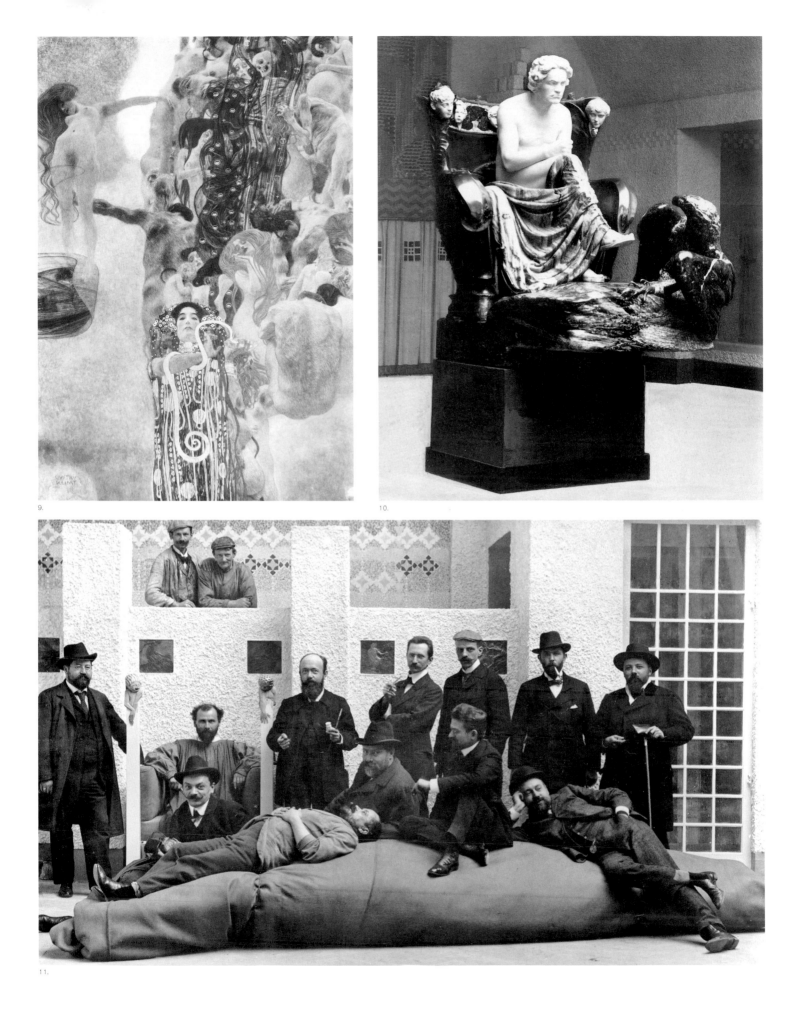

9.

10.

11.

of medicine only by one backward hovering arm and the outstretched arm of a male below her. The viewer looks up from below at this well-endowed, healthy young woman, complete with knee-length dark cascading locks, buoyant breasts, and pubic hair. This daring voyeuristic device of a perspective *di sotto in sù* (so ubiquitous in Auguste Rodin's *Gates of Hell*, Klimt's obvious inspiration) caused even greater public uproar than had the frontal (but elderly) despairing male nude in *Philosophy*. Hardly discussed was Klimt's specific setting of humankind's continuum of procreation as an unconscious dream state in which the protagonists are merely swept along by the inexorable urges of nature (in line with the artist's "helpless" infatuation with Alma). This was the same erotically charged realm to which Freud had drawn attention in his November 1899 publication (dated 1900 by his publisher in a bid for Neu Wien immediacy) *Die Traumdeutung (The Interpretation of Dreams)*—a book few read at the time but about which everyone talked knowingly.

One of the cultural highpoints of Vienna's golden decade that garnered international attention was the collaboration by Klimt and Mahler in an extraordinary multimedia event staged at the Secession in 1902. For their fourteenth exhibition (April 15–June 27) the Secession artists had decided to honor two idols, both adopted from Germany—one living and in the prime of life, the other dead for seventy-five years. The objects of this collective pilgrimage were the versatile sculptor, painter, and graphic artist Max Klinger from Leipzig, and Ludwig van Beethoven from Bonn. The purpose of the exhibition was to present a work in which all the artistic disciplines—painting, sculpture, architecture, music (which Moll asked Mahler to provide), and poetry—would be thematically combined to create a *Gesamtkunstwerk*. Never had an exhibition been so lavishly, so lovingly, so "*gesamt*-ly" prepared. A group photograph [Fig. 11] shows Klimt on a makeshift "throne" and, immediately in front of him wearing a hat, Koloman Moser, while Moll reclines on the far right. These Viennese artists created a complete interior decoration of murals, stained-glass windows, fountains, sculpture, and wall plaques as a "frame" for their guest artist's stunning, life-size, polychromatic image of Beethoven in the act of creation, with throne, mountain peak, and empyrean eagle at his feet [Fig. 10].

Two long side rooms conditioned the visitor for the Klinger climax, which had been installed, as in a temple, in the center room. The left-side hall contained a great frieze by Klimt with allegories referring to Friedrich Schiller's "An die Freude" ("Ode to Joy"), and it was in this room that Mahler assembled his musicians to perform when the Klinger statue was unveiled. He chose the closing chorus from the final movement of the Ninth Symphony and rescored it for wind and brass only. The Schiller passage he had chosen to recast from the "Ode to Joy"—"Ahnest du den Schöpfer, Welt?" (Do you sense the creator, World?)—was one that pointed to astral heights—"Such' ihn über'm Sternenzelt" ("Seek him above the starry

9. Gustav Klimt, *Medicine* (final state), oil on canvas, 1901–07. Ceiling panel created for the Great Hall of the University of Vienna, destroyed by fire in 1945

10. Max Klinger, *Beethoven Monument*, marble, ivory, marble, stone, and bronze, 1886–1902, as installed at the fourteenth exhibition of the Vienna Secession, April 1902

11. Secession artists at the opening of their fourteenth exhibition: seated on the "throne," Gustav Klimt; immediately in front of him wearing a hat, Koloman Moser; reclining on far right, Carl Moll. Photograph by Moritz Nähr, April 1902. Neue Galerie New York

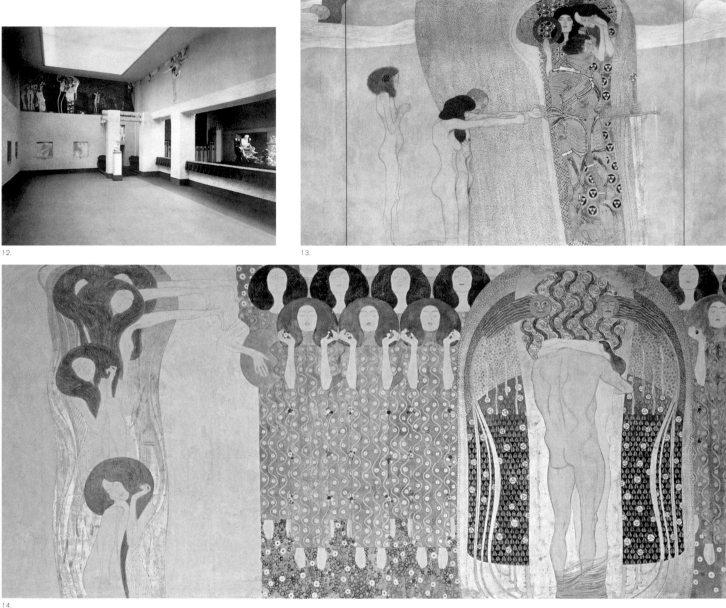

12. Gustav Klimt, *Beethoven Frieze*, casein colors on a stucco base with semiprecious stone inlay, 1902, as installed on three walls at the fourteenth exhibition of the Vienna Secession, April 1902. Klinger's *Beethoven Monument* is visible in center room on the right

13. Gustav Klimt, *Beethoven Frieze*, detail showing *The Weak Implore the Strong*, 1902

14. Gustav Klimt, *Beethoven Frieze*, detail showing *Poetry and the Kiss of Pure Love*, 1902

canopy")—very much in keeping with the Secession setting and with Klinger's Olympian conception. At the lavish private opening in the late afternoon of April 14, Mahler conducted the powerful ensemble and Alma proudly reported that with the new instrumentation the music "rang out as starkly as granite."[12]

Klimt's *Beethoven Frieze* (*Beethovenfries*) was equally impressive. Executed in casein colors on a stucco base with inlaid semiprecious stones, the imagery was divided into seven compartments that extended along the upper part of three walls—two long and one short [Fig. 12]. The long left wall was a statement of humanity's yearning for happiness [Fig. 13]: on bent knees, the weak implore the strong and a knight in golden armor is urged to take up the struggle for

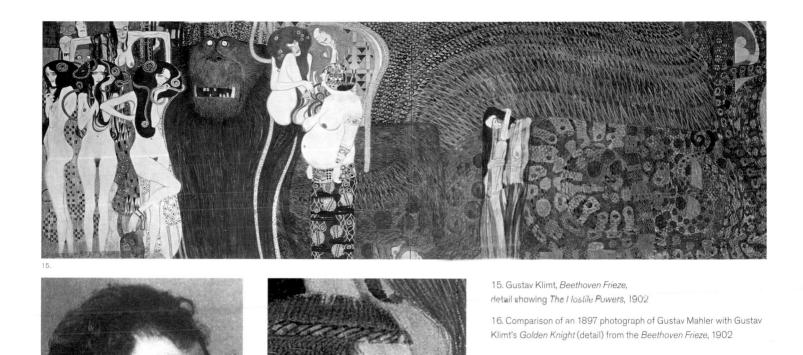

15.

16A.

16B.

15. Gustav Klimt, *Beethoven Frieze,*
detail showing *The Hostile Powers*, 1902

16. Comparison of an 1897 photograph of Gustav Mahler with Gustav
Klimt's *Golden Knight* (detail) from the *Beethoven Frieze*, 1902

happiness, "wie ein Held zum Siegen" (as a hero to victory). Facing the hero-knight on the opposite wall [Fig. 14] is what will be his consolation, Poetry and the (naked) kiss of "pure love" before a floating heavenly choir. But before he can reach this solace with its "kiss for the whole world" he must pass through an evil army of sins and vices, the Hostile Powers.

Only after encountering the gruesome realm depicted on the short wall [Fig. 15] can the hero be led to a "kingdom not of this world, but a higher one of pure joy." Klimt's schema, parallel in scope to Mahler's symphonic programs, thus takes its philosophical point of departure from the Ninth's uplifting fourth movement, but dwells for considerable motivic time in the underworld (reminiscent of the artist's juxtapositions in his university panels). Typhon, the monstrous giant, is shown as a kind of winged brown ape, with fanged jaws (the teeth were mother-of-pearl

17. Caricature from *Kikeriki*, 1902, no. 33, last page. "Mahler's Unpleasant Adventure in the Secession": "Got you at last! Just wait, you symphony-wrecker!"

insets) and far-reaching shadowy wings. On the left are his terrifying daughters, the three Gorgons, with serpents for hair, sinuous bodies, demonic, pale faces, and eyes that could turn one into stone. The horrible genealogy (or offspring) of this subterranean world is seen above the Gorgons in the wildly staring countenances of Disease, Insanity, and Death. Balancing the Gorgons on the right is the trio of sins: Indecency, Licentiousness, and bloated Intemperance (the latter a nod to Aubrey Beardsley's popular 1897 rendition of the grossly obese Ali Baba). Further along to the right against the glistening coils of an enormous snake is a contorted image that might have invited Freud's attention: "Gnawing Worry," an eloquent personification of psychic suffering. At the extreme upper right of this short wall a floating female figure with closed eyes and outstretched arms again represents humanity's longing to fly over these encumbrances. Not surprisingly, reviewers saw all this as "painted pornography" with the representation of Licentiousness belonging to "the most extreme of what the field of obscene art has ever produced."[13]

That Klimt's knight-hero might also symbolize a modern-day musician-hero—Mahler—was a visual implication [Figs. 16A, 16B] capable of being instantly appreciated in 1902. The painter's position as controversial artist subject to vicious public attacks was such that he could sincerely empathize with the composer's parallel role as isolated cultural combatant. Beethoven was the artist-messiah, and Mahler, through his intrepid interpretation of Beethoven, was the artist-warrior who would lead his listeners into an aesthetic kingdom not of this world, but on the heights.

Not everyone held this exalted view of the uncompromising opera conductor who composed symphonies on the side and had even dared several times to revise Beethoven's Ninth. A caricature from *Kikeriki* [Fig. 17] titled "Unangenehmes Abenteuer Mahler's in der Secession" (Mahler's unpleasant adventure in the Secession) pokes fun at the conductor's accumulated sins in remodeling the Ninth, and shows Klinger's Beethoven swatting the surprised maestro with his robe (revealing a fancy pair of polka-dot jockey shorts), while the angel faces on the throne jeer and the eagle at his feet squawks approvingly. Beethoven says: "Hab' ich Dich endlich! Na wart, Du Symphonieverhunzer!" (Got you at last! Just wait, you symphony-wrecker!) It was the usual fare of high praise plus hearty condemnation for Mahler, but certainly he never regretted the brief collaboration in the service of music and art that had so pleased Alma and brought him into such stimulating contact with the Secession and Klimt.[14]

A guestbook page [Fig. 18] dated September 25, 1903, with the distinctive signatures of the one and only "Alma" (no surname needed) and her two Gustavs, illustrates the fact that since his marriage to Alma, Mahler had increasingly been drawn into the circle of artists surrounding Klimt and her stepfather, Moll. One of

these artists was Alfred Roller, co-founder of the Secession, editor of the group's exquisite *Ver Sacrum* periodical, and professor at the Kunstgewerbeschule. He was also a visionary stage designer who could work miracles with light alone, eschewing naturalistic tableaux and props. He was just the man for Mahler, the opera reformer. The two immediately became close friends, and from 1903 on Mahler employed Roller for breakthrough productions of Mozart, Beethoven, and Wagner at the Hofoper (performances that their unmusical employer, the emperor, rarely attended).

Eros, both thematically and visually, had suffused Klimt's first two university paintings, *Philosophy* and *Medicine*. How would the third and final allegory address its stated theme, *Jurisprudence*? The shocking answer awaited visitors to the Secession's eighteenth exhibition (November–December 1903), which was devoted completely to a retrospective of eighty of Klimt's allegories, portraits, landscapes, and drawings. Ensconced four rooms deep within Olbrich's versatile building, the artist's three monumental university panels dominated an austere space, resonantly designed once again by Moser. Commanding center stage in *Jurisprudence* [Fig. 19] was not impartial Law but avenging Punishment! In the dock a weary, lone representative (criminal or innocent?) replaces the multifigured human towers of the previous two allegories. The haunting frontal confrontation of *Philosophy*'s sphinx and *Medicine*'s Hygeia is now multiplied. In a dark netherworld, three avenging Furies (naked, voluptuous, and inescapably modern looking) face the beholder with sinuous body stances, exuding sensuality. Their victim is the enfeebled old man, whose frailty is emphasized by his nakedness, his hands pulled behind him as a huge octopus-like creature relentlessly encases him within spangled tentacles. The center Fury is implacable, her resolute wide stare fixed and unswerving. The bright upper tier of the picture, separated from the vast dark realm below, reveals a second frontal female trio. From left to right they are the remote (literally so) personifications of naked Truth, Justice—anchored by a great long sword—and Law, identified by the "Lex" on her tablet. Below them, appearing like a mosaic's scattered tesserae, are seven disembodied miniature portrait busts of contemporary judges (recalling Honoré Daumier's cynical implications, as one critic pointed out). The tiny heads are reminiscent of the disproportionately small "Dumba" head in *Schubert at the Piano*, which was on exhibit in the same room with the allegories. Klimt's startling topsy-turvy schema clearly implies that *Jurisprudence* is impotent: remote and far removed from the fate of ordinary mortals whose suffering continues down in the real world, and whose "punishment" is rendered not by Law, not even by fate, but by avenging Furies.

Such an indictment of the law profession, accompanied by painted female figures who were blatantly "naked" rather than heroically *nude* as had hitherto befitted allegory, simply could not be tolerated. Eighty-seven professors signed a petition

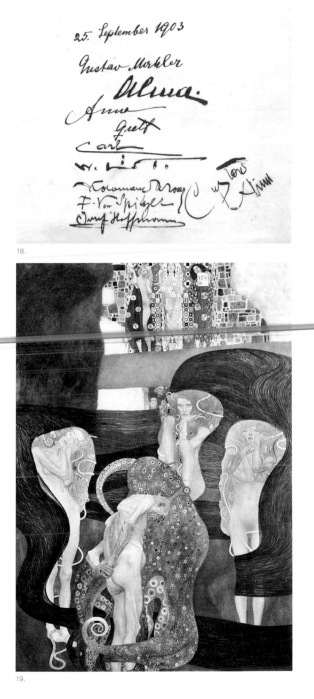

18.

19.

18. Guestbook page dated September 25, 1903, with signatures of Gustav and Alma Mahler and Gustav Klimt. Gesellschaft der Musikfreunde Archiv, Vienna

19. Gustav Klimt, *Jurisprudence*, final state, oil on canvas, 1903–07. Ceiling panel created for the Great Hall of the University of Vienna, destroyed by fire in 1945

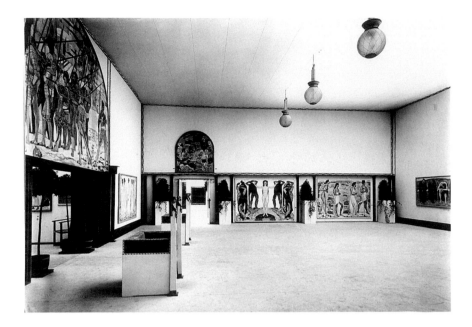

20. Ferdinand Hodler, installation of paintings at the Vienna Secession's nineteenth exhibition, January 1904

demanding that Klimt's pictures be rejected as unfit to adorn their university building. Berta Zuckerkandl's husband, Emil, a noted anatomist to whom the city would later raise a statue, was one of the few professors defending Klimt. (His dissecting class and lectures on "art forms in nature," which Klimt had attended with sketchbook in hand, revealed the world of cytogenetics to the artist, with rich results for the artist's decorative fills.) A storm of protest and praise was unleashed. Pro-Klimt were the literary voices of Ludwig Hevesi, Hermann Bahr, Berta Zuckerkandl (who drew attention to the artist's new world of "color sounds" and "color dissonances"), and Felix Salten (of later *Bambi* fame). A luminary in the turmoil was Mahler-detester Karl Kraus, cantankerous editor of the satirical quarterly *Die Fackel* (it was he who would famously define Freud's psychoanalysis as "the disease of which it pretends to be the cure"). Concerning *Jurisprudence* he wrote: "He wanted to paint Law, and he symbolized criminal law."[15]

Ultimately, in 1905, the besieged artist, despite his stoic "viel Schimpf, viel Ehre" (much insult, much honor) attitude, decided to refund the sizeable advance he had received years earlier for the now violently contested works. In withdrawing them from the public domain he also began a personal removal from public life, confining himself to painting landscapes studded with genetic elements and fulfilling private commissions for exquisitely elegant society portraits.

At least no demand was made that Klimt be sent to jail for his painterly assaults on tradition. The same was not true for Mahler, who one Viennese critic suggested should spend a few years in prison, so outraged was he by the eruption of pantheistic forces in the composer's Third Symphony, with its women's and boys' choruses as well as an alto solo intoning a Nietzsche text. Just as Klimt had introduced the jolting distraction of alluring grisettes into high-

21. Gustav Mahler conducting a rehearsal of his Eighth Symphony, Munich 1910. Stadtarchiv Munich

minded statements on the human condition, so Mahler used the commonplace—cacophonic brass and drum evocations of those military band marches so familiar to him from Iglau days—to offset the tender, the beautiful, the dreamlike, the hymnic, and the mystical in his music. "O Mensch! Gib Acht!" (Oh Man! Take heed!) Like Klimt, Mahler desired to encompass all: to plumb the depths and also to scale the heights.[16] But how could a composer of huge symphonic mystery plays—that confessed and asked uncomfortable, even eschatological questions of their audiences—fare in a self-satisfied, hedonistic city like Vienna, which thrived on escapism, *Gemütlichkeit*, and enshrinement of the status quo? "Ich wechsle nicht gerne" (I do not like change) declared Franz Josef frequently, and neither did most of his subjects, as Mahler would learn to his despair during his ten-year tenure at the Hofoper.

Presented from January 22 to March 6, 1904, the Secession's nineteenth exhibition [Fig. 20] featured thirty-one works by the important Swiss painter Ferdinand Hodler, creator of compelling mountain vistas and monumental figures who, in their poster-like clarity and rhythmic insistence, expressed either vitalistic defiance or philosophic resignation in the face of death—themes dear to both Klimt and Mahler. In fact Mahler was present at several informal musical get-togethers at the Molls's Hohe Warte house held in honor of the visiting Swiss celebrity. The impact of Hodler's metaphysical iconography on Vienna was enormous. Not only had Klimt responded to Hodler's suspended, prolonged "legatos" (witness the floating heavenly choir in his *Beethoven Frieze*), but a compelling parallel, at once both earthy and visionary, can be sensed between the pastoral scaffoldings of Mahler's titanic musical textures [Fig. 21] and Hodler's huge archetypal figures, who pace the earth addressing the great question of life and death.

In person, Hodler was more physical than metaphysical. As Alma described him: "Ferdinand Hodler was like a tree, uncouth and gigantic. There was not a woman he did not deem his prey, without prelude or postscript. He even laid hands on Berta Zuckerkandl, who gave him a resounding box on the ear."[17]

The year 1905, which brought the first national strike in the history of the Dual Monarchy, was one of great change for Klimt and one of creative continuity for Mahler, at work during the summer months on his (mostly) joyous Seventh Symphony. This was the year the artist bought back his university paintings from the state, after yet another virulent raking-over by the press. "I want to escape from all the unedifying absurdities and feel free again," he declared in an interview of April 5 with the sympathetic Zuckerkandl. And in June, Klimt, with seventeen of his more modernist ("stylist") colleagues, seceded from the Secession when an opposing faction (the "naturalists") accused them of having sold out to commercialism.

At the end of the year, Mahler offered to resign from the Hofoper when the court censor banned his friend Richard Strauss's blood-curdling *Salome*, which Mahler wanted to stage in Vienna on the same day as its world premiere in Dresden (December 9). But the Kaiser, who did not like change, naturally did not accept resignations—not from ministers, and certainly not from opera directors. On a brighter note, the next to last day of the year saw the premiere of Franz Lehár's *The Merry Widow*, the celebrated love waltz ("Lippen schweigen": Lips are silent) that would have, in Alma's words, the following charming impact on her and Gustav when they saw a later performance:

> We went to the *Merry Widow* and enjoyed it. We danced together when we got home and played Lehár's waltz from memory; but the exact run of one passage defied our utmost efforts. So we went to Doblinger's and while Mahler asked about the sale of his compositions I casually turned the pages of the various piano editions of the *Merry Widow*, and found the passage I wanted. I sang it as soon as we were in the street in case it slipped my memory a second time.[18]

There may have been a musical consequence as well: some one minute and forty seconds into one of the rondo episodes of the finale of Mahler's Seventh Symphony, a four-note quotation on trumpets in quick 4/4 time announces the beginning notes of Lehár's waltz and glides upward toward a gaggle of excited woodwinds. How appropriate for the composer who was constantly compelled to intrude earthly merriment into his heavenly joys.

The 150th anniversary of Mozart's birth, in the year 1906, gave Mahler plenty to do: forty five performances of four of the composer's operas during the 1905–06

season. Two of them, *Don Giovanni* and *The Marriage of Figaro*, were new productions with Roller's relentlessly reformist scenic designs. They were (of course) violently critiqued in the press, and the "decline" of the Opera under Mahler was loudly lamented.

As for Klimt, exit from the Secession had not cut him off from like-minded colleagues. Olbrich's great exhibition building was no longer available to them. But Klimt and his friends—including Roller and Moll—optimistically organized a new core group, the Österreichischer Künstlerbund (Austrian Artists' Association). (Klimt would become its president in 1912.) This group also included Josef Hoffmann, a founder of the Wiener Werkstätte, and Otto Wagner, architect of the metropolitan railway stations, including the exquisite one on Vienna's Karlsplatz. In a manifesto-like letter to the city's minister of education, they explained that their goal was not to limit themselves to exhibitions but to endeavor to exert the greatest possible influence of art on everyday life: "No life is so rich that it cannot become richer through art, no life so poor that it has no room for art."[19]

That same year, 1906, Klimt made his first trip to Brussels in response to a commission from the wealthy young Belgian industrialist Adolphe Stoclet. Stoclet did indeed become richer through art by asking Klimt to decorate the dining room of his new villa, the Hoffmann-designed Palais Stoclet. The artist devised a decorative "tree of life" continuum with outspread spiral branches extending along the two long walls of the dining room. Reversing and clothing the naked but "pure" kiss from his *Beethoven Frieze*, Klimt juxtaposed it on the opposite wall with the exquisitely gowned figure of a lone and longing woman, caught in a frozen dance step: *Expectation* (*Die Erwartung*). In the kissing couple, *Fulfillment* (*Die Erfüllung*), the eventual culmination of mutual desire is subtly enacted in the ornate intercourse of oculated circles and erect rectangles. This unusual project was delegated to the Wiener Werkstätte for execution in fine materials, including semiprecious stones, coral, and gold mosaic. Increasingly for Klimt, decoration would become emblematic content as with the biological/ornamental fills of his portraits. If for Freud anatomy was destiny, for Klimt anatomy could be decoration, both symbolically and cumulatively.

The last year of Vienna's golden decade, 1907, was a pivotal one for Klimt, at the height of his own Golden Period. The artist finished final alterations to his three university panels, snatched back by him from the public domain. In a bold and financially lucrative gesture, he exhibited them at Vienna's prestigious Galerie Miethke to the delight of appreciative private collectors. Unabashedly continuing his pursuit of Eros, he drew a series of erotic nudes that were published as illustrations to Lucian's *Dialogues of the Hetaerae*.

It was in this year that Klimt also completed the first of two sumptuous portraits of Adele Bloch-Bauer—immediately and correctly dubbed "Byzantine" by Alma. The glimmering, gold-studded portrait (inspired by the artist's 1903 trip to Ravenna to see the sixth-century mosaics of Justinian and Theodora at San Vitale) includes repeated Egyptian eye-triangles and Mycenaean swirls (shown even in foreshortened view as part of the armchair definition on the right). The contrast between the organically isolated head—so realistic with its pale, rouged face—and the flatness of the overwhelming ornamental surround is pungent. Is this a disinterested high-society portrait or another Klimtian femme fatale—her jeweled collier de chien (dog collar, or neck-collar) suggesting decapitation? Perhaps both, since gossip then and now has linked the artist sexually with his attractive twenty-five-year-old sitter.

As with his allegories and portraits, so with Klimt's landscapes. They are mosaic tableaux that celebrate the phenomena of fecundity and regeneration. Nature, for both Klimt and Mahler, was a necessary experience that provided vital motivic inspiration. Avid walkers as well as rowboat enthusiasts, both regularly spent their summer months at mountain-ringed Austrian lakes. Klimt, from 1897 on, resided for some twenty summers with the Flöge family at various sites on the Attersee near Salzburg. Mahler also summered in the Salzkammergut at Steinbach on the Attersee and, after 1899, in his own villa at Maiernigg on the Wörthersee in Carinthia.

But the summer of 1907 would be the last that Alma and Gustav spent at Maiernigg: the lovely house on the water and the work hut where the composer had written his Fifth, Sixth, Seventh, and Eighth Symphonies became odious to him after the sudden death from diphtheritic scarlet fever of their daughter Maria. She was only four and a half. The family physician, alarmed at Mahler's rundown appearance, examined him and discovered the presence of a defective heart valve, a diagnosis confirmed by two specialists back in Vienna.[20] From then on, Mahler worked against time (he would die four years later, not yet fifty one, with a Tenth Symphony uncompleted). He gave in at last to the vicious press campaigns and intrigues that continued to be waged against him—the "intransigent" director who had the nerve to insist that a single language be sung throughout any given opera.[21] A final, magnificent performance of Fidelio on October 15, 1907, was conducted by Mahler, but not to a full house, due to the animosity of the local opera clique. Finally relieved, at his request, of his post at the Hofoper (he left behind the many decorations he had been awarded in his desk drawer), Mahler bid farewell to his Vienna public nineteen days later at a special concert of the Gesellschaft der Musikfreunde with a performance of his Second ("Resurrection") Symphony. His ten-year reign at the Hofoper was over; a new life would begin in the new world.

A well-kept surprise greeted Alma and Gustav when they arrived early in the morning of December 9 at Vienna's Westbahnhof [Fig. 22] to board the Orient

Express on the first leg of their trip to America. Two hundred friends loaded down with fruit and flowers were waiting to say goodbye and wish them well. Among those present was Gustav Klimt. As the train pulled slowly out of the station, the artist, usually so taciturn, summed up the emotions felt by all in a single word: "Vorbei!" (It's over!)

The golden decade of the two Gustavs' Vienna had been made more golden by the luster of their extraordinary contributions to art and music. These contributions would not be fully appreciated until two world wars had changed Austria and the world forever.

22.

22. Train leaving Vienna's Westbahnhof, 1895. Photographer unknown

NOTES

1. Even Mahler occasionally indulged in playing four-handed Schubert on the piano with Bruno Walter, merrily inventing Viennese dialect verses to Schubert's melodies.

2. Alma Mahler-Werfel, *And the Bridge is Love* (New York: Harcourt Brace, 1958), p. 11.

3. Alma Mahler-Werfel, *Diaries 1898–1902*, trans. and ed. by Antony Beaumont, Suite 4, January 1898–March 1989 (Ithaca, NY: Cornell University Press, 1999), pp. 5–18.

4. Mahler-Werfel, *And the Bridge is Love*, p. 12.

5. Mahler-Werfel, *Diaries 1898–1902*, p. 105.

6. Ibid., p. 143.

7. Mahler-Werfel, *And the Bridge is Love*, p. 143.

8. Postcard reproduced in Mahler-Werfel, *Diaries, 1898–1902*, p. 116.

9. Henry-Louis de La Grange, *Gustav Mahler, Vienna: The Years of Challenge (1897–1904)*, vol. 2 (Oxford: Oxford University Press, 1995), p. 697.

10. Alma Mahler-Werfel, *Gustav Mahler: Memories and Letters* (1946), revised and enlarged edition, ed. Donald Mitchell (Seattle: University of Washington Press, 1971), p. 16.

11. Mahler-Werfel, *And the Bridge is Love*, p. 19.

12. Mahler-Werfel, *Gustav Mahler: Memories and Letters*, p. 37.

13. Review of April 20, 1902, as collected by Hermann Bahr in his *Gegen Klimt* (Vienna: J. Eisenstein, 1903) and quoted in Christian M. Nebehay, *Gustav Klimt: Dokumentation* (Vienna: Galerie Christian M. Nebehay, 1969), p. 297. For an extended discussion of the Secession's apotheosis of Beethoven see my *Changing Image of Beethoven: A Study in Mythmaking* (New York: Rizzoli, 1987), pp. 388–415.

14. Klimt's Mahler-as-knight figure was reproduced in a little book published by the critic Paul Stefan as homage to Mahler for his fiftieth birthday: Stefan, *Ein Bild seiner Persönlichkeit in Widmungen* (Munich: Piper, 1910).

15. Karl Kraus, *Die Fackel*, vol. 5, no. 147, November 1903.

16. An insight into this penchant for colliding disparate musical elements emerged during Mahler's consultation with Freud in 1910 at a crisis point in his marriage (partially described by Alma in *Gustav Mahler: Memories and Letters*, p. 175). A 1925 letter Freud wrote to Marie Bonaparte about his meeting with Mahler reported that during the course of their prolonged conversation, Mahler suddenly said he now understood the reason for the intrusion of commonplace melodies in his music: he recalled that as a young boy during a painful scene between his parents he had rushed out of the house into the street, only to hear a hurdy-gurdy blaring forth the drinking song "Ach, du lieber Augustin"—thus forever linking intense feelings with trivial vernacular music in his mind. See Ernest Jones, *Sigmund Freud: Life and Work*, vol. 2 (London: Hogarth, 1955), p. 89.

17. Mahler-Werfel, *Gustav Mahler: Memories and Letters*, p. 62.

18. Ibid., p. 120.

19. Gottfried Fliedl, *Gustav Klimt* (Cologne: Taschen, 1989), p. 156.

20. I am grateful to my ever-gracious colleague, Henry-Louis de La Grange, for clarifying the initial nature (mitral regurgitation) of Mahler's heart condition.

21. Mahler was not the first victim of ceaseless denunciation at the Hofoper: during the construction of Vienna's great house, malicious criticism drove one of its two architects, Eduard van der Null, to hang himself in April of 1868.

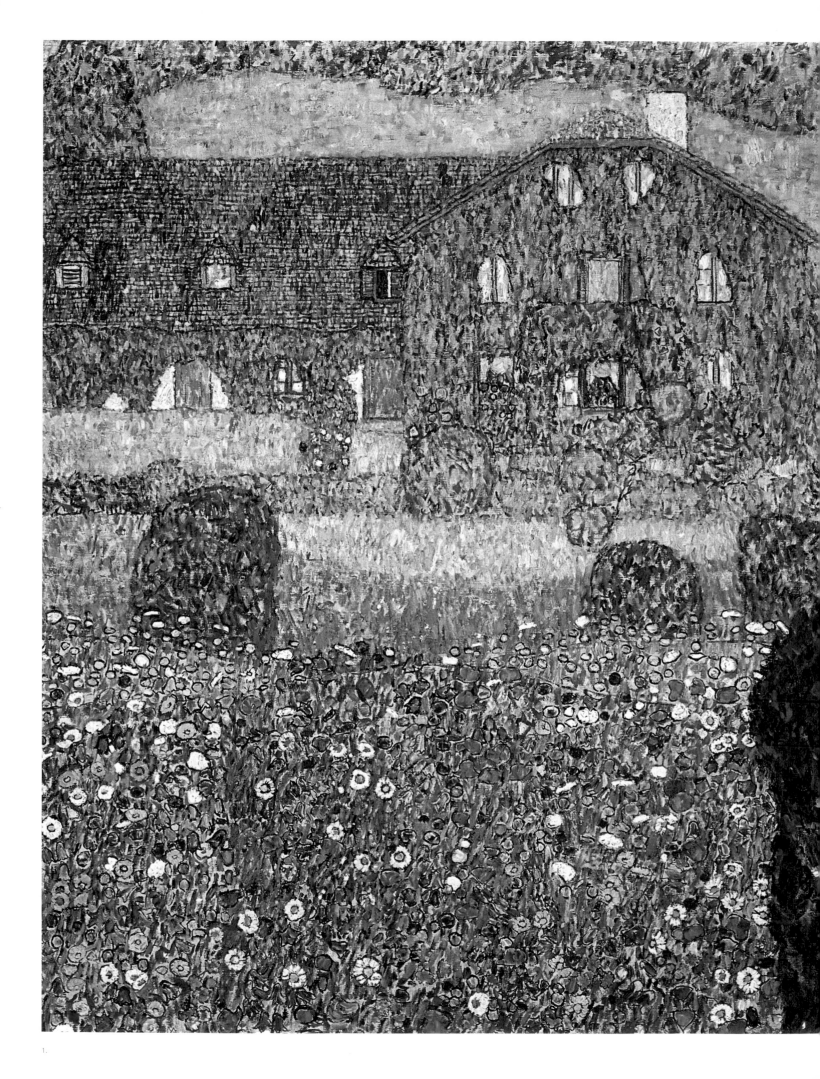

SOPHIE LILLIE

The Golden Age of Klimt

The Artist's Great Patrons: Lederer, Zuckerkandl, and Bloch-Bauer

In 2006, Austria restored five paintings by Gustav Klimt from the collection of Ferdinand and Adele Bloch-Bauer to their rightful owners. It was a momentous step forward in the movement to restitute artworks that were misappropriated during World War II. The event brought renewed public attention to the work of Klimt—already one of the most popular and celebrated figures of Austrian art.

But those Bloch-Bauer canvases are only five of a total of ten paintings and seventeen drawings by Klimt that Austria has returned since 1998, when the country adopted a new bill to govern the restitution of Holocaust-era art from its federal collections.[1] The first Klimt works to be recovered under this law were sixteen studies for *Adele Bloch-Bauer I* from the Graphische Sammlung Albertina,[2] followed in 1999–2000 by the Albertina's restitution of the drawing *Portrait of a Lady in a Fur Collar* (*Dame mit Federboa*, ca. 1916) to the heirs of Siegfried Kantor.[3] In the same year, no fewer than four major Klimt paintings were deaccessioned from the Österreichische Galerie Belvedere: *Country House on the Attersee* (*Landhaus am Attersee*, ca. 1914) [Fig. 1] to the heirs of Jenny Steiner; *Apple Tree II* (*Apfelbaum II*, 1916), to the heirs of Nora Stiasny; and *Lady with Hat and Feather Boa* (*Dame mit Hut und Federboa*, 1909) and *Farm House with Birch Trees* (*Bauernhaus mit Birken*, 1900) to the heirs of Georg Lasus.[4] Finally, in 2002–03, the heirs of Bernhard Altmann recovered a portrait of a lady (1898–99);[5] and in 2006, Klimt's two portraits of Adele Bloch-Bauer and three landscapes were returned to the Bloch-Bauer heirs. The total value of Klimt works restituted by Austria between 1998 and 2006 amounted to a staggering estimated four hundred million dollars.

One curious side effect of Austria's newest policies on art restitution is that the nature of Klimt's reception internationally has changed dramatically, in terms both of the dissemination of the artist's oeuvre and of the prices it commands. Perhaps the most important factor in bringing about this change is the fact that objects returned under the Art Restitution Act—unlike other works considered of national importance—are exempt from Austria's rigorous export laws. These laws in the

1. Gustav Klimt, *Country House on the Attersee*, ca. 1914, oil on canvas. Private Collection

2. Serena Lederer in her salon, ca. 1930. Works by Klimt mounted on the wall behind her (from left to right): *Wally* (1916), *Golden Apple Tree* (1903), and her own portrait (1899). Photograph by Martin Gerlach Jr., Österreichische Nationalbibliothek Bildarchiv, Vienna

past have restricted the number of high-quality Klimt works (and other Austrian masterpieces) on the international market and have kept market values for these pieces artificially low—the local market being naturally limited. Before 1998, the highest price ever fetched by a Klimt painting was at Christie's in 1997, when his *Schloss Kammer on the Attersee II* (*Schloss Kammer am Attersee II*, 1909) sold for nearly 23.5 million dollars.[6] It took the sale of *Country House on the Attersee* at Sotheby's in 2003—the very first restituted Klimt work ever to be sold at public auction—to bring the world record up: the painting sold for an astonishing 29.1 million dollars.[7] This was a nearly 25 percent appreciation in just five years, and a price almost double that paid for the other major Klimt work sold in 1997, *Litzlberg Cellar on the Attersee* (*Litzlbergkeller am Attersee*, 1915–16).[8] This record has since been superseded, of course, by the sale of *Adele Bloch-Bauer I* to the Neue Galerie New York, and Christie's Bloch-Bauer auction in November 2006, a blockbuster event that culled nearly 197 million dollars—more than any other auction in history.

Restitution and sales have renewed interest not only in Klimt the artist, but in his prewar patrons. Klimt prided himself in a unique following of supporters. Three of the most important were August Lederer, Victor Zuckerkandl, and Ferdinand Bloch-Bauer—all major industrialists who had made their fortunes as business entrepreneurs in the years shortly preceding the turn of the century, and who were willing to put a sizable portion of their wealth toward the arts. In the final years of the Hapsburg monarchy, this new urban elite personified Vienna's ascendant liberalism: here was a new haute bourgeoisie quite separate from Austria's aristocracy; it reveled in the conspicuous consumption of art and culture, thus emphasizing its own social status. Lederer, Zuckerkandl, and Bloch-Bauer belonged to a small avant-garde who progressed from being mere onlookers to becoming veritable protagonists in the cultural process. After the scandal surrounding Klimt's commission of faculty paintings for the University of Vienna, he was denied both public commissions and an appointment at the Akademie der Bildenden Künste (Academy of Fine Arts). The artist's patrons permitted him to operate uniquely independently, despite these obstacles.

Indicative of Klimt's reliance on these families are the myriad portraits he made of his patrons' wives and daughters, with many of whom he forged strong alliances. They include the portraits of August's wife, Serena Lederer[9] [Fig. 2], and their daughter Elisabeth Bachofen-Echt;[10] the two portraits of Adele Bloch-Bauer;[11] and those of Victor Zuckerkandl's wife, Paula,[12] and his sister-in-law, Amalie Zuckerkandl.[13] Among Klimt's many other important female portraits are those of Sonja Knips (wife of the iron industrialist Anton Knips);[14] Marie Henneberg (wife of photographer Hugo Henneberg);[15] Gertrud Felsövanyi (daughter of Anton Loew, the founder of Vienna's renowned Sanatorium Loew);[16] Hermine Gallia (wife of Moritz Gallia, a producer of light bulbs);[17] Margarethe Stonborough-

Wittgenstein (daughter of the Secession's financier Karl Wittgenstein, and sister of the philosopher Ludwig Wittgenstein);[18] Fritza Riedler (wife of the engineer Alois Riedler);[19] Eugenia "Mäda" Primavesi (wife of the industrialist Otto Primavesi) and their daughter Mäda;[20] and the 1916 portrait of Friederike Beer, the partner of the artist Hans Böhler.[21] Klimt shared with these figures of Vienna society an intellectual kinship based on his absolute notion of true art as being "created by few for the appreciation of few"—the motto of the first publication of the Secession journal, *Ver Sacrum*, in 1898.[22]

Many of these families were uniquely interwoven, through kinship, business, or simply close acquaintanceship. The Lederers and the Zuckerkandls both originated from the Hungarian town of Györ (Raab); August Lederer and Ferdinand Bloch-Bauer both maintained factories in the northern Bohemian town of Jungbunzlau (now Mladá Boleslav); and the Bloch-Bauer and the Zuckerkandl families were close as friends.

The fact that so many of Klimt's patrons were Jewish further added to the sense of intimacy—although it is erroneous to think that all or even most of Klimt's clients were Jewish. Many of his greatest patrons, such as Nicolaus Dumba,[23] Sonja Knips, and Otto and Mäda Primavesi were not, others, such as the industrialist Karl Wittgenstein, had long separated themselves from their Jewish roots. Still, the conspicuous number of Jews among Klimt's clients prompted certain of his contemporaries to dismiss his work as "gout juif," or "Jewish taste"—a description coined by Austrian critic Karl Kraus.[24] Today, some scholars infer a special affinity between Vienna's avant garde and the city's Jewish élite at the fin de siècle—a speculative supposition that tends to mystify the era and to detract from more salient underlying social and economic factors. But from the point of view of provenance research, the "Jewishness" of Klimt's early patrons is significant, as this certainly shaped their fate—and the fate of their collections following Hitler's annexation of Austria in March 1938, the "Anschluss."

Klimt's work held a certain interest for the Nazis, but its appeal to them was contradictory. Although the artist did not belong to the chosen group of nineteenth-century artists whom the Nazis particularly favored, they cautiously acknowledged him as one of Austria's great cultural assets—despite his Jewish clientele. The ambiguously positive nature of this relationship is manifested on the one hand by such tributes as the Klimt retrospective that took place in 1943 under the patronage of the Reich governor of Vienna, Baldur von Schirach;[25] and the publication of a Klimt monograph by the well-known set designer Emil Pirchan in the preceding year.[26] On the other hand, since art preservation laws did not apply to contemporary artists, the Nazis did not summarily prevent the export of Klimt works, and in fact released a number of high-quality paintings—such as *Baby* (1917–18) from the collection of Otto Kallir (the painting now hangs at the

National Gallery of Art in Washington, D.C.).[27] Aside from the Lederer collection, only three Klimt paintings were seized by the municipal authorities to prevent their export from Austria: two Bloch-Bauer canvases and *Hanakin* (1883–85) from the collection of Robert Pollak.[28] With respect to Klimt works, art preservation was thus not the highest priority for the National Socialists. Most of the artist's paintings that were seized by the Nazis were impounded by the revenue authorities as security for punitive taxes and charges, or confiscated as "enemy property" by the Gestapo—and neither public office attributed interest in these works beyond their simple monetary value.

AUGUST AND SERENA LEDERER

The industrialist August Lederer and his wife, Sidonie ("Serena") [Fig. 3],[29] owned the largest and most important private collection of Klimt works, boasting seminal examples from all of the artist's major periods, including two of the notorious university faculty paintings.

August Lederer was the owner of a spirits factory in Györ, which he had taken over from the state monopoly and remodeled into a prosperous modern business. He was also the owner of a factory for industrial starch products in Jungbunzlau. He and his wife began collecting art soon after their marriage in 1892. Serena had most likely been introduced to Klimt by her uncle, Adam Politzer [Fig. 4],[30] a famous otologist and professor at the University of Vienna (and an art collector in his own right),[31] who had hired the young artist for medical illustrations. In fact, Serena's association with Klimt is testified by the inclusion of her portrait, at age twenty-one, together with her sisters Aranka Munk and Irma Politzer, in Klimt's painting *Auditorium in the Old Burgtheater* (*Zuschauerraum im alten Burgtheater*) [Figs. 5, 6], depicting the interior of the imperial theater on Michaelerplatz shortly before it was torn down in 1888.[32]

3. August and Serena Lederer at Schloss Dietrichstein, 1930s. Private Collection

4. Adam Politzer, Vienna, ca. 1900. Photograph by Victor Angerer, Österreichische Nationalbibliothek Bildarchiv, Vienna

The Lederers' art collection, one of the finest in Vienna, held not only many of Klimt's works, but also a great number of excellent Italian Renaissance and Old Master works. The collection's appraisal in 1927 by Leo Planiscig, a curator of Vienna's Kunsthistorisches Museum, amounted to some ten million Austrian schillings, with modern works presenting a mere portion of that value, or 1.3 million schillings.[33] The collection was kept in the Lederers' apartment in Vienna's first district, Bartensteingasse 8, located in the immediate vicinity of Vienna's Rathaus (town hall) and parliament. A number of pieces were kept in the Lederer's summer residence at Schloss Dietrichstein in Hadersdorf-Weidlinggau, a suburb of Vienna. In 1921, the collection was officially recognized as a cultural landmark by the Staatsdenkmalamt (Austrian Monuments Office); this status exempted the Lederers from paying taxes on their art collection in exchange for the collection being made accessible to art scholars on a given number of days per year.[34]

5.

Most significantly, the Lederers owned two of three panels that had been intended for the Great Hall of the University of Vienna, depicting the faculties *Philosophy* (*Philosophie*, 1900–07) and *Jurisprudence* (*Jurisprudenz*, 1903–07) [Fig. 7];[35] they also owned the preliminary sketches for these works.[36] Klimt's 1894 commission for this project had met with public scandal. In 1905, Klimt withdrew the paintings in protest and, with August Lederer's help, returned his honorarium of thirty thousand kronen. In return, Lederer acquired *Philosophy*, while the other two panels went to Klimt's colleague Koloman Moser, a co-founder of the Secession and the Wiener Werkstätte. To make space for the 13-by-10-foot panel, the Lederers had two rooms knocked into one and invited Josef Hoffmann to redesign the space in 1905.[37] After Moser's death in 1918, the Lederers acquired *Jurisprudence* and helped arrange for the sale of the third, *Medicine* (*Medizin*, 1901–07) to the Belvedere's Moderne Galerie, an acquisition that was co-funded by Ferdinand Bloch-Bauer, Sonja Knips, and Hugo Koller, husband of the painter Broncia Koller-Pinell.[38]

The Lederers' acquisition in 1915 of the *Beethoven Frieze* (*Beethovenfries*, 1902) [Fig. 8][39] was similarly prestigious. Illustrating Beethoven's Ninth Symphony, the monumental wall frieze measuring 6½ by 85 feet had originally been created for the Secession's fourteenth exhibition in 1902, a show of works grouped around Max Klinger's statue of the composer Ludwig van Beethoven.[40] When that exhibition closed, the frieze stayed in place; it was included in the Secession's Klimt retrospective in the following year,[41] and was meant to be destroyed

5. Gustav Klimt, *Auditorium in the Old Burgtheater*, ca. 1888, oil on canvas. Wien Museum, Vienna

6. Detail of Gustav Klimt's *Auditorium in the Old Burgtheater*, 1888, showing, from left to right: Serena's sister Aranka Munk with husband Alexander Munk; Tinka Politzer (the sister-in-law of Serena's sister Irma Politzer); Sigmund Politzer (Irma's husband); the unmarried Serena Pulitzer (with hat); and Irma Politzer.

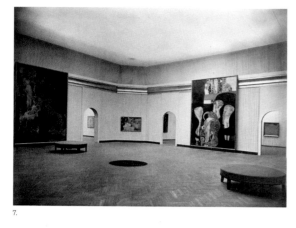

7.

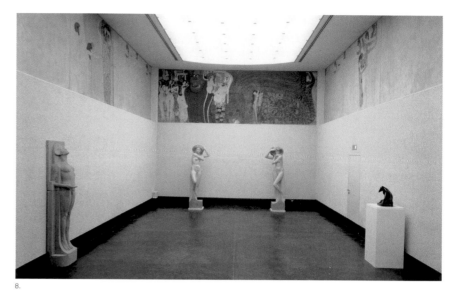

8.

7. Gustav Klimt's *Philosophy* and *Jurisprudence* mounted at the Klimt *Gedächtnisausstellung* at the Vienna Secession, 1928. Österreichische Nationalbibliothek Bildarchiv, Vienna

8. Gustav Klimt, *Beethoven Frieze*, 1902, casein colors on a stucco base with semiprecious stone inlay. Modern installation of the frieze, Österreichische Galerie Belvedere, Vienna

afterward. Luckily, that process was stopped by Carl Reininghaus,[42] a major patron of the Secession, who happened by just as workmen had begun chipping the frieze off the wall. Reininghaus ordered that it be carefully dismantled, sawed into seven segments, and placed in storage. Some eleven years later, Reininghaus sold the *Beethoven Frieze* to Lederer through Egon Schiele, who received one thousand kronen as an introductory commission. Reininghaus later explained his move to Lederer's son, Erich: "Previously it was I who paid for the storage depot, and now it is your father's turn to pay these fees!"[43]

Paintings from all of Klimt's major periods were exhibited at the Lederer apartment. One of the most prized works was the *supraporte* titled *Schubert at the Piano* (*Schubert am Klavier*, 1898–99) [Fig. 9]—in the words of the art critic Hermann Bahr, "the most beautiful painting ever painted by an Austrian"—which the Lederers had acquired from the Nicolaus Dumba collection along with its pair, *Music II* (*Die Musik II*, 1898). Landscapes in the Lederer collection were *Farm Garden with Crucifix* (*Bauerngarten mit Kruzifix*, 1911–12) [Fig. 10]; *Malcesine on Lake Garda* (*Malcesine am Gardasee*, 1913); *Garden Path with Chicken* (*Gartenweg mit Hühnern*, 1916) [Fig. 11]; and *Gastein* (1917). The Lederers also owned two versions of Klimt's *Apple Tree*, one being *Golden Apple Tree* (*Goldener Apfelbaum*, 1903), a very early expression of the artist's "Gold Period"; the painting was acquired from Klimt's estate in 1919. Erotic depictions of women were *Wally* (1916), *The Girlfriends* (*Die Freundinnen*, 1916–17) [Fig. 12], and a lascivious interpretation of *Leda* (1917).[44] Finally, the Lederer collection included a unique grouping of three generations of family portraits by Klimt: his 1899 portrait of Serena Lederer [Fig. 13] (possibly the very first Klimt work to be acquired by the Lederers, for the purported sum of 35,000 kronen); the 1917 portrait of Serena's mother, Charlotte Pulitzer [Fig. 14];[45] as well as the portrait of her daughter, Elisabeth Bachofen-Echt, executed in 1914–16 [Fig. 15.].

9.

10.

The Lederers also owned countless Klimt drawings, including some one hundred preliminary sketches for the *Beethoven Frieze* (a gift from Klimt to thank August Lederer for its acquisition) and two hundred drawings from Klimt's estate. The latter were bought from the gallery of Gustav Nebehay, where they had been exhibited in 1919, the year after Klimt's death.[46] Serena Lederer's discriminating taste is legendary. "What do all of them cost together, Herr Nebehay?" she is said to have barked during her visit to the show. "I am not accustomed to joking!" she clarified, and then commanded the stunned Nebehay to: "add them up!"—declaring all of the exhibited works sold.[47]

The Lederers' unequivocal endorsement of Klimt's work led to the artist's acceptance into their social circle, and at the salons held by Serena [Fig. 16]—whom Josef Hoffmann called "the best-dressed woman in Vienna."[48] Klimt was invited to weekly lunches at the Lederer home and was hired as a drawing teacher for both Serena and her young daughter Elisabeth [Fig. 17]. Klimt was also responsible for introducing Schiele to the Lederers and for arranging his invitation in 1912 to the family home in Györ—an estate furnished entirely by Eduard Josef Wimmer-Wisgrill of the Wiener Werkstätte—where Schiele was to paint the portrait of the Lederer's oldest son, Erich, then aged fifteen.[49] Although August and Serena Lederer did not take to Schiele's work, and in the course of the years bought only two paintings from him, Schiele's visit laid the foundation for his lasting friendship with Erich Lederer, who would become one of Schiele's foremost patrons and collectors. One Klimt painting that Erich Lederer owned in his own right, *Procession of the Dead* (*Zug der Toten*, 1903), particularly evidences Schiele's association with Klimt.[50]

9. Gustav Klimt, *Schubert at the Piano*, 1898–99, oil on canvas. Destroyed by fire in 1945

10. Gustav Klimt, *Farm Garden with Crucifix*, 1911–12, oil on canvas. Destroyed by fire in 1945

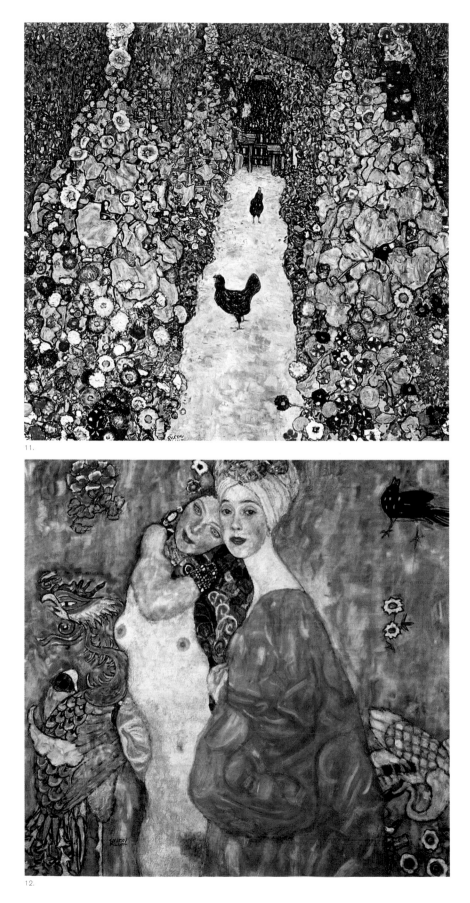

11.

12.

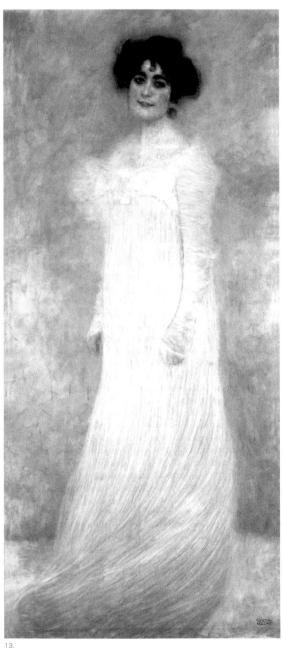

13.

11. Gustav Klimt, *Garden Path with Chickens*, 1916, oil on canvas.
Destroyed by fire in 1945

12. Gustav Klimt, *The Girlfriends*, 1916–17, oil on canvas.
Destroyed by fire in 1945

13. Gustav Klimt, *Portrait of Serena Lederer*, 1899, oil on canvas.
The Metropolitan Museum of Art, New York

August and Serena Lederer were regular lenders to Klimt exhibitions, although their family portraits were never publicly shown. One of the most widely known works was *Schubert at the Piano*, which they loaned to the 1923 show *Von Füger bis Klimt*[51] and to the 1928 *Klimt Gedächtnisausstellung* at the Vienna Secession commemorating the tenth anniversary of the artist's death—this show also featured *Music*, *Philosophy*, and *Jurisprudence*.[52] The Lederers lent one Klimt painting, *Farm Garden with Crucifix*, and one Schiele painting, *Mödling*, to the 1934 show *Austria in London* at Dorland Hall,[53] and in 1936, the year of August Lederer's death, many pieces from their collection were shown at the Secession.[54] In the following year, *Farm Garden with Crucifix*, *Malcesine*, *Girlfriends*, and *Leda*, as well as numerous Klimt drawings were included in the exhibition of Austrian contemporary art at the Paris World's Fair and subsequently traveled to the show *Österreichische Kunst im 20. Jahrhundert* at the Kunsthalle in Bern, Switzerland.[55] These two exhibitions, which coincided with the Nazis' *Entartete Kunst* show in Munich, provided a final forum for the presentation of Austrian modernism in the looming shadow of dictatorship.

It is a cruel irony, in hindsight, that these paintings were returned to Vienna so shortly before Hitler's annexation of Austria in 1938, since the majority of Lederer's property was seized soon after the "Anschluss." As a Hungarian citizen, Serena Lederer attempted to evade the Nazis' mandatory registration of so-called Jewish assets, but ultimately failed: the Lederer spirits emporium was, naturally, of great interest to the Vermögensverkehrstelle, the department of assets control within the Nazi Wirtschaftsministerium (Ministry of Economic Affairs) that monitored the expropriation of Jewish property.[56]

In March 1939, Serena Lederer's application for export license before the Zentralstelle für Denkmalschutz (as the Monuments Office was then known)[57] prompted the collection's seizure by municipal authorities.[58] Dozens of artworks were subsequently entered into the "Reich List"—a central registry of cultural treasures in the German Reich.[59] At considerable risk to her own safety, Serena Lederer stayed on in Vienna to try and extract her property from the Nazis, living under police supervision at the Hotel Sacher from April through December 1939, when she finally fled to Hungary.

In attending to the expropriation of Lederer property, the Nazis appointed Hermann Berchtold as interim manager of the family's business. To cover taxes and charges that the business faced, Berchtold was eager to see the collection "liquidated" as quickly as possible. Meanwhile, the Monuments Office was intent on preventing such a sale, to allow public collections to acquire Lederer works, and rallied the support of the Reich Minister of Finance and the Ministry for Internal and Cultural Affairs. Lists of works they hoped to secure had been submitted by all of the leading institutions, including the Kunsthistorische

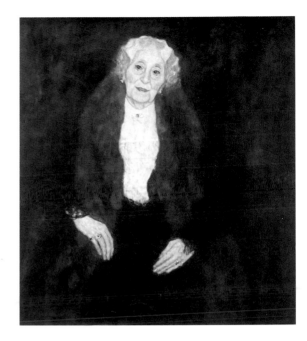

14. Gustav Klimt, *Portrait of Charlotte Pulitzer*, 1917, oil on canvas. Current whereabouts unknown. Courtesy Galerie Welz, Vienna.

Museum, the Belvedere, the Kunstgewerbemuseum, the Städtische Sammlungen (now called the Wien Museum), the Volkskundemuseum, the Heeresmuseum, the Albertina, the "Führermuseum" (the monumental museum of Germanic art that Hitler planned in the town of Linz),[60] and various museums in the provinces and the Zentralstelle itself.[61] Hermann Goering likewise sought to acquire the Lederers' two Lucas Cranach portraits as well as Cranach's *Venus and Amor*.[62]

In January 1940, Vienna's public prosecutor brought criminal charges against Serena Lederer and two of her children, Erich Lederer [Fig. 18] and Elisabeth Bachofen-Echt [Fig. 17].[63] This brought about the impoundment of all Lederer assets, including their summer residence at Schloss Dietrichstein, a safe held with the Creditanstalt bank, and shipping goods deposited with a local shipping company, Spedition Kirchner. These goods were confiscated by the Gestapo in 1941 and sold through the Verwertungsstelle für jüdisches Umzugsgut der Geheimen Staatspolizei (called "Vugesta"), the organization responsible for the sale of what was dubbed "Jewish" shipping goods.[64]

In a final foray to save herself, Elisabeth Bachofen-Echt (whose husband Wolfgang Bachofen-Echt had filed for divorce from his Jewish wife in 1938) declared herself the illegitimate daughter of Gustav Klimt and subjected herself to an agonizing examination of her racial makeup by the Reichssippenamt (the government office dealing with questions of race). This institution ultimately supported Elisabeth's petition in March 1940, acknowledging Klimt's paternity and thus declaring her of "mixed" rather than "Jewish" descent.[65] Although her situation remained extremely vulnerable, this status tenuously allowed Elisabeth to survive in Vienna, where she died in October 1944, at fifty years of age.

Serena Lederer's own similarly desperate attempts to save her collection failed. She sent countless letters and cables to the Monuments Office pleading that her artworks be spared,[66] and even offered to donate several pieces to the German Reich if she would be permitted to take other works with her.[67] This proposal was denied by the Zentralstelle, which declared it "intolerable" that cultural assets "remain in Jewish hands, let alone leave German territory."[68] The only works to be released (although they were not relinquished to the family) by the Nazi authorities were four family portraits—Klimt's depictions of Serena Lederer, Charlotte Pulitzer, and Elisabeth Bachofen-Echt, and Schiele's 1912 portrait of Erich Lederer.[69] Serena's and Elisabeth's portraits resurfaced at Vienna's Dorotheum auction house in 1948, when they were withdrawn from the sale and restored to Erich Lederer.[70] The portrait of Charlotte Pulitzer, however, was never found.

The majority of Klimt's paintings from the Lederer collection were last presented in the spring of 1943, at the Klimt retrospective commemorating the eightieth anniversary of the artist's birth, a show organized by the Reich governor of Vienna,

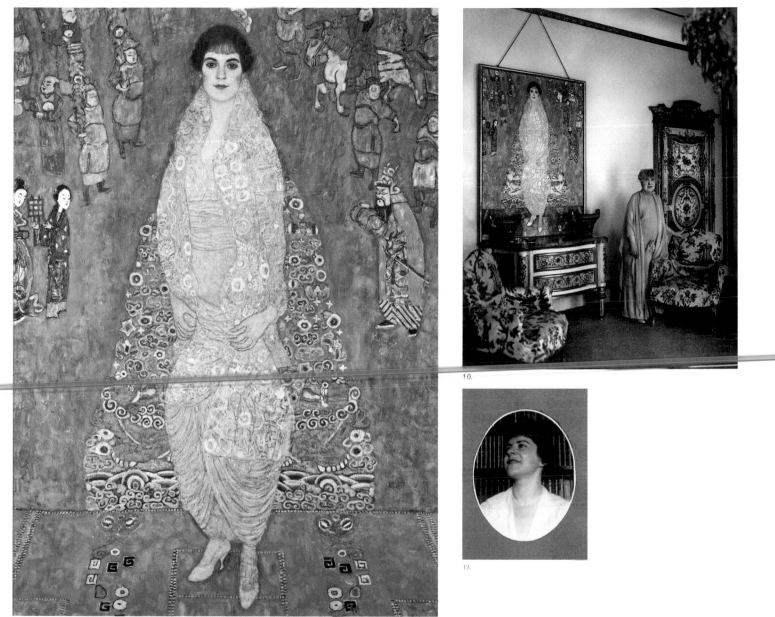

15.

10.

17.

Baldur von Schirach, in the former Secession building—which was at this time called the "Ausstellungshaus Friedrichstrasse."[71] Serena Lederer died soon after, in March 1943, in Budapest.[72] In the following year, the Monuments Office placed most of the Lederer collection in storage at Schloss Immendorf near Marchfeld in Lower Austria. Following Germany's capitulation in May 1945, the Immendorf art repository was burned in a fire set by retreating Nazi storm troopers to prevent it from falling into the hands of the oncoming Red Army.[73] Many magnificent Italian Old Master paintings, two Schiele works, and all of the Lederers' Klimts—except for the family portraits and the *Beethoven Frieze* (which had been separately stored in nearby Schloss Thürnthal)—were thus irretrievably lost. It was the greatest single loss of Klimt works in history.

15. Gustav Klimt, *Portrait of Elisabeth Bachofen-Echt*, 1914–16, oil on canvas. Private Collection, courtesy Neue Galerie New York

16. Serena Lederer with Gustav Klimt's portrait of her daughter, Elisabeth Bachofen-Echt, mounted in her salon, ca. 1930. Photograph by Martin Gerlach Jr., Österreichische Nationalbibliothek Bildarchiv, Vienna

17. Elisabeth Bachofen-Echt, ca. 1920. Private Collection

18.

19.

18. Erich Lederer and his wife, Elisabeth, ca. 1937.
Private Collection

19. Gustav Klimt's *Beethoven Frieze* in storage at Stift Altenburg,
ca. 1956. Private Collection

In the immediate postwar period, the recovery of Lederer works that the Nazis had assigned to Austrian museums was made more difficult by the need to obtain export licenses for restituted works.[74] In the early 1950s, some works were released, such as the *Madonna dell'Umiltà* by the Maestro del Bambino Vispo, a triptych by Jacobello del Fiore, and two Cranach portraits (now at the National Gallery of Art in Washington, D.C.).[75] In exchange for export permits, Erich Lederer was pressed to bequeath several of the collection's best works to the Austrian state, including a panel by Gentile Bellini, *Cardinal Bessarion and Two Members of the Scuola della Carità in Prayer with the Bessarion Reliquary* (ca. 1472), watercolors by Moritz von Schwind and Franz Xaver Petter, as well as six Schiele drawings.[76] These works were returned to the Lederer heirs only in 1999, following the Austrian Restitution Act[77] (the Bellini was subsequently acquired, in 2001, by the National Gallery in London).[78]

The most difficult negotiations surrounded the *Beethoven Frieze*. Lederer was determined to recover this last vestige of his parents' Klimt collection—he went so far as to suggest to the director of the Austrian Monuments Office, Otto Demus, that he, Lederer, would renounce *all* his family's works in exchange for its return.[79] Demus rejected this suggestion outright, however, and personally placed an export embargo on the *Beethoven Frieze* in 1950,[80] despite his private confession that he found the "horse trade" for export licenses "endlessly embarrassing and odious."[81] The *Beethoven Frieze* remained in storage at Schloss Thürnthal until 1956, when it was transferred to Stift Altenburg [Fig. 19], a monastery in Lower Austria, where the work was kept in appallingly inadequate conditions. Finally, in 1961, the *Beethoven Frieze* was moved to a former stable at Schloss Belvedere. It was ultimately acquired by the Austrian state in 1973—although it was still unclear where the frieze would be mounted. Federal Chancellor Bruno Kreisky was keen to secure it for the planned United Nations headquarters in Vienna. Erich Lederer's last wish before his death in 1985, that the *Beethoven Frieze* be mounted in the lobby of Vienna's Staatsoper, was not fulfilled. That year, the frieze was publicly shown—for the first time in over eighty years—at the exhibition *Traum und Wirklichkeit* at the Vienna Künstlerhaus, and was later mounted in the basement of the Secession, where it remains on permanent display.[82] In memory of her husband, Erich Lederer's widow, Elisabeth, bequeathed eleven studies for the *Beethoven Frieze* to the Albertina in 1985.[83]

In her great enthusiasm for Klimt, Serena Lederer introduced her sisters to the artist's work. In 1900, her sister Jenny [Fig. 20] and Jenny's husband Wilhelm Steiner[84] also commissioned the artist to create a posthumous portrait of their daughter, Trude [Figs. 22, 23],[85] who had died that year at the age of thirteen. Other Klimt paintings in the Steiner collection were *Water Serpents II* (*Wasserschlangen II*, 1904–07) [Fig. 24],[86] a painting thought to have been acquired in 1911 (the year after its inclusion at the ninth *Esposizione Internazionale* in Venice); the 1912

portrait of Mäda Primavesi,[87] which was bought from the Primavesi family, possibly in 1931; and *Country House on the Attersee*, one of Klimt's most important landscape pieces.

In 1938, the Steiner collection was impounded by Vienna's Finanzamt (internal revenue office) on the Nazis' punitive taxes and charges, and was put up for sale by the Dorotheum auction house in 1940–41.[88] Among the objects thus dispersed were the three Klimt paintings, several Klimt drawings, two Schiele paintings, and numerous Old Master works. On the intervention of Reich governor von Schirach, however, *Water Serpents II* was withdrawn from the sale to allow for its acquisition by the film director Gustav Ucicky [Fig 21], an illegitimate son of Klimt who ended up with many of his father's works from Nazi-looted collections.[89] The painting was never recovered.

The only painting Jenny Steiner retrieved from Austria after the war was the portrait of Mäda Primavesi, which was returned by the Historisches Museum der Stadt Wien (now called the Wien Museum) in 1951.[90] The painting was later given to New York's Metropolitan Museum of Art as a gift in memory of Jenny Steiner by her daughter Clara Mertens and her husband André. One year earlier, an export embargo on the Schiele painting *Mother with Two Children* (*Mutter mit zwei Kindern*, 1917) had preceded the painting's acquisition by the Belvedere.[91] Finally, in 2001, the painting *Country House on the Attersee* was returned to the Steiner heirs by the Belvedere, which had acquired the painting in 1963 as a permanent loan, and in 1995 as a gift of Emma Danzinger in memory of her husband, Michael Danzinger.[92]

20. Jenny Steiner, 1892. Photograph by Károly Koller, Budapest. Private Collection

21. Gustav Ucicky, ca. 1938. Private Collection

Serena's older sister, Aranka,[93] and her husband, Alexander Munk, also commissioned a posthumous portrait, of their daughter Ria,[94] who had committed suicide in 1911 at the age of twenty-four, following her unhappy love affair with the writer Hanns Heinz Ewers. Klimt made numerous sketches for the depiction and in the end painted three versions of Ria's portrait.[95] The first, *Ria Munk on her Deathbed* (*Fräulein Ria Munk auf dem Totenbett*, 1911–12) [Fig. 25] was painted immediately after her death;[96] a second portrait, which her parents rejected, was later reworked by Klimt and renamed *The Dancer* (*Die Tänzerin*, 1916–18).[97] Klimt's final version, his *Portrait of Ria Munk III* (1917–18) [Fig. 26], was unfinished when the artist died in 1918.[98] This painting was later mounted in Aranka Munk's summer residence in Bad Aussee, a small town nestled in the Salzkammergut region; Aranka acquired this villa after the divorce from her husband in 1913, about a year and a half after Ria's death.

Aranka Munk and her younger daughter, Lola Kraus (Ria's sister),[99] were deported to Lodz on October 19, 1941; Aranka, who was seventy-nine, died there within a few weeks. In the following year, Lola Kraus was deported from Lodz to Chelmo, where she is thought to have perished.[100] Pursuant to the Eleventh

22.

23.

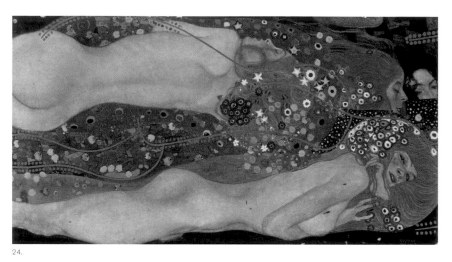

24.

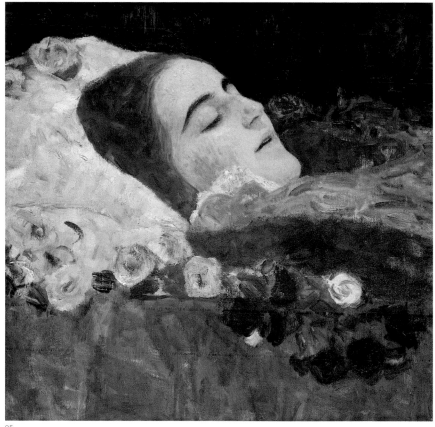

25.

22. Gustav Klimt, *Portrait of Trude Steiner*, 1900, oil on canvas. Current whereabouts unknown. Courtesy Galerie Welz, Vienna

23. Jenny Steiner's children (left to right): Daisy, Georg, and Trude, 1897. This image of Trude served as a model for Klimt's posthumous portrait. Photograph by Carl Pietzner, Vienna. Private Collection

24. Gustav Klimt, *Water Serpents II*, 1904–07, oil on canvas. Private Collection

25. Gustav Klimt, *Ria Munk on Her Deathbed*, 1911–12, oil on canvas. Private Collection, courtesy Richard Nagy, London

Decree to the Reich Civil Code, all of Munk's assets were confiscated as enemy property in October 1942, including her Bad Aussee home, furniture, carpets, decorative objects, and artworks, including Ria's portrait and two drawings by the Belgian Symbolist painter Fernand Khnopff.[101]

After the war, the third portrait of Ria resurfaced with the German art dealer Wolfgang Gurlitt, who had moved to Bad Aussee in 1940.[102] In June 1952, Gurlitt

brokered the sale of his collection to the city of Linz, thus setting the stage for the Wolfgang Gurlitt Museum (later known as the Neue Galerie der Stadt Linz). Over the course of the next years, this museum would acquire some 111 oils and 450 works on paper from Gurlitt. On account of its dubious provenance, however, Ria's portrait was initially rejected by Linz officials in 1952, and only acquired four years later, in an exchange.[103] A claim for the painting's restitution from the Lentos Museum is currently pending.

VICTOR AND PAULA ZUCKERKANDL

The collection of Victor and Paula Zuckerkandl[104] is one of the finest examples of the integration of Klimt's work within the context of the Wiener Werkstätte, and of his association with the architect Josef Hoffmann.[105]

Victor Zuckerkandl [Fig. 27], a wealthy steel magnate, was the founder of the Sanatorium Westend [Fig. 30] in Purkersdorf, an elegant suburb of Vienna. This exclusive spa offered baths and physical therapy for the treatment of neurological disorders and tuberculosis. The sanatorium boasted many celebrity patients, including Arthur Schnitzler, Egon Friedell, Gustav Mahler, and Arnold Schöenberg. The central building, or Kurhaus, was designed by Hoffmann in 1904 and completely furnished by the Wiener Werkstätte. Hoffmann's plans—encompassing everything from the building's layout to the cutlery—were nurtured by the belief in the redemptive potentials of art and architecture to better society: he demanded of his clients an uncompromising subordination to the notion of the *Gesamtkunstwerk*, or "total, unified work of art."

Zuckerkandl's acquaintance with both Hoffmann and Klimt was forged by his sister-in-law, the writer and critic Berta Zuckerkandl [Fig. 29], one of Klimt's most vocal supporters.[106] Berta was the wife of Victor's brother, Emil Zuckerkandl [Fig. 28],[107] a pioneering anatomist and professor at the University of Vienna, and one of only eleven professors to support Klimt in the scandal surrounding the faculty panels. Berta herself came from an impressive lineage: her father, Moritz Szeps [Fig. 31], was the editor-in-chief of the *Neues Wiener Tagblatt*, and her brother Julius Szeps held the same position at the *Wiener Allgemeine Zeitung*, another important daily newspaper. Berta's sister Sophie was married to Paul Clemenceau, brother of the French statesman (and later prime minister) Georges Clemenceau. This connection would have both diplomatic impact in the peace negotiations ending World War I and personal significance in rescuing Berta's family from Austria during World War II.

Victor Zuckerkandl's collection included at least seven major Klimt landscapes, spanning the length of the artist's oeuvre, including *Rose Bushes under Trees* (*Rosen unter Bäumen*, ca. 1905)[108] and *Poppy Field* (*Mohnwiese*, 1907),[109] which Zuckerkandl acquired from Vienna's most important dealer of the era, the Galerie

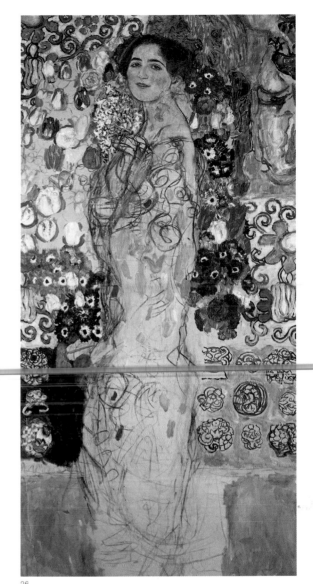

26.

27.

26. Gustav Klimt, *Portrait of Ria Munk III*, 1917–18, oil on canvas. Lentos Kunstmuseum, Linz

27. Victor Zuckerkandl, ca. 1920s. Private Collection

28. Emil Zuckerkandl, 1909. Photograph by d'Ora-Benda, Vienna. Österreichische Nationalbibliothek Bildarchiv, Vienna

29. Berta Zuckerkandl, 1910. Photograph by Atelier Madame d'Ora, Vienna. Österreichische Nationalbibliothek, Vienna

30. Josef Hoffmann, drawing of the Sanatorium Westend at Purkersdorf, ca. 1902. Private Collection

31. Caricature of Moritz Szeps by László von Frecskay, published in *Die Bombe*, 1886. Österreichische Nationalbibliothek Bildarchiv, Vienna

Miethke, in 1911 and 1908 respectively.[110] Zuckerkandl acquired later works directly from the artist; these were *Alley in the Park of Schloss Kammer* (*Allee im Park von Schloss Kammer*, 1912) [Fig. 32];[111] *Forester House in Weissenbach on the Attersee* (*Forsthaus in Weissenbach am Attersee*, 1914) [Fig. 33];[112] *Church in Cassone* (*Kirche in Cassone*, 1913);[113] *Malcesine on Lake Garda*; and *Unterach on the Attersee* (*Unterach am Attersee*, 1915).[114] The only figurative Klimt work was *Pallas Athene* (1898)[115]—the first ot Klimt's allegorical depictions of the *femme fatale* archetype, which Zuckerkandl acquired in 1914 from the industrialist and financier of the Wiener Werkstätte, Fritz Waerndorfer.[116] Finally, in about 1912, Zuckerkandl commissioned Klimt with the portrait of his wife, Paula [Fig. 34].[117]

A planned move to Berlin, where Zuckerkandl was to serve as the director of the iron manufacturer Schlesische Eisenwerke Gleiwitz, occasioned the auction of most of his collection through the Viennese art dealer C. J. Wawra in 1916.[118] The sale catalogue, comprising well over three hundred lots, showed an impressive collection of twenty-two works by nineteenth-century Austrian artist Rudolf von Alt, and works by Ferdinand Georg Waldmüller and August von Pettenkofen, as well as miniatures and porcelain. Two discrete segments of the Zuckerkandl collection, however, were not dispersed. One was his collection of Asian art, formerly kept in a special pavilion at Purkersdorf; this he bequeathed to the museum in the German city of Breslau (now in Poland). The other was his collection of Klimt works, most of which he retained, permitting Wawra to sell only *Pallas Athene* and seven drawings.[119] The remaining Klimt paintings accompanied Zuckerkandl to his new home in Berlin, where in 1916, the year of his move, he loaned *Forester House in Weissenbach* to an exhibition of Austrian art at the Berlin Secession. He eventually sold this painting to the Austrian artist Hans Böhler, another important collector of Klimt and Schiele works.

In 1927, Victor Zuckerkandl died in Berlin, followed within a few weeks by the death of his wife, Paula.[120] Named as their heirs were Victor's sister, Amalie Redlich [Fig. 35],[121] and his sister-in-law, Therese (the widow of his brother Robert Zuckerkandl); Paula's brothers, Ernst and Richard Freund; and their nieces and nephews: Fritz [Fig. 36] (the son of Bertha and Emil Zuckerkandl)[122] and Victor Zuckerkandl Jr.,[123] Nora Stiasny,[124] and Hermine ("Mini") Müller-Hofmann[125] (the latter three were the children of Victor's brother, urologist Otto Zuckerkandl,[126] and his wife, Amalie). Most of the artworks in the Zuckerkandl estate—including some thirty works by von Alt—were auctioned off in 1928, again by Wawra.[127] Some family members, particularly Amalie Redlich, opposed this move, and thus chose to buy back works at the sale.[128]

That year, Zuckerkandl's Klimt paintings were exhibited at the *Klimt Gedächtnisausstellung* and there posted for sale.[129] Nonetheless, six of the seven Klimt paintings listed in the Zuckerkandl estate were retained by family members

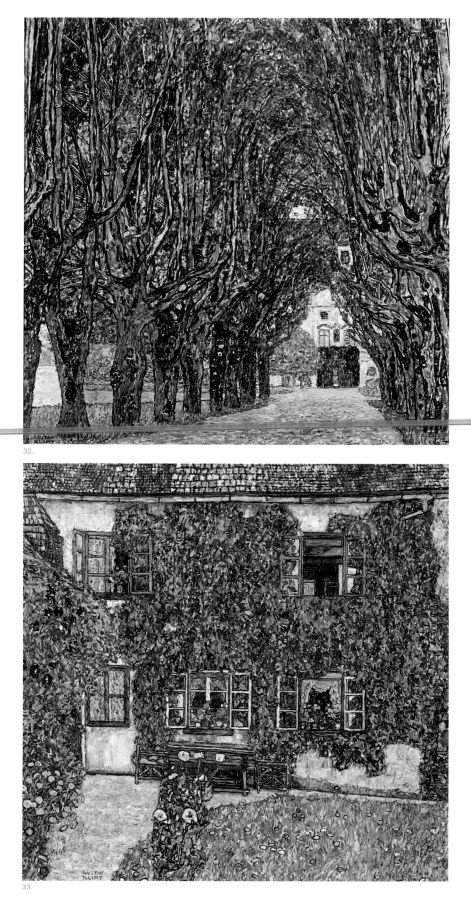

32.

33.

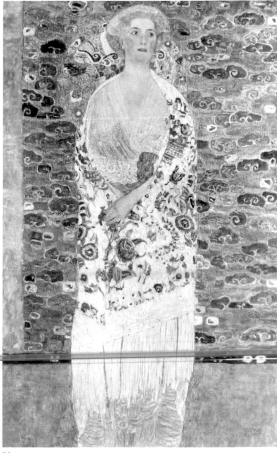

34.

32. Gustav Klimt, *Alley in the Park of Schloss Kammer*, 1912, oil on canvas. Österreichische Galerie Belvedere, Vienna

33. Gustav Klimt, *Forester House in Weissenbach on the Attersee*, 1912, oil on canvas. Neue Galerie New York

34. Gustav Klimt, *Portrait of Paula Zuckerkandl*, 1912, oil on canvas. Current whereabouts unknown. Courtesy Galerie Welz, Vienna

for the time being; only one painting, *Alley in the Park of Schloss Kammer*, was sold by the Zuckerkandl heirs to the Belvedere.[130] Amalie Redlich acquired *Church in Cassone*; Paula's portrait went to her brother Richard Freund in Berlin, under the provision that the painting be bequeathed to the Belvedere upon his death; and *Malcesine* went to Berta Zuckerkandl and her son Fritz. They later sold the painting to August and Serena Lederer, however, and acquired *Poppy Field* in its stead.

Following the "Anschluss" in 1938, the Sanatorium Westend was "Aryanized" by the Österreichische Kontrollbank (Austrian Control Bank) and sold in the following year to the ophthalmologist Hans Gnad.[131] Gnad also seized one of nine Zuckerkandl villas on the sanatorium grounds, requisitioning for himself Hoffmann furniture, at least one Klimt oil painting (*Poppy Field*), and a Klimt watercolor, as well as several works by Fritz Zuckerkandl's wife, the painter Gertrude ("Trude") Stekel.[132]

The fate of Zuckerkandl's other Klimt paintings, such as *Unterach on the Attersee* (which later resurfaced with Galerie Welz and was sold in 1944 to the Landesgalerie Salzburg),[133] is largely unclear. The portrait of Paula Zuckerkandl was destroyed during an air raid on Berlin in the fall of 1942, soon after the suicide of Paula's brother Richard Freund; the family's 1928 pledge to bequeath it to the Belvedere unless the painting were "burned, stolen, or claimed by other unlikely occurrences"[134] had eerily anticipated the tragic course of events.

Poppy Field [Fig. 37] was the only one of the Zuckerkandl paintings to be recovered after the war. Trude, her son Emile, and Berta Zuckerkandl managed with the help of Clemenceau to flee to France, and there they were reunited with Fritz, who had worked in France since 1934. From southern France, the family escaped by ship to Morocco, and in 1941 continued on to Algiers, where they remained until 1945 [Fig. 39]. But in 1948, an export embargo placed upon *Poppy Field* by the Monuments Office trapped the painting in Austria,[135] necessitating its temporary placement with Fritz Zuckerkandl's cousin Hermine Müller-Hofmann, the only surviving relative who had returned to live in Vienna. With no hope of ever recovering the work, Fritz's son, Emile (who had since embarked on a career as a molecular biologist in the United States), finally sold the painting in 1957 to the Austrian collector Rudolf Leopold for the sum of thirty thousand schillings (ca. one thousand U.S. dollars). Leopold in the same year traded the painting with the Belvedere, receiving Egon Schiele's *Cardinal and Nun* (*Kardinal und Nonne*, 1912) in exchange.[136]

Victor's inherited artworks were not the only Klimt pieces misappropriated from Zuckerkandl family members. Along with *Church in Cassone* [Fig. 38], which she had acquired from her brother's estate, the collection of Amalie Redlich included two other Klimt paintings described simply as a pair of "flowering meadows"[137] and thought to date from about 1906. The identity of these paintings has not been fully

35. Amalie Redlich with her daughter Tildi, ca. 1908.
Private Collection

36. Fritz and Trude Zuckerkandl at Château de l'Aubraie, the country estate of the Clemenceau family in Féole, Vendée, France, in the 1930s. Private Collection

37. Gustav Klimt, *Poppy Field*, 1907, oil on canvas.
Österreichische Galerie Belvedere, Vienna

37.

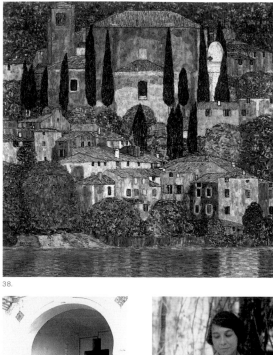

38.

39.

40.

41.

42.

38. Gustav Klimt, *Church in Cassone*, 1913, oil on canvas. Österreichische Galerie Belvedere, Vienna

39. Berta Zuckerkandl in Algiers, 1940. Private Collection

40. Mathilde "Tildi" Jorisch with son Georges, 1928. Private Collection

41. Nora Stiasny with her son Otto (left) and her nephews Rudi (center) and Viki Müller-Hofmann (right) in Altaussee, July 1928. Private Collection

42. Victor Zuckerkandl Jr., ca. 1950s. Private Collection

established: it is unclear whether Redlich in fact owned works that have been misattributed in the Klimt literature to other owners, or whether she owned Klimt works that are not presently known. In the event of the former, it is conceivable that Redlich acquired not one but two paintings from the Zuckerkandl estate, the second being *Rose Bushes under Trees*—a painting that would seem to fit the description "flowering meadow." This painting reemerged on the market through the director of the Wiener Werkstätte, Philipp Häusler,[138] and was acquired in 1980 by the Musée d'Orsay in Paris. Häusler claimed to have acquired this painting from the Zuckerkandl estate—but the truth of this statement appears questionable, both on account of Häusler's affiliation with the Nazi Party and in consideration of his role in the misappropriation of another Klimt painting owned by Redlich's niece, Nora Stiasny. Another possible "flowering meadow" is in fact titled *Flowering Meadow* (*Blühende Wiese*, 1906),[139] a roughly contemporaneous work, which Redlich herself might have acquired from the artist. Its full history also remains unclear, since the painting's provenance appears to have been mistaken in the early documentations of Klimt's works leading up to the 1967 catalogue raisonné by Fritz Novotny and Johannes Dobai.[140]

After being evicted from her Purkersdorf home in 1939, Amalie Redlich assigned *Church in Cassone* and the two landscapes (as well as paintings by such artists as Waldmüller and Angelika Kaufmann) to the shipping company Zdenko Dworak. To ensure the safekeeping of her crates, Redlich bought off Dworak's foreman with a hefty bribe of two thousand reichsmarks and generously tipped his crew[141]—no doubt a risky move, but one that ultimately seems to have secured her property from being seized by the Gestapo. Two years later, on October 23, 1941, Amalie Redlich and her daughter Mathilde ("Tildi") Jorisch [Fig. 40][142] were deported to Lodz.[143] In 1947, Redlich's son-in-law, Louis Jorisch, located the crates at Dworak's facilities, only to find that all had been pried open and the valuables removed—damage for which Dworak unconvincingly blamed Soviet military forces. In the 1960s, *Church in Cassone* resurfaced in a private collection in the Austrian city of Graz.[144]

Amalie Redlich's niece, Nora Stiasny [Fig. 41], is also known to have owned one Klimt painting in her own right, *Apple Tree II* [Fig. 43], which she acquired from her brother, Victor Zuckerkandl Jr. [Fig. 42]. The painting hung in Nora Stiasny's home on the Purkersdorf grounds, where she lived with her husband, Paul Stiasny, the sanatorium's managing director, from 1930 onward. The misappropriation of *Apple Tree II* was attended to by Philipp Häusler, with whom Nora Stiasny had had an affair in younger years. In August 1938, Häusler brokered the painting's forced sale to one of his clients, Adolf Frey, at 395 reichsmarks—a small fraction of its actual worth (the director of the Belvedere, Bruno Grimschitz,[145] had appraised the work at 2,500–3,000 reichsmarks). Frey later reneged on the sale, claiming he had been misled into thinking that the painting he had acquired was Klimt's

Golden Apple Tree. The ensuing dispute between Stiasny, Frey, and Gustav Ucicky, who had similarly made a bid for the painting, prompted an investigation by the Vermögensverkehrsstelle to check what it dubbed "the Jewess's successively greater demands."[146] For the sum of one hundred reichsmarks, Stiasny later pawned *Apple Tree II* to Häusler, who had promised its safekeeping but instead deceived her by selling the painting soon thereafter to Ucicky.

After her eviction from Purkersdorf, Nora Stiasny found temporary refuge with her mother, Amalie ("Maltschi") Zuckerkandl [Fig. 44],[147] who lived in Vienna's historic center, at Grünangergasse 2—across the street from the city's Neue Galerie, a coincidence that would later have significant bearing. In her youth, Amalie had been portrayed by Klimt [Fig. 46]; it was one of the artist's last paintings, and was still unfinished when he died in 1918. After her divorce from Otto Zuckerkandl the following year, Amalie sold her portrait at least twice during the 1920s to her friend Ferdinand Bloch-Bauer, who bought the painting only to return it, as a means of financially supporting Amalie. Bloch-Bauer was first recorded as the painting's owner in 1928, when he loaned the painting to the *Gedächtnisausstellung* at the Vienna Secession.[148] In 1939, the painting was inventoried by the Nazis at the Palais Bloch-Bauer, but it is believed that Ferdinand managed to negotiate its release and return it to Amalie.

In 1942, Amalie's daughter, Hermine Müller-Hofmann, sold her mother's portrait for 1,600 reichsmarks—far less than its actual worth—to Vita Künstler, then managing director of Vienna's Neue Galerie, whose owner, Otto Kallir-Nirenstein, had fled to the United States. Müller-Hofmann needed the money in order to procure false papers declaring her of "mixed" rather than "Jewish" descent, at a cost of 7,000 reichsmarks—a sum roughly equivalent to the annual pension her husband, the artist Wilhelm Müller-Hofmann, received following his dismissal by the Nazis from his position at the Kunstgewerbeschule (School of Applied Arts). These papers gave modest security, and Hermine and Wilhelm Müller-Hofmann [Fig. 45] managed to survive near Chiemsee in Southern Germany.[149]

Amalie Zuckerkandl, then seventy-three, and Nora Stiasny were deported to the Izbica camp in Poland on April 9, 1942. Meanwhile, Nora's husband, Paul, fled to Prague, together with the couple's teenage son, Otto. In October 1942, Otto was deported from Prague to Theresienstadt, and from there to Auschwitz, where he was killed. A similar fate met his father, who perished at Auschwitz the following year.[150]

In 1988, Künstler bequeathed the Amalie Zuckerkandl portrait to the Belvedere. Contesting claims for the painting's restitution by the Zuckerkandl and Bloch-Bauer families are currently pending. A claim for *Apple Tree II*, which the Belvedere acquired as a bequest of Gustav Ucicky in 1961, led to the painting's restitution to the heirs of Nora Stiasny in October 2000.[151]

43.

44.

45.

43. Gustav Klimt, *Apple Tree II*, 1916, oil on canvas. Private Collection

44. Amalie Zuckerkandl (foreground) with husband Otto and daughter Hermine (right), Brioni, Italy, ca. 1914. Private Collection

45. Hermine and Wilhelm Müller-Hofmann near Chiemsee in the 1940s. Private Collection

46.

47.

48

46. Gustav Klimt, *Portrait of Amalie Zuckerkandl*, 1917–18, oil on canvas. Österreichische Galerie Belvedere, Vienna

47. Ferdinand Bloch-Bauer, ca. 1935. Private Collection

48. Adele Bloch-Bauer, ca. 1910.
Courtesy Österreichische Galerie Belvedere, Vienna

FERDINAND AND ADELE BLOCH-BAUER

The collection of Ferdinand and Adele Bloch-Bauer [Figs. 47, 48][152] is the only one of the large prewar Klimt collections that, having been torn apart in the Nazi period, was reassembled at the Belvedere in the late 1940s, where the paintings remained until their restitution some sixty years later.

Ferdinand was a wealthy sugar magnate who had garnered a fortune as a pioneer of the burgeoning Austro-Hungarian sugar-beet industry. His primary business interests lay in the Chropiner Zuckerfabriks-Aktiengesellschaft, a sugar factory in Moravia, and the Österreichische Zuckerindustrie-Aktiengesellschaft, a large sugar plant in Bruck-an-der-Leitha, in Lower Austria.[153] In 1899 Ferdinand Bloch married Adele Bauer, the daughter of the director general of the Wiener Bankenverein, Moritz Bauer.[154] Ferdinand's brother Gustav in the previous year had married Adele's sister, Therese ("Thedy").[155] Following the death of all five of the Bauer brothers in the space of a few years, thus ending the Bauer line, the brothers Ferdinand and Gustav Bloch joined their name with their wives' in 1917 to form the double-barreled Bloch-Bauer.

As a collector, Ferdinand Bloch-Bauer was most earnestly dedicated to his collection of porcelain from the k. k. Wiener Porzellanmanufaktur (Imperial Viennese Porcelain Manufactory).[156] He also took a keen interest in Vienna's Biedermeier, the period predating the liberal revolution of 1848, and owned ten paintings by its most important protagonist, Ferdinand Georg Waldmüller.[157]

Adele's great passion was for the work of Klimt. Ferdinand had twice commissioned large portraits of his wife—the 1907 *Adele Bloch-Bauer I* [Fig. 51], the iconic expression of the artist's Golden Period, and the 1912 *Adele Bloch-Bauer II*

[Fig. 52], heralding Klimt's later, boldly colorful period. The Bloch-Bauers also owned four Klimt landscapes—*Beech Forest* (*Birkenwald*, 1903) [Fig. 53], *Schloss Kammer on the Attersee III* (*Schloss Kammer am Attersee III*, 1910), *Apple Tree I* (*Apfelbaum I*, ca. 1912) [Fig. 54], and *Houses in Unterach on the Attersee* (*Häuser in Unterach am Attersee*, 1916) [Fig. 55], some of which had been purchased from the artist's estate.[158] In 1928, three years after Adele's death, Ferdinand acquired Klimt's unfinished portrait of Amalie Zuckerkandl, which was displayed separately from the rest of the Klimt paintings in Ferdinand's bedroom.

Adele's first portrait had initially been intended as a gift for her parents [Fig. 50] on their wedding anniversary in 1903, but this plan was abandoned as the process took longer than expected. The painting was completed only in 1907, and was exhibited in the same year both at the Wiener Werkstätte and at the *Internationale Kunstausstellung* [Fig. 49] in Mannheim, and at the *Kunstschau* in Vienna in 1908. In fact, Adele's portrait as well as the Bloch-Bauers' other Klimt works would be loaned to all important exhibitions of Klimt's work, including the 1910 *Esposizione Internazionale* in Venice and the 1918 show *Ein Jahrhundert Wiener Malerei* at the Kunsthaus Zurich.

49. Gustav Klimt's *Adele Bloch-Bauer I* at the *Internationale Kunstausstellung*, Mannheim, 1907

50. Moritz and Jeanette Bauer, ca. 1874. Private Collection

The painting's undeniable sensuality has prompted several critics, most prominently the American psychiatrist Salomon Greenberg, to suggest that Adele Bloch-Bauer and Gustav Klimt were in fact lovers, but there is no solid evidence to support this theory.[159] It is more likely that Klimt was indebted primarily to Ferdinand as one of his most important—certainly one of his wealthiest—patrons, the only one of his admirers able to afford the commission of not one, but two portraits of his wife.

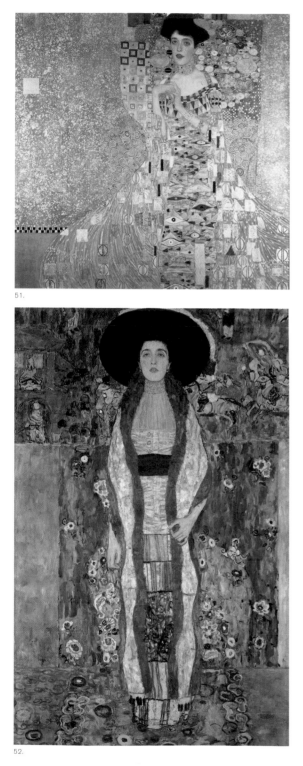

51. Gustav Klimt, *Adele Bloch-Bauer I*, 1907, oil on canvas.
Neue Galerie New York. This acquisition made available in part
through the heirs of the Estates of Ferdinand and Adele Bloch-Bauer

52. Gustav Klimt, *Adele Bloch-Bauer II*, 1912, oil on canvas.
Private Collection

Ferdinand was also a major benefactor to the Belvedere, serving as a founding member and sponsor of the Österreichische Staatsgalerieverein, the association established in 1912 to support the Moderne Galerie (the Belvedere's contemporary collection).[160] In 1919, Ferdinand donated the generous sum of five thousand kronen to co-fund the museum's purchase of Klimt's *Medicine*, the third of his panels representing the faculties of the University of Vienna.[161] Ferdinand remained a leading benefactor after 1921, when the Staatsgalerieverein was renamed Verein der Museumsfreunde (Society of Friends of Austrian Museums), and its interests expanded to include all public collections.[162] In 1919, Ferdinand gave the Belvedere Adele's portraits and the four landscapes on long-term loan,[163] possibly to facilitate the couple's move to a small mansion at Elisabethstrasse 18, in Vienna's elegant first district. The paintings were returned in the early 1920s, and mounted at the Palais Bloch-Bauer, in a room that was dedicated to the artist, the so-called Klimt-Zimmer.

In 1925, Adele died of encephalitis, at the age of forty-three. Ferdinand was Adele's sole heir, as the couple had remained childless: at least one baby had been stillborn, and a second, Fritz, died within a day of his birth in 1904. In her last will and testament, Adele bequeathed money to two organizations closely associated with her friend Julius Tandler, a pioneer of social reform and a long-serving city councilor of Vienna's Social Democratic municipal government in the 1920s and early 1930s. One of her beneficiaries was the Kinderfreunde (the leading socialist organization for children, which maintained schools and orphanages); the other was the Bereitschaft (an association affiliated with the Freemasons, dedicated to social-reform issues such as workers' education and women's suffrage). She also left her library to the Volksheim Ottakring, a school for adult education that held art shows. Finally, Adele requested that Ferdinand leave Klimt's portraits and the four landscapes to the Belvedere upon his death.[164]

In the meantime, Ferdinand left the Klimt-Zimmer untouched, but renamed it the "Gedenkzimmer" (memorial room)—in commemoration of artist and sitter alike. He continued to lend the paintings to exhibitions, most significantly the 1928 *Klimt Gedächtnisausstellung*; the 1934 show *Austria in London*; and the Paris World's Fair and Bern exhibition of 1937.[165] Anticipating Adele's request by several years, Ferdinand bequeathed Klimt's *Schloss Kammer* to the Belvedere in 1936.[166] He replaced it in the Gedenkzimmer with his own portrait by Oskar Kokoschka, whom Ferdinand had been supporting to a significant degree.[167] This was Ferdinand's last major art purchase before the "Anschluss"—and the only painting that he was to recover from Austria during his lifetime.

Ferdinand fled Vienna on the eve of the "Anschluss," on March 12, 1938. On April 27, the Nazis filed criminal charges against him for evasion of income and corporation taxes for the years 1927 to 1937—an amount in excess of 260,000 reichsmarks—and issued a security order shortly thereafter. In the fall of 1938, the

53.

54.

Austrian internal revenue office impounded Ferdinand's entire property to secure alleged tax debts, which had by then skyrocketed to 700,000 reichsmarks.[168]

On January 28, 1939, museum officials entered the Palais Bloch-Bauer to inspect the art collection.[169] The majority of the artworks were subsequently placed on the "Reich List" and barred from export.[170] Several works were claimed as trophies for the private collections of Adolf Hitler and Hermann Göring; others were reserved for the "Führermuseum" in Linz. The best porcelain objects went to the Städtische Sammlungen and the Kunstgewerbemuseum (now called MAK-Österreichisches Museum für angewandte Kunst). The remainder, some four hundred pieces, were put up for public auction in June 1941 by the Kunst- und Auktionshaus Kärntnerstrasse.[171]

Attending to the expropriation process as Bloch-Bauer's legal representative was a lawyer with the oddly appropriate name Erich Führer.[172] Führer was a vehement anti-Semite, and a veteran of the Ostmärkische Burschenschaft (the Nazis' leading university fraternity), and had served as defense counsel for the instigators of the failed Nazi putsch of July 1934. Immediately following the "Anschluss," Führer's notoriety secured his promotion to the rank of SS-Hauptsturmführer and his election as vice-president of Vienna's bar association.

The fact that the Nazis accorded less value to Klimt's works than to other pieces in the Bloch-Bauer collection allowed Führer to dispose of these paintings rather more freely than other works. In fact, only two of the Klimt paintings in the Bloch-Bauer collection—*Beech Forest* and *Apple Tree I*—were seized by the municipal authorities, to prevent their being taken out of the country.[173] As Jewish family portraits, the paintings of Adele and of Amalie Zuckerkandl were exempt from such restrictions.

55. Gustav Klimt, *Houses in Unterach on the Attersee*, 1916, oil on canvas. Private Collection

Despite Führer's knowledge of Adele Bloch-Bauer's bequest, in 1941 he sold Adele's golden portrait and *Apple Tree I* to the Belvedere,[174] headed at the time by Bruno Grimschitz, an intimate connoisseur of the Bloch-Bauer collection. In exchange, Grimschitz surrendered *Schloss Kammer* (Ferdinand's erstwhile bequest) to Führer,[175] who in turn sold that painting to Klimt's son, the infamously prodigious collector Ucicky. In 1942, Führer brokered the sale of *Beech Forest* to the Städtische Sammlungen, and, in the following year, he sold *Adele Bloch-Bauer II* to the Belvedere.[176] All five Bloch-Bauer paintings were presented in the 1943 Klimt retrospective at the Secession.[177] To hide the subject's Jewish origins, *Adele I* was referred to in the catalogue simply as a "portrait of a lady against gold background," and *Adele II* as a "lady standing."

Ferdinand himself had escaped to Czechoslovakia, taking temporary refuge at his summer residence near Prague, the castle of Jungfer-Březan (Panenské Břežany) in Brandeis-an-der-Elbe (Brandýs nad Labem). In the fall of 1938, anticipating Hitler's imminent invasion of Czechoslovakia, Ferdinand fled to France, and upon the outbreak of war in September 1939, from there on to Zurich, where he was to remain until his death in November 1945. Meanwhile, both of Ferdinand's homes were "Aryanized" by the Nazis: the Palais Bloch-Bauer on Elisabethstrasse was taken over in 1940 by the Deutsche Reichsbahn, the German railroad,[178] and Jungfer-Březan ultimately went to the Deputy Reichsprotektor of Bohemia and Moravia, Reinhard Heydrich, a chief architect of the Nazis' "Final Solution."

Ferdinand Bloch-Bauer died on November 13, 1945, in Zurich, at the age of eighty-one; only a few months after the Nazis' defeat. He died alone, having renounced all previous wills and naming as his heirs three of his brother's children: Louise Gutmann, Maria Altmann, and Robert Bentley.[179] Since his entire property had been ransacked and liquidated by the Nazis, Ferdinand left his nieces and nephews no more than a share in whatever might be recovered in the future. For the next decades, they would devote themselves to restoring their uncle's stolen fortune.

In the immediate postwar period, Ferdinand, and later his heirs, retained the young lawyer Gustav Rinesch—a friend of Ferdinand's nephew Robert Bloch-Bauer from his university days—to pursue their restitution claims.[180] In 1947, British property control recovered at least fourteen Bloch-Bauer paintings from Erich Führer's apartment in 1947—the same year that Führer was sentenced to three years of hard labor on the count of high treason (he was released on early parole in 1948).[181] Objects that had been designated for Hitler's museum in Linz were retrieved from the American Allies' Munich collecting point, and were restored to Austria by the United States Military Administration; other works were located at the Städtische Sammlungen and the Kunstgewerbemuseum. Again, export embargoes prevented their return to Ferdinand's heirs.[182]

In January 1948, Rinesch filed a claim with the Belvedere for those three works in the museum's possession: the two portraits of Adele, and *Apple Tree I*.[183] However, through his dealings with the director of the Belvedere, Karl Garzarolli,[184] Rinesch was quickly discouraged, and surmised that it would be almost impossible to revoke the Belvedere's acquisition of the Klimt works.

Rinesch then hoped to use the paintings as leverage to extract other Bloch-Bauer property from Austria, and thus formally conceded to Adele's bequest on April 12, 1948.[185] This concession permitted Austria not only to confirm retroactively its title to the three works at the Belvedere, but also to apply Adele's last will and testament with respect to those remaining Klimt works not yet in its possession. The museum thus secured *Houses in Unterach on the Attersee*, which had been discovered by officials of the Monuments Office in the apartment of Ferdinand's nephew, Karl Bloch-Bauer;[186] later that year, the Belvedere successfully removed *Beech Forest* from the Städtische Sammlungen.[187] In 1949, the Belvedere located *Schloss Kammer* in Gustav Ucicky's collection and brokered an agreement with Ucicky, whereby he would be permitted to keep the painting as a lifetime loan on the condition of his bequest of three other Klimt paintings to the museum. All of Ucicky's promised gifts came from pillaged collections [Fig. 56].[188] In 1988, the Belvedere finally reunited all seven Bloch-Bauer works, when Klimt's portrait of Amalie Zuckerkandl was received as a bequest from the art dealer Vita Künstler.[189]

A decade was to pass before the Belvedere's title to these works was formally challenged under Austria's 1998 Art Restitution Act—prompted in part by investigations by the Austrian journalist Hubertus Czernin and his publication of a two-part monograph on the Bloch-Bauer case, titled simply *Die Fälschung* (The deception).[190] In 1999, the Bloch-Bauer claim was submitted to the advisory council that rules on restitution issues, but was promptly thrown out. Austria's only concession at the time was the return of sixteen Klimt drawings and nineteen porcelain objects that the Bloch-Bauer heirs had been pressed to donate in 1948 in exchange for export licenses.[191]

In the wake of Austria's refusal in 1999 to return the paintings, Maria Altmann and her attorney, E. Randol Schoenberg, filed a complaint with the Los Angeles federal courts against the Republic of Austria in August 2000, ultimately taking the case before the United States Supreme Court. In June 2004, the U.S. Supreme Court upheld Altmann's right to proceed under the Foreign Sovereignties Immunity Act and ruled six-to-three in her favor.[192] In the following year, Schoenberg accepted the offer to allow an arbitration panel of three Austrian judges to rule on the case. In January 2006, this arbitration panel ordered the return of all paintings except the portrait of Amalie Zuckerkandl to the Bloch-Bauer heirs, marking the most monumental recovery in Austrian history.

56.

56. Interior views of the Ucicky residence, Vienna, 1957.
Visible paintings by Gustav Klimt are (from top left):
Apple Tree II (1916), from the collection of Nora Stiasny; *Portrait of
Gertrud Felsövanyi* (1902), from the Felsövanyi collection; *Water
Serpents II* (1904–07), from the collection of Jenny Steiner; *Schloss
Kammer on the Attersee III* (1910), from the collection of Ferdinand
and Adele Bloch-Bauer. Österrechische Nationalbibliothek, Vienna

THE ENDURING IMPACT OF KLIMT'S EARLY PATRONS

August and Serena Lederer, Victor and Paula Zuckerkandl, and Ferdinand and Adele Bloch-Bauer were among Klimt's earliest collectors; they enabled him to work independently and helped to establish his reputation. And this relationship was reciprocal: Klimt's very rare and valuable artworks elevated the status of his collectors, reinforcing their position as Vienna's cultural avant-garde and economic elite. The rapport between the artist and his patrons was nurtured by the mutual conviction that "if you cannot appeal to all through your deeds and art, please only a few. To appeal to all is awful"—a quote from Austrian dramatist Friedrich Schiller that Klimt had inscribed as a programmatic dictum on his groundbreaking work *Nuda Veritas* (1899).[193]

Although the individual works in the Lederer, Zuckerkandl, and Bloch-Bauer collections had different fates under the Nazis, these great pre war collections had a common larger destiny: none of them survived intact. While the advent of National Socialism quite generally ended the age of private collecting, the shattering of these collections stands out as having merely preceded these families' persecution and murder in the Holocaust.

For decades, Austria prided itself on its rich cultural history, but erased the memory of the rightful owners of those works that it had acquired, directly or indirectly, as a result of Nazi spoliation. Masterpieces such as the golden portrait of Adele Bloch-Bauer became icons of collective cultural identity; but the processes leading to the expropriation of such works were glossed over—just as Austria glossed over its own role in and responsibility for the Nazis' atrocities. The rise of figures such as Gustav Ucicky, Klimt's son whose acquisitions in the Nazi era until recently were never seriously questioned, were symptomatic of this phenomenon.

Having set out to undo this historic wrong, Austria's Art Restitution Act in 1998 contributed, perhaps inadvertently, to a revitalization of the study of pre war private collecting and patronage in Austria. With respect to works by Klimt, recent restitutions have revealed the singular contribution of his earliest patrons to Austrian modernism during the fin de siècle. Restitution policies have also dramatically influenced the propagation of Klimt's work. Ironically, the current waiver of export embargoes has proven more effective in promoting the artist worldwide than were Austria's former policies to retain his works for the Austrian state. Klimt is better known and estimated more highly today than ever before—an achievement that is significantly due to the memory of his earliest collectors.

The author gratefully acknowledges the help of the following persons whose support was invaluable in the writing of this essay: Maria Altmann; Nelly Auersperg; Frits Bossen; Franz Eder; Anita Gallian; Georg Gaugusch; Maren Gröning; Robert Holzbauer; Georges Jorisch; Marianne and Wilhelm Kirstein; Monika Mayer; Müller-

Hofmann family; Ulrike Niemeth; Alfred J. Noll; Anneliese Schallmeiner; E. Randol Schoenberg; Werner J. Schweiger; Jenny Steiner heirs; Michael Wladika and Emile Zuckerkandl. A special thank you goes to Ruth Pleyer for her help with the Zuckerkandl collection.

NOTES

1 Federal Law of December 4, 1998, regarding the return of artworks from Austrian federal museums and public collections; *Federal Law Gazette*, 1998/I/181.

2 Graphische Sammlung Albertina (GSA), inv. 30695–710. Bundesministerium für Unterricht und kulturelle Angelegenheiten (Federal Ministry of Education and Cultural Affairs—BMUK), *Restitutionsbericht 1998/1999*, item III.

3 Alice Strobl, *Gustav Klimt: Die Zeichnungen* (Salzburg: Galerie Welz, 1980–89), no. 2666a. GSA, inv. 29544; Bundesministerium für Bildung, Wissenschaft und Kultur (Federal Ministry of Education, Science and Culture—BMBWK), *Restitutionsbericht 1999/2000*, item V.

4 Fritz Novotny and Johannes Dobai, *Gustav Klimt* (Salzburg: Galerie Welz, 1967), nos. 189, 195 (provenance erroneously cited as August Lederer), 161, 110. Österreichische Galerie Belvedere (ÖG) inv. 8983, 5447, 5448, 4415; BMBWK, *Restitutionsbericht 1999/2000*, items XXV–XXVII.

5 Novotny and Dobai, *Gustav Klimt*, no. 97. ÖG Inv. 5449; BMBWK, *Restitutionsbericht 2002/2003*, item VIII.

6 Ibid., no. 166. *German and Austrian Art*, Christie's, London, October 9, 1997, lot 198.

7 *Impressionist and Modern Art*, Sotheby's, New York, November 5, 2003.

8 Novotny and Dobai, *Gustav Klimt*, no. 193. *Impressionist and Modern Art*, Sotheby's, New York, May 13, 1997, lot 43.

9 Ibid., no. 103. Metropolitan Museum of Art, New York, inv. 1980.412. Purchase, Wolfe Fund, and Rogers and Munsey Funds, Gift of Henry Walters, and Bequests of Catharine Lorillard Wolfe and Collis P. Huntington, by exchange, 1980.

10 Ibid., no. 188. Private collection, New York. Elisabeth Bachofen-Echt (née Lederer, b. January 20, 1894, Vienna, d. October 19, 1944, Vienna). On the Bachofen-Echt collection, see Tobias G. Natter and Gerbert Frodl, eds., *Klimt und die Frauen*, exh. cat. (Vienna/New Haven, CT: Österreichische Galerie Belvedere, Yale University Press, 2001), pp. 132–35; Sophie Lillie, *Was einmal war, Handbuch der enteigneten Kunstsammlungen Wiens* (Vienna: Czernin, 2003), pp. 144–48.

11 Novotny and Dobai, *Gustav Klimt*, no. 150. Neue Galerie New York. Acquisition made possible in part through the generosity of the heirs of the Estates of Ferdinand and Adele Bloch-Bauer. Novotny and Dobai, *Gustav Klimt*, no. 177.

12 Ibid., no. 178. Presumed destroyed in World War II.

13 Ibid., no. 213. ÖG, inv. 7700.

14 Sonja Knips (née Freiin Potier des Echelles, b. December 2, 1873, Krakow [now Poland], d. June 25, 1959, Vienna). On the Knips collection, see Natter and Frodl, *Klimt und die Frauen*, pp. 84–87; Tobias G. Natter, *Die Welt von Klimt, Schiele und Kokoschka: Sammler und Mäzene* (Cologne: DuMont, 2003), pp. 27–37.

15 Novotny and Dobai, *Gustav Klimt*, no. 123. Staatliche Galerie Moritzburg, Halle, Germany. Dr. Hugo Henneberg, physicist (b. July 27, 1863, Vienna, d. July 11, 1918). Marie Henneberg (née Hinterhuber, b. September 23, 1851, Salzburg, d. June 23, 1931, Vienna). On Hugo and Marie Henneberg, see Natter and Frodl, *Klimt und die Frauen*, pp. 94–97.

16 Novotny and Dobai, *Gustav Klimt*, no. 125. Private collection, Vienna. Dr. Anton Loew, owner of Sanatorium Loew (b. 1847, Pressburg [now Bratislava, Slovakia], d. September 14, 1907, Vienna); Gertrude Felsövanyi (née Loew, first marriage Terramare, b. November 16, 1883, d. March 1964, California). On the Felsövanyi collection, see Natter and Frodl, *Klimt und die Frauen*, p. 98 f.; Lillie, *Was einmal war*, pp. 356–59.

17 Novotny and Dobai, *Gustav Klimt*, no. 138. National Gallery, London, on extended loan to the Tate Modern, London, inv. LO1893. Moriz Gallia (b. November 15, 1858, Bisenz, Moravia, d. August 17, 1918, Vienna); Hermine Gallia (née Hamburger, b. June 14, 1870, Freudenthal [now Bruntál, Czech Republic], d. February 6, 1936, Vienna). On the Gallia collection, see Terence Lane, *Vienna 1913: Josef Hoffmann's Gallia Apartment*, exh. cat. (Melbourne: National Gallery of Victoria, 1984); Natter and Frodl, *Klimt und die Frauen*, pp. 104–107.

18 Novotny and Dobai, *Gustav Klimt*, no. 142. Bayerische Staatsgemäldesammlungen, Neue Pinakothek, Munich, inv. 13074. Karl Wittgenstein, iron and steel industrialist (b. April 8, 1847, Vienna, d. January 20, 1913, Vienna); Margarethe (Margaret) Stonborough-Wittgenstein (née Wittgenstein, b. September 19,

1882, d. September 27, 1958, Vienna). On the Wittgenstein collection, see Natter and Frodl, *Klimt und die Frauen*, p. 108 ff.; Natter, *Sammler und Mäzene*, pp. 38–53; Lillie, *Was einmal war*, pp. 1332–39; Ursula Prokop, *Margaret Stonborough-Wittgenstein: Bauherrin, Intellektuelle Mäzenin* (Vienna/Cologne/Weimar: Böhlau, 2003).

19 Novotny and Dobai, *Gustav Klimt*, no. 143. ÖG, inv. 3379. Dr. Alois Riedler, engineer, professor at the Technische Hochschule zu Berlin-Charlottenburg (b. May 19, 1850, Graz, Austria, d. October 25, 1936); Friederike ("Fritza") Riedler, née Langer (b. September 9, 1860, Berlin, d. April 8, 1927, Vienna). On Alois and Fritza Riedler, see Natter and Frodl, *Klimt und die Frauen*, pp. 111–14. Karl-Heinz Manegold, "Alois Riedler," in W. Treue and W. König, *Berlinische Lebensbilder*, vol. 6: Techniker (Berlin: Colloquium, 1990), pp. 293–307.

20 Novotny and Dobai, *Gustav Klimt*, no. 187. Toyota Municipal Museum of Art, Japan. Novotny and Dobai, no. 179. Metropolitan Museum of Art, New York, inv. 64.148. Gift of André and Clara Mertens, in memory of her mother, Jenny Pulitzer Steiner. Otto Clemens Primavesi, industrialist (b. February 27, 1868, Olmütz [Olomouc], Moravia, d. February 8, 1926); Eugenia ("Mäda") Primavesi (née Butschek, b. June 13, 1874, Vienna, d. May 31, 1962, Vienna). On the Primavesi collection, see Natter and Frodl, *Klimt und die Frauen*, pp. 126–31; Natter, *Sammler und Mäzene*, pp. 72–86; Claudia Klein-Primavesi, *Die Familie Primavesi und die Künstler Hanak, Hoffmann, Klimt: 100 Jahre Wiener Werkstätte* (Vienna: privately published, 2004); idem., *Die Familie Primavesi und die Wiener Werkstätte: Josef Hoffmann und Gustav Klimt als Freunde und Künstler* (Vienna: privately published, 2006).

21 Novotny and Dobai, *Gustav Klimt*, no. 196. Tel Aviv Museum of Art, Mizne-Blumental Collection. Hans Böhler, artist (b. September 11, 1884, Vienna, d. September 17, 1961, Vienna); Friederike (Federica) Beer-Monti (b. January 27, 1891, Vienna, d. July 1980). On the Böhler collection, see Natter, *Sammler und Mäzene*, pp. 186–94.

22 "Wahre Kunst wird von wenigen für die Wertschätzung weniger gemacht."

23 Nicolaus Dumba, industrialist and banker (b. July 24, 1830, Vienna, d. March 23, 1900, Budapest). On the Dumba collection, see Natter, *Sammler und Mäzene*, pp. 18–26.

24 Karl Kraus, *Die Fackel*, vol. 2, no. 41, May 1900, p. 22.

25 *Gustav Klimt*, Ausstellungshaus Friedrichstrasse (formerly Secession), February 7–March 7, 1943 (with exh. cat.).

26 Emil Pirchan, *Gustav Klimt: Ein Künstler aus Wien* (Vienna: Wallishauser, 1942).

27 Novotny and Dobai, *Gustav Klimt*, no. 221. National Gallery of Art, inv. 1978.41.1, Gift of Otto and Franziska Kallir with the help of the Carol and Edwin Gaines Fullinwider Fund. On the Kallir collection, see Jane Kallir, *Saved from Europe: Otto Kallir and the History of the Galerie St. Etienne*, exh. cat. commemorating the sixtieth anniversary of Galerie St. Etienne, New York, 1999; *Otto Kallir-Nirenstein: Ein Wegbereiter österreichischer Kunst*, exh. cat. (Vienna: Historisches Museum der Stadt Wien, 1986); Lillie, *Was einmal war*, pp. 540–45.

28 Novotny and Dobai, *Gustav Klimt*, no. 27. Bundesdenkmalamt (Austrian Federal Monuments Office—BDA), photo archive, I 66, 67, 1542. On the Robert Pollak collection, see Lillie, *Was einmal war*, pp. 884–89.

29 August Lederer, industrialist (b. May 3, 1857, Böhmisch Leipa [now âeská Lípa, Czech Republic], d. April 30, 1936, Vienna); Sidonie ("Serena") Lederer (née Pulitzer, b. May 20, 1867, Budapest, d. March 27, 1943, Budapest). On the Lederer collection, see Christian M. Nebehay, *Gustav Klimt, Egon Schiele und die Familie Lederer* (Bern: Galerie Kornfeld, 1987); Natter and Frodl, *Klimt und die Frauen*, pp. 88–91; Natter, *Sammer und Mäzene*, pp. 111–39; Lillie, *Was einmal war*, pp. 656–71.

30 Hofrat Professor Dr. Adam Politzer, otologist (b. October 1, 1835, Alberti, Hungary, d. August 10, 1920, Vienna).

31 *Versteigerung der Gemäldesammlung Hofrat Prof. Dr. A. Politzer*, Glückselig und Wärndorfer, Vienna, 1920; *Sammlung des in Wien verstorbenen Hofrats Professor Dr. A. Politzer*, Amsler und Ruthardt, Berlin, May 18–20, 1922; *Nachlässe Prof. Dr. A. Politzer, Wien, Hofrat Franz Breitfeldner, Wien*, Kende, Vienna, 1928.

32 Novotny and Dobai, *Gustav Klimt*, no. 44. Wien Museum, inv. 31318.

33 BDA, Restitutionsmaterialien (Rest. Mat.), box 9, file 2a: Sammlung Lederer 1940–46. Leo Planiscig, Appraisal of the Lederer collection, August 1, 1927.

34 BDA, Ausfuhrmaterialien (Ausf. Mat.), notary file no. 1788/21, August Lederer.

35 Novotny and Dobai, *Gustav Klimt*, nos. 105, 128. Destroyed by fire at Schloss Immendorf, 1945.

36 Ibid., nos. 86, 87. Destroyed by fire at Schloss Immendorf, 1945.

37 Eduard Sekler, *Josef Hoffmann: Das architektonische Werk* (Salzburg/Vienna: Residenz, 1982), p. 94.

38 ÖG Archive, no. 134/1919. Franz Martin Haberditzl to Bloch-Bauer, April 1, 1919.

39 Novotny and Dobai, *Gustav Klimt*, no. 127. ÖG, inv. 5987; on permanent loan to the Vereinigung bildender KünstlerInnen Wiener Secession.

40 *Klinger Beethoven*, fourteenth exh. cat. (Vienna: Secession, 1902).

41 *Gustav Klimt*, eighteenth exh. cat. (Vienna: Secession, 1903).

42 Carl Reininghaus, industrialist (b. November 10, 1857, Graz, d. October 29, 1929). Major collector of Austrian modernist art, particularly by Egon Schiele and Ferdinand Hodler. On the Reininghaus collection, see Natter, *Sammler und Mäzene*, pp. 165–77.

43 Nebehay, *Familie Lederer*, pp. 35–38.

44 Novotny and Dobai, *Gustav Klimt*, nos. 101, 89, 174, 186, 215, 219, 133, 200, 201, 202. Destroyed at Schloss Immendorf, 1945.

45 Ibid., no. 190. Current whereabouts unknown.

46 *Gustav Klimt: Die Zeichnung*, exh. cat. (Vienna: Gustav Nebehay, 1919).

47 Christian M. Nebehay, *Die Goldenen Sessel meines Vaters: Gustav Nebehay (1881–1935), Antiquar und Kunsthändler in Leipzig, Wien und Berlin* (Vienna: Brandstätter, 1983), p. 115.

48 Christian M. Nebehay, *Gustav Klimt: Dokumentation* (Vienna: Galerie Christian M. Nebehay, 1969), p. 176.

49 Erich Lederer (b. September 13, 1896, Vienna, d. January 19, 1985, Geneva). On the Erich Lederer collection, see Natter, *Sammler und Mäzene*, pp. 154–64; Sophie Lillie, "A Legacy Forlorn: The Fate of Egon Schiele's Early Collectors," in *Egon Schiele: The Ronald S. Lauder and Serge Sabarsky Collections*, exh. cat. (New York: Neue Galerie New York, 2000), pp. 110–39.

50 Novotny and Dobai, *Gustav Klimt*, no. 131. Destroyed by fire at Schloss Immendorf, 1945.

51 *Von Füger bis Klimt: Die Malerei des XIX. Jahrhunderts in Meisterwerken aus Wiener Privatbesitz*, exh. cat., Verein der Museumsfreunde in Wien, ed. Franz Ottmann (Vienna: Hölzel, 1923), no. LV.

52 *Klimt Gedächtnisausstellung*, ninety-ninth exh. cat. (Vienna: Secession, 1928), nos. 3–6.

53 *Austria in London: Austrian National Exhibition of Industry, Art, Travel, Sport*, exh. cat. (London: Dorland Hall, 1934), p. 68, nos. 49, 54.

54 *Ausstellung von Erwerbungen und Widmungen zu Gunsten der öffentlichen Sammlungen 1912—1936 sowie von Kunstwerken aus Privatbesitz*, exh. cat. commemorating the twenty-fifth anniversary of the foundation of the Österreichische Staatsgalerieverein (later renamed Verein der Museumsfreunde) (Vienna: Secession, 1936), nos. 1–9.

55 Exposition d'Art Autrichien, Musée du Jeu de Paume des Tuileries, Paris, 1937 (Paris: Braun et Cie., 1937), nos. 368–89. Other Lederer works included nos. 490, 500–508, 526–27.

56 Österreichisches Staatsarchiv (Austrian State Archives—ÖStA), Archiv der Republik (Archives of the Republic—AdR), Vermögensverkehrsstelle (VVSt), Vermögensanmeldung (Assets Report—VA) 63953, Serena Lederer; VA 50856, Erich Lederer.

57 BDA, Rest. Mat., box 9, file 2a, fol. 253 f. Application for export license, no. 6236/39, Serena Lederer.

58 Ibid., box 8: Ursprungsverzeichnisse, file 3. Report by the Zentralstelle für Denkmalschutz (Central Office for Monuments Preservation—ZfD), no. IV-4-b-333977/39.

59 Ibid., box 9, file 1: Sammlung Lederer 1922–39 (I), fols. 28–44. Reich List Serena Lederer.

60 On the "Führermuseum," see Birgit Schwarz, *Hitlers Museum: Die Fotoalben Gemäldegalerie Linz: Dokumente zum "Führermuseum"* (Vienna/Cologne/Weimar: Böhlau, 2004).

61 BDA, Rest. Mat., box 9, file 1, fols. 60–91. Inventory of museums and public offices interested in the distribution of seized artworks.

62 Ibid., box 9, file 1a: Sammlung Lederer 1922–39 (II), fol. 109 f. Josef Zykan to Ministerium für innere und kulturelle Angelegenheiten (Ministry of Internal and Cultural Affairs), October 13, 1939.

63 ÖStA, AdR, VVSt, VA 63953, Serena Lederer; VA 50856, Erich Lederer. Staatliche Verwaltung des Reichgaues Wien (State Administration of Vienna) to Staatsanwaltschaft im Landesgericht für Strafsachen (Public Prosecutor of Vienna's Criminal Court), January 18, 1940.

64 ÖStA, AdR, VVSt, *VUGESTA Journal*, vol. 1, no. 255; vol. 6, no. 3519, Serena Lederer.

65 Application to the Reichssippenamt. Private archive, Vienna.

66 For Serena Lederer's letters to the ZfD, see BDA, Rest. Mat., box 9, folder 2a: Sammlung Lederer 1940–46.

67 BDA, Rest. Mat., box 9, file 2a, fol. 207, declaration of intended gift, October 28, 1940; fol. 197, declaration of intended gift, December 17, 1940.

68 Ibid., fol. 179 f. NSDAP: Vereinigte Grenzlandämter der Gauleitungen Wien und Niederdonau to ZfD, November 22, 1940.

69 Jane Kallir, *Egon Schiele: Complete Works* (1st ed., New York: Abrams, 1990; exp. ed., New York: Thames and Hudson, 1998), no. P235. Öffentliche Kunstsammlung Basel, inv. G1986.16, Gift of Elisabeth Lederer in memory of her husband.

70 Dorotheum, Vienna, March 18–20, 1948, lot nos. 76, 75.

71 *Klimt*, 1943 exh. cat., cat. nos. 6, 7, 9, 20, 22, 25, 39, 46, (51?), 52, 56, 61.

72 Wiener Stadt- und Landesarchiv (Archives of the City of Vienna—WSt&LA), BG Innere Stadt, Verl. GZ 22 A 271/43, Serena Lederer.

MARIA ALTMANN

Aunt Adele

Interview with Renée Price

RENÉE PRICE: What are your memories of Adele Bloch-Bauer? I remember you saying that she was rather aloof and that she walked the grounds at her home of Jungfer-Březan with two German shepherds at her side. What else do you remember?

MARIA ALTMANN: Adele was always *very* elegant. She wore a long, white flowing dress, and she was very thin. She constantly smoked—which was very unusual for a woman in those days. I always say that she was a woman of today who lived in a world of yesterday. She would have loved to go to the university, she would have loved to work. But it wasn't done at that time.

I tried very hard to become close to her, but it didn't work. I just think that she didn't know what to do with a child. I don't blame her: my mother had five healthy children, and she never had any, though she wanted one very much.

RP: Do you recognize your aunt in Klimt's paintings?

MA: I saw her only when I was a child, but the elegance that comes through in the paintings came through when she was in the same room, too.

Maria Altmann, Vienna, 1938. Private Collection

RP: Do you remember the Klimt room in the Bloch-Bauer residence?

MA: I remember it well. I was in Austria recently, and the people who now live in the house took me through and tried to show me all the rooms. I didn't recognize much—but in my mind, I have a very clear picture of the room with those wonderful paintings.

RP: Adele is often described as a woman who was ahead of her time, someone who embraced modernity and was unimpressed with convention. Did Ferdinand share his wife's view?

MA: My uncle lived for one thing, and that was work. He was always working, always busy. Ferdinand and Adele were so different from one another, yet their relationship was based on mutual respect.

RP: Do you think he shared her views on modern art?

MA: Definitely. I'm sure that she did everything she could to introduce him to this art, because he was so involved with his own work; this was something outside his ordinary experience.

RP: What are your memories of Ferdinand?

MA: I remember him very well. He was somewhat abrupt and hard, but I think he had a warm side that he did not often show.

RP: How was Ferdinand's philanthropy viewed by his family?

MA: He was always very generous. When I became engaged and got married, he gave me 100,000 schillings, and he gave the same amount to my sister when she married. That was a lot of money! Also, Adele bequeathed money to the Wiener Kunstfreunde and the Bereitschaft—an organization dedicated to social reform issues such as women's suffrage.

RP: Tell us about your own parents. Your father, Gustav Bloch-Bauer, was a lawyer. What was he like?

MA: My father was the person I loved most in the world—and still do! But I don't think he worked very much as a lawyer. Don't forget, my father was really old enough to be my grandfather: when I was six, he was sixty.

RP: Where was his office?

MA: The office was a few doors down from where we lived in Vienna, on Stubenbastei.

RP: He was very much involved in music and the arts.

MA: He was the one who helped my uncle with everything artistic. My uncle didn't have time to buy art and collect it. It was my father who did all these things.

RP: Do you know how your uncle Ferdinand came to hire Erich Führer, a known anti-Semite, as his lawyer?

MA: I'm convinced that it was not my uncle who chose Führer, but Führer who chose my uncle.

RP: Ferdinand fled Austria in 1938, just before the "Anschluss." How did he support himself in Prague and then Switzerland?

MA: He was living off the kindness of friends, as he had no money of his own. Still, he lived in the best hotel in Zurich, the Baur au Lac. What he missed so much were the people he had once been surrounded by—people he had known for decades who knew him well.

RP: It must have been lonely for him.

MA: He felt lonely and deserted. Even while he was still in Vienna, after Adele died, he was very lonely.

RP: In the postwar period, were you personally involved in any restitution proceedings involving the Bloch-Bauer properties?

MA: No. My husband was always telling me: "Please get your own lawyer. Ours is a wonderful person—he's a wonderful friend of the family—but I don't think he is doing enough to get these things back."

RP: How did you first learn about the details of the Klimt restitution case?

MA: It was through my beloved Hubertus Czernin. He was an absolutely wonderful, totally unselfish person. He wrote about the issue in the newspaper, and made the point the Klimt paintings did not belong to the Belvedere. In Vienna, he took me to see Culture Minister Elisabeth Gehrer, whom I'd never met before. I spent two hours with her, talking about anything and everything—but not *the* thing. Then I wrote her a letter and said: "Thank you for your time. I hope now we can move forward." She never answered the letter. She never answered *any* of my letters!

RP: What was the most difficult aspect of the legal case for you personally?

MA: Everybody told me that I was insane to try because there was absolutely no chance. My niece, Nelly Auersberg, asked me: "Why do you spend money you'll never see again?" Nobody believed that

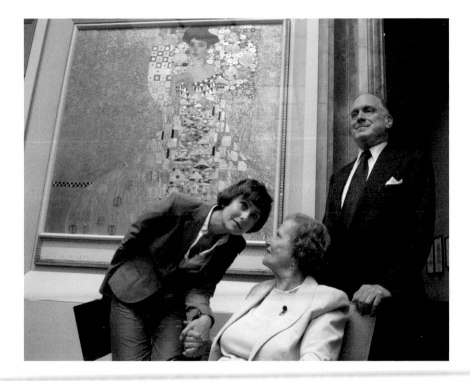

Ronald S. Lauder and Renée Price with Maria Altmann in front of Gustav Klimt's 1907 *Adele Bloch-Bauer I,* at the unveiling of the painting at the Neue Galerie New York on July 12, 2006. Photograph by Bebeto Matthews

it would go through. But I don't know… I just had a feeling that it might.

RP: A poll following the announcement of the arbitration panel's ruling showed that two-thirds of all Austrians supported the restitution. Do you feel that the Bloch-Bauer case contributed to a change in Austria?

MA: When I was in Vienna recently, the last thing I expected was that people would come to me to say they were happy about the paintings. I was just hoping that nobody would try to accost me! Instead, three different people approached me on the street and said: "We recognize you from the newspaper. We only want to tell you how happy we are that you got the paintings."

RP: Adele Bloch-Bauer has become a household name. How do you hope this case will be remembered?

MA: Through the portrait of Adele finding a home in New York. Could there be any better way for the case to be remembered?

RP: Can you say something about your family's choice of the Neue Galerie as a place to preserve and display this painting?

MA: I saw the portrait of Adele Bloch-Bauer in Vienna and in Los Angeles, but its display at the Neue Galerie is just gorgeous. It hangs there perfectly. I couldn't imagine a better or more beautiful place for it.

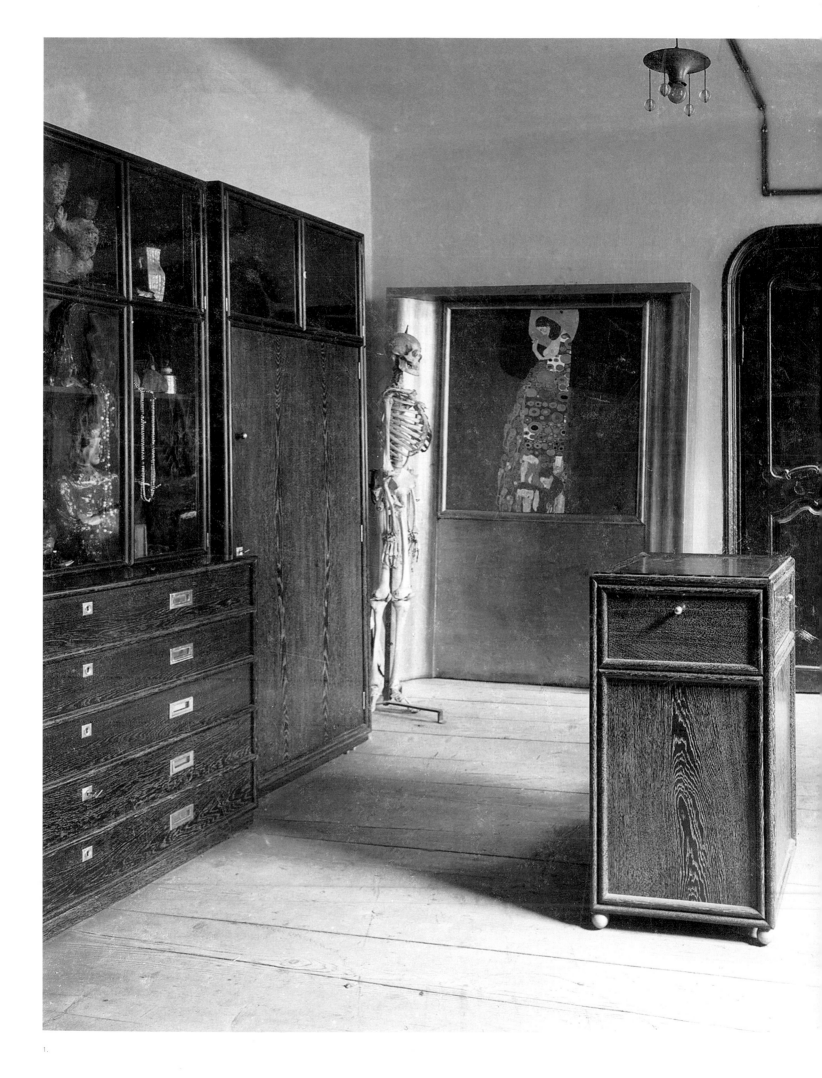

The Ateliers of Gustav Klimt

A Synthesis of the Arts

Artists' studios always have something appealing about them. They offer the prospect of insight into the working methods and private life of the artist—and into the effects of these things on his or her oeuvre. The setting will, we hope, enable us to draw conclusions about the artist's mental and emotional world.

This is certainly the case with the workspaces of Gustav Klimt. While many other artists of the day—among them Franz von Stuck, Hans Makart, and Franz Matsch—were happy to show their studios, Klimt attached great importance throughout his life to keeping his private sphere hidden from public view. His studio was part of that private life, accessible only to models, clients, and friends. Wild rumors circulated about Klimt's secluded studio even during his lifetime. He was suspected of having had sexual relationships with many of the women he portrayed—some of them prominent social figures, and there was talk that his models sauntered about the studio naked, awaiting "service."[1]

Klimt did not have his own residence; until his death he shared a domicile with his two sisters and his mother;[2] there he occupied a single room, furnished in the classic Biedermeier style [Fig. 2]. He spent the majority of his daytime hours in his studio. The artist claimed that he was "not especially interesting as a person" and coyly asserted that "whoever wants to know something about me as an artist—and that is the only thing that matters—must look attentively at my paintings … and glean from them who I am and what I want."[3] Such efforts to shield his private life from the public only fed the rumors of goings-on in his studio and raised the public's curiosity further. (Some of the rumors were of course well founded: Klimt was a notorious womanizer, and during his lifetime acknowledged the paternity of two children; another fourteen were claimed shortly before and after his death.)

Klimt worked in three studios during his artistic career: from 1883 to 1892 he shared a studio with his brother Ernst and the painter Franz Matsch; together they formed a working association dubbed the Künstler-Compagnie (Artists' company) at Sandwirtgasse 8 in Vienna's sixth district. From 1892 to 1912 Klimt had his

2.

1. Opposite: Large antechamber of Gustav Klimt's studio, with furniture by the Wiener Werkstätte and his painting *Hope II* (with the exhibition mount), at Josefstädter Strasse 21. Photograph by Moritz Nähr, 1912. Österreichische Nationalbibliothek, Vienna

2. Gustav Klimt's room in his mother's apartment, Westbahnstrasse 36, in Vienna's seventh district. Watercolor by Julius Zimpel (Klimt's nephew), 1918. Private Collection, Vienna

3.

3. Floor plan of Gustav Klimt's studio at Josefstädter Strasse 21

own studio at Josefstädter Strasse 21 in Vienna's eighth district. His last workspace, at Feldmühlgasse 11 in Vienna's thirteenth district, was used from the spring of 1912 until his death in early 1918. Thus Klimt spent the longest period—and his most fruitful years in artistic terms—in the studio on the Josefstädter Strasse. That workspace and its furnishings provide a trove of insights into Klimt's art and thinking.

Just after Klimt died, Egon Schiele described the Josefstädter Strasse studio:

> It was … in a garden—one of those old, hidden gardens that the Josefstadt has in such abundance, where at one end, shaded by high trees, stood a low house with many windows. One entered between the flowers and the ivy. That was Klimt's workshop for many years. A glazed door provided access into an antechamber, where there were stacks of stretched frames and other materials for painting; three other workrooms adjoined it. On the floor lay hundreds of drawings. Klimt always wore a blue smock with large pleats that extended to his heels. That was how he came to the glass door when visitors and models knocked.[4]

The art critic Berta Zuckerkandl, on the other hand, reported that there was a note from Klimt at the door indicating that he would not answer a knock; access was granted only to those who used a secret signal worked out with the artist in advance.

If any of those privileged visitors expected splendid rooms in accordance with the lifestyles of Klimt's clients, they were in for a surprise. The "low house" that Schiele described was a ground-floor building that had been remodeled during the Biedermeier period. It had a small entrance door, and six windows across its sixty-foot length. The studio had windows on only one of its long sides, so it was not flooded with light. The walls were thick and probably a little damp; the floor consisted of softwood planks. Ordinary iron stoves heated the rooms. The structure had no basement.

We know the studio building from a few photographs, taken in 1912 by Klimt's friend Moritz Nähr,[5] in which it is visible, in some cases only in the background [Figs. 4, 5, 6]. The building was demolished in the same year, when the whole district was redeveloped—it is likely that the photographs were taken to commemorate the beloved space before its destruction. The interior of the studio is known from a single photograph [Fig. 1],[6] which also reveals the furnishings designed by Josef Hoffmann. The image shows one of three workrooms in a row; sadly, no photographs exist of the room in which Klimt created most of his paintings. We do know from floor plans of the space that it measured 186.2 square feet [Fig. 3]. Photographs of Klimt's last studio, on Feldmühlgasse, give us some idea how it may

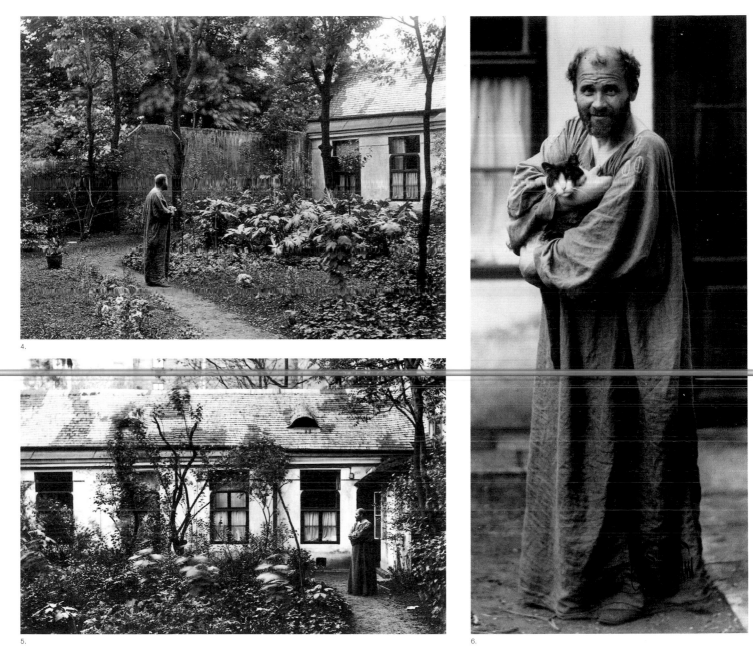

have been furnished [Fig. 7].[7] Still in existence, fortunately, are Hoffmann's pieces for two workrooms; these have survived nearly intact.

Klimt was a creature of habit, tremendously susceptible to external influence—as is testified in the hundreds of postcards he sent his companion Emilie Flöge. Inclement weather made him melancholy, and even minimal climatic changes could have such powerful effects on him that he would be unable to work for days. Changes in his studio space were naturally particularly hard for him to bear.

4. Gustav Klimt in the garden courtyard of his studio at Josefstädter Strasse 21. Photograph by Moritz Nähr, 1912. Österreichische Nationalbibliothek, Vienna

5. View of Gustav Klimt's studio building at Josefstädter Strasse 21

6. Gustav Klimt in front of the entrance to his studio at Josefstädter Strasse 21. Photograph by Moritz Nähr, 1912. Neue Galerie New York

7.

7. Gustav Klimt's studio at Feldmühlgasse 11, showing furniture from the Josefstädter Strasse 21 studio. Photograph from 1918

8. Group photograph from the time of the founding of the Wiener Secession. From left to right: Josef Hoffmann, Carl Moll, Gustav Klimt, Alfred Roller, Fritz Waerndorfer (with cigarette); standing in the rear: Koloman Moser (wearing hat). Photograph from 1898

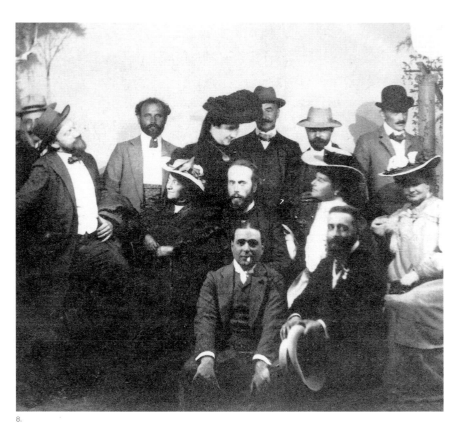

8.

A letter of late August 1903 to his lover at the time, Marie ("Mizzi") Zimmermann, demonstrates this very clearly—and includes interesting hints about the furnishings of his studio. Klimt wrote: "The gentleman from the Cottage district wanted to have my studio redecorated at his expense as a surprise—I was not supposed to know anything about it—the concierge would not permit it but asked me. I had all the trouble in the world stopping the whole thing, which was well meant—with all the work I have at present and my agitation, I absolutely cannot do with such things. The matter was postponed until after the exhibition."[8]

The "gentleman from the Cottage" was Fritz Waerndorfer, one of the great Viennese art patrons and a founder of the Wiener Werkstätte artists' cooperative, which had opened its doors earlier in 1903. Waerndorfer resided in Vienna's affluent eighteenth district (known as "the Cottage").[9] His proposed refurbishment of Klimt's studio turned out to be one of the Wiener Werkstätte's most significant early commissions.

Josef Hoffmann and Koloman Moser were Waerndorfer's Wiener Werkstätte co-founders, and were among Klimt's closest friends. The three artists (along with seventeen others) had left the Künstlerhaus, the cooperative of Austrian artists, in 1897, and had gone on to found the Vienna Secession [Fig. 8]. The vanguard artists of fin-de-siècle Vienna firmly believed in the equal stature of the fine arts

and decorative arts. They also promoted the related concept of the *Gesamtkunstwerk*: a creation in which all elements are harmoniously synthesized and coordinated—whether in the realm of architecture, the fine arts, or decorative arts. In their view, the designer/artist and the executing artisan were one and the same. Under the guidance of artists, the aesthetic values of the pre-industrial age would thus be redefined.

The Vienna Secession and above all the Wiener Werkstätte were the chief champions of the notion of the *Gesamtkunstwerk*. Klimt and Hoffmann played leading roles in both organizations, and Hoffmann's design for the furnishings of Klimt's studio would certainly have had the *Gesamtkunstwerk* as its guiding objective. It is not surprising that Waerndorfer wanted to have the Wiener Werkstätte furnish Klimt's studio, almost as soon as the cooperative was founded.

The original furnishings of the studio (as can be seen in Nähr's photograph) consisted of a large wall unit, a freestanding storage cabinet for art supplies, a writing table and armchair, a ceiling lamp suspended in the middle of the room, two high-backed chairs in the adjoining workroom, and a small table. It seems that these pieces were produced in late 1903 or early 1904—there are stylistic similarities with, for example, the furnishings for Karl Wittgenstein's residence, which were produced around this time; and the punch marks on the lamp also indicate this dating. The armchair seen in the photograph was first produced in 1905, and so must have been added to the furnishings at a later point. The mount seen in the background that displays the painting *Hope II* (*Die Hoffnung II*, 1907–08)[10] was not one of the original studio furnishings. It was produced in 1909 or 1910, from a design either by Hoffmann or by his colleague Eduard Josef Wimmer-Wisgrill; it was installed at the *Internationale Kunstschau* in 1909 and the Venice *Esposizione Internazionale* in 1910.[11] Klimt evidently found this display mount suited his painting very well and hence exhibited the painting together with it.[12]

All of these furniture designs are examples of the artistic trend toward geometric minimalism, as implemented by Hoffmann and Moser. As of 1902 their designs were characterized by a radical elimination of all decorative accessories: structure was reduced to its essential, weight-bearing components. The large cabinet is composed of four independent cases divided by simple trim along the edges [Fig. 9]. Each of these cases has a different depth, which emphasizes the volume and three-dimensionality of the cabinet. The only elements that might be considered "decorative" are the escutcheons and the folding handles attached to the drawers. The overall impression of the cabinet is that of a block of houses, in miniature. This approach to design is found again and again in Hoffmann's work—with the patent intention of demonstrating the equal value of the disciplines of the arts: the contours of the cabinet, if enlarged, could be applied to a work of architecture—to

9. Large storage cabinet from Gustav Klimt's studio designed by Josef Hoffmann

the façade of a house, say [Fig. 11]—and, if reduced in size, to craft objects, such as a 1905 brooch [Fig. 10].[13] The same principle holds for the room's art supply cabinet: although its form is determined entirely by its function—to hold brushes, palettes, tubes of paint, and other items—this object seems as balanced as a sculpture, with which the artist has come to terms with the proportions of planes and volumes [Fig. 13].

According to records in the Wiener Werkstätte archives, the ceiling lamp was a unique piece, designed and produced specifically for Klimt. It represents a refinement of the lighting fixtures that Hoffmann designed for the rooms of the Wiener Werkstätte and for several other interiors [Fig. 15] .

The studio furniture thus corresponds quite clearly to what Hoffmann imagined were Klimt's needs, and appears to have been adapted to the artist's requirements: the large wall cabinet was for Klimt's books, clothing, items from his collection, and his own artworks; and the "Malkasten" (paint box) was meant to hold art supplies. The armchair was presumably intended primarily for guests, though there is a photograph that shows Klimt sitting in it [Fig. 12]. The sitting area and seats in the small adjoining room—of which, as noted above, no contemporary photographs exist—were intended to provide Klimt with a place to have discussions with his clients.

We do not know whether Klimt was pleased with these furnishings—in their time they were ultramodern and trendy, and at the same time monumental. But the artist did not allow Hoffmann to design his entire studio—or even a single room—completely, as Hoffmann did for most of the interiors he conceptualized.

10.

11.

Hence there were no floor coverings, no wallpaper or murals that matched the furnishings. We see in Nähr's photographs that the small writing table and the armchair stand a little to the side. The raised electrical cord extending from the light switch to the ceiling lamp is a temporary measure that the purist Hoffmann could never have supported.

The furnishing of the studio remained an incomplete project for eight years. The reason for this is obvious: Klimt would tolerate no alteration to the space beyond the installation of the furniture; it would have thrown off his equilibrium and hampered him in his work. Though Klimt was a proponent of the *Gesamtkunstwerk*, he initially wanted nothing of it within his own four walls, so extreme was his aversion to change to his immediate surroundings. Only in his next and last studio on Feldmühlgasse did Klimt allow Hoffmann to re-display the furniture, supplement it with a carpet, and create a completely designed antechamber [Fig. 14]. There, Klimt was apparently not bothered by the transformation of practical furniture, which was now subordinate to a grander scheme. And now Hoffmann was finally able to put into full practice his design principle of the *Gesamtkunstwerk*.

It is uncertain whether Hoffmann's studio furnishings found their way into Klimt's artwork. Klimt himself wrote nothing about it, although several of his paintings do contain decorative elements that are strikingly reminiscent of the pieces. For example, there is a black-and-white band in the portrait of Margarethe Stonborough-Wittgenstein that resembles the wooden trim on the upper edge of the armchair. A similar decorative element is found in Klimt's 1907 *Adele Bloch-Bauer I*. And in his 1906 portrait of Fritza Riedler there is a rectangular field that recalls the front of the supply cabinet.

10. Brooch executed by the Wiener Werkstätte according to a 1905 design by Josef Hoffmann. The brooch was bought that year by Klimt and given to his companion, Emilie Flöge.

11. View of the façade of the Austrian Pavilion at the 1910 Venice Biennale. Its articulation is very similar to that of the cabinet in the studio and of the Wiener Werkstätte brooch Klimt gave to Emilie Flöge.

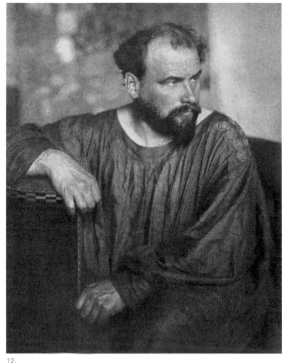

12.

13.

14.

12. Photograph from the book *25 Jahre Wiener Werkstätte*, published on the occasion of the twenty-fifth anniversary of the Wiener Werkstätte. Gustav Klimt is seated on the armchair designed by Josef Hoffmann in 1905.

13. Storage cabinet for art supplies

14. Antechamber of Gustav Klimt's studio at Feldmühlgasse 11 in Vienna's thirteenth district. Unlike the studio spaces at Josefstädter Strasse 21, this room was completely designed by Hoffmann, using all the furniture from the Josefstädter Strasse studio.

In summary, these furnishings provide compelling evidence of the artistic collaboration between Hoffmann and Klimt—two artists who ultimately shared aesthetic values. These pieces provide a record of the artistic path on which Hoffmann had embarked in 1902: toward a rigorous reduction to essentials of functionality, disposing of every extraneous element. This path, which Hoffmann pursued over the course of about three years, produced minimalist results in interiors, architecture, and craft objects that were decades ahead of their time and anticipated essential aspects of the design of the Bauhaus and beyond.

NOTES

1 See the quotation from Franz Servaes in Tobias G. Natter's essay "Gustav Klimt and *The Dialogues of the Hetaerae*" in this volume, in which Klimt's models are described as "mysterious, naked women … always ready at a signal from the master to hold still obediently whenever he spotted a pose, a movement, that attracted his sense of beauty when captured hurriedly in a quick sketch." Servaes, "Gustav Klimt," *Velhagen und Klasings Monatshefte* (1918–19), pp. 23–24.

2 Vienna 7, Westbahnstrasse 36, 3rd floor (from 1890 to 1918).

3 Undated typescript, Vienna, Stadt- und Landesbibliothek, inv. no. 152980, quoted by Susanna Partsch in Christoph Hölz, ed., *Gegenwelten: Gustav Klimt; Künstlerleben im Fin de Siècle* (Munich: Bayerische Vereinsbank, Abteilung Öffentlichkeitsarbeit, 1996). The passage is translated in Christian M. Nebehay, *Gustav Klimt: From Drawing to Painting* (New York: Abrams, 1994), p. 284.

4 Translated from Fritz Karpfen, ed., *Das Egon Schiele Buch* (Vienna: Wiener Graphische Werkstätte, 1921), pp. 87–88.

5 Klimt's friend Moritz Nähr was a professional photographer. In 1943 he donated several photographs he had taken of the artist and his studio to the Österreichische Nationalbibliothek. The portfolio with these photographs, which was probably assembled by Nähr, is annotated with the date "1912."

6 This photograph by Nähr was taken at the same time as the ones he took of Klimt in the garden. All of these photographs must have been made shortly before Klimt moved out prior to the demolition of the house in late spring or summer 1912. All evidence suggests the photographs were taken simply to remember his longtime workspace, since in the twenty years in which Klimt had used the studio, apparently not a single photograph had been taken.

7 The furnishings consisted of a large couch—presumably the piece of furniture on which many of Klimt's sitters are portrayed seated or reclining—two large easels, seats, and several "paint boxes." Because daylight entered the studio only from one side, the position of the two easels and the couch can be seen clearly in the photographs.

8 See Nebehay, *Gustav Klimt: From Drawing to Painting*, p. 269. The exhibition that Klimt refers to was the Vienna Secession show that opened November 14, 1903, and ran until January 1904.

9 Waerndorfer was a friend of Klimt's, admired him enormously as an artist, and bought the following paintings from him: *Pallas Athena* (*Pallas Athene*, 1898), *Orchard in the Evening* (*Obstgarten am Abend*, 1899), *Still Pond in the Schloss Kammer Park* (*Stiller Weiher im Schlosspark von Kammern*, 1899), *Farmer's Garden with Birches* (*Bauerngarten mit Birken*, 1900), and *Hope I* (*Die Hoffnung I*, 1903). See Renée Price's essay "Gustav Klimt and America" in this volume on why Waerndorfer disposed of these works.

10 Klimt began the painting *Hope II* (*Die Hoffnung II*) in 1907, completed it in 1908, and lent it to several exhibitions, including the *Internationale Kunstschau* in 1909 and the Venice Biennale (*Esposizione Internazionale*) in 1910. In the meantime he repeatedly added to and changed it. In 1914 he finally sold it to the Primavesis, but it is not known whether he included the large frame.

11 Opinions vary as to who designed the mount. John Collins attributes it to Wimmer-Wisgrill, who curated the Venice exhibition. Christian Witt-Dörring and the author believe the designer of the mount to be Hoffmann, based on stylistic characteristics and the fact that Hoffmann designed several frames for Klimt paintings.

12 This was also very much in keeping with the idea on which the *Kunstschau* was based: the fine arts and the decorative arts side by side and on equal footing.

13 A brooch designed by Hoffmann and produced by the Wiener Werkstätte for Klimt shortly after this cabinet was designed reveals striking similarities in terms of the division and articulation of space. And the façade of the Austrian Pavilion for the 1910 Venice Biennale looks like a greatly enlarged version of the cabinet [Figs. 10 and 11].

15. Josef Hoffmann, ceiling fixture from the Klimt studio

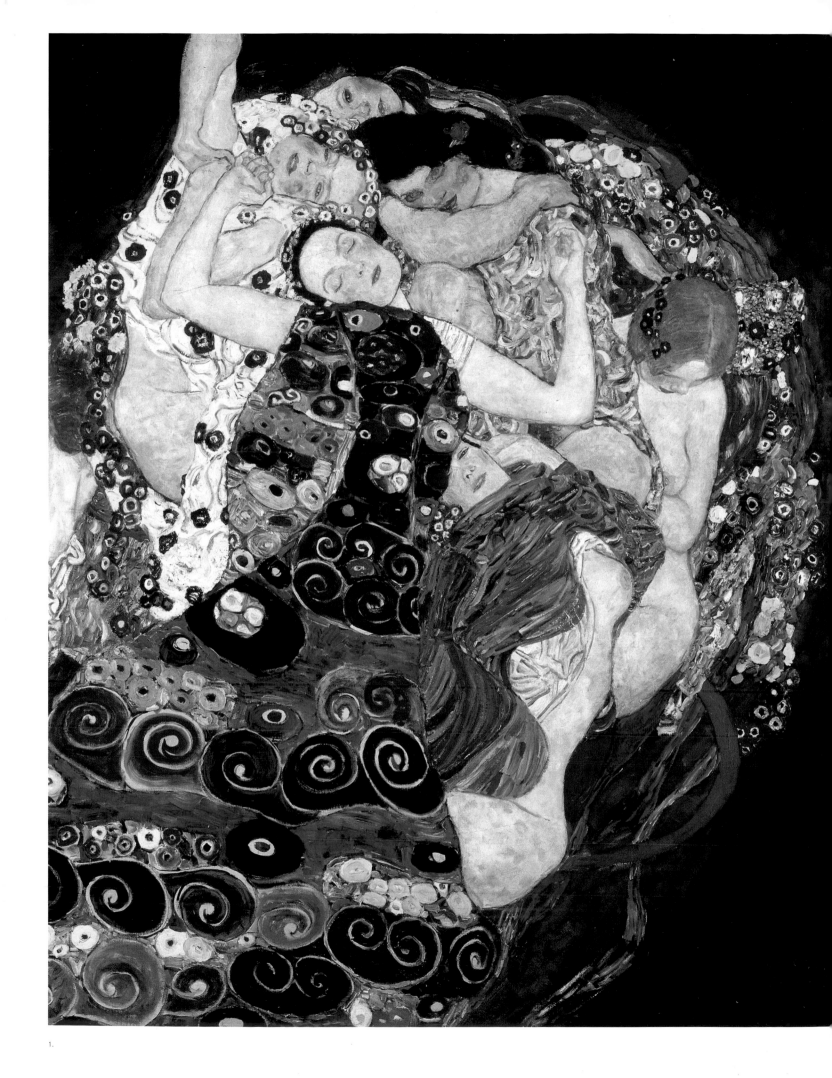

MARIAN BISANZ-PRAKKEN

Gustav Klimt: The Late Work
New Light on *The Virgin* and *The Bride*

Among the most important, and enigmatic, projects of the last five years of Gustav Klimt's life are the allegorical works *The Virgin* (*Die Jungfrau*, 1913) and *The Bride* (*Die Braut*, 1917–18, unfinished). The two paintings are closely related thematically: the focus in both cases is on stages of erotic awareness and the associated emotional states of the woman. The importance of these themes to Klimt is indicated by the large quantity of preliminary drawings he made for each of these paintings. More than half of his late sketches fall into the category of female eroticism; the remaining sheets are for the most part anonymous portrait studies and preparatory works for portrait paintings. During the course of my research on the artist's drawings at the Albertina in Vienna—undertaken with a view to creating a supplemental volume for the Klimt *catalogue raisonné*—several new considerations relating to these two works have come to light.

DEVELOPMENTS IN THE LATE YEARS
Information on Klimt's late allegories is extremely sparse. The artist was never very forthcoming himself, and after 1910 he began to withdraw even further into his own world. The great role he had played at the Secession until 1905, and for the *Kunstschau* in Vienna (1908–09), at the height of his Golden Style, had run its course. He spent his days in the seclusion of his studios, on Josefstädter Strasse (until 1912), and then in St. Veit, on Feldmühlgasse (until his death in 1918). When his erotic drawings were included in an exhibition of his work at the Galerie Miethke in 1910, critics condemned the "obscene" and "morbid" character of his art. Klimt was deeply offended, declaring that he wished "never again" to exhibit in Vienna.[1] From that point on, the artist exhibited his work almost exclusively abroad. He earned his living primarily with lucrative commissions for portraits of women; most of his allegories and landscape paintings were not commissioned works.

Klimt's working style in his late years changed fundamentally. He derived essential inspiration during trips to Spain and Paris that he took with Carl Moll in the winter of 1909–10. Klimt's last major commission in his Golden Style was the mosaic frieze for the dining room of the Palais Stoclet in Brussels, which he

1. Gustav Klimt, *The Virgin*, 1913, oil on canvas. National Gallery, Prague

described after its completion in October 1911 as a work "that was surely the final logical consequence of my ornamental development."[2] In his landscapes, portraits, and allegories after 1910 his brushwork became looser; he painted in powerful, brilliant colors, and the spatial complexity of his compositions reveals a new perception of visible reality.

THE VIRGIN: THE PAINTING

One essential step toward this artistic reorientation was the painting *The Virgin*, for which Klimt made his first studies around 1912 [Fig. 1].[3] What was new in comparison to his earlier allegories—such as *Philosophy* (*Philosophie*, 1900–07) and *Medicine* (*Medizin*, 1901–07), in which the naked figures are positioned parallel to the picture plane—is the circular motion of the partially veiled female bodies, crowded together around and behind the front figure. It is, however, not the women themselves who cause this movement; on the contrary, each of the six women (who embody a broad scale of types and temperaments) is fixed in a particular position. What causes the overall sense of movement of these isolated figures lost in their thoughts is the pulsation caused by the interaction of the dark, rhythmic contours of their bodies and the wavy lines of the draperies, bows, and garlands of flowers. This bubble-like dream image propels its indeterminate substance forward, weightless and with no apparent destination.

At first glance this oval complex gives the impression of a chaotic, irresolvable tangle. But a closer examination of the six female figures arranged around the main one reveals that their placement is based on a balanced, programmatically determined diversity.

The gaunt figure at the lower left of the composition, with her angular silhouette and cramped position, is very close to the expressive physical ideal manifested in the female figures by Egon Schiele. This psychologically tense figure seems to represent the antithesis of the erotically relaxed female figure opposite her, at the lower right. A continuous wavy line describes the curves of this woman, from her thigh to her protruding breast. The flowing contours of the colorful drapery heighten her bright, soft physical form. Her sensuality is also suggested by her sybaritic, dreamy facial expression, with half-closed eyelids and slightly open lips.

To the right, just above this sensuous female figure, Klimt placed another, entirely different feminine type—demure and girlish. Her arm pressed to her body, her head sunk (perhaps in shame) and turned slightly to the side, this young woman conveys an impression of diffidence and shyness. Her flat coiffure with its severe part and the delicate wreath of flowers underscores the innocence of this figure.

Squeezed precisely between her and the central "virgin" is a very voluptuous female figure with flowing hair and legs spread wide. Her face is resting on her

arm; her elbow is propped on her raised knee. Her pubic hair is visible near the base of her left thigh (she is the only woman in the painting whose pudendum is seen). This figure's voluminous physical form is powerfully outlined; her hair is dark auburn. Her skin is pinkish and fleshy, contrasting with the mother-of-pearl sheen of the other women's bodies. Her full, slightly open mouth, her cheeks, and the flower in her dark hair are brilliantly red. This figure's immediate proximity to the otherworldly "virgin" makes her being seem all the more animalistic, her sensuality almost offensive.

The two women's faces, depicted closely side by side, reveal the extremes within the overall typological spectrum of this work. The flat, frontal face of the central "virgin" seems almost a mask, closed and mysterious. The face of the dark-haired woman, by contrast, projects nearly plastically, enticing and seductive; her gaze, demonic in its way, is the magical point of attraction in this allegory. The other women turn their heads away—lost in thought or reverie.

Klimt's newly discovered penchant for torsion and complicated positions, brought to bear intensely for the first time in *The Virgin*, is particularly evident in the figure at the upper left of the composition. Her thighs are twisted to the side, while her upper body is bent sideways, and her horizontally inclined face turns toward the viewer. In this figure Klimt emphasizes—in contrast to the rounded shapes of the women on the right—the angular outlines of the hips and the raised, crooked arms. The woman's tense position, her pathos-filled gesture, and her rapt facial expression seem to express joyful expectation. A brilliant yellow veil, strewn with floral motifs, flows down from her head; a lavish wreath of flowers frames her face. From the preliminary studies it is clear that Klimt conceived this subject as a bride—a prefiguration of the motif of his later, unfinished painting, *The Bride*.[4]

The differences among the four faces at the very top of the painting are heightened by their schematic arrangement—reminiscent of a four-leaf clover. Each physiognomy reflects a specific emotional state: lustfulness, mysterious internalization, joyful ecstasy, and—in the face at the very top—dreamy absentmindedness. These four faces seem a distillation of the overall concept of allegory: each woman representing her own type, and her own mood.

In typical fashion, Klimt plays with conflating and confusing the levels of dream and reality. Paradoxically, the six women who belong to the unreal sphere of this vision have a strong and palpable physical presence, while the dominant title figure—the ostensible source of this dream—seems a two-dimensional, stylized, and untouchable symbolic figure. Her body is entirely covered by a long, elaborately ornamented garment; only her arms, raised like a marionette's, are uncovered. The slightly diagonal position of the dreaming "virgin," who offers herself to the viewer with thighs spread wide (although they are veiled), is an

indefinite synthesis of dancing and floating. Around this unapproachable main figure assemble—in clockwise order, beginning with the figure on the lower left—embodiments of inhibition, joyful ecstasy, trance, lust, shyness, and sensuality.

THE DRAWINGS FOR THE VIRGIN

All of Klimt's studies for these figures were prepared with ostensibly anachronistic academic discipline. Klimt was grappling obsessively with the universe of the female psyche and the life of the senses, even beyond his work on *The Virgin*.

It is striking how openly Klimt addressed the erotic aspect of his theme in the drawings. Things that are discreetly hidden under veils, or suggested only indirectly in the painting—doubtless with the public response in mind—are undisguised in the intimate drawings. The focus of numerous studies is on the female genitals, openly offered, especially in the drawings for the main figure, who in the painting is largely immaterialized.

The theme of masturbation, which Klimt first tackled in the context of *Water Serpents I* (*Wasserschlangen I*, 1904–07), runs like a thread through this group of studies. With his sure instinct for the nuances of feminine eroticism, Klimt registered the actions and reactions of women who gave themselves over to this intimate activity before his eyes uninhibitedly (Klimt's charismatic hold over his models was legendary). The artist repeatedly walked the line between spontaneous depiction of stimulation—somehow transferred seismographically to the tip of his pencil—and his efforts to subject the positions and movements of the models to a strict spatial order. Again and again Klimt set himself this challenge; every study, even the most cursory, is a world of its own, with its own specific sets of problems and rules. In the field of tension between spontaneity and discipline, between naturalness and higher order, Klimt felt his way, sheet by sheet, toward the essence of the motif to be depicted, with each work becoming an autonomous step on the way to a definitive solution.

One factor in his particular fixation on the female sex may have been the idea that the mystery of human life starts out from this point; precisely in the moments of highest ecstasy the female figures seem to come closest to this mystery. Sexuality as a mysterious life principle played an important role in the Japanese culture that Klimt studied closely; his drawings were fundamentally influenced by the art of Japanese erotic woodcuts.[5] In this respect *The Virgin* falls under the set of life themes "becoming, prolific being, and passing away" to which Klimt dedicated himself in many allegorical works, from *Philosophy* onward.[6]

Looking over the complete set of studies for *The Virgin*, one finds a great range of temperaments, moods, and stages of erotic awareness—from dreaminess to the heights of ecstasy. Klimt obviously wanted to work out a taxonomy of female

appearance that was as all-encompassing and as diverse as possible; the spectrum of his nude studies extends from the young girl to the fully mature woman. At the same time, it is evident that Klimt was striving to bring the physical features and postures of his models into accordance with certain looks and specific moods; the external characteristics of the women who posed for him are correspondingly varied. Hence round, soft forms, drooping shoulders, and a head bent forward express shyness and passivity; at the other end of the scale are those models whose tense musculature is connected to autoerotic activity; and the models for the main figure often evince especially lyrical qualities—a sublimated sensuality, an otherworldly, poetic presence. Between these extremes there are many variants of the passive equilibrium of reclining, sitting, or propped-up models: from angular, muscled girls to plump women with soft physical forms. The facial expressions of the women are just as varied—from dreamy to lascivious to boldly challenging.

The innovation of this group of studies is the typological diversity combined with the artist's clear interest in the physical qualities of the female body. The models were neither aestheticized nor idealized (as they had been the days of the "ver sacrum" [sacred spring] of the early Secession). The women posing were now depicted in all naturalness.

In that spirit Klimt employed drawing techniques that emphasized the outlines of the body. He had used such modes from the start of his career, but in these studies of nudes he used his drawing instrument in a novel way—sometimes using sharp lines to focus on certain imperfections, such as grooves, folds, or flab; other times setting off the figures from the empty background by means of dense concentrations of lines along the contours. By constantly altering the pressure of his pencil, he was able to convey space, plasticity, and light values, despite his self-imposed restriction on the depiction of outlines.

With an eye to the rotating overall movement of his figures, Klimt drew his models posed in diagonal positions, in zigzag arrangements, or in winding, snake-like postures. Often Klimt used several models to get to the essence of a specific pose or a particular body part—a jutting hip, a swelling breast. In doing so he tried again and again to affix the figures, despite the diversity of axes, into continuous contours. These wavy contours sometimes take up the entire width of the sheet, causing a relationship of tension (characteristic of his work) between space and plane. In the final painting, too, the three-dimensionally rendered figures are defined and characterized almost exclusively by their contours.

It is typical of Klimt that he never exceeded the boundaries of anatomical plausibility, neither in the studies nor in the final painting; there are never extreme distortions of body parts like those found in the work of his younger colleague

2.

2. Otto Schmidt (attributed to), *Female Nude*, ca. 1900.
From Johannes Grosse, *Die Schönheit des Menschen:
Ihr Schauen, Bilden und Bekleiden* (1912)

3. Otto Schmidt (attributed to), *Female Nude*, ca. 1900.
From Johannes Grosse, *Die Schönheit des Menschen:
Ihr Schauen, Bilden und Bekleiden* (1912)

4. Otto Schmidt (attributed to), *Female Nude*, ca. 1900.
From Johannes Grosse, *Die Schönheit des Menschen:
Ihr Schauen, Bilden und Bekleiden* (1912)

5. Otto Schmidt (attributed to), *Female Nude*, ca. 1900.
From Johannes Grosse, *Die Schönheit des Menschen:
Ihr Schauen, Bilden und Bekleiden* (1912)

6. Otto Schmidt (attributed to), *Female Nude*, ca. 1900.
From Johannes Grosse, *Die Schönheit des Menschen:
Ihr Schauen, Bilden und Bekleiden* (1912)

7. Gustav Klimt, *Reclining Female Nude*, 1914–15,
pencil on paper. Private Collection

Schiele. For all the complexity of postures and perspectives, Klimt remained faithful to visible reality. However, he sublimated his immediate impressions to poetic creations of lines like no other artist; ultimately the female figures in his drawings escape from graspable reality. Klimt was, however, always inspired by the physical presence of female models.

THE VIRGIN AND NUDE PHOTOGRAPHY

This strong connection to physical reality seems to suggest that, along with many inspirations from other visual arts, photography may have played an important role for Klimt. This suspicion was triggered by my more or less chance encounter with the 1912 popular science publication *Die Schönheit des Menschen: Ihr Schauen, Bilden und Bekleiden* (The beauty of humans: Appearance, form, and attire), by the medical doctor Johannes Grosse.

This illustrated study of nudes—mainly women—contains four sections in the theoretical part: "Schönheit in Natur und Kunst" (Beauty in nature and art), "Schönheit und Kleidung" (Beauty and clothing), "Schönheit und Kultur" (Beauty and culture), "Schönheit und gymnastische Bildung" (Beauty and gymnastic training). These treatises—pseudoscientific to today's audiences—are followed by illustrations "from life and from works of art," including several photographs of nude women, and comments by the author, under the title "Schönheit, Vorzüge und Fehler der weiblichen Gestalt" (The beauty, merits, and flaws of the female figure).[7] Each plate comprises three to four photographs, showing several examples of standing and reclining nude figures. Using criteria that are partly aesthetic and partly "medical," the author encourages the reader to perceive the naked female body in a new and unprecedented manner. One plate, titled *Zeit der Blüte* (Age of blossoming), shows close-up photographs of various young models whose poses and facial expressions suggest qualities such as shyness or uninhibitedness.[8] These illustrations demonstrate, in the good doctor's professional opinion, "the soft, gradual, swelling, organic growth of youthful mammary glands out of the flatness of the bodies with no stretching of the skin, without the hanging or distortion of form that set in with maturity and slackening." On one of these photographs he comments succinctly: "Maiden type"[9] [Fig. 2].

Grosse's remarks on the standing nudes run a remarkable gamut: "Wonderfully curving, wavy line from the right hand to the foot. … Knee poor. Short lower leg" [Fig. 3]; "Blossoming forms of a harmonious, soft, youthful form"; "Withered forms. The lines are more marked, less soft and round, almost straight and angular"; "Mature female type … soft lines, yet emphasized by a certain power"; "Softer forms. Shallow domelike form of the breast" [Fig. 5]; "Coarse form"; "Extremely mobile articulation of the body, like that of an insect body"; "In this peculiar position, the body almost gives the impression of an animalistic being" [Fig. 6]; "Fresh forms, half-child, half-virgin" [Fig. 4]; and so on.[10]

3.

4.

5.

6.

7.

The author makes a concerted effort to convey to the reader the gravity of his project: "It is … presumed that anyone looking at these pictures will absorb the content of this book completely. … These illustrations serve no purposes other than as evidence for the text."[11] It is an extraordinary use of photography. Grosse did not base his descriptions on photographs taken especially for his purpose, but made use of nude photographs that were already in existence, as we see from the list of sources from which he took his material—art book publishers, photographic societies, and private collections.[12]

As I perused the pages of Grosse's book, the analogies to Klimt's project for the painting *The Virgin* all but leapt out, and I wondered whether the painter could have known of this publication. The richly varied, sometimes complicated or contorted positions of the models in the photographs have remarkable parallels with the nude studies for *The Virgin*. Moreover, even the way in which these photographs are categorized and described according to typology corresponds to the spectrum presented by Klimt: from the virgin to the mature woman, with all the nuances in between. Klimt's way of seeing and of working is also comparable to Grosse's method of describing the figures in terms of contour lines [Fig. 7]. Grosse even devotes a separate chapter of his book to what he terms the "wave rhythm," in which he emphasizes the great advantages of photography, which permits a precise recording of contours: "If we project the human body onto a plane by means of drawing or—particularly instructive for theoretical study—photography, the result is the pure lines of the body, which in its genuine, three-dimensional, stereoscopic manifestation are not as evident for an untrained, unartistic eye because of the curved surfaces of the boundary of the organic shape and the constant flux of the organic form in motion and its changing position."[13] The "wave rhythms" of the contours, according to the author, convey the external features of the human body (particularly the female body), from its first flowering to its decay. The highest ideal is represented by the "austere virgin beauty"; the play of wavy lines is found "especially beautiful on the budding virgin body unfolding its first flowers."[14] The author underlines the great value that the virgin has within the spectrum of femininity elsewhere as well: "With the destruction of virginity … the virgin beauty is bent and broken as well, the girl's whole spiritual and physical power and flowering."[15]

The question arose whether the points of contact between Grosse's publication and Klimt's *Virgin*, in terms of both illustrations and content, were merely coincidental or a case of direct inspiration. After all, the book was published during the initial preparations for Klimt's painting; he might well have encountered it. Or was this perhaps a case of commonalities based on general views and patterns of thought of the time?

On the basis of further research, it became clear that the publication in question should be seen as a relatively late example of a wide-ranging phenomenon: the early understanding of nude photography, which originated in Paris around 1850.[16] It was an era of fusion and interpenetration between painting and photography—each medium affecting the other profoundly—and nude photography played an essential role in this interplay from the outset.[17] Klimt made creative use of photography, above all in the context of his historical commissions and portraiture—including portraits of the dead; until now, however, there has been no discussion of possible inspiration from the rich field of nude photography.[18] Addressing the issue is, unfortunately, made more difficult by the fact that there is not a single concrete hint to point us in this direction. It should, however, be remembered that at the turn of the twentieth century, Vienna was one of the most important international centers of nude photography. It is difficult to imagine that such impressive production would have escaped Klimt's attention.[19]

The spectrum of photographs of naked bodies produced in Vienna around 1900 ranged from artistically ambitious renderings to amateurish pictures of an erotic or pornographic nature—and of course the boundaries dividing these categories were often fluid. The demand for photographs of female nudes was huge, but for reasons of morality, the sale of such photographs was prohibited. Nude photography was an extremely lucrative but also risky business for both producers and middlemen: it could lead to arrest and the destruction of entire archives.[20] The trade of photographs of nudes was thus kept well hidden.

The photographer Otto Schmidt distinguished himself artistically from 1880 on with his photographs of landscapes and architectural motifs, city views, Viennese characters, and especially nudes, which he published himself.[21] Schmidt advertised his nude photographs discreetly in an illustrated catalogue, addressing artists in particular (needless to say, it was an exclusively male, voyeuristic clientele):

> In addition to the art photographs presented here, I publish a large collection of nude photographic studies of females and children, which should be especially useful to the artist for study purposes, and is easily accessible thanks to the low price demanded for the smaller formats. The large variety of available positions and models as well as the Viennese nude material, known for its high quality, will satisfy every artist and will provide useful material, which will be of great value to all those gentlemen who are not in a position to have a suitable nude model available.[22]

In order to demonstrate the "large variety of available positions and models," Schmidt assembled his nude photographs into twenty-four images in "cabinet"

8.

GUSTAV KLIMT: THE LATE WORK

format (roughly postcard sized) [Fig. 8]. These tableaux were then photographed and offered as sample cards, each individual image assigned its own order number. The known surviving examples reveal a spectrum of types and sometimes very revealing poses, with models ranging from puberty to sexual maturity.[23]

At the turn of the century, Schmidt was internationally famous; his nude photographs are found in many of the illustrated books that flooded the market toward the end of the 1800s. The only way photographs of naked bodies could be legitimately distributed was in publications that served scientific, artistic, or educational goals. There were numerous richly illustrated volumes—with titles like *Die Schönheit des weiblichen Körpers* (The beauty of the female body), *Die Schönheit des menschlichen Körpers* (The beauty of the human body) [Fig. 9], *Die Anmut des Frauenleibes* (The charms of the female body), *Die Rassenschönheit des Weibes* (Woman's racial beauty), *Streifzüge im Reiche der Frauen-Schönheit* (Excursions through the world of female beauty), *Die Schönheit des Menschen* (The beauty of humans), and so on.[24]

In educational texts by renowned scientists, the extensive visual materials were explained from aesthetic, anatomical, medical, art historical, ethnological, and even racial perspectives. Authors never tired of pointing out how educational the "pure" observation of beautiful undressed people—above all women—could be.[25] Officially, indeed, these often lavish works were dedicated to women in general (sometimes even to mothers), and doctors and artists. The true audience, however, was never mentioned, and could not be addressed openly: the upstanding middle-class male readers who, with these very tasteful books, devoted themselves to an extensive study of naked femininity in all its facets.

"I have attempted to erect a temple to living female beauty," wrote Dr. C. H. Stratz in his 1898 preface to the eighth edition of his standard work *Die Schönheit des weiblichen Körpers*.[26] In this "temple," however, he referred painstakingly to small details of the pictured female bodies that deviated from the canon of beauty—for example: "folds of the skin above the [left] hip where the pelvis is bent," or "furrows from the pressure of stockings below the knee of a twenty-three-year-old girl."[27] The photographs by Schmidt and others in *Die Schönheit des menschlichen Körpers* were accompanied by categorizing descriptions, such as "Slender female body with attractive, powerful thorax; moderately large, somewhat low-set cup breasts; well-defined and curved mons veneris; powerful feet." "Powerful, well-developed girl's body with full, round breasts, broad hips, full thighs, and arms." "Mature female bodies, whose full round breasts are already slightly sinking."[28]

The question of whether Klimt was inspired by nude photography for the typological variety and the realistic depiction of his models cannot be answered definitively. In the (admittedly incomplete) record of books in his possession,

8. Otto Schmidt, *The Viennese Nude: Portfolio of Original Photographs*, 1904. Albertina, Vienna, inv. Foto2007/9/1

9. Cover image of Eduard Daelen, et al., *Die Schönheit des menschlichen Körpers* (second edition, 1907)

there are no publications with photographs of nude female models; his personal effects included no nude photographs, as far as is known.[29] The search for sources of inspiration for his motifs is, for practical reasons, essentially destined to fail. The original twenty thousand photographs by Schmidt, without question the most famous Viennese photographer of nudes,[30] have survived only in part; many of Klimt's studies for *The Virgin* were presumably lost as well. Still, it is difficult to imagine that Klimt, who was on the one hand demonstrably interested in photography, and on the other fixated on feminine eroticism, would have been unaware of nude photography in his day. At the time Klimt was preparing for *The Virgin*, Schmidt had already been largely forgotten, but the fame of his nude photographs, most of which were made in the years before and after 1900, had not yet faded.[31]

In their time, Schmidt's nude photographs were highly praised internationally, not least for their sweet and poetic "Viennese" qualities.[32] His works often go far beyond the usual banal, clinical, or merely voyeuristic. By capturing certain positions, gestures, or facial expressions, Schmidt was able to render his models' distinct characters. His nude photographs are striking for the intense concentration on the carefully lit figure, whose contours stand out sharply from the background, which is usually kept dark. The simple standard props include a sofa and draperies or textiles that emphasize the forms of the body or add dynamic accents. Schmidt was particularly concerned with achieving a balanced composition of the figure in the plane. Despite their often complicated postures, the models seem surprisingly natural.

In all these characteristics, the work of the prominent nude photographer and that of the famous draftsman coincide. Juxtaposing certain photographs and drawings reveals not identical motifs, but rather multilayered commonalities in the creations of these two personalities.[33] A few examples of pairings have been selected here, with a view to considering a diversity of types, postures, and moods.

Schmidt's photograph of a slender figure with eyes closed, outstretched on the sofa in a contorted, serpentine pose, recalls the drawing of a reclining nude figure by Klimt (rendered in a vertical format) [Figs. 10, 11]. With the broadly spanning upper contour line, the elevated hips and the projecting breast loom up in both cases; both women have dreamy facial expressions.

In another photograph, a full-figured woman lying on a carpet fills the full width of the frame; the sharp edges of the image succinctly emphasize the round, subtly lit forms of her body [Fig. 12]. Klimt's nude drawing of a woman sitting half-upright and bent to the side features a comparable fullness of body and emphasis on line; the folds of skin at her waist form sharp lines [Fig. 13]. Much as in the photograph,

10. Otto Schmidt, *Female Nude*, ca. 1900, photograph. Albertina, Vienna

11. Gustav Klimt, *Reclining Girl, Nude Facing Right, Arms Crossed Behind Head*, 1913, pencil on paper, study for *The Virgin*, 1913. Original presentation, vertical. Private Collection, Graz. Courtesy Strobl Archive, Vienna

12.

13.

Klimt creates a three-dimensional effect with the simple curved line at the pressure point where the fleshy substance of one thigh overlaps the other slightly. In both cases, the model holds her arms over her head.

In both Schmidt's oeuvre and in Klimt's, the round body type is often associated with a phlegmatic or melancholic mood. In Klimt's study of a seated woman hiding her face behind her bent arms, this gesture of shame or sadness bears a remarkable similarity to Schmidt's nude photograph of a seated woman [Figs. 14, 15]. In both body type and posture, the Klimt figure here recalls the nude photograph of a seated woman whose mien is also characterized by a certain shyness [Fig. 16]. All three images manifest a simple concentration on sharply outlined physical forms.

12. Otto Schmidt, *Female Nude*, ca. 1900, photograph. Albertina, Vienna, inv. Foto2007/9/24

13. Gustav Klimt, *Female Nude, Right Hand Resting on Forehead*, 1913, pencil on paper, study for *The Virgin*, 1913. Original presentation, vertical. Whereabouts unknown

14.

15.

16.

17.

18.

19.

20.

Common motifs are repeatedly found among the photographs and drawings, whether it is the position of a bent leg [Figs. 17, 18], the complicated zigzag position of a pronounced backside [Figs. 19, 20], or lower legs hanging down from the edge of the bed [Figs. 21, 22, 23].[34] In its concentrated depiction of a reclining figure viewed from behind, Klimt's study is very similar to a photograph by Schmidt [Figs. 24, 25]. The focus in both cases is on a backside that looms high up.

Another girl is photographed frontally, in a seated posture involving several twists, holding her hands together behind her head, which is turned to the side. She seems almost afloat [Fig. 26]. She smiles, and her long hair is crowned by a wreath of flowers (young girls with wreaths of artificial flora in their hair are found frequently in the photographs in Schmidt's estate). Klimt's study for the main figure in The Virgin has a very comparable posture, in which the coiling curves of the female body are particularly emphasized [Fig. 27]. Both models exude a sense of relaxation. The girl in Schmidt's photograph conveys an impression—coincidental or not—of a very young bride. The model in another photograph by Schmidt is nearly identical to Klimt's figure, particularly in terms of the position of her upper body [Fig. 28].

This is only a selection of many possible comparisons that reveal striking correspondences between the works of the draftsman and the photographer. The images bring us back to the question: was Klimt inspired by nude photographs in his preparatory works for The Virgin? It is difficult to imagine that the similarities here are coincidental, given the frequency and complexity of the analogies. Klimt's Virgin, the nude photographs from around 1900, and the publications that profited from those photographs have one important thing in common: a wide-ranging typology "taxonomy" of the female body.

The intellectual superstructure in all three cases is the superiority of the man, who divides femininity into categories. Klimt is thus the master of the poses and actions of his models, which he selects based on certain criteria. He is the stage director of their moods; he records the crucial moments, the physical subtleties, and the sensuous nuances. Then he subordinates all these elements to a single idea: woman is a passive creature, at the mercy of her emotions and sexuality, with no will of her own. As if in a trance, she flows along, guided by her stable, male antithesis, who, though invisible, is palpably present. The psychological nuances of the women depicted are not reflecting their *inner* lives, but are registered primarily in various degrees of sexual states—as acknowledged from the male perspective.

The photographer, in turn, adapts the range of his models to the predilections of his male clientele. The women and young girls are positioned and lit in such a way

14. Otto Schmidt, *Female Nude*, ca. 1900, photograph. Albertina, Vienna, inv. Foto2007/9/28

15. Gustav Klimt, *Frontal Female Nude with Covered Face*, 1913, pencil on paper, study for *The Virgin*, 1913. Albertina, Vienna

16. Otto Schmidt, *Female Nude*, ca. 1900, photograph. Albertina, Vienna, inv. Foto2007/9/27

17. Otto Schmidt, *Female Nude*, ca. 1900, photograph. Albertina, Vienna, inv. Foto2007/9/23

18. Gustav Klimt, *Reclining Female Nude with Covered Lower Legs*, 1914–15, blue pencil on paper, Collection Eberhard W. Kornfeld, Bern

19. Otto Schmidt, *Female Nude*, ca. 1900, photograph. Albertina, Vienna, inv. Foto2007/9/22

20. Gustav Klimt, *Reclining Half-Nude*, 1914, pencil on paper, Wien Museum, Vienna, inv. 101059

21.

24.

22.

25.

23.

that their external qualities can be assessed optimally. Further categorization is bestowed on these models when their photographs are used as illustrations in the aforementioned books on the beauty of women—written by men for men. Once again, their physical features are subjected to a specific rigorous codex of moral and aesthetic criteria.

What links Klimt, more than other artists, to these nude photographs is the combination of the momentary with the eternal, of the realistic with the universal. The photograph immortalizes in the truest sense the "decisive moment." In his drawings Klimt sums up his sensory impressions; in this sense he has a "photographic" gaze. In the sublimating power of the art of lines he is, however, vastly superior to photography.

21. Otto Schmidt, *Female Nude*, ca. 1900, photograph (detail). Albertina, Vienna, inv. Foto2007/9/2

22. Gustav Klimt, *Reclining Half-Nude*, ca. 1912–13, pencil on paper, study for *The Virgin*, 1913. The Metropolitan Museum of Art, New York, inv. 1984.433.199, Bequest of Scofield Thayer, 1982

23. Gustav Klimt, *Reclining Nude*, 1916–17, pencil on paper, study for *Girlfriends*, 1916–17. Whereabouts unknown

24. Otto Schmidt, *Female Nude*, ca. 1900, photograph. Albertina, Vienna, inv. Foto2007/9/25

GUSTAV KLIMT: THE LATE WORK

26.

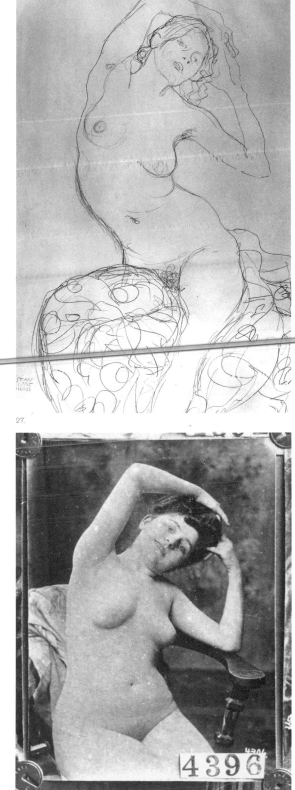

27.

28.

25. Gustav Klimt, *Reclining Nude from Back*, 1913, pencil on paper, study for *The Virgin*, 1913. Private Collection

26. Otto Schmidt, *Nude Girl with a Crown of Flowers*, ca. 1900, photograph. Albertina, Vienna, inv. Foto2007/9/26

27. Gustav Klimt, *Sitting Nude, Arms Crossed Behind Her Head*, 1913, pencil on paper. Graphische Sammlung der ETH Zürich, inv. 1959/49

28. Otto Schmidt, *Female Nude*, ca. 1900, photograph (detail). Albertina, Vienna, inv. Foto2007/9/2

29. Gustav Klimt, *The Bride*, 1917–18, oil on canvas.
Courtesy Österreichische Galerie Belvedere, Vienna

THE BRIDE: THE DRAWINGS AND THE PAINTING

In the years after the completion of *The Virgin*, Klimt continued his study of nude female models with uninterrupted intensity.[35] Along with individual figures, who (as before) are devoted to their erotic daydreams, he sketched groups of two or three models in the context of the painting *The Girlfriends* (*Die Freundinnen*, 1916–17), in which he again took up the theme of lesbianism.[36] Heterosexual couples were also part of his repertoire.[37] For the painting *Leda* (1917) he produced several sheets in which he concentrated on the motif of the pronounced, extremely curved buttocks.[38] The studies for *Adam and Eve* (*Adam*

GUSTAV KLIMT: THE LATE WORK

und Eva, 1917–18, unfinished) are of a classical repose; for the frontal figure of Eve, he chose a heavy, round female type with long hair and broad hips.[39]

In many respects, Klimt's preparatory works for The Bride pick up on his studies for The Virgin and on the drawings of intervening years [Fig. 29].[40] But they reveal essential new aspects: this late group of drawings has a more encompassing taxonomy of types, body postures, and erotic moods; and Klimt's working method is characterized by extremes in a way never seen before. Often he almost lets the shapes dissolve in vibrating formations of lines, while capturing other figures in sharp contours.

This complex of contrasts is connected to the fundamental differences among the three main elements of the allegory, which are emphatically distinguished from one another. The colorful tangle of voluptuous female bodies and fragments of faces on the left, some of which are covered by draperies and veils, recalls The Virgin. Once again, the scale of facial expressions, which signal the various stages of erotic awareness, range from dreamy absence by way of pleasure-filled sensuality to immediately inviting eye contact with the viewer. New elements include the sleeping baby at lower left—Klimt also devoted an entire painting to this motif [see p. 21]—and the presence of a man.

In The Bride, the man's body, wrapped in an orange garment, is bracketed by female figures; only his face rises above the colorful chaos on the right. He is apparently trying (in vain) to free himself from this sensuous entanglement. His worried face is bent over the young bride in the center, whose head is inclined to his side and turned toward him. Her mask-like, round face with closed eyes, smiling mouth, and red cheeks is the epitome of virginal innocence. Her pigtails further suggest that she is a young girl, while her body as a whole remains hidden beneath her blue garment. As the central figure in the allegory, she is jammed between the group on the left and the figure of the girl on the right, who, like her immediate surroundings, is largely unfinished.

This seminude, drifting figure of a girl, with her legs spread and raised as in a dance, and her genitals visible through her transparent skirt, has always posed many riddles.[41] By emphasizing her ascetic, overly slender body and her gaunt arm bent at a right angle, Klimt was clearly echoing the stylized body ideal in depictions by George Minne and Jan Toorop—a physical type that had provided him with essential inspiration shortly after 1900.[42] The insistent realism of the voluptuous, sensuous women on the left contrasts clearly with the unreal-seeming, girlishly symbolic figure. Whereas her frontal body is openly offered, her dreamy face, turned right and in profile, with eyes nearly closed, seems to be turned away from the world in a sphere of meditation. The contrast between body and soul thus represented is further emphasized by a scarf wrapped around her

DIE
HETÄREN
GESPRÄCHE
DES
LVKIAN

TOBIAS G. NATTER

Gustav Klimt and
The Dialogues of the Hetaerae
Erotic Boundaries in Vienna Around 1900

In late 1905, the Leipzig publisher Julius Zeitler received a note from the Wiener Werkstätte, complaining that "everyone in Vienna" had supposedly gotten their hands on the new publication *Die Hetärengespräche* (*The Dialogues of the Hetaerae*), with illustrations by Gustav Klimt, before they had[1] [Figs. 2, 3]. The reproach was understandable. The Wiener Werkstätte had produced the volume, and the design of its art director, Josef Hoffmann, was a crucial component in the book's instantaneous popularity.

Eventually the annoyance faded, and what remained was a work that is still topical today: several subsequent printings testify to the book's continued salience.[2] Interestingly, however, later editions of the volume have been aimed primarily at amateurs and art lovers, but have been largely passed over by scholars.[3]

This discrepancy between the book's popular success and its lack of attention among academics is notable, and speaks of the publication's dichotomous nature. *Die Hetärengespräche* with Klimt's illustrations belongs, without question, to the front rank of great European book productions; even at the time of its publication it was considered one of the finest Jugendstil books to have appeared on the market. Its content, however, was deemed by many to be obscene, and the new publication was soon relegated to the realm of "erotica." It was through this dialectic of form and content that *Die Hetärengespräche* became a chief object in the changing relationship between the public and artistic transgression in fin-de-siècle Vienna.

LUCIAN OF SAMOSATA

Dialogues of the Hetaerae was written in the middle of the second century AD by Lucian of Samosata. As the title indicates, it consists of a series of casual and very frank conversations among *hetaerae*, or courtesans, on the subjects of love and carnal relations. We do not know how much Klimt knew about the life of the text's author and the reception of his works, but the artist likely appreciated *Dialogues of the Hetaerae* best of Lucian's ample literary production. It is

2.

3.

1. Opposite: Cover of *Die Hetärengespräche des Lukian*, version "A," premium edition

2. Wiener Werkstätte postcard to Dr. Julius Zeitler (recto), December 31, 1905. Deutsches Literaturarchiv, Marbach

3. Wiener Werkstätte postcard to Dr. Julius Zeitler (verso), December 31, 1905. Deutsches Literaturarchiv, Marbach

DIE WOLLUST DER PRÜGEL III.

CHRYSIS, 17 Jahre, Courtisane
AMPELIS, 35 Jahre, Courtisane

AMPELIS: Das sag' ich dir, Chrysis, einer, der nicht eifersüchtig ist und in Wut kommt, der seine Geliebte nicht halb lahm schlägt, sie nicht bei den Haaren zieht und ihr die Kleider vom Leib reißt, der ist auch gar nicht verliebt.

CHRYSIS: Hat denn wirklich die Liebe keine andern Proben als diese, o Ampelis?

AMPELIS: Nein, alles das macht ein heißblütiger Mann. Was das andere anlangt, die Küsse, die Tränen, die Worte, die Besuche — das ist nur der Anfang der Liebe. Das Feuer und die Leidenschaft kommen aus der Eifersucht. Wenn dich also, wie du sagst, Gorgias geschlagen hat, wenn er eifersüchtig ist, so hoffe dir viel und verlange dir, daß er weiter so macht.

CHRYSIS: Weiter so? Was sagst du da? Jeden Tag Prügel?

AMPELIS: Nein. Aber er soll sich ärgern, wenn du einen andern als ihn ansiehst. Wenn er dich nicht liebte, weshalb sollte er darüber wütend sein, daß du einen andern Liebhaber hast?

CHRYSIS: Aber ich hab' keinen andern! Er bildet sich ein, ich liebe diesen Geldsack, weil ich unlängst mit ihm ein par Worte gesprochen habe.

AMPELIS: Das ist sehr gut, daß er dich von den Reichen gesucht glaubt. Das wird ihm noch mehr Kummer machen, und er wird mit denen ein Wettrennen veranstalten und nicht zurückbleiben wollen.

CHRYSIS: Und währenddem schimpft er und haut mich und gibt mir keinen Pfennig.

AMPELIS: Er wird schon. Die Eifersucht wird ihm keine Ruhe lassen.

CHRYSIS: Aber ich seh' nicht ein, Liebchen, wie du verlangen kannst, daß ich mich schlagen lassen soll.

AMPELIS: Das hab' ich doch nicht gesagt. Ich weiß nur, daß die Männer erst dann ordentlich verliebt werden, wenn sie sich vernachlässigt glauben. Bildet er sich ein, der einzige zu sein, so läßt sein Eifer bald nach. Das sage ich dir aus meiner zwanzigjährigen Erfahrung als Hetäre, und du bist, glaube ich, noch nicht einmal achtzehn im ganzen. Laß dir erzählen, wie es mir, es ist noch gar nicht lange her, ergangen ist.

Der Geldwechsler Demophantos, der hinter der Poikile wohnt, war damals mein Lieb-

12.

13.

14.

of Klimt's drawings—and in this respect was a forward-thinker for his time—but his take on the image of woman is anything but progressive. "God gave us women," he writes; "everything about the woman belongs to lust"; "every part of woman is 'sex.'" With such remarks, Bahr places himself in unfortunate philosophical proximity to Otto Weininger, whose magnum opus, *Geschlecht und Charakter* (*Sex and Character*), published in Vienna in 1903, is a notoriously misogynistic and anti-modern treatise. Bahr, too, may have been indulging in the construction of an asymmetrical hierarchy of the sexes—quite characteristic of his era but of course entirely outmoded today [Fig. 15].

Klimt repeatedly transgressed moral boundaries in his works, but his understanding of the balance of the sexes was similarly traditional, as is clear from his approach to the subject of homosexuality. He often addressed this "taboo" theme, but was bound to the gender constructs of the nineteenth century. Klimt was a proponent of the perennial male fascination with lesbian scenes: smiling tolerantly (not to say lasciviously) at the notion of love and sex between women, rather than taking it seriously. He showed no interest in depicting scenes of male homosexual love, nor did he take part in the debate on homosexuality that emerged in Vienna (indeed, throughout Europe) during the fin de siècle. Klimt's male gaze toward women was drawn by his subjects' visual seductiveness and immediacy; his perspective was one of full control over the situation. His voyeurism was thus wholly hedonistic;[21] his artistic risks followed personal aesthetic proclivities, and were by no means politically motivated.

Although Klimt would not serve particularly well as a poster boy for the modern queer movement, his contribution to its roots should not be underestimated. Vienna in this period was certainly a source of much radical rethinking that led to later revolutions in the understanding and acceptance of homosexuality. Same-sex love was a much-discussed topic—and not only among the medical and legal circles of the day: in 1897, activist Otto de Joux[22] published the world's first manifesto by an openly homosexual man, calling upon those "dispossessed of the joy of love" (as he put it) to seek emancipation, organize, create networks, found a journalistic outlet, work to shape public opinion, and so forth.[23] As long as homosexuality was considered "nameless," Klimt's depictions would play an important role in public debate, if only for the power of their presence.

Up until his death in 1918, Klimt's peccadilloes and involvements in a number of art scandals attracted much attention (far more than, say, Freud's academic research, which was not the talk of the town nearly as often as Klimt's involvement in scandals was). No one, it seemed, crossed boundaries or broke down barriers quite as openly as Klimt did—he broke down barriers by dauntlessly exposing a world that had previously been relegated to the realm of fantasy. No artist had as many enemies in Vienna around 1900, not even Schiele or Oskar

15.

12. Pages from *Die Hetärengespräche*, with Gustav Klimt, *Reclining Half-Nude, Positioned over a Chair*, 1904, pencil drawing

13. Gustav Klimt, *Reclining Half-Nude Facing Right, with Raised Right Leg*, 1904, pencil drawing (from *Die Hetärengespräche*)

14. Gustav Klimt, *Reclining Nude Facing Right with Neckband*, 1904, pencil drawing (from *Die Hetärengespräche*)

15. Hermann Bahr in his study, with Klimt's 1899 *Nuda Veritas*, ca. 1905

EMILY BRAUN

Ornament as Evolution
Gustav Klimt and Berta Zuckerkandl

Looked at in one way each breadth stands alone, the bloated curves and flourishes—a kind of "debased Romanesque" with delirium tremens—go waddling up and down in isolated columns of fatuity.

But, on the other hand, they connect diagonally, and the sprawling outlines run off in great slanting waves of optic horror, like a lot of wallowing seaweeds in full chase.

… I didn't realize for a long time what the thing was that showed behind, that dim sub-pattern, but now I am quite sure it is a woman.

By daylight she is subdued, quiet. I fancy it is the pattern that keeps her so still. It is so puzzling. It keeps me quiet by the hour.
—Charlotte Perkins Gilman, *The Yellow Wall-Paper*, 1892

[Gustav Klimt] dissolves the female body into wonderful, decorative lines to create his ideal figure. He does away with anything accidental, any individual characteristics, so that only the typical, a sublime extract, of the modern female type is captured in pure style.
—Berta Zuckerkandl, "Gustav Klimt: On the opening of his exhibition," *Wiener Allgemeine Zeitung*, 1903

Despite the decade and an ocean separating one woman's harrowing account of her nervous breakdown from another's praise of archetypal feminine beauty, the dominant template has not changed: the female figure is overcome by or merges with a profusion of pattern. Charlotte Perkins Gilman's *horror vacui*—the hysteria of the creative woman reduced to the merely ornamental—was an image of protest against the stifling social conventions that led women to madness; by contrast, Berta Zuckerkandl extolled Klimt's ability to render the fairer of the species in all her ornamental glory. Although their pairing of ornament and women was used to different ends, the two writers were united by an unconventional feminism, impassioned by scientific knowledge of the day and informed by Charles Darwin's theories of evolution.[1]

1. Gustav Klimt, *Water Serpents I*, 1904–07 (detail)

That Klimt's art should be interpreted in such "sexist" terms by a major critic of the time does not surprise: what gives one pause is that the author is a woman. How is it that an artist of Klimt's stature agreed to have a female journalist as a chief spokesperson for his art, at a time when few women had bylines on the cultural pages of the mass dailies? And how did Zuckerkandl reconcile her identity as an ambitious intellectual and member of the progressive women's movement with his apotheosis of female sexuality? Aside from their mutually beneficial professional relationship, the answer lies in a shared enthusiasm for the biological sciences that naturalized the politics of sexual difference and directly influenced Klimt's modernist aesthetics.

Zuckerkandl's role as Klimt's interlocutor forces us to reconsider longstanding perceptions of the artist as a misogynist painter of *femmes fatales*, an earthbound satyr or art-for-art's-sake hedonist, seemingly unaware of scientific or social issues.[2] Studies of his intimate relationship and artistic collaborations with the fashion designer Emilie Flöge, as well as his alliances with women patrons (most of them Jewish) have complicated these stereotypes. Klimt's images of women, though encased in fin-de-siècle conventions, were anything but demeaning. The profusion of nature's beauty in his canvases represents not entrapment but the awe-inspiring origins of life and sexual selection. More than simply a decorative overlay or trope of modernist abstraction, Klimt's ornament plays a precise symbolic and narrative function. Influenced by German Romantic *Naturphilosophie* and its subsequent transformations in the science of Darwin and Ernst Haeckel, Klimt embedded his paintings with identifiable signs of evolutionary biology. In a telling metaphor, Zuckerkandl wrote that his early work contained "the embryological cells inherent in all of his later developments."[3] Indeed, the role of ornament in his oeuvre can be seen as a conscious progression from the use of biological forms to the use of cultural ones, wherein the geometric motifs of mankind's earliest civilizations bear homology to their original, organically derived progenitors.

Berta Zuckerkandl (b. 1864, d. 1945) [Fig. 2] did not have to worry about being smothered by ugly wallpaper—her colleagues Josef Hoffmann and Dagobert Peche, principals of the Wiener Werkstätte, designed her apartment in Vienna, where she presided over one of the most influential salons in the city.[4] Far from being an expendable, feminine embellishment, her salon had a primary role in cross-cultural pollination. Klimt, Hoffmann, Otto Wagner, Gustav Mahler, and the Jung Wien writers Stefan Zweig, Peter Altenberg, and Hugo von Hofmannsthal were among the habitués. And as a foremost theorist of the Secession (the idea for the movement was generated in her home), Zuckerkandl avoided the social pitfalls of being perceived as mere decorative object. Powerful enough to be dubbed, pejoratively, "the puppeteer of the Viennese cultural scene" by Karl Kraus, she was referred to deferentially as the "royal advisor" for her family's connection to Crown Prince Rudolf, and for her role as an effective middleman.[5]

2. Berta Zuckerkandl, 1908. Photograph by Atelier d'Ora-Benda. Bildarchiv der Österreichischen Nationalbibliothek, Vienna

3

Zuckerkandl and the writers Ludwig Hevesi and Hermann Bahr made up the triumvirate of critics on the forefront of proselytizing for the new art [Fig. 3]. Hevesi claimed, with a deliberate military analogy, that Zuckerkandl relished the polemical and fearlessly headed off to the front line with "heavy munitions." "In this fight my weapon was my pen," she concurred, "my battlefield the *Wiener Allgemeine Zeitung*." In particular, she defended Klimt against controversy and censorship arising from his explicit depiction of female nudity. When he went public with his reasons for buying back his much-maligned university murals in 1905, he granted Zuckerkandl the exclusive interview.[6]

Born into the public sphere, Zuckerkandl was the daughter of Moritz Szeps, the chief editor of the *Neues Wiener Tagblatt*, one of the leading liberal newspapers in the city. "She inherited what few people could learn," opined Hevesi. "She had journalism in her blood."[7] Zuckerkandl grew up in a home that often hosted receptions for statesmen and intellectuals; her father's connections to French statesman Georges Clemenceau led to the marriage of her sister Sophie to his younger brother Paul. The sisters' respective salons formed a cultural axis between Paris and Vienna, underlining their liberal orientation toward the French Republic and away from Bismarck's militarism and the pan-Germanic movement. For in shaping a distinctive national art, Zuckerkandl emphasized that the Austro-Hungarian genus incorporated a variety of ethnicities, languages, and religions (including her own Jewish roots): "It was a question of defending a purely Austrian

3. Caricatures of Hermann Bahr, Berta Zuckerkandl, and Ludwig Hevesi by Bertha Czegka, 1902, from the Kunstgewerbeschule's festival almanac. "Black on White: From Viennese Authors to Viennese Pupils of the Kunstgewerbeschule for their Celebration on February 6, 1902." IMAGNO/Austrian Archives, Vienna

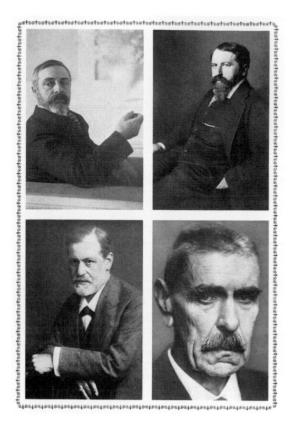

4. Top row, from left: Emil Zuckerkandl, Arthur Schnitzler;
bottom row, from left: Sigmund Freud, Julius Wagner von Jauregg.
From *Österreich intim: Erinnerungen 1892–1942*
by Berta Zuckerkandl

culture, a form of art that would weld together all the characteristics of our multitude of constituent peoples into a new and proud unity."[8]

Equally important for consideration here is the fact that Zuckerkandl enjoyed a marriage to Emil Zuckerkandl (b. 1849, d. 1910) [Fig. 4], a renowned professor of anatomy at the University of Vienna medical school, at that time the foremost institution of its kind in Europe.[9] Comparative anatomy, paleontology, and, later, embryology, along with exacting observations of domesticated species, provided the scientific foundations for Darwin's theory of evolution by natural selection. Berta Zuckerkandl recalled that her husband's mention of Darwin's ideas during his inaugural public lecture at the university in 1888 so offended conservative Catholics that the minister of education demanded (unsuccessfully) his resignation.[10] Just over a decade later, Klimt's university murals came under similar ideological fire because their content was rife with allusions to evolutionary science. When eleven professors petitioned against Klimt's *Philosophy* (*Philosophie*, 1900–07) [Fig. 9], Emil Zuckerkandl, then the chair of the medical faculty, led the counterprotest group.[11] Through Emil, Klimt gained entry to the dissecting room to draw cadavers, facilitating the unsparing veracity of his figures—*in nuditate veritas*—that so enraged ideological conservatives and the aesthetic champions of an idealizing classicism.[12]

As much as Berta esteemed her husband (at times noting Emil's psychological "absence" from her and their only child Fritz, as he worked on his important discoveries) she admitted to the initial discomfort of having to adjust to a lower economic level after her marriage. That Klimt never painted Berta Zuckerkandl may be due to the fact that the couple could not afford it: they lived relatively modestly on Emil's university salary. In 1929, Berta and her son Fritz acquired a Klimt landscape from the estate of Emil's brother, Victor Zuckerkandl; he was a wealthy businessman who had numerous Klimt paintings in his collection and, through Berta's intervention, commissioned Werkstätte artists to design the Purkersdorf Sanatorium. It is also possible that Berta did not desire to be painted by Klimt, ambitiously preferring to be *his* portraitist, rendering an image of the artist for posterity through the lines of her pen.

At the Zuckerkandl home, Klimt and the stars of the Viennese cultural firmament mixed with the brilliant medical scientists of the day. The psychiatrists Richard Krafft-Ebing and Julius Wagner von Jauregg and the surgeon Theodor Billroth were among the regulars, along with Berta's brother-in-law Otto Zuckerkandl, a surgeon and urologist. The two worlds were brought together in the writer Arthur Schnitzler, a specialist in nasal surgery (as well as contemporary sexual mores), who studied under Emil, and whose father, Johann, was a famed laryngologist [Fig. 4]. Berta's memoirs make clear the fascination she had for her husband's research and for his colleagues, and display her knowledge of the school's

venerable history, from its founder, Karl von Rokitansky, to the latest genius, Sigmund Freud.[13] Her relationship to science went beyond privileged access: as a member of the progressive women's movement, she was committed to the education of the masses—"a social rather than a socialist movement," as she put it. It was a time, too, when the discoveries of scientists held interest for a broad public; the tradition of popular science—including the reception of Darwin's ideas—was particularly strong in the German-speaking nations.[14] The first popular science magazine to be published in Austria, *Das Wissen für Alle*, was founded in 1901 by none other than Moritz Szeps, in support of his daughter's conviction that "intellectual democratization" spurred human progress.[15]

Certainly, the research of two medical giants—Krafft-Ebing and Freud—served to "prove" women's lower evolutionary rank and circumscribed female sexuality from the perspective of biological determinism. Yet other leading scientists, notably Emil Zuckerkandl, were active "feminists," and supported higher education for women, which was significantly lacking in Austria. Emil served on the committee of the Association for Extended Women's Education and taught classes in anatomy to female art and grammar-school students.[16] In her memoir, Berta proudly wrote that her husband scoffed at the idea that women were less intelligent than men, and that he staunchly supported the admission of women into Austrian universities. She also claimed that Emil was the first faculty member to choose women research assistants after they were finally allowed, in 1900, to take degrees at the medical school:

> I remember that the Dean of the University argued that my husband, as an anatomist, should know perfectly well that women's brains were less developed than those of men. My husband answered that he also knew perfectly well that "out of a hundred male students who tried to pass their medical examinations, ninety-seven were complete asses, and it could reasonably be expected that not more than ninety-seven out of a hundred women students would be absolute geese." [17]

For their part, theorists of the first generation of women progressives—to which Berta Zuckerkandl belonged—upheld the essentialist roles of procreation and motherhood but fought against the determinist perception that these precluded women's social and political parity with men. As Harriet Anderson has documented, cultural regeneration in the form of intellectual awakening, rather than a break with traditional notions of womanhood, motivated the largely middle-class constituency of feminists. Marie Lang and Rosa Mayreder, leading figures of the General Austrian Women's Association, openly supported modernist art and literature for its exploration of female sexuality and its critique of the double standard of bourgeois morality. "The artistic Secession of Gustav Klimt and Josef Hoffmann and the secession of women, the women's movement, were often

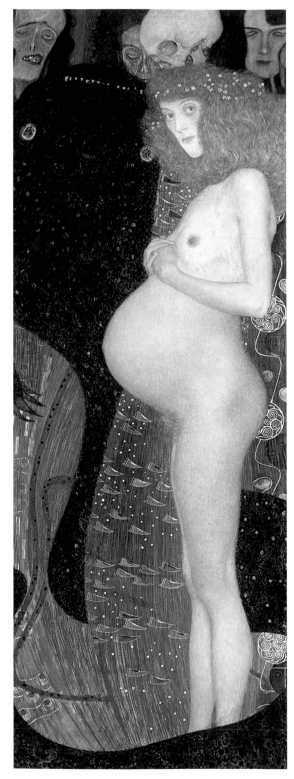

5. Gustav Klimt, *Hope I*, 1903, oil on canvas.
National Gallery of Canada, Ottawa

mentioned in the same breath."[18] The interests of the two groups also dovetailed in their dedication to the reform of women's fashions.[19] Conversely, antifeminists—who were rampant in fin-de-siècle Vienna—used the fear of societal degeneration as a weapon against sex education and female emancipation.

The public outcry (by men) over Klimt's nudes attests that his exploration of human reproduction touched on an explosive social issue: submitting Eros to scientific materialism, he implied that neither God nor man, but only nature's will, controlled the evolution of the human species. Zuckerkandl pointedly addressed Klimt's challenge to "the cowardly hypocrisy of the present day" in an article devoted entirely to his 1903 painting *Hope I* (*Die Hoffnung I*) [Fig. 5], and its upcoming exhibition at the summer 1909 *Kunstschau*. (Although this work has been traditionally titled in English *Hope I*, the translation *Expectancy* more accurately reflects its content.) Zuckerkandl aimed to offset the expected controversy generated by the image of a pregnant nude in profile, pubic hair and all:

> Gustav Klimt painted the body of a naked woman in the final stages of pregnancy, her body in bloom, deformed and misshapen. The woman stands motionless, in a chaste and sacred manner, lost in her own world, contemplating *the immense process going on inside her* [italics added] … . She does not feel death behind her, nor is she aware of the gloomy figures floating quietly around her. It is a glorification of motherhood, of her unconscious heroism, shown with the most honorable and artistic mastery.[20]

Indignant that Klimt had been forced to withdraw the work from his personal retrospective six years earlier, Zuckerkandl referred to a recently published book on motherhood to demonstrate that *Hope I* belonged to a venerable tradition in the history of Christian art: "Was there ever a better topic for the depiction of women than the drama of motherhood?" To those who objected that pregnancy and parturition were subjects best shown in private, she rejoined with examples from cathedral doors, church altarpieces, and public museums. The reaction of earlier audiences was not shock, she asserted, but simply "It is natural!"—in contrast to the feigned propriety of her contemporary viewers, who could accept nudity in old masterworks, because "the patina of age mitigates the original crudeness."[21]

"It is natural!" reiterated Zuckerkandl—a mother herself—with rhetorical flourish. In an even more naturalist exposure of "the immense process going on inside her," Klimt depicted a dark blue, balloon-shaped creature with long tail and prehensile claw, poised next to the swollen womb. Described by reviewers then and now as a dragon or monster (threatening or comic), it makes manifest Klimt's knowledge of embryology, or what Darwin termed "a picture, more or less obscured, of the common parent form of each great class of animals."[22] Far from the detailed

Zitterroche
(Torpedo marmorata Risso).

8.

6.

7.

rendition of the human fetus found in the work of Edvard Munch and Aubrey Beardsley, Klimt invented a hybrid that explicates the origins of humans from the lowest forms of life.[23] "Ontogeny recapitulates phylogeny," succinctly stated the zoologist Ernst Haeckel (Darwin's chief proponent in the German-speaking nations), meaning that the stages of embryonic growth compressed the whole history of the evolution of the species [Fig. 6]. Hugely influential from the 1870s on, in science and in the public imagination, Haeckel's radical "biogenetic law" sought to explain the common descent of fish, amphibians, reptiles, birds, primates, and humans.[24]

Klimt's creature lyrically embodies this "monstrous" proposition: it draws on the tadpole shape, circular ears and eyes, and tail (what becomes the os coccyx in humans) found in Haeckel's chart of the developing embryo. Not content to stop the evolutionary line at mammals, Klimt intentionally referred to the lowest class of vertebrates. A source for the fish-like being can be found in the images of electric or torpedo rays (down to the toothy grimaces and googly eyes) from the four-volume *Illustrierte Naturgeschichte der Thiere* (Illustrated natural history of animals) that Klimt had in his personal library [Figs. 7, 8, 15].[25] Filled with detailed black-and-white drawings of the various classes of living organisms, including microscopic cell formations, these volumes are a previously undocumented source for the diverse specimens, structures, and decorative patterns in Klimt's paintings. The sharp spines on the back of the *Raja clavata* may have inspired the triangular shapes that issue forth from the skull above and dart between the two

6. "Anthropogeny, or the Development of Man," mammal embryos, from *The Evolution of Man*, vol. 1, by Ernst Haeckel, 1879

7. "Torpedo marmorata Risso," from *Illustrierte Naturgeschichte der Thiere*, edited by Philipp Leopold Martin, 1882

8. "Raja clavata Linné," from *Illustrierte Naturgeschichte der Thiere*, edited by Philipp Leopold Martin, 1882

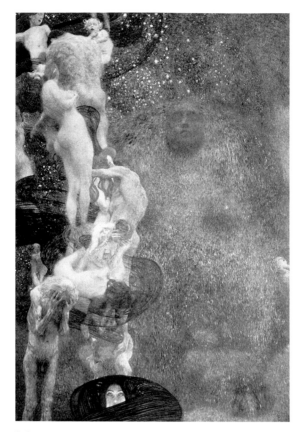

9. Gustav Klimt, *Philosophy*, 1900–07, oil on canvas.
Ceiling panel for the Great Hall of the University of Vienna,
destroyed by fire in 1945

protagonists of *Hope I* in an amniotic field of blue [Fig. 5]. A figure of both the unknown future and the prodigious past, the extrauterine apparition represents the developing promise of the unborn child, as well as the underlying threat of deformation (reversion) or even death. The mother's calm anticipation, as Zuckerkandl observed, was heroic indeed; Klimt himself had recently experienced the death of his own son Otto Zimmermann, at about eighteen months of age.[26]

Klimt painted *Hope I* while working on *Jurisprudence* (*Jurisprudenz*, 1903–07), the last of his university murals. In these monumental allegories for Vienna's preeminent institution of higher learning, he preempted Freud's assertion that Darwinism was the second great blow dealt by scientific research to "the universal narcissism of men."[27] Klimt's depictions of Philosophy and Medicine acknowledged that traditional metaphysics and systems of knowledge had been radically altered by the discovery of fundamental mechanisms of biological change. The principles of natural selection had revealed the false positives of both a divine Creator and the immortality of the soul. The murals narrate the loss of transcendence and humanity's privileged position in the universe, with columns of entangled bodies flowing ceaselessly in an indeterminate direction. Officials of the university complained that Klimt extolled confusion, not lucid science; but in fact he allowed the latest research into his pictures all too clearly, as evidenced by a common clinical refrain: his art represented "the specific medical field of gynecology"; it was better "suited for an anatomical museum" or "a Krafft-Ebing institute."[28]

The allegorical program of *Philosophy* [Fig. 9] was given in a text accompanying its debut in 1900, at the seventh Secession exhibition: "On the left: genesis, reproduction, decay. On the right: the globe of the world, the riddle of the universe. Rising from below: the illuminated figure of knowledge." It reads as a virtual engagement with Darwin's closing paragraphs in *On the Origin of Species*, describing an evolutionary time, "whilst this planet has gone cycling on," incommensurate with the span of individual life, and endless growth and procreation, kept in check "by the war of nature." The shimmering figure of the Sphinx represents the "riddle of the universe" (or *Welträtsel*—significantly, as in the title of Haeckel's 1899 bestseller on evolution). While critics have focused on the Sphinx's enigmatic presence, Klimt's purpose was to reiterate the answer to the question posed in the classical story: the three ages of man, a mythic narrative now understood as the biological imperative of the species.[29] Herein lies the materialist meaning of existence, as one reviewer pessimistically concluded: "Humanity remains just a tool in the hands of nature, exploited only for her own immutable and eternal purpose: reproduction."[30]

In *Medicine* (*Medizin*, 1901–07) [Fig. 10], Klimt likewise interpreted the struggle for existence as Darwin intended it—a metaphoric survival against environmental odds—and not as a pugnacious armed battle (*Kampf ums Dasein*), seen in Hans Canon's *The Cycle of Life* (*Der Kreislauf des Lebens*) installed in 1885 in Vienna's Naturhistorisches Museum. Cures may temporarily assuage bodily suffering, but famine, disease, and Death—here pictured in the lifeline of the throng—continue by nature's indomitable will. Hygeia, the goddess of health, appears in a viscous garb of stylized golden algae, filaments, and polyps. Her origins as a snake transformed out of the primordial swamp exemplify the kinship of evolutionary theory and recurrent myths of metamorphosis, making factual, as Gillian Beer has written, the imaginary "interdependence between beauty and beast."[31] Significantly, Zuckerkandl reserved her one criticism of Klimt for this work, gently asserting that he had "not emphasized enough the themes of cure and healing, which are obviously part of the meaning of medicine." Her sensitivity pointed to what was then a deep division within the University of Vienna medical school, between the proponents of therapeutic skepticism, who vaunted research and diagnosis, and the "therapeutic optimists," Emil Zuckerkandl among them, who promoted the physician's role in healing.[32]

Nowhere is the evolutionary challenge to Christian theology more apparent than in *Medicine*'s revisionist view of Creation. In a provocative allusion to the *Creation of Adam* from Michelangelo's Sistine Chapel, where God's hand reaches out to touch Adam's, Klimt renders the arms of a mortal man and woman extended in vain, the possibility of their union left to chance. In Klimt's version, Woman, not the divine Creator, bears the generative power of life; instead of the billowy cloud of drapery used to carry God in the Sistine fresco, she is borne on high by what Hevesi described, in 1901, as a blue-colored uterus motif, enveloping an infant or a late-stage embryo.[33] For Zuckerkandl, Klimt's university allegories demonstrated the "influence of contemporary scientific knowledge," and his ability to probe the "endless ceasing and becoming" deep beneath the surface of things: "The transformation of matter, for instance, is a scientific finding, which has changed our understanding of phenomena. In accordance with these dynamics, Klimt made the parturient wife central to the ideas of his painting. She represents the renewal of life that wins over illness and death."[34]

Klimt's interpretation of the womb corresponds to Haeckel's widely published images of the human embryo in utero, sheathed by a transparent vellum lining [Fig. 11]. The transparent human fabric appears again in *The Three Ages of Woman* (*Die drei Lebensalter*, 1905) [Fig. 12], where it conjoins mother and child and issues forth from her pelvis, inscribed by the decorative curve of a blue umbilical cord (a motif clearly visible in the second state of *Medicine*). Next to this new life, Klimt sympathetically records the geriatric body, or what Zuckerkandl described as "the stupor of a decaying organism in pain."[35]

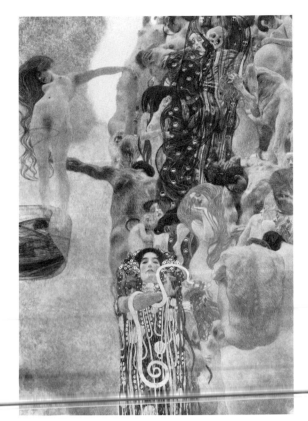

10. Gustav Klimt, *Medicine*, 1901–07, oil on canvas. Ceiling panel for the Great Hall of the University of Vienna, destroyed by fire in 1945

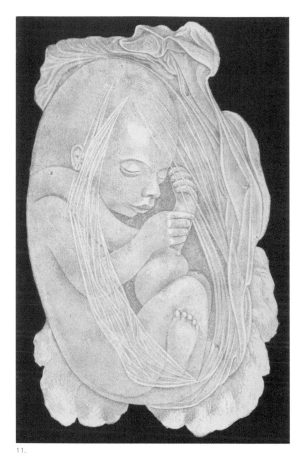

11.

12.

11. "Anthropogeny, or the Development of Man," human fetus, from *The Evolution of Man*, vol. 1, by Ernst Haeckel, 1879

12. Gustav Klimt, *The Three Ages of Woman*, 1905, oil on canvas. Galleria Nazionale d'Arte Moderna, Rome

In the late nineteenth century, images of scantily draped women served as a standard allegory of nature unveiled and possessed by male science, reinforcing the unequal power relation between the sexes.[36] Klimt resorts to this trope only in the figure of Death in *Medicine*, who proffers the ultimate truth from behind an organza shroud, decorated with distinct circles and crosses in a binary gender code. Otherwise, Klimt dispensed with coy or theatrical unveiling, as evidenced in *Nuda Veritas* (1899) [Fig. 13], his manifesto of art and science as nature in plain sight. Here the uterine veil appears in a tadpole shape, formed by blue lines that swell behind the womb and lower body of the allegorical female figure; the watery hue also refers to the domain of our ancient human origins in the sea. The fertile daisy adorns her hair, while below her snakes the phallic serpent of classical and biblical myth, whose meaning is redoubled as a fellow vertebrate. On either side rise the luminous, globular heads of dandelion flowers—the genus *Leontodon taraxacum*, as Hevesi insisted on noting—which disseminate their seed through the wind, mingling the Secession's spread of new ideas with nature's own adaptive mechanisms.[37]

In a reversal of the self-absorbed female, she holds the allegorical mirror up to the male viewer so that he might see his own reflection as mere flesh, but now

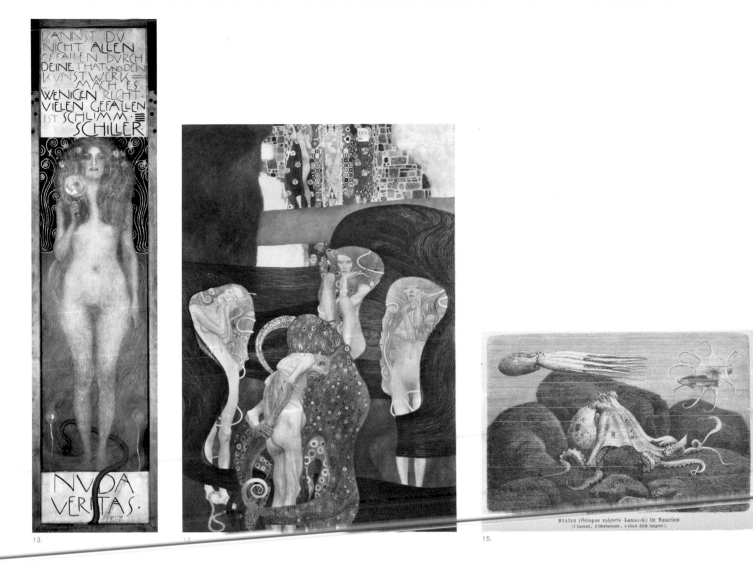

13.
14.
15.

without the moral compass that governed previous depictions of nudity. Klimt's "truth" upset the traditional allegorical function of the female as a vehicle for a higher ideal or spiritual transcendence because, after Darwin, the body in painting stands nakedly for itself: a biological species subject to the same procreative laws as every other organism. Hence the frequent charges of pornography leveled against Klimt for both the public university murals and the *Beethoven Frieze* (*Beethovenfries*, 1902). In the latter, he embellished the act of consummation in a womb-enshrined embrace, the embryonic veil binding male and female in a common destiny as it swirls around their lower legs. "'The final aim of all love intrigues,'" wrote Darwin, quoting Arthur Schopenhauer, "' … is really of more importance than all other ends in human life. What it all turns upon is nothing less than the composition of the next generation … . It is not the weal or woe of any one individual, but that of the human race to come, which is here at stake.'"[37]

Despite the compositional differences found in the third university mural, *Jurisprudence* [Fig. 14] also elaborated the evolutionary theme, interpreting its given subject as the higher moral sense of the human species. The vertical registers in diminishing perspective mark the ascent of man's social instincts, from brutal impulse and vendetta to organized institutions of collective self-preservation: the courts of law. Man has only recently emerged from a state of

13. Gustav Klimt, *Nuda Veritas*, 1899, oil on canvas. Österreichische Galerie Belvedere, Vienna

14. Gustav Klimt, *Jurisprudence*, 1903–07, oil on canvas. Ceiling panel for the Great Hall of the University of Vienna, destroyed by fire in 1945

15. "Octopus vulgaris Lamarck," from *Illustrierte Naturgeschichte der Thiere*, edited by Philipp Leopold Martin, 1882

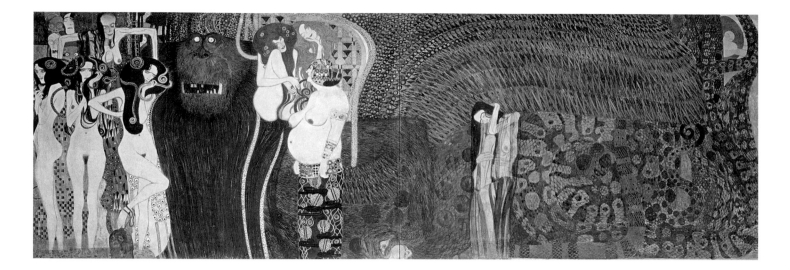

16. Gustav Klimt, *Beethoven Frieze*, 1902, casein colors on a stucco base with semiprecious stone inlay

barbarism, as late-nineteenth-century anthropologists noted, and Klimt devotes most of the panel to the dark recesses of criminality. He links the aged man in the dock and his deviant behavior to bestial biological origins, invoking the return of the repressed with the tentacular embrace of a primeval octopus (a source for which is found in the *Illustrierte Naturgeschichte der Thiere* [Fig. 15]. The three Furies of archaic Greek myth, sent from the depths of Tartarus, symbolize primeval forms of penal retribution. They are, as Hevesi observed, allegories of vengeful, and hence lesser, morals from a remote time, "like lemures in the twentieth century. Klimt conceived them with [Jan] Toorop's daughters and they bear their father's features."[39] As befits humanity's rise to civilization, embodied in Truth, Justice, and Law above, Klimt's ornament transforms from the germinating papillae and writhing arabesques below to the structured circles, squares, and triangles on high, redolent of the already "cultured" Geometric Style.

The linking of moral degradation to animal descent rather than free will comes to the fore in Klimt's *Beethoven Frieze*, where Typhon, the ancient Greek evil giant, appears unconventionally as a gorilla [Fig. 16], a primate dangerously close to man. ("The Devil in the form of Baboon is our grandfather!" exclaimed Darwin in his notebooks.)[40] The unwelcome ancestor had strayed into high art in the Paris Salon of 1859, with Emmanuel Frémiet's sculpture *Gorilla Carrying Off a Negress* (*Gorille enlevant une femme*), which the artist reprised with even greater notoriety in 1887.[41] Klimt's choice, though previously uncommented on, underscores the *Beethoven Frieze* as an allegory of "the struggle for happiness" in evolutionary terms: overcoming the "hostile" forces of nature by the altruistic virtues necessary for the welfare of the human species. The three Gorgons of Disease, Insanity, and Death—the afflictions of the body—accompany the unruly beast, along with personifications of Licentiousness, Intemperance, and Indecency—reversions of the soul. These precise behaviors are the same three Darwin uses in his writing on the moral sense, to distinguish savage from civilized societies.[42] The resolute

ORNAMENT AS EVOLUTION

knight is compelled by the "internal driving forces" of Ambition and Sympathy, the latter being the marker of true humanity, continues Darwin, since it extends the strong desire for the common good beyond the tribe to all nations and races. Humanity progresses through procreation and the arts, Klimt affirms—the only means of triumph over the inevitability of death.

The narrative unfolds further by nature's ornamental design, the lower realm articulated by serpentine line and hairy filaments running profligate in a cavernous realm of reptilian motifs and snakeskin patterns. Sources for the gorgeously flecked and striated worms, winding and slung in several of Klimt's canvases of the period, can be found in his copy of the *Illustrierte Naturgeschichte der Thiere* [Fig. 17]. Skulls dissipate into amoeba-like organisms forming the backdrop for "Gnawing Worry," an anguished creature who sinks into the reticulated coils of despair. In contrast, the kingdom of higher humanity is rendered in spaces of empty white and transcendent gold, where the biologically grounded spores, eggs, and flowers obligingly disperse in regulated rhythms and parallel trajectories. "Klimt's senses grasp the invisible and immaterial in shapes and lines," confirms Zuckerkandl, "as he searches for the secrets that cover everything alive."[43] It should be noted that Klimt's iconography of the tree of life, which first appears at the base of the culminating kiss in the *Beethoven Frieze*, and grows into the main motif of the Palais Stoclet composition (Stoclettfrieze, 1905–11) [see pp. 179 and 380 in "Klimt and Fashion"], consists of a symmetrical and horizontal branching structure; it follows the same arboreal diagram of diversification by genealogical descent published by Darwin and extrapolated by Haeckel in his sprawling phylogenetic trees [Fig. 18].

The overly exaggerated facial features of Klimt's personifications also refer to characteristics of man's lower ilk. The snarls, sneers, teeth-baring grimaces, and furrowed brows displayed by Typhon's cortege and by the leering visages in *Hope I* conform to Darwin's examples in *The Expression of the Emotions in Man and Animals*. Distinguishing his approach from that of physiognomy (interpreting personalities from body types), Darwin analyzed the instinctive movement of facial muscles as concrete evidence of our "single stock parent ancestry." Emotional expressions are not unique to the human species, but are reflex responses to danger and pleasure inherited from the lower primates. As if to drive home the point, Klimt surmounts the Gorgons with a repulsive female who apes the square-armed pose of the gorilla, in the hulking attitude of primal attack or defense. Darwin's observation that the uncontrollable contraction of the facial muscles destroys beauty, finds confirmation in the serene and symmetrical grace of the choral figures in the *Beethoven Frieze*. Their upward-turned faces and open palms typify devotion, one of the few learned or culturally acquired emotions that had not, according to Darwin, affected "the hearts of men, whilst they remained during the past ages in an uncivilized condition."[44]

17. "Worms," from *Illustrierte Naturgeschichte der Thiere*, edited by Philipp Leopold Martin, 1882

18. "General Morphology of Organisms: Tree of Reptiles," from *The Evolution of Man* by Ernst Haeckel, 1879

19.

20.

19. Gustav Klimt, *Moving Water*, 1898, oil on canvas. Private Collection

20. Gustav Klimt, *Nixies* (*Silver fish*), ca. 1899, oil on canvas. Wien Museum

The more threatening themes of a Darwinian worldview—namely degeneration and extinction—inspired nineteenth-century artists, from Frémiet's libidinous gorilla to Odilon Redon's graphically black universe of despondent, mutant species. The heightened reception of Darwin in France after defeat in the 1870–71 Franco-Prussian War fed into widespread fear of racial and national decline.[45] Closer to home, in the exhibitions of the Secession, Klimt saw the works of Max Klinger and Arnold Böcklin, where a descriptive realism combined with fantastic storylines of primal urges and marine ancestry. As in Klimt's work, the influences of Schopenhauer and Nietzsche only enhanced these artists' pessimistic interpretation of sexual drives and aggressive social struggle.[46] On the whole, however, Klimt departs from the masculine brutalism of his Germanic peers. Grotesque breeds of humankind and fish, for example, appear only aberrantly in the early *Moving Water* (*Bewegtes Wasser*, 1898) [Fig. 19] and *Nixies* (*Nixen*, ca. 1899) [Fig. 20]. Nor do his women emerge from a dark, primeval slime, in a metaphor of abject sexuality, as seen in the work of his compatriot Alfred Kubin. Instead, after the somber inclinations of the university murals, Klimt turned to more lyrical expressions of what Darwin hailed as "the beauty and infinite complexity of the co-adaptations between all organic beings." It was precisely through ornamental profusion—the visual proof of nature's own superabundant diversity—that Klimt revealed the "inextricable web of affinities" binding humankind to the most basic of single-celled organisms.[47]

In his series of Nereid paintings, *Goldfish* (*Goldfische*, 1901–02), *Water Serpents I* (*Wasserschlangen I*, 1904–07) and *Water Serpents II* (*Wasserschlangen II*, 1904–07) [Figs. 21, 22, 23], Klimt bypassed the male-gendered gorilla for the sexually ambiguous ascidians: in the watery depths lay the ancient prototype of the vertebrate kingdom, as recapitulated in the gills of the human embryo. Like Böcklin, Klimt animates his worlds with "fairytale creatures," Zuckerkandl acknowledges, but the coloristic fantasies of his "magical waters" have no peer.[48] Modern-day women loll in the shimmering currents, their slinky contours entangled with amphibians, fish, sea anemones, starfish, and algae. The cropped human forms create a flowing sensation that evokes nature's infinitesimally small and endless process. Whereas the imaginary hybrids of other artists fill the vanished "missing links" (nature does not make leaps, Darwin admonished),[49] Klimt deliberately draws out the morphological affinities—serpentine lines and blooming ova—between the least- and highest-developed animals.

The scandalous reception of Klimt's work derived not only from the irruption of the "Godless" natural sciences in the work of art, but also from his flamboyant vision of ornament as evolution. This fusion of beauty and functionality was one of the most problematic aspects of Darwin's theory of sexual selection, introduced in *The Descent of Man*, because the presence of embellishment in nature, ranging from

21.　　　　　　　　　　　22.

color to song, appeared to qualify the purely mechanistic conception of biological adaptation. Ornamental characteristics were secondary sexual characteristics (male, no less than female) that determined inherited traits and the successful propagation of species. Darwin accounted for the puzzling amount of finery bedecking men and beasts alike; the devastating result was that the aesthetic sense was no longer considered exclusive to humans, but commonplace in the animal kingdom.

21. Gustav Klimt, *Goldfish*, 1901–02, oil on canvas. Private Collection

22. Gustav Klimt, *Water Serpents I*, 1904–07, oil on canvas. Österreichische Galerie Belvedere, Vienna

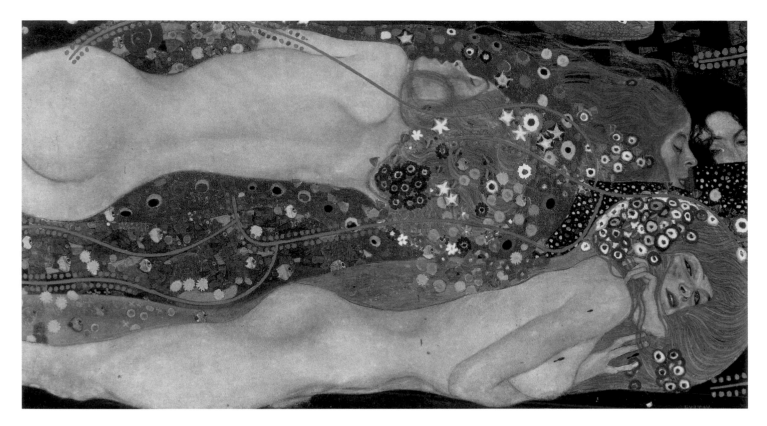

23. Gustav Klimt, *Water Serpents II*, 1904–07,
oil on canvas. Private Collection

In Klimt's fecund patterning of line, aureole, and hue, nature—no less than woman—is seductively adorned. Preening males predominate in the courtship rituals of the lower animals, yet among the human race, Darwin argued, females have garnered the more attractive characteristics and compete for the opposite sex. *Water Serpents I* and *II*, as well as *Goldfish*, visualize this biological imperative of beauty with decorative abandon and indecorous display of flesh. In discerning the most notable aesthetic preferences transmitted over time, Darwin focused above all on the hairless bodies and long tresses inherited and bequeathed by women. [50] Dominated by abstracted shapes of pearlescent flesh and a prodigious flow of hair, Klimt's compositions emphasize these two attributes of evolutionary design. Zuckerkandl, not surprisingly, reveled in her anatomical descriptions of Klimt's sexually resplendent female: "The iridescent flesh tone of her slender body, the phosphorescent gloss of her skin, the quadratic form of her forehead and the sinful, ginger-colored hair create a unified whole of the deepest psychological and painterly effect."[51]

The single-sex community of beings, notably in *Water Serpents I* and *II*, court the period's fascination with lesbianism, but also allude to the hermaphroditic character of the lowest classes of animals. Klimt's enthrallment with humankind's aquatic beginnings extended to his extravagant use of mother-of-pearl—an organic material derived from the inner shell of bisexual mollusks—in his portraits of contemporary women. In his infamous essay "Ornament and Crime" (1908), the

24A. 24B. 25.

architect Adolf Loos railed against the Secession's "primitive" cult of decoration; perhaps what was threatening to Loos was not so much the erotic and atavistic element, but the notion of ultimate regression to gender anarchy and lack of sexual dimorphism found in the earliest forms of life.[52]

Darwin's intellectual legacy was imaginatively visualized in the specimen-rich installations of Vienna's Naturhistorisches Museum, in illustrated natural history publications like the one in Klimt's library, and in Haeckel's lushly color-printed volumes, which did the most to propagate the aesthetics of biological forms.[53] In his *Radiolarian Atlas* of 1862, Haeckel documented the diversity of single-celled organisms, accenting the microscopically perceived structures with jeweled hues. The glimmering shapes and flecks of gold that swim alongside Klimt's Nereids refer to the natural ornamental complexity of these normally invisible animals. An artist as well as a scientist, Haeckel sought the "naked truth" of nature's law of descent in the details of organic structure and the "morphological chain."[54] His *Art Forms in Nature* (*Kunstformen der Natur*, 1899–1904) furnished Art Nouveau artists with the gorgeous array of classes and species, such as the magnificently embellished ostracions that may have inspired the speckled, moiré creature with luminous eyes swimming in Klimt's *Goldfish* [Figs. 25, 21].

Haeckel was equally important for popularizing the link between Goethe's scientific studies of natural forms and Darwin's biological materialism.[55] While there is no evidence to suggest that Klimt officially subscribed to Haeckel's monism—an updated theory of romantic pantheism—he was profoundly influenced by Goethe. Alma Mahler-Werfel claimed that the artist was never without a copy of Goethe's *Faust* in his pocket. Goethe's meditations on the origin of species in the gloaming sea permeate the scenes of *Faust, Part Two*: "From dragons of the sea, in their swift

24A. "Collozoum inerme;" and 24B. "Acanthometra" organism group, from *Art Forms from the Ocean: The Radiolarian Atlas* by Ernst Haeckel, 1862

25. "Ostraciontes," from *Art Forms in Nature* by Ernst Haeckel, 1899–1904

30 Anonymous reviewer, "Personal-und-Atelier-Nachrichten," *Die Kunst für Alle* (*Die Kunst*), vol. 15, 1900, p. 500. Ludwig Hevesi's description of *Philosophy* was also replete with metaphors of origin and the struggle for existence; see the translation of his essay in Christian Nebehay, *Gustav Klimt: From Drawing to Painting* (New York: Abrams, 1994), p. 69.

31 Beer, *Darwin's Plots*, p. 9.

32 Berta Zuckerkandl, "Wiener Ausstellungen," *Die Kunst für Alle* (*Die Kunst*), vol. 16, 1901, p. 356. Luprecht, *"What People Call Pessimism,"* pp. 1–50.

33 Ludwig Hevesi, cited in Dobai, "Gustav Klimt's '*Hope I*,'" pp. 7 and 15, n. 24.

34 Zuckerkandl, "Gustav Klimt: Zur Eröffnung seiner Ausstellung."

35 Berta Zuckerkandl, "Kunst und Kultur: Die Kunstschau 1908," *Wiener Allgemeine Zeitung*, June 6, 1908.

36 Ludmilla Jordanova, *Sexual Visions: Images of Gender in Science and Medicine Between the Eighteenth and Twentieth Centuries* (New York: Harvester Wheatsheaf, 1989), especially chap. 5, "Nature Unveiling Before Science," pp. 87–110.

37 Ludwig Hevesi, reprinted in Nebehay, *Gustav Klimt: From Drawing to Painting*, p. 91; see also Novotny and Dobai, *Gustav Klimt*, p. 382.

38 Darwin, *The Descent of Man*, p. 653.

39 Ludwig Hevesi, "Goldene Gewissensbisse" (1903), reprinted in Otto Breicha, ed., *Gustav Klimt: die goldene Pforte: Werk, Wesen, Wirkung: Bilder und Schriften zu Leben und Werk* (Salzburg: Galerie Welz, 1978), p. 72. Continuing the metaphor of hybrid ancestral origins, Hevesi notes that "conscience is depicted by the mighty giant polyp … . His skin is speckled with spots just like a tiger, a deep-sea tiger of the most novel construction."

40 James Moore and Adrian Desmond, quoting Darwin's notebooks of 1837–38, in their introduction to his *Descent of Man*, p. xxii.

41 On the iconography of the ape in the fine arts and popular culture since Darwin, see Ted Gott, *Kiss of the Beast* (South Brisbane, Australia: Queensland Art Gallery, 2005). I thank Douglas Druick for this reference.

42 Darwin, *Descent of Man*, pp. 142–43. Klimt's program for the *Beethoven Frieze* published in the XIV Secession catalogue is reprinted in Novotny and Dobai, *Gustav Klimt*, p. 387.

43 Zuckerkandl, "Gustav Klimt: Zur Eröffnung seiner Ausstellung."

44 Charles Darwin, *The Expression of the Emotions in Man and Animals* (1872) (Chicago: University of Chicago Press, 1965); see especially pp. 14, 218, 359. Darwin, whose book was published in German in 1877 as *Der Ausdruck der Gemüthsbewegungen bei dem Menschen und den Thieren*, based many of his observations on the experiments of Guillaume Duchenne, the author of "Mécanisme de la physionomie humaine" (1862), who took photographs of the effects of electrical prompting of the facial muscles. The two drew different conclusions, however.

45 Barbara Larson, "Evolution and Degeneration in the Early Work of Odilon Redon," *Nineteenth Century Art World Wide*, vol. 2, Spring 2003, Special Issue, *The Darwin Effect: Evolution and Nineteenth Century Visual Culture*, eds. Linda Nochlin and Martha Lucy. See also Martha Lucy, "The Evolutionary Body: Refiguring the Nude in Post-Darwinian French Art" (Ph.D. dissertation, Institute of Fine Arts, New York University, 2004).

46 See Marsha Morton's excellent essay "'Impulses and Desires': Klinger's Darwinism in Nature and Society," *Nineteenth Century Art World Wide*, vol. 2, Spring 2003.

47 Darwin, *Origin of Species*, pp. 153, 415. The metaphoric capacity of Darwin's view of nature and its influence on late-nineteenth-century literature and thought are beautifully elaborated by Beer in *Darwin's Plots*, especially chap. 3, "Analogy, Metaphor, and Narrative in *The Origin*," pp. 79–103.

48 Berta Zuckerkandl, "Von Ausstellungen and Sammlungen," *Die Kunst für Alle* (*Die Kunst*), vol. 19, 1903–04, p. 163.

49 Darwin, *Origin of Species*, p. 233.

50 Darwin, *Descent of Man*, pp. 668–74.

51 Zuckerkandl, "Gustav Klimt: Zur Eröffnung seiner Ausstellung."

52 Adolf Loos, "Ornament and Crime," in *The Architecture of Adolf Loos*, eds. Yehuda Safran and Wilfried Wang (London: Arts Council of Great Britain, 1985), pp. 100–103. For a slightly different interpretation of Loos's fear of atavism linked to Cesare Lombroso's criminal anthropology, see Jimmy Canales and Andrew Herscher, "Criminal Skins: Tattoos and Modern Architecture in the Work of Adolf Loos," *Architectural History*, vol. 48, 2005, pp. 235–55.

53 Christa Riedl-Dorn, *Das Haus der Wunder: Zur Geschichte des Naturhistorischen Museums in Wien* (Vienna: Holzhausen, 1998). Vienna's Naturhistorisches Museum, designed by Gottfried Semper,

opened in 1889. Darwin was the only living notable to be represented among the statues adorning the roof, while a copy of *The Descent of Man* was depicted in the interior frieze decoration by Viktor Tilgner. The museum's holdings were rich in specimens collected during the 1857–59 circumnavigation of the globe by the S. M. *Novara*, an Austrian naval frigate; Emil Zuckerkandl participated in the cataloguing of the *Novara* expedition (Riedl-Dorn, pp. 169, 187–88).

Ernst Haeckel, *Art Forms from the Ocean: The Radiolarian Atlas of 1862*, with an introductory essay by Olaf Breidbach (New York: Prestel, 2005); and Breidbach, *Visions of Nature: The Art and Science of Ernst Haeckel* (New York: Prestel, 2006). See also Erika Krause, "L'influence de Ernst Haeckel sur l'Art nouveau," in Jean Clair, ed., *L'âme au corps: Arts e Sciences, 1793–1993* (Paris: Réunion des musées nationaux, 1993), pp. 342–50, and Paul Greenhalgh, ed., *Art Nouveau 1890–1914* (London: Victoria and Albert Museum, 2000).

54 Ernst Haeckel, in one of his most stridently pro-evolution tracts, *The Dagger of Darkness: Three Lectures on Evolution*, trans. Joseph McCabe (Girard, KS: Appeal to Reason, 1905), p. 56, writes that the zoologist or anthropologist "seeks to discover the naked truth, as it is yielded by the great result of modern science, in which there is no longer any doubt that man is really a descendant of the ape."

55 References to Johann Wolfgang von Goethe and his achievement as an evolutionary theorist are found throughout Haeckel's texts; see in particular *The History of Creation: or the Development of the Earth and Its Inhabitants by the Action of Natural Causes* (New York: D. Appleton and Co., 1892).

56 Johann Wolfgang von Goethe, *Faust, Part Two*, trans. Philip Wayne (London: Penguin, 1959), pp. 144, 116. Alma Mahler-Werfel, *Mein Leben* (Frankfurt: Fischer, 1960), p. 77. Berta Zuckerkandl makes the comparison between the "young and beautiful" women of Goethe's *Faust* and Klimt's depiction of the Furies in *Jurisprudence* in "Von Ausstellungen and Sammlungen," p. 162.

57 Hevesi, "Goldene Gewissensbisse," p. 72.

58 Berta Zuckerkandl, "Kunstschau 1908 in Wien," *Wiener Allgemeine Zeitung*, October 15, 1908.

59 Zuckerkandl, *Österreich intim*, p. 133.

60 Gustav Klimt, quoted in Nebehay, *Gustav Klimt: From Drawing to Painting*, p. 284.

61 Tobias Natter and Gerbert Frodl, eds., *Klimt's Women* (Vienna/New Haven, CT: Österreichische Galerie Belvedere; Yale University Press, 2001).

62 Klimt's informed appropriations of preclassical sources are well documented in M. E. Warlick, "Mythic Rebirth in Gustav Klimt's Palais Stoclet Frieze: New Considerations of Its Egyptianizing Form and Content," *Art Bulletin*, vol. 74, March 1992, pp. 115–34; Lisa Florman, "Gustav Klimt and the Precedent of Ancient Greece," *Art Bulletin*, vol. 72, June 1990, pp. 310–26 (Florman argues for the influence of Nietzsche on Klimt's preferences for an archaic ornamental style); and J. Leshko, "Klimt, Kokoschka und die mykenischen Funde," *Mitteilungen der Österreichischen Galerie*, vol. 13, 1969, pp. 16–40.

63 Alois Riegl, *Problems of Style: Foundations for a History of Ornament*, trans. Evelyn Kain (Princeton, NJ: Princeton University Press, 1992), especially pp. 4, 21–23, 229. Warlick, "Mythic Rebirth in Gustav Klimt's Stoclet Frieze," following Leshko, "Klimt, Kokoschka und die mykenischen Funde," also posits the influence of Riegl on Klimt. According to Wolfgang Kemp in his introduction to Riegl, *The Group Portraiture of Holland* (Los Angeles: Getty Research Institute for the History of Art and the Humanities, 1999), p. 21, Riegl backed Klimt's supporters at the university (where he taught from 1897 to 1905) by writing a professional opinion, but only after some hesitation.

64 Comini, *Gustav Klimt*, p. 23. As Comini has shown, the background of *Judith I* is based on the Assyrian palace relief of Sennacherib.

65 See Natter and Frodl, *Klimt's Women*, pp. 146–47. The portrait of Amalie Zuckerkandl remained unfinished, though the artist was paid for it. Amalie converted to Judaism when she married Otto Zuckerkandl in 1895; they divorced in 1919. Klimt had also painted the *Portrait of Paula Zuckerkandl*, the wife of Victor, in 1912. See Novotny and Dobai, *Gustav Klimt*, nos. 213 and 188. Otto and Paula Zuckerkandl remained childless, and both died in 1927. The portrait of Paula, left in storage in Berlin, was likely destroyed during World War II with the Allied bombing. Another sister-in-law of Berta's, Amalie Redlich, who was the sister of Emil, Otto, and Victor, was deported with her daughter Mathilde Jorisch to Lodz in 1941. See Sophie Lillie, *Was einmal war: Handbuch der enteigneten Kunstsammlungen Wiens* (Vienna: Czernin, 2003), pp. 920 and 1258.

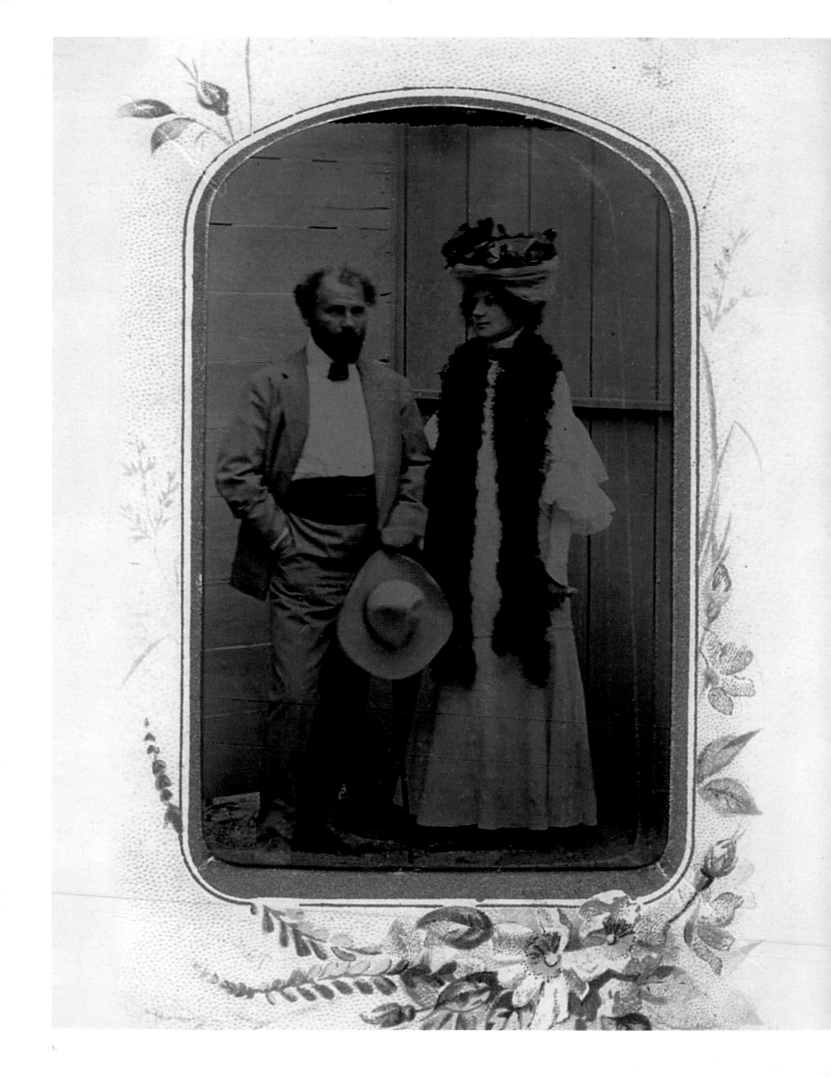

JANIS STAGGS

"Dear Midi": Gustav Klimt and Emilie Flöge

And now dear Midi again the most heartfelt things from your GUSTAV.
March 5, 1909[1]

"Send for Emilie"—these are the words Gustav Klimt uttered when he suffered a stroke in January 1918. That request has become almost legendary, and has led many to speculate about the nature of his relationship with Emilie Flöge.[2] Although both Klimt and Flöge led extremely private lives, and exposed little about their inner emotions to the world, there are clues—photographs from their shared vacations, gifts they exchanged, correspondences, and Klimt's portraits of Flöge—with which we may attempt to reconstruct and consider the intriguing bond between them. Over the course of some twenty-seven years, their friendship, which began when Flöge was only seventeen and Klimt was twenty-nine, evolved from a quickly lit mutual infatuation to a close and profoundly respectful partnership [Fig. 1].

Flöge's estate was acquired in 1983 by art historian and dealer Wolfgang Georg Fischer, whose documentation of its contents (published in 1987) shed much light on the mystery of the Klimt-Flöge relationship. The estate contained Wiener Werkstätte jewelry and objects, an extensive textile collection, photographs, and nearly four hundred epistles from Klimt to Flöge, ranging in date from 1897 to 1917.[3] Surprisingly, no letters from Flöge to Klimt have surfaced.

Emilie Louise Flöge was born in Vienna on August 30, 1874, the fourth and last child of Hermann and Barbara Flöge.[4] Her father was a wood carver and manufacturer of meerschaum pipes. It is not clear how the Klimt and Flöge families met, but soon Klimt and his brother Ernst were employing the pretty Flöge sisters as models for one of their paintings in Vienna's Burgtheater. The ties between the Flöge and Klimt families were solidified when Emilie's sister Helene married Ernst in 1891. Gustav and Emilie had certainly met by the time of the wedding. Despite the twelve-year age difference, they recognized each other as kindred spirits, and a platonic friendship was soon established between them.

1. Gustav Klimt and Emilie Flöge, ca. 1905. Photographer unknown. Courtesy Wolfgang Georg Fischer Archive

2. Letter from Gustav Klimt to "Liebe Midi!" (Emilie Flöge), May 29, 1897. Leopold Collection Vienna, courtesy Im Kinsky, Vienna

A card from Klimt to Flöge, the earliest correspondence between them that survives, refers to their first known connection in public—attending French language lessons together. Klimt regretfully missed a lesson on April 14, 1897: "Dear Emilie! It is unfortunately impossible for me to go class today, you will have to show off your wisdom alone, repeat, according to best lack of knowledge with the Fräulein, may she have forbearance with me and grant me kind forgiveness. Best wishes, Gust."[5]

Later that same spring (just weeks after the founding of the Vienna Secession, of which Klimt was president), he traveled to Munich and stayed at the Hotel Leinfelder. From there, the artist wrote to Flöge. This letter of late May 1897, which is of particular interest in the study of their evolving relationship, came to light only in May 2000, when it was offered for auction in Vienna as an article from the Flöge estate.[6] Klimt used the hotel's stationary, and personalized his missive with a flourish—sketching a heart fluttering on a pair of wings [Fig. 2]. This is the first documented time that Gustav refers in writing to Emilie as "Liebe Midi!"[7] The letter is fairly brief, and he apologizes for not writing sooner (as an aside, he notes being disturbed by a waiter who was inserting newspapers into their holders). He expresses his pleasure at the anticipation of returning home. Klimt's closing words provide an illuminating surprise: "Reunion with my heart and now beautiful dear Miderl a long kiss."

Flöge was twenty-two at the time she received this letter. Hansjörg Krug surmises that Klimt's yearning tone and the allusion to the "long kiss" are proof of a romantic liaison between them. Krug also points out that the letter was not addressed directly to Emilie and sent to the Flöge home, but was instead sent *postlagernd*, meaning that it had to be retrieved from the post office, and was directed to "Helene Kraus"—perhaps a pseudonym for Emilie, or a trusted friend who protected the secret affair between Gustav and Emilie.

Only some of Klimt's postcards and letters to Flöge are known to survive. Helene Donner (née Klimt, Emilie's niece) has claimed that her aunt Emilie "burnt two laundry-baskets full" of correspondence from Klimt.[8] The letters and cards that were shared by the family from Emilie's estate in 1983 were initially met by scholars with some disappointment; most of them read like rather mundane entries in a diary—discussions of the weather, health, travel, concerts attended, work-related matters, and other day-to-day concerns.[9] The letter of May 1897, which came to light some seventeen years after the first trove of holdings from Flöge's estate, suggests that there may be further material yet to be discovered.[10] Still, even without incontrovertible evidence of a love affair, the notes and letters of Flöge's estate that have appeared yield some very revealing information if they are read carefully.

On July 7, 1908, Klimt sent Flöge three postcards. This was not unusual for him (nor for the era); he often sent multiple cards in one day. (Klimt did not acquire a telephone until 1912; he trusted the efficiency of the Austro-Hungarian postal system to help him maintain contact with Emilie.) The third card of this day in July showed a Wiener Werkstätte design depicting a willow tree covered with hearts. In his note, he refers to a letter from Flöge, complaining that it was not a pleasure to read, and that it left many things unsaid. Somewhat perplexingly, he requests an explanation for the "lack of flowers."[11] He then changes the subject abruptly, announcing his imminent departure for Munich [Fig. 3].

The reference to the "lack of flowers" and the suggestive image—the tree with countless hearts—carry symbolic weight, strongly indicating a romantic tie between the couple. This card raises many questions. What might have provoked Klimt's gentle complaint? The note seems to demonstrate that Flöge was no longer a mere "Fräulein" in his eyes, but a woman to be respected and who had a certain power over him. The very next day he sent another card, begging her to be a little more friendly in her next letter.[12]

Less than a year later, in March 1909, Flöge traveled to Paris to attend fashion shows and pay visits to the major couture houses. Klimt apparently missed her terribly while she was away. On March 5, he sent her four pieces of correspondence. His first card is cheerful, mentioning the weather: "Cold. Winter—deep snow—everything amazingly white!—Our spring is waiting for you. ..." By his third card, prosaic details of daily life have crept in, and he is amusingly frank: "Today very hungry." For his final thoughts of the day, Klimt wrote Flöge a long letter—the second documented time he addressed her as "Liebe Midi!" In this letter, Klimt sympathizes with her about the bad weather, and explains that he is unable to join her in Paris because his health has not been good. He emphasizes his fond feelings for her, calling her "Liebe Midi" several times throughout the letter. Near the end, he pointedly asks: "You haven't really said anything about your travels—no adventures ... or weren't there any adventures?"[13] Klimt's prod had the desired effect: Flöge responded promptly. A surviving reply card from Klimt, dated March 9, expressed his "pleasure at receiving her sweet letter, which revived [him] very, very much!"[14]

Later that year, Klimt took a trip to Spain. In his postcard of November 1 to Flöge, he mentions that he dreamed of her, and creates playful variants of her nickname, sounding almost lovesick: "I'm looking forward right royally to my dear silly Midelinchen, Midessa, etc.—perhaps she'll come to the station. ... I dreamed of her on my first and last nights in Spain."[15]

Because Gustav's "Midi" purportedly purged all written evidence of a shared passion, any conjecture of a liaison between the two is speculative. In the context of Viennese society, the couple projected an image of unimpeachable propriety.

3. Recto of Wiener Werkstätte postcard (design no. 69) from Gustav Klimt to Emilie Flöge, sent July 7, 1908

8. 9.

creation of this portrait. The stunning gown she wears in the painting has often been labeled an example of *Reformkleider*, of the type that Flöge herself might have created. The upper portion is evocative of the fitted boleros she designed and often wore, as can be seen in several extant photographs [Figs. 8, 9]. The painting is encrusted with precious materials: Flöge's sheath is crafted with lapis lazuli, and a delicate tracery of spirals runs the length of her body. Delicate gold and silver touches provide a balance to the dominant dark hue. Her pose is confident, one hand on her hip—like a model on a runway, showing this fabulous dress design to its best advantage. Yet her candid expression and flushed cheeks are the giveaways that she is no professional mannequin, and the indistinct, diffused background places her in a fantasy realm. The ornamental halo surrounding Flöge's coiffure gives her the aura of an iconic figure.

Klimt painted this extraordinary garment with a chief aim of flattering his sitter. Her close-fitting sheath dress, as envisioned by Klimt, is a conflation of the avant-garde styles of the day and historical precedents. The long sleeves, which balloon at her elbows, are associated with the radical *Reformkleider*, a hallmark of which was a new freedom of movement. But the dress also echoes the close-fitting gowns worn by Egyptian women, which hugged feminine curves. These were often elaborately decorated, and were supported with wide shoulder straps that extended to just beneath the bodice. Broad necklaces that covered the breasts, or pectorals, were often added for adornment. Flöge's gown recalls the overall concept of these ancient prototypes, and her decorative bodice is a refinement of the Egyptian pectoral, as bejeweled as the textile of her dress.

Klimt's interest in ancient Egypt extended back at least to the period when he and Emilie met. In 1890, he was assigned to create a spandrel on the subject of Egypt for the ceiling of Vienna's Kunsthistorisches Museum, and undoubtedly studied pieces in the museum's collection to ensure the historical accuracy of his work. The finished painting bears some resemblance to a sarcophagus made for the goddess Isis, from the time of Egypt's twenty-first dynasty (ca. 1000 BC) [Fig.10]. The dress of the figure on this spandrel is similar to that in the Flöge portrait, but with a slight variation—vulture's wings are gently wrapped around this figure's lower legs—a motif associated with Isis and royalty.

Some scholars have suggested a link between Klimt and Flöge and the ancient myth of Osiris and Isis,[24] and indeed there are a number of parallels between the two couples. Isis was the wife of Osiris, and also his sister; Klimt and Flöge were close companions, and they were also brother- and sister-in-law. In the ancient story, Osiris is murdered by his brother, Seth; Isis then gathers Osiris's remains and prepares them for a proper burial. Likewise, after Klimt's death, Flöge set aside a room where she preserved furniture and other articles from the artist's last studio, including a number of his drawings, and silk textiles he had collected from China and Japan. A guest who was privileged to enter this room referred to it as the "Klimt shrine, [Emilie's] holiest-of-holies."[25]

Klimt's 1902 portrait of Emilie must have had a very special and personal meaning for him. He signed it twice in the lower-right corner, in a style that is evocative of Japanese stencils. In the upper square signature box, he spelled out his full name and added the date; in the lower box, only his initials appear. This double signing may be linked to the Secession's fourteenth show, which opened in April 1902 and was devoted to Ludwig van Beethoven. The catalogue of that exhibition included reproductions of the participating artists' signets—all of which were enclosed within squares. (Many of Josef Hoffmann's early brooch designs were also square-shaped, and it is known that Flöge eventually owned a number of these square brooches. She usually wore them at her throat, like chokers—much the way Klimt has draped a square piece of the dress around her neck in the 1902 portrait.)

Evidently, this exquisite portrait of 1902 did not meet with Flöge's approval—and Klimt's mother did not care for it, either. The artist began negotiations with the Niederösterreichisches Landesmuseum (now the Wien Museum) for the sale of the painting in 1904. Perhaps he was reluctant to sell it: the price he set was very high—twelve thousand kronen, more than the entire annual budget of the museum.[26] But the acquisition was completed in 1908. Klimt mentioned the transaction in his correspondence to Flöge on three occasions. July 6, 1908: "Today you are 'sold off' or 'cashed in'—I got a telling-off from mother yesterday." Later that same day, he wrote again: "Mother is indignant and has ordered me to produce a new PORTRAIT as quickly as possible." The final reference to the

10. Detail of the sarcophagus for the goddess Isis, 21st Dynasty (1000 BC), presumed to be from Thebes. Kunsthistorisches Museum, Vienna

14. "Das Reformkleid," fashion designs by Schwestern Flöge. Published in *Hohe Warte*, 1905–06

15. Reception room at the Schwestern Flöge salon, showing fireplace designed by Koloman Moser for the Wiener Werkstätte, 1904. MAK—Austrian Museum of Applied Arts/Contemporary Art, Vienna

16. Reception room at the Schwestern Flöge salon, designed by Koloman Moser for the Wiener Werkstätte, 1904. Published in *Hohe Warte*, 1904–05

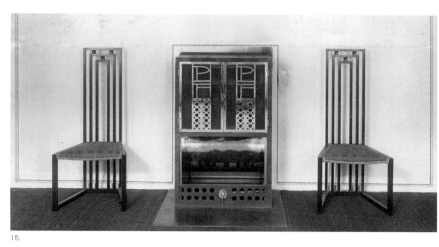

15.

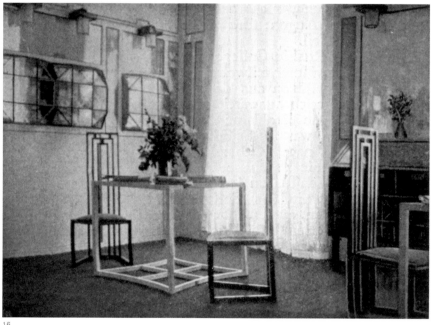

16.

reception room [Fig. 15]. That fireplace incorporated Pauline's initials, "PF," in a decorative metalwork grille, probably an acknowledgment to her as the founder of the business. Another advertisement in *Hohe Warte* [Fig. 16] provides a different view of the same reception room; it shows that a table and vitrine that were later placed in the salon were originally located here.[37] A closer view reveals that Wiener Werkstätte jewelry was displayed in this vitrine—the distinctive leather boxes are clearly visible [Fig. 17].[38] Emilie also featured her collection of folk textiles throughout the salon.[39] Their vibrant colors provided a sharp contrast to the black-and-white decorative spaces devised by Hoffmann and Moser.

In addition to the two pieces of furniture that remain—the table and vitrine, both by Moser—two mosaic plaques designed for Schwestern Flöge survive [Figs. 18, 19]. Both emphasize the name of the salon, in bold capital letters, in the same

17.

18.

19.

typeface used for the firm's logo on its stationery and garment labels. The smaller mosaic—with glass tesserae of deep blue, green, gold, and white—uses a similar palette to that of Klimt's 1902 portrait of Flöge. The pattern of juxtaposing triangles on the larger plaque recalls the boleros designed and worn by Emilie.[40]

Mirrors were naturally an important component in these spaces, for women's self-inspection in the latest fashions. The fitting room designed by Hoffmann featured large, adjustable mirrors [Fig. 20]. The salon was also outfitted with sophisticated lighting fixtures made by the Wiener Werkstätte—one photograph shows an example of a light on the floor in a fitting room. Six floor-level, bulb-fitted reflector lamps were made for the salon to ensure that the long hems of the gowns were perfectly tailored (like any artists, the sisters took the quality of their craft very seriously, down to the smallest detail).[41]

17. Reception room at the Schwestern Flöge salon, designed by Koloman Moser for the Wiener Werkstätte, 1904. This view shows a vitrine designed by Moser; inside it the tops of three leather boxes for Wiener Werkstätte jewelry can be seen. MAK—Austrian Museum of Applied Arts/Contemporary Art, Vienna

18. Mosaic sign of the Schwestern Flöge salon, probably designed by Koloman Moser and executed by Leopold Förstner, 1904. MAK—Austrian Museum of Applied Arts/Contemporary Art, Vienna

19. Mosaic sign of the Schwestern Flöge salon, probably designed by Koloman Moser and executed by Leopold Förstner, 1904. MAK—Austrian Museum of Applied Arts/Contemporary Art, Vienna

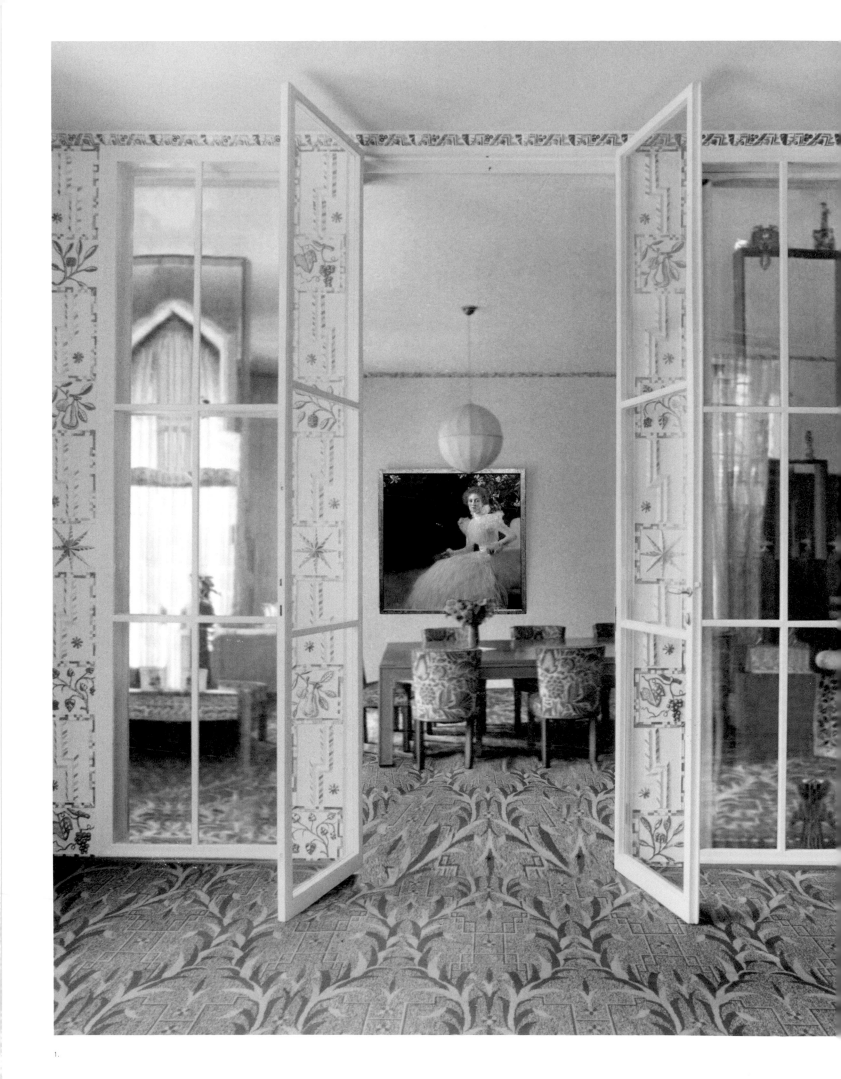

MANU VON MILLER

Embracing Modernism
Gustav Klimt and Sonja Knips

Rarely have the wealthy and bourgeois worked as directly with the local avant-garde as in Vienna at the turn of the twentieth century. The patronage of the arts in that era led to the construction of great art spaces in which the elegant furniture of Josef Hoffmann encountered the unique paintings of Gustav Klimt. It was a period when the rich and beautiful commissioned portraits from Klimt repeatedly, attended his exhibitions, and purchased his paintings on a regular basis.

Sonja Knips was one of several affluent members of Viennese society whose portrait was painted by Klimt; she also owned an apartment, a country house, and a villa—all built and decorated by Josef Hoffmann. But she stood out from other female art patrons of her time and place—such as Adele Bloch-Bauer, Serena Lederer, and Fritza Riedler, other women of the haute bourgeoisie who collected works of the Viennese Secession and the Wiener Werkstätte. Sonja Knips was the first woman to have her portrait painted by Klimt; she was one of the earliest supporters of the Wiener Werkstätte; and she fervently embraced the modernist idea of the arts and aesthetics permeating all aspects of life.[1] Recently published source materials from the collection of the Knips family reveal much about Sonja Knips, and shed light upon aspects of Klimt's life and person that were previously unknown.

Klimt's 1898 *Portrait of Sonja Knips* likewise contains hints about the life of the artist. It was his first portrait of a Viennese society woman—a woman with whom he had had an affair years before. The work represented an important turning point for the painter: with the *Portrait of Sonja Knips*, Klimt bade farewell to his previous artistic activity as a "decorative" painter and moved his art in a patently new direction. And the painter in turn had an enormous influence on Sonja Knips, who managed—largely through his influence—to break free of the rigid bourgeois conventions of her time, and to create her own highly personal approach to aesthetics and collecting.

2.

1. View of the dining room at the Villa Knips, showing Klimt's 1898 *Portrait of Sonja Knips*. Private Collection

2. *Sonja Knips (Standing Woman with Cape),* ca. 1887, pencil with white heightening. Private Collection, New York. This drawing appears in the checklist for this catalogue under a different title with a different date. See Cat. no. D20

THE ARTIST ENTERS SOCIETY

How did Klimt gain entrée to the circles of Viennese high society—contacts that enabled him to create paintings that today are considered the incunabula of Jugendstil portraiture? The artist was born in 1862, and grew up with six siblings in a very poor family. His father was a simple engraver, unable to feed his family adequately. At the age of twenty, Klimt and his brother Ernst, along with the painter Franz Matsch, founded an artists' workshop known as the Künstler-Compagnie (Artists' company); the commissions Klimt received through the organization provided some much-needed security for his family. He was invited to paint a massive mural for the ceiling of the staircase at Vienna's new Burgtheater (1886–88); the work earned Klimt the Imperial Golden Order of Merit and established his reputation as a brilliant portraitist.

Around this time, the artist encountered two women of Vienna's upper social echelons who would have a profound impact on his life: the young Alma Mahler-Werfel and the fashion designer Emilie Flöge. Alma, who was both beautiful and ambitious, met Klimt at the house of her stepfather, Carl Moll (Klimt's co-founder of the Secession). In her memoirs, Alma wrote that she was immediately infatuated with Klimt, who was similarly fascinated by this dynamic seventeen-year-old girl.[2]

The artist was linked to Emilie Flöge first through his brother Ernst, who married Emilie's sister Helene in 1891. Sadly, the marriage did not last long: Ernst died fifteen months later of pericarditis. Gustav's ties to the Flöge family were reinforced when he assumed guardianship of his brother's daughter, Helene. Emilie, a great admirer of Klimt's art, became both his muse and his longtime companion. Beginning in 1904, she and her sisters, Pauline and Helene, ran a successful fashion salon, known as the Schwestern Flöge, which was visited by many Viennese society women. It is not known to what extent Emilie may have encouraged her clients to patronize the artist, but it seems more than likely that certain of Klimt's portrait commissions may have resulted from this valuable contact.

It has not thus far been determined exactly when or how Klimt met Sonja Knips. We know from entries in her diary that she was a client of the Flöge fashion salon—but Klimt's portrait of her predates the opening of the fashion house by seven years. There is one drawing, however, that has enabled us at last to establish a much earlier point for their first meeting. It is now possible to say with certainty that Klimt must have been acquainted with Sonja by 1887—nearly a decade before he painted her portrait—when he was working on his painting *Auditorium in the Old Burgtheater* (Zuschauerraum im alten Burgtheater).[3]

Vienna's city council had commissioned Klimt and Matsch in 1887 to memorialize the auditorium of the old Burgtheater on Michaelerplatz, as the building was slated

for demolition. For his painting, Klimt chose a perspective from the stage, creating a perfect encapsulation of a night at the theater, the audience filled with the most important figures of the era in Viennese society. He apparently made preparatory sketches in the theater during actual performances and intermissions.[4]

One of these drawings, *Sonja Knips* (*Standing Woman with Cape, Seen from the Front*) [Fig. 2] is of particular salience with regard to the question of when Klimt first encountered Sonja Knips. There is notable disagreement among scholars as to the date of this drawing. The art historian Max Eisler dates the sketch to 1888 and sees it as a figure study for the interior of the Burgtheater.[5] But in the catalogue of a 1976 exhibition at the Museum Folkwang in Essen, the same drawing is associated with the auditorium of the theater in the Eszterházy Palace in Totis, Hungary, and is accordingly dated 1893.[6] Alice Strobl, editor of the catalogue raisonné of Klimt's drawings, proposes a date around 1896, citing the drawing's formal technique.[7] Strobl also connects this drawing with an oil portrait of a woman, published in the March 1898 edition of the journal *Ver Sacrum*—that painting, now thought to be lost, was dated 1897.[8] But—judging from the difference in age and facial physiognomy in the two depictions—it seems obvious that the drawing *Sonja Knips* cannot be a preparatory study for that oil portrait: the drawing shows a young girl, while the painting clearly depicts a middle-aged woman.

As other sketches for the Burgtheater were rendered with a very comparable loose cross-hatching technique, it is not unreasonable to assume that this drawing is likewise a preliminary study for the Burgtheater painting, and may be dated around 1887.[9] A comparison with the 1898 *Portrait of Sonja Knips* makes it clear that this sketch depicts the same woman, although at a younger age. The correspondences of physiognomy between the drawing and the painting—and with surviving photographs of Knips from the period around 1888—are unmistakable: the oval face, the almond-shaped eyes, the fine and accurately drawn eyebrows, the thin lips and determined gaze [Fig. 3]. All of these factors indicate compellingly that the depiction is indeed of Sonja—who at the time of the drawing would have been just fifteen years old.

SONJA POTIER DES ECHELLES

Sonja Freiin Potier des Echelles was born on December 2, 1873, in Lemberg (now L'viv), Galicia, where her father was stationed. Sonja, baptized Sophia Amalia Maria, was the eldest of three children. Hers was an old and respected Austrian family, with several Austrian officers among their numbers; a family tree traces their ancestors back to 1475. The Potiers were originally from Lorraine. After Sonja's grandfather, Leopold Potier, an Austrian officer, distinguished himself by his bravery in the battle of Saint-Julien and Les Echelles during the French-Austrian conflict, he was elevated to the rank of nobility with the title Freiherr Potier des Echelles, and was named a knight of the Austrian Imperial and Royal

3. Sonja Knips as a young girl (right) with her sister, Gisela, ca. 1888. Private Collection

Military Order of Maria Theresa. Sonja's father, Maximilian, served as Imperial and Royal Lieutenant General, and her brother, Egmont, would also pursue an officer's career.

The Potier des Echelles family was respected in society but far from wealthy. An officer's salary was just sufficient to educate Sonja in languages and piano—in the manner then traditional for respectable bourgeois girls—but it was not enough to ensure financial independence for Sonja, Egmont, and their sister Gisela. After her father died, the family had to survive on a modest pension. Sonja's mother insisted that she study for a career; she attended a teachers' seminary in Vienna and though she completed her training, she had no great desire to become a teacher. One viable alternative avenue of employment for a young girl who came from a good home but was not wealthy was to become a companion to a well-to-do elderly woman. Sonja took on just such a position, spending her afternoons reading aloud and keeping company at the Vienna home of Josefine Krassl-Traissenegg at Favoritengasse 20. It was at the Krassl home that she met her future husband, the industrial magnate Anton Knips. The Krassls, an old Viennese family, and the Knipses, whose ancestors had come from Saxony, were related and together ran the C. T. Petzold ironworks company in Neudeck, Bohemia. The firm had offices in Vienna, at Gumpendorferstrasse 15; this was the building into which Sonja and Anton moved after they were married.

Like many marriages of the period, Sonja's, which took place on February 15, 1896, was one of nobility paired with wealth. Seen from the outside, the match provided Sonja with everything that could be desired by a young woman of the day in Vienna: a large apartment; an affluent, upstanding husband (hence material security); and the increasing attention of Viennese society. But Sonja and Anton were a distinctly mismatched couple: he was an urban creature through and through, while Sonja preferred life on the more rural outskirts of the city. Anton was friendly, inconspicuous, and not greatly sophisticated—a businessman who lived primarily for his firm. He was not especially interested in his wife's activities: he shared neither her love of socializing nor her enthusiasm for modern art and young artists.

Anton appreciated the associated costs even less. Sonja's diary entries, and anecdotes that have been handed down, suggest that domestic bliss in the Knips household was often disturbed by Sonja's "cautiousness in financial matters," as she herself once ironically expressed it. Nevertheless, Sonja was always able to get her way in the end. Anton paid for various home renovations she demanded, and the elegant furniture for the apartment on Gumpendorferstrasse; he paid to build a country home with a boathouse in Seeboden, Carinthia, as well as a villa with furniture in Vienna. He also provided the financial means for Sonja's extravagant taste in clothes and her remarkable art collection. The couple remained married, despite their essential differences, until Anton's death in May 1946.

NOTES ON A FAN

By 1898, when Klimt created his *Portrait of Sonja Knips*, she and the painter had already been friends for some ten years. It had begun with the drawing for the Burgtheater, and blossomed at some point into an amorous relationship. How long the affair lasted is unknown, but the fact of Gustav and Sonja's romance is substantiated by notations on a paper fan found among Sonja Knips's personal effects [Fig. 4].

Evidently, in the tradition of the day, the fan had served Knips as a kind of poetry album.[10] The folded sheet in front is printed with a colorful chromolithograph. Amid dense foliage, bouquets of violets and lilacs, and a picture of a pair of lovers, there are cartouches that Sonja's friends and family filled with aphorisms, signatures, and dates. Klimt graced the fan himself by covering its back with a Persian poem, four lines from Goethe's romantic singspiel *Claudine von Villa Bella*,[11] and an illustration. The date of these writings is noted in his hand as January 3, 1895, a little more than a year before Sonja's marriage to Anton.

Klimt's biographers have described him as negligent in matters of correspondence. To his longtime companion Emilie Flöge, Klimt most often sent postcards, with brief and matter-of-fact messages. He wrote letters that were only slightly more forthcoming to Marie ("Mizzi") Zimmermann, with whom he spent more than three years of his life and who bore him two sons, Gustav and Otto.[12] The notations on Sonja's fan thus take on singular importance in several respects: both the length and the content of the messages make the fan a true rarity.

When open, the fan reveals a vertical rectangle within a gold ground; here Klimt transcribed in black letters a love poem by Hafez, whose erotic verses are considered to reflect the life of the senses. This particular poem is about a fisherwoman whose beauty serves as bait for hearts. In the adjacent narrow field on the fan, Klimt translated the poem into an illustration. In the lower third of this composition sits a young woman, wearing a white garment and a hat, holding a fishing pole in her hand. She has cast her hook into the sea—indicated by wavy lines—and is about to reel in little red hearts. The Goethe quotation next to the lines of the Persian poem concisely sums up the content of the tale, and transforms the fan into a love letter:

Liebe schwärmt auf allen Wegen;
Treue wohnt für sich allein.
Liebe kommt uns rasch entgegen;
aufgesucht will Treue sein.

Love moves in rapture on every path;
Fidelity keeps only to herself.

Love always comes rushing toward us;
Fidelity prefers to be sought out.

Klimt's decoration of the fan clearly reveals his deep affection for Sonja. The question is raised: did the couple ever consider marriage? Although oral tradition should of course be accepted with caution, the love affair between Klimt and Sonja is said to have ended because he was unwilling to marry her.[13] If this was the case, it may well have been because Klimt—who was a notorious womanizer—was also concerned that the binds of marriage and a family would restrict his artistic activities.

The fan seems to have served a dual function: it was at once a love note and a farewell. The date January 3, 1895, suggests that Klimt's notations on the fan were bringing an end to the liaison—Sonja would marry Anton Knips within the year. Interestingly, this was not the only case of Klimt ending a love affair through this unique epistolary medium: the artist is known to have given a fan to another lover as a farewell, this one inscribed with the succinct and unequivocal message: "Rather an end with horror than horror without end."[14]

The romance with Klimt gave Sonja's emotional equilibrium a jolt that would push her life in a different direction. Scarcely a year after her wedding, she sat for Klimt's portrait of her. It is hard to imagine that the painting could have been produced without their recent love affair being in the minds of both artist and sitter. She may have viewed the portrait as an enduring reminder of the relationship; it was noted by an acquaintance of Sonja's that even in her later years, her eyes would light up when she was asked about the history of the painting's creation.[15]

SYMPHONY IN PINK: THE PORTRAIT OF SONJA KNIPS

By the time Klimt painted the *Portrait of Sonja Knips* [Fig. 5], he had long since ceased to be an unknown. He was thirty-six, and could look back on fifteen years of activity, during which he had painted important murals in public buildings on Vienna's Ringstrasse and in theaters in and around Vienna. Indeed, this portrait marks a turning point from the theatrical paintings—which were largely influenced by classical Greek conventions and the work of Hans Makart—and a turn toward a heavily symbolic style. The portrait thus occupies a key position in Klimt's oeuvre, marking an end point to one phase and serving as a prelude to his famous series of depictions of Vienna's society women.

The *Portrait of Sonja Knips* was produced at a time during which Sigmund Freud was formulating his theory of the structure of drives in human behavior. What Freud discovered about the human psyche and the subconscious had an artistic counterpart in the decorative interactions of the human form with ornament in

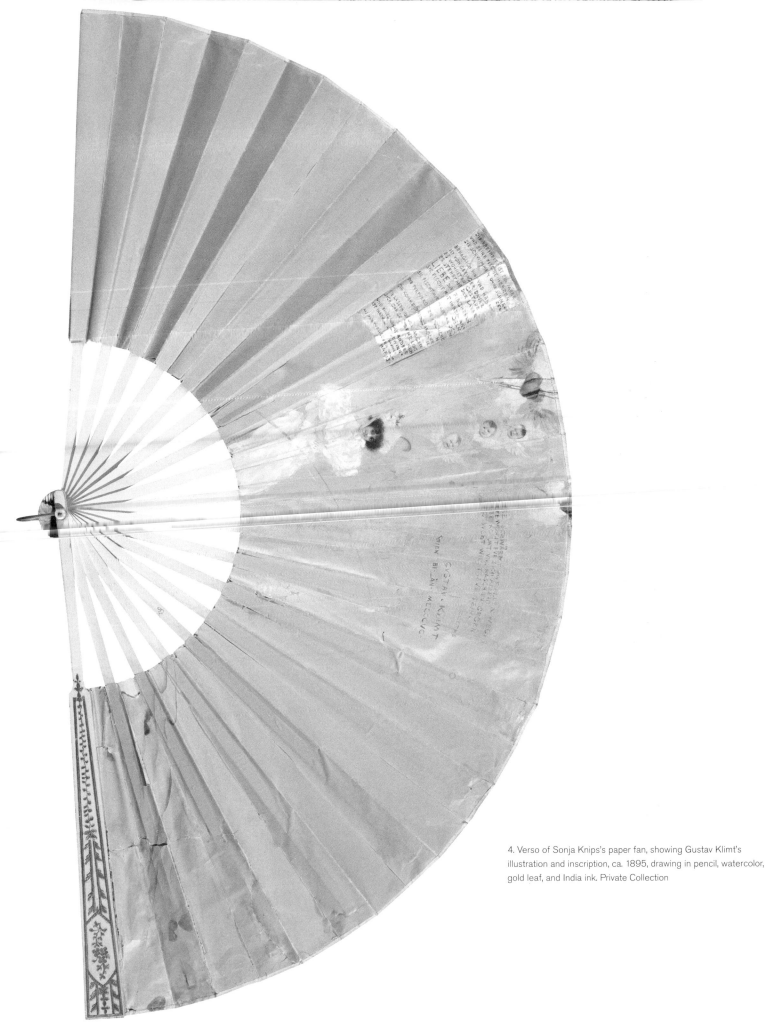

4. Verso of Sonja Knips's paper fan, showing Gustav Klimt's illustration and inscription, ca. 1895, drawing in pencil, watercolor, gold leaf, and India ink. Private Collection

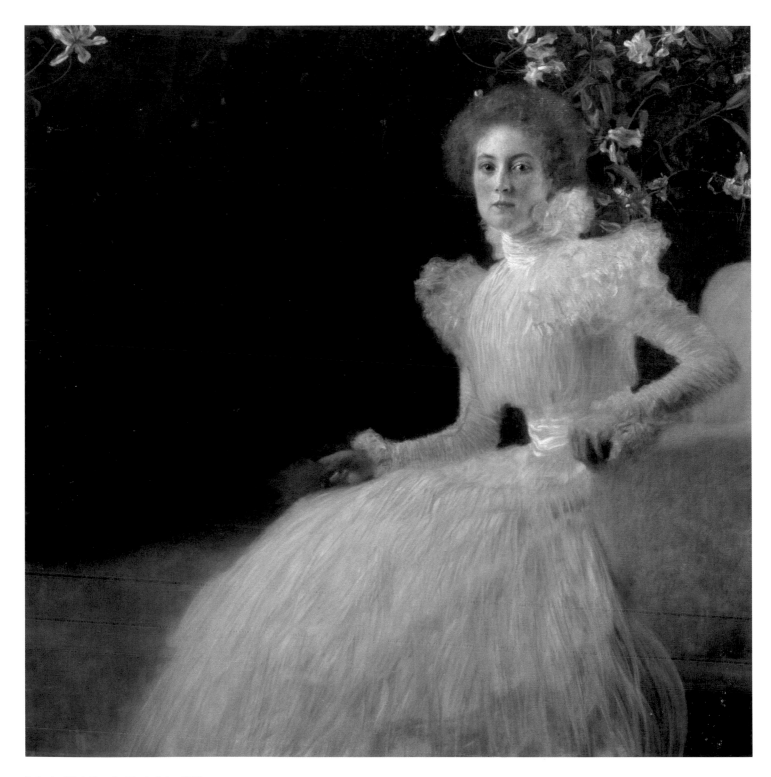

5. Gustav Klimt, *Portrait of Sonja Knips*, 1898,
oil on canvas. Österreichische Galerie Belvedere, Vienna

Klimt's later portraits. In the *Portrait of Sonja Knips*, Klimt placed a veil, or filter, between the visible world and the unconscious, bringing the sitter's psychological state to the fore in the erotic aspect of the painting. This was not the erotics of the typical fin-de-siècle *femme fatale*, but rather of a physically potent woman with great sensuous presence, as well as the freshness of youth—Sonja was at the time of the painting twenty-three years old.

Here, Klimt was formulating for the first time qualities that would be fully developed later, in his mature portrait style. He also combines in a masterly fashion the stylistic features of Impressionism and Japonisme with elements of the Pre-Raphaelites and Symbolists. Perhaps most notably, the *Portrait of Sonja Knips* has correspondences in style to the paintings of the American James McNeill Whistler, whose works Klimt knew primarily from reproductions in journals such as the *Studio* and the *Art Journal*.

Klimt shared with Whistler a penchant for elaborate and effective systems of decoration (consider Whistler's 1877–78 designs for the Peacock Room, and Klimt's mural paintings for the Palais Stoclet, 1905–11). They both had an abiding interest in Far Eastern arts, and were drawn toward creating a break from representational depiction and planar pictorial conventions. Aspects of music entered into the work of both painters (albeit in different ways), and the landscapes of both open up to become meditative spaces.[16] Klimt translated the vocabulary he had borrowed from the American painter into a highly personal lexicon—expressed above all in the effects of his subjects' clothing, an essential element in his oeuvre. Klimt's "white women" portraits—Serena Lederer (1899), Gertha Felsovanyi (1902), and Hermine Gallia (1903–04)—recall Whistler's depictions of girls dressed in white and surrounded by flowers, known as his *Symphonies in White* (painted between 1862 and 1873). We see particularly in Klimt's *Portrait of Margarethe Stonborough-Wittgenstein* (1905) to what extent he radicalized Whistler's approach. Airy fabric, with the most delicate nuances of color, has an almost ethereal legerity in Whistler's paintings. The American artist composed using shades of white that flow into one another, and a glaze-like application of paint, to produce likenesses that seem to capture the very essence of their sitters. In the Stonborough-Wittgenstein portrait, Klimt strove to create the transparency in which Thomas Zaunschirm has identified the artist's effort to come to terms with "erotic proximity and distance."[17] Although Klimt took great care in his painting to make the various fabrics of the dress seem transparent, the body is not visible beneath the gossamer-like fabric. In later paintings, by contrast, the garments of Klimt's subjects have a decorative function, "dissolving" materiality into an ornamental surface, and locking the sitters into the paintings' linear backgrounds. The women wearing these clothes are thus trapped, revealed as prisoners of an ossified social structure.

6.

7.

6. Gustav Klimt's sketchbook, given by the artist to Sonja Knips, 1897–1900. Österreichische Galerie Belvedere, Vienna

7. Gustav Klimt, ca. 1898. This photograph was inserted into the sketchbook given by Klimt to Sonja Knips, 1897–1900. Österreichische Galerie Belvedere, Vienna

8. Gustav Klimt, preparatory sketch for
Portrait of Sonja Knips, 1898, black chalk on paper.
Albertina, Vienna, Inv. no. 31.933

In addition to its painterly and formal aspects, details of form and content—such as the subject's seated posture, her facial expression, the small red sketchbook in her hand, and the diffuse background—give the painting a great and enigmatic charm. Moreover, the work alludes to the upheavals of the social position of women around the turn of the century, and at the same time illuminates the intimate relationship between painter and model.

One of the central impulses behind Klimt's *Portrait of Sonja Knips* is the idea of the *Gesamtkunstwerk*: the artisanship of the frame is bound inseparably to the painting; the whole is intended to illustrate the synthesis of the fine and applied arts. Klimt entrusted his brother Georg, a goldsmith, with the task of making the frame. Georg applied rosettes and a thin leaf of matte gold imprinted with waves and spirals to the slender strips of stained wood.[18]

There are interesting parallels between this painting of Sonja Knips and Klimt's nature compositions—the square format being one of the most obvious. His landscapes often seem to be "excerpts," featuring neither sky nor horizon line. The painter located subjects for his nature scenes using optical aids, such as a telescope, opera glasses, or a "viewfinder"—a piece of cardboard punched with a hole.[19] It seems almost as if he had used some such optical procedure for his *Portrait of Sonja Knips* as well. Although the cameras of the time did not have zoom lenses, photographic magnification comes to mind when looking at the painting: Sonja, sitting in an armchair in the right half of the painting, seems to be "zoomed" in on, as if by a lens, while the artist has cut out everything in the composition that appeared superfluous. This impression is reinforced by the fact that, on one hand, the painting has pictorial space continuing outward on all sides, while on the other, the hem of her dress, the armchair, and the flowers are cut off.

With this artful composition, Klimt captured his subject at the point of rising from her seat—and on a larger level, on the verge of a more profound change. The painting not only illustrates Sonja Knips's vitality and youth, it also shows her readiness and determination to lead a life beyond the bourgeois order. At the time of the painting's creation, she was indeed gradually integrating into her everyday life the aesthetic and artistic concerns that Klimt advocated. She would soon rid the apartment where she lived with her husband of its heavy, dark furniture, to have the rooms redesigned by Hoffmann and the Wiener Werkstätte. Her later move from their shared apartment to a villa she had built on the outskirts of the city was further evidence of her unconventional lifestyle. By portraying Sonja Knips at this liminal instant, Klimt provides a clue that he was aware of her desire to pursue a freer and more modern way of living.

The *Portrait of Sonja Knips* has engendered much speculation among art historians on the nature of the relationship between Klimt and his subject; the discovery of Sonja Knips's paper fan allows us now to interpret it definitively as a love affair. The art dealer Christian M. Nebehay has viewed the little red book that she holds in the portrait as an indication that the two had a familiar relationship.[20] According to an earlier account by Sonja herself, Klimt gave her the sketchbook during the course of creating the painting, simply to provide a color accent that was lacking[21]—but she is holding a small book in several of the preliminary sketches for the portrait, and so Klimt's purportedly spontaneous idea of including this accessory in the painting is questionable.[22] That red sketchbook, bound in morocco leather, is said to have been given as a gift from Sonja to the artist, who then returned it filled with sketches.[23] It is known that, while it was in her possession, she kept a small photograph of Klimt in this sketchbook—this fact alone is enough to allow us to conclude that her relationship with the artist was more than just a social acquaintance [Figs. 6, 7].

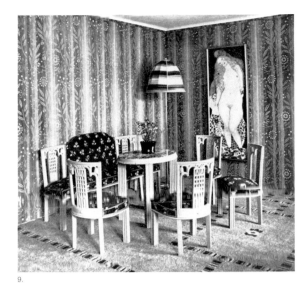
9.

10.

9. Small salon at the Villa Knips, showing Gustav Klimt's 1917–18 painting *Adam and Eve*. The fabric covering the suite furniture is Dagobert Peche's "Pappelrose" (Poplar rose). Reproduced in *Moderne Bauformen*, 1926

10. Josef Hoffmann–designed living room and study at the Knips apartment in Vienna, 1903. Reproduced in *Interieur*, 1903

15. Gown by the Wiener Werkstätte.
The fabric is Eduard Josef Wimmer-Wisgrill's "Ameise" (Ant).
Reproduced in *Photohand Mode*, 1911.
MAK—Austrian Museum of Applied Arts/Contemporary Art, Vienna

depiction of the life of human drives—lust, rage, and devotion—which runs like a thread through Klimt's work, is seen in a most elemental form in *Adam and Eve*. The pair are depicted as prototypes of the conflict between man and woman, at the mercy of their own perennially fraught emotions. Eve dominates the painting, displaying her naked shape seductively. She occupies a large part of the picture plane, obstructing our view of the body of the man sleeping behind her. A wildcat's pelt is spread out between the couple—the animal, associated with the Maenads of Greek mythology, symbolizes untamed Eros.[41] Perhaps Sonja saw an aspect of herself in this female nude, whose fine facial features evince both superiority and erotic suggestion.

Unlike Sonja Knips's portrait—for which (according to her diary) she commissioned Josef Hoffmann to "create a worthy space,"[42] and which occupied a central place in her villa later—the painting *Adam and Eve* was not intended for the eyes of her guests. It was hung in the small boudoir that adjoined to her bedroom; here, Sonja took care of her correspondence and private matters. In order to give this room an intimate character, Hoffmann took the step of combining many different patterns and colors [Fig. 9]. Although for viewers today (and for purists of interior design) this small, opulently decorated space may seem overly elaborate and busy, Hoffmann could not have hung the painting—with its iridescent shimmer of flesh tones—against a wall pattern with greater contrast and more tension. The small interior is, in the spirit of Charles Baudelaire's verse, a yearningly invoked realm of dreams, where "luxe, calme, et volupté" reign.[43]

SONJA KNIPS AND VIENNESE MODERNISM

When Sonja married Anton Knips, her life took a turn in the direction of this Baudelairean principle. She started her married life out by fulfilling society's expectations as a solicitous wife and mother (the couple had two sons, Rudolf and Herbert). Soon, however, she became an attentive observer of the Viennese art scene. In an interview late in her life she confessed that she had been no fan of lavish balls, but that she had often attended "the theater and concerts, but above all never missed an opening at the Secession."[44] Through Klimt, she met many proponents of the avant garde.

In Sonja Knips's effort to embrace the artistic trends of the time, she began to put into practice the doctrine (touted by Klimt) of filling her own quotidian world with elements of aesthetic and artistic value. After her marriage to Anton, the couple moved into the large apartment on Gumpendorferstrasse, across from the famous Café Sperl and not far from the Secession building. In keeping with typical bourgeois tastes of the day, the rooms were decorated with dark, massive furniture, heavy curtains, carpets, and tapestries. Sonja rejected the somberness of the apartment from the beginning: she wanted an exquisite, bright ambiance with modern furniture and colorful fabrics. She persuaded Anton that their home should

16.

17.

be "modernized," and in 1901 (thus before the founding of the Wiener Werkstätte) she commissioned thirty-one-year-old Hoffmann to handle the redesign. Her diary notes that she first saw works by the young architect and designer three years earlier, in 1898.

In order to make the costs for the renovation somewhat more acceptable to her husband—who considered this "modernization" to be both superfluous and too expensive—Sonja shrewdly planned for the work to be done in three phases. The construction of the "worthy space" for her portrait by Klimt came first, followed by the plan for a combination living room/study (this was featured in a 1903 issue of the well-known journal *Interieur*, as a showpiece of the new style of living).[45] Innovations included the strict articulation of walls and furniture, rooted in the basic geometric element of the square [Fig. 10].

The color scheme of the room was subdued and simple—gray, black, and white. Indeed, the only color accent in the room was the painting *Fruit Trees* (*Obstbäume*), which Klimt had painted while on holiday at Attersee in the summer of 1901.[46] The painting, with its square format, fit perfectly into the geometric pattern and chromatic tonality of the room. A landscape in autumnal afternoon

16. Wiener Werkstätte "Ameise" (Ant) fabric, by Eduard Josef Wimmer-Wisgrill, 1910–11. MAK— Austrian Museum of Applied Arts/Contemporary Art, Vienna

17. Sonja Knips in a silk *Reformkleid* by Salon Schwestern Flöge, 1905–06. Necklace by Koloman Moser, 1905. Private Collection

HANSJÖRG KRUG

Gustav Klimt's Last Notebook

A simple, melancholy, and yet sometimes cheerful, pleasure-loving person lives in the unadorned garden house, the scent of flowers outside, beautiful women inside—that is the milieu in which he lives, in which he works. Year in and year out he makes his morning pilgrimage by foot to Schönbrunn, enjoys his lavish breakfast at the Tivoli, and then strolls, with book in hand and his handsome apostle's head uncovered, bathing in the sun, back through the park to his studio, where he then works, without breaking for lunch, until the late evening.
—Carl Moll, 1928[1]

Two photographs taken around 1914 show Gustav Klimt, with his hat and a book in hand, on his way to or from the Meierei Tivoli café: one shows him next to one of the stone sphinxes of the old bridge over Grünbergstrasse, and in the other he is in the garden of the Meierei, sitting at a table with friends and reading a newspaper.[2]

The "unadorned garden house" refers to Klimt's last studio, at Feldmühlgasse 11 (formerly no. 9), where he worked in Unter-St. Veit from 1912 onward.[3] The "beautiful women" were Klimt's models, of whom Berta Zuckerkandl said that "there were always several of them waiting in the anteroom, so that he had a continuous and various supply of models available for the theme 'woman.'"[4] Franz Servaes commented on the "mysterious, naked women" who seemed to be part of the atmosphere of the place.[5] The studio was also described as "the painter's voluntary hermitage" that "friends rarely dared enter."[6]

Though little is known with certainty of Klimt's life, these anecdotes can be compared with entries in his 1917 notebook, the sole surviving notebook of the many he "seems to have kept regularly."[7] From this notebook, which reflects the reality of his daily life, as well as the entries on two written pages in his sketchbook of the same year,[8] twelve postcards he sent to Emilie Flöge,[9] two letters to Othmar Fritsch and Felix Albrecht Harta, and a page of notes,[10] probably recording a conversation with Josef Hoffmann about Klimt's participation in the

3.

1. Gustav Klimt walking over the Grünbergstrasse bridge by the sphinx sculpture, at Schloss Schönbrunn, 1914. Neue Galerie New York, Gift of C. M. Nebehay Antiquariat, Vienna

2. Gustav Klimt having breakfast in the garden of the Meierei Tivoli, Vienna, 1914. Neue Galerie New York, Gift of C. M. Nebehay Antiquariat, Vienna

3. Cover of Gustav Klimt's 1917 notebook. Neue Galerie New York, All photographs of the notebook by John Gilliland

Österreichische Kunstausstellung in Stockholm,[11] we know how much the artist earned that year and have a record of his daily movements, which cannot be said of any other year. This notebook, together with the sketchbook of that same year, are the only ones of many to have survived,[12] apart from an early sketchbook in the possession of Sonja Knips.[13]

Until recently, Klimt's 1917 notebook had not been examined. It is probable that the first mention of the notebook as containing "nothing revealing"[14]—a remark we now know to be inaccurate—explains this lack of investigation. Indeed, Klimt's handwriting is often almost illegible, his use of abbreviations extensive, and the entries are not obviously promising at first glance: this initial negative assessment is not surprising.

Klimt purchased the notebook at Josef Arazym's book and stationery store at Hietzinger Hauptstrasse 46, not far from his studio [Fig. 4].[15] It is bound in stiff black leather; the insides of both covers are lined with a patterned, linen-like paper; and the word "Agenda" is printed in white in the upper left corner of the front cover. [Figs. 3, 5].

This small detail must have pleased Klimt, as it is underlined with a dotted line that begins and ends in spirals—a small ornament that also occurs in the notebook itself[16] and, in many variations, in several of Klimt's paintings.[17] [Fig. 6]

The well-preserved notebook, 5⅓ inches tall and 3½ inches wide, consists of a title page ("Agenda") and 192 lined pages (each 5 by 3 inches) with printed dates, but not the days of the week, which Klimt nearly always added. Because the pages for the month of July were mistakenly bound in front of those for the month of June, Klimt usually corrected the printed names for the months June and July. His entries in black lead pencil, or occasionally in red or blue pencil, are found on the inside pages of the front and back flyleaves, on the title page, and on 338 of the 384 pages [Fig. 7].

Entered in the notebook are 1,598 names, nearly always with dates indicated, and twelve more or less factual notes:

> *Pechhütte* (inside front flyleaf); *Damen ver*(reist ?) (ladies departed ?) (February 11); *11 Kino* (11 am cinema) (April 19); *4 grossgrün/1 mal* (4 large green/1 time) (April 28); *morgen Sonn*(tag) (tomorrow Sun[day]) (May 12); *Wieden* (May 12); *männ*(licher)/*Amerikane*(r) (ma[le] America[n]) (June 2); *Land* (July 31); *Friede ?* (peace ?) (recto of the blank leaf following page September 30); *Werksta*(tt) /*Werkst*(att)/*Werk*(statt) (Work/Worksh/Worksh[op]) (October 20), (November 2), (November 12), (November 16), (November 19), (November 20), (November 22),

4. Josef Arazym's book and stationery store
Papierhandlung at Hietzinger Hauptstrasse 46, Vienna, 1935

(November 24), (November 26), (November 29), (December 3), (December 7), (December 11), (December 14), (December 17), (December 22); *Tuch gestohl*(en) (cloth stol[en]) (October 29); *Werkstatt abholen/Wipplin* (gerstrasse) (Workshop pick up/Wipplin[gerstrasse]) (November 6).

There are also notes associated with names: *Blo Hut/grüne Federn* (Blo hat/green feathers) (April 20); *Gib schicken* (Gib send) (May 11); *Bilderkauf Krizsek* (painting purchase Kriszek) (May 12); *Hen Ad schicken* (Hen Ad send) (May 12), *Hul Els Foto* (Hul Els photo) (May 22); *Tull männl*(ich) (Tull ma[le]) (June 9); *Schöm M/Mi Stammb*(uch) (Schöm family al[bum]) (July 5), (July 6), (July 10); *Schöm M Tel*[ephone] *171811* (October 8); *Görz Check/Scheck* (October 18), (October 31), (November 10); *Dry kurz* (Dry briefly) (October 26); *May abholen/Wipplin*(gerstrasse) (May pick up Wipplin[gerstrasse]) (November 6); *Wag Ber Werkstatt* (Wag Ber workshop) (November 29).

The 311 names mentioned identify 207 people, although this number is only approximate. The individual names cannot be attributed precisely given Klimt's habit of abbreviating them to two, three, or four letters, which he did not always apply consistently. The following names occur in full form: *Beer, Bauer, Beitel, Beran Brünn, Böhler, Böhm, Braun, Deutsch, Fuchs, Gluck, Görz, Graz, Gropius, Halban, Hanslik, Hauer, Heinr. Herrmann, Hulak, König, Gabrie*[le] *Kovacs, Krickl, Krizsek, Kutschera, Lederer, Mayer, Dr Mikes, Moll, Munk, Osterreicher, Paul Saboy, Jola. Sandheygl, Schreiber, Schreiner, Schwarz, Unger, Rudolph Weinhauser.* For fourteen names Klimt also noted addresses.

The notes *1 time, 2 times, 3 times, 4 times, 5 times, 6 times, 6½ times, 7 times, 8 times,* and *9 times* are found next to thirty-eight names, and Klimt indicated sums between 2 and 148 kronen as payments next to sixty names; only the names *Mar* and *Rid* have both payment and time remarks.

It is as yet unknown why Klimt added a cross (+) next to individual names between June 15 and July 11.

Klimt noted the names of 207 people in all, who were in his studio on 245 weekdays at certain times between 9, 9:30, or 10 in the morning and 6 in the late afternoon and on forty-one Sundays and three holidays around 3:30 in the afternoon; there is only one entry after 6 pm (June 8: *Gis 7:30*). Eighty-three people were in the studio once, fifty-three were there over two to five days, sixteen over six to ten days, thirty-three over eleven to twenty days, thirteen over twenty-one to thirty days, and nine were there more than thirty days over the course of the year. Of these 207 people, only a few can be identified, whether their names were written out or abbreviated, but it is reasonable to assume that those who were in

5.

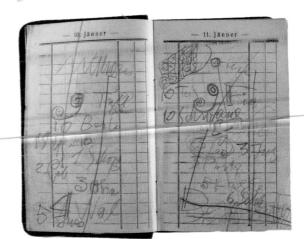

6.

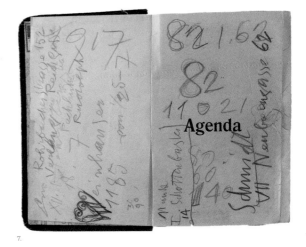

7.

5. Gustav Klimt's 1917 notebook, inside cover with Arazym label

6. Gustav Klimt's 1917 notebook, pages for January 10 and 11

7. Gustav Klimt's 1917 notebook, "Agenda" page

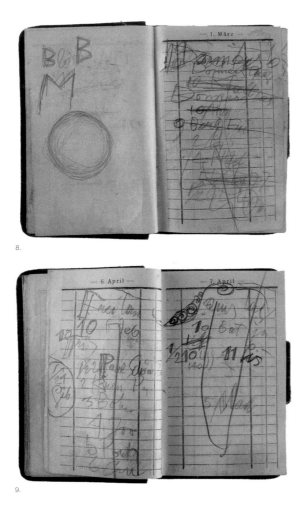

8.

9.

8. Gustav Klimt's 1917 notebook, page for March 1

9. Gustav Klimt's 1917 notebook, pages for April 6 and 7

his studio for more than twenty days of the year were Klimt's models: *Bauer* (25), *Berl Fri/Fritz* (21), *Dry* (28), *Dry sen* (23), *Gis* (24), *Gos* (39), *Hed* (28), *Hul Els* (28), *Jus* (33), *Lu/Luc* (89), *Mar* (21), *May/Mayer* (48), *Paul* (39), *Hel Pork* (26), *Roy* (41), *Schrei/Schreiber* (23), *Sold/Sold Am* (23), *Stick* (21), *Tris* (36), *Uss* (75), and *Mar/Mary Veit* (30). With eighty-nine and seventy-five recorded visits, respectively, the models Lu/Luc and Uss were there most frequently. Of the forty-one visits by the model Roy, for example, only one—on April 4—was at 3:30 pm; all her other visits to his studio were in the morning at 9, 9:30, 10, 10:30, or 11 am. It is perhaps no coincidence that the 164 visits in all by the two models Lu/Luc and Uss roughly correspond to the seventy-three known drawings[18] for the painting *Adam and Eve* (*Adam und Eva*, 1917–18) and the "approximately 140 studies and sketches"[19] for the painting *The Bride* (*Die Braut*, 1917–18). The thirty-eight names with *times* noted and the sixty names for which *payments* are mentioned are also clearly those of models. However, these models, unlike those mentioned above, were in his studio infrequently; present perhaps one to three days a month. It is not absolutely clear what these *times* notes signify. For example, Klimt noted next to the name *Mar* on May 23: *9 times and 2 kr*[onen]; on October 30: *20 kr*[onen] *and 1 time*; on December 4 and 11: *8 eggs 20 k*[ronen] *5 times and 20 kr*[onen] *8 eggs 6 times*, which perhaps is supposed to mean that he paid the model Mar nine, one, five, or six times or for nine, one, five, or six visits, and that he gave her moreover altogether sixty-two kronen and sixteen eggs. Presumably, therefore, these *times* indications have to do with Klimt's payments to his models. Further evidence of this is the fact that he noted *May even* on November 16, which surely means that he did not owe the model May any money. No system is evident in the sequences of payments, nor can we explain why Klimt wrote *I(ich) 4 or 5* (or 10, 20, 30, 100) *K*[ronen] next to seventeen payments (Feb 16 and 19; March 8; May 1, 5, 10, and 23; June 4, 9, and 12; July 9; Oct 16, 17, and 29/two times; Nov 1 and 26). It is striking that the *times* and *payments* notations are less frequent next to the names of the models who were in his studio most often: next to *Lu/Luc* (89), for example, there is just one payment of two kronen on June 19, and next to *Uss* (75) there are neither *times* nor *payments* notes. In 1917 Klimt paid forty-one models a total of 735 kronen.

The food shortages from which the vast majority of Vienna's population was suffering toward the end of the fourth year of World War I were presumably why Klimt gave the model Mar sixteen eggs along with a payment of forty kronen (December 4 and 11). In December 1917 eggs were very valuable. On October 21 of that year Arthur Schnitzler wrote in his diary: "Another year of war—and the misery is becoming so unspeakable that it is almost unimaginable today."[20]

The people listed in the notebook who can be identified, either with certainty or more speculatively, are listed here in alphabetical order.

Beer Place II 1810/VI Laimgruben 4/door 10 (inside back flyleaf): **FRIEDERIKE MARIA BEER** (b. 1891, d. 1980). Klimt noted a telephone number and an address, though one that does not appear in *Lehmann's Allgemeiner Wohnungs-Anzeiger* for 1917. It is also worth noting that the address of Beer's mother, Isabella Beer, who owned the Kaiserbar at Krugerstrasse 3, is not listed there either; probably Beer was subletting at Laimgrubengasse 4. From 1907 on she was friends with Hans Böhler, who lived in Vienna's fourth district, at Schwindgasse 16, and had his studio in Vienna's sixth district, at Linke Wienzeile 52, which was quite close to the Laimgrubengasse. The portrait of her that Klimt painted in 1915–16 was paid for by Böhler.[21]

Beran Brno (March 6): **ALOIS BERAN**, owner of the cloth and wool-goods factory Moritz Berans Söhne in Brno, a *kaiserlich königlicher Kommerzialrat* (an imperial/royal title conferred on industrial magnates),[22] and father of the painter Bruno Beran (b. 1888, d. 1979),[23] who exhibited at the Galerie Miethke in December 1913[24] and was acquainted with Egon Schiele.[25] Alois Beran visited Klimt's studio on March 3 at 10:30 am; he paid four thousand kronen as a final payment for the landscape *Orchard with Roses* (*Obstgarten mit Rosen*),[26] noted in the list of receipts in the sketchbook from 1917: *March 6 landsc[ape] Beran fin[al] 4,000.*[27] This landscape, painted in 1911–12 and exhibited at the Deutsch-Böhmischer Kunstlerbund (German-Bohemian artists' association) in Prague in 1914, was not paid for by Beran until 1916 or 1917 [Fig. 10]. In some cases there were several years between the production and sale of Klimt's landscapes, which were rarely commissioned works. Beran must have known Klimt for some time. He also owned the painting *The Black Feather Hat* (*Lady with Feather Hat*) (*Der Schwarze Federhut*, 1910),[28] which was sold to Rudolf Kahler by the Galerie Miethke in November 1910;[29] it is not known, however, when Beran acquired this painting.

Bera/Beran (January 26, February 23, March 10, April 2, April 20, May 2, May 21, October 13, November 17, November 28, December 11): perhaps a model by the name of **BERANEK**, who also visited Egon Schiele sixteen times in 1918.[30] Klimt's entry of October 13 is also significant: *Bera 10 soap 1 time.*

Bloch B[auer] (verso of the blank leaf preceding March 1): presumably **ADELE BLOCH-BAUER** (b. 1881, d. 1925);[31] with its double *M* and sketched circle (or sphere?), this is a mysterious entry by Klimt [Fig. 8].

Böhler (inside back flyleaf): probably **HANS BÖHLER** (b. 1884, d. 1961), painter, draftsman, and graphic artist, and friend of Klimt's;[32] he owned the paintings *Schloss Kammer on the Attersee II* (*Schloss Kammer am Attersee II,* before 1910), *Death and Life* (*Tod und Leben*, 1908–15), and *Italian Garden Landscape* (*Italienische Gartenlandschaft,* 1917).[33]

10. Gustav Klimt, *Orchard with Roses,* 1912, oil on canvas. Private Collection

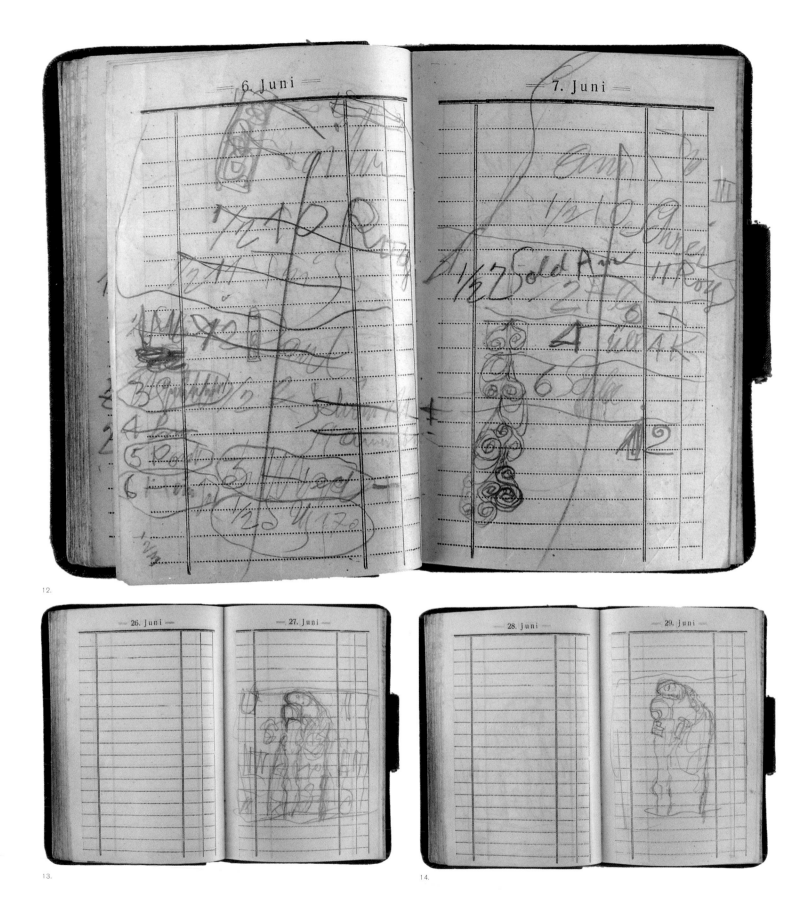

12.

13.

14.

GUSTAV KLIMT'S LAST NOTEBOOK

On the page for September 3 Klimt noted his monthly receipts from January to October: *Jan*[uary] *7100/Feb*[ruary] *1600/Mar*[ch] *12,000/April 765/May 12,200/June 6,400/July 13,000/August 0/Septem*[ber] *1,250/Octob*[er] *13,000/Novem*[ber]/*Dece*[mber]; the sum of 67,315 kronen corresponds approximately to the 68,135 kronen for the months from January to October in the list of receipts in the 1917 sketchbook;[114] only the figures for March and October differ (March: notebook 12,000/sketchbook 14,000; October: notebook 13,000/sketchbook 12,000). The sum of the receipts from January to December noted in the sketchbook is 84,715 kronen; together with several figures on another leaf of the 1917 sketchbook,[115] which are presumably primarily from the sale of drawings and are not included in the first list and which total 28,000 kronen, we find that Klimt's receipts for 1917 total 112,715 kronen.[116] The name *Gerstb*[auer][117] occurs twice next to single figures in the notes in the sketchbook; it is that of the Bank- und Wechselhaus M. Gerstbauer in Vienna's first district, at Kohlmarkt 9, second floor.[118]

The four drawings by Klimt in his notebook, of which Alice Strobl describes and illustrates just two in the catalogue raisonné of his drawings, are: a composition sketch for the painting *The Girlfriends* (*Die Freundinnen*, 1916–17);[119] a second composition, without accessory ornaments, for the same painting,[120] two sketches of an ornament (on one leaf) that is very similar to one in the sketchbook of 1917,[121] and the somewhat mysterious *Half-Length of a Figure Facing Right, Two Hands*. [Figs. 13, 14, 16].[122]

In addition to these four larger sketches, which correspond to the ones in the 1917 sketchbook, there are also three small sketches in the notebook[123] and numerous small ornaments and ornamental shapes, which frequently seem to be nothing but spontaneous doodling.[124] In addition, Klimt ornamented the vertical strokes of the large initial *D*'s of Tuesday (*Dienstag*) and Thursday (*Donnerstag*) more than thirty times within narrower and broader pairs of lines. He did the same, if less frequently, when the letters *B*, *F*, *H*, *M*, *P*, *S*, and *W* occur. [Figs. 12, 15, 17]

The numbers 4, 6, and 9 are often decorated with small ornaments or ornamental loops and spirals.

It would appear that Klimt also sketched when he wrote, that his hand was never at rest; when he crossed out entries and pages he did so with furious, nervous strokes, once so powerfully that he tore through the paper (May 13–14). That is striking, and it distinguishes Klimt's notebook from Schiele's of 1918, in which the meetings and visits are entered meticulously and cleanly in a beautiful, regular cursive hand.[125]

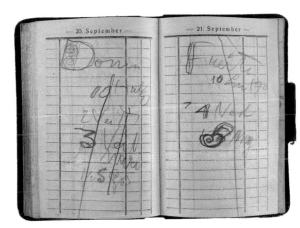

15.

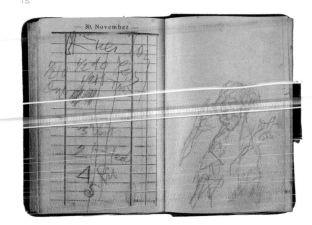

16.

12. Gustav Klimt's 1917 notebook, pages for July 6 and 7

13. Gustav Klimt's 1917 notebook, page for July 27

14. Gustav Klimt's 1917 notebook, page for July 29

15. Gustav Klimt's 1917 notebook, pages for September 20 and 21

16. Gustav Klimt's 1917 notebook, page for November 30

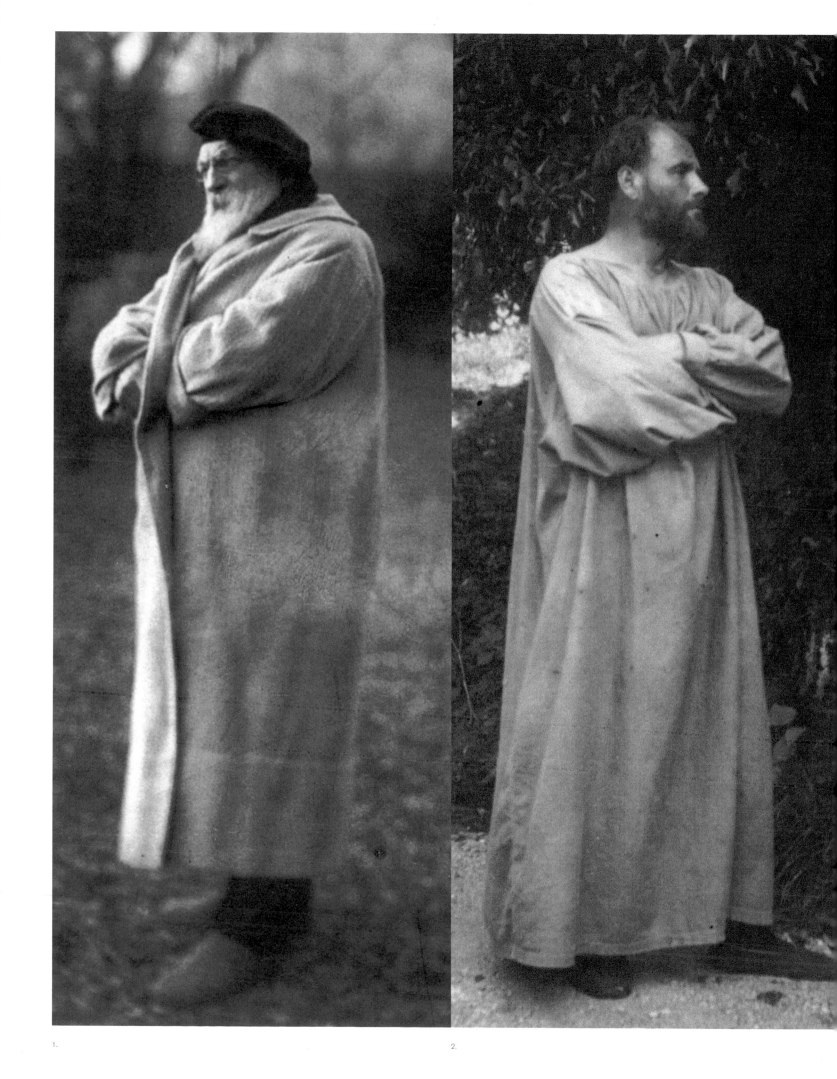

RENÉE PRICE

The Kiss: Gustav Klimt and Auguste Rodin

The will to tie all Viennese developments most significantly to each other and to the local conditions and traditions of the city risks reemploying an isolating provincialism. The vision of Viennese art that favors proximate contexts over larger ones, and immediate associations over broader judgments—that would pair Klimt with Freud to the exclusion of, say, Rodin—can share this risk.

Twenty years have passed since these insightful lines were written,[1] and yet in the two intervening decades, scholars have left the connections between the art of Gustav Klimt [Fig. 2] and that of Auguste Rodin [Fig. 1] largely unexplored. Klimt deeply admired Rodin, who was more than twenty years his elder, and whom he first met in June 1902. That summer, the French artist spent two days in Vienna after having visited Prague, where the second-largest exhibition ever held of his sculpture and drawings had been presented.[2] The Prague show was so enormously successful that it eclipsed the concurrent fourteenth exhibition of the Vienna Secession, dedicated to Ludwig van Beethoven, for which Klimt had designed his nearly one-hundred-foot-long *Beethoven Frieze* (*Beethovenfries*). During that brief stay in Vienna, Rodin paid his respects to the Secession's exhibition, at the focal point of which stood Max Klinger's sculpted monument to the great German composer. Shortly thereafter, Berta Zuckerkandl, journalist and *salonnière* of Viennese society,[3] introduced Rodin to Klimt, and translated the French master's remarks for the Austrian. When the two men met for tea in the Prater park, Rodin apparently said "a few polite words" about Klimt's *Beethoven Frieze*, but remained silent on the subject of Klinger's sculpture.[4] Certainly, however, the French artist would have been aware that the Viennese Secessionists viewed Klinger's polychromatic monument as superior to Rodin's own works.[5]

Although this was Rodin's first and only visit to Vienna, he was no stranger to the Austrian public. His ties to the Viennese art world were more than partly due to Klimt, who, along with the architect Josef Hoffmann and fellow painter Carl Moll,

1. Eugène Druet, *Auguste Rodin in the Pose of Balzac,* ca. 1914, platinum print. Los Angeles County Museum of Art, Gift of the B. Gerald Cantor Art Foundation

2. Gustav Klimt on the Attersee, ca. 1910, silver gelatin print. Courtesy Asenbaum Photo Archive, Vienna

3. "Rodin in Weimar" cartoon, as reproduced on the back cover of *Jugend*, issue no. 11, March 1906

had supervised the exhibitions at the Secession since its inception. They had elected Rodin a corresponding member at the start, and had invited him to participate in the very first Secession show; no fewer than twelve of his sculptures were presented in that 1898 exhibition. That same year—possibly on Klimt's recommendation—Rodin was also asked to participate in the *Jubiläums-Ausstellung* (Jubilee exhibition) in honor of Emperor Franz Josef held at the Urania, a center for adult education. The five sculptures shown there won Rodin a gold medal. In the following year, two Rodin sculptures were included in the fourth Secession exhibition. And the 1900 Secession show featured fourteen works by only three artists: Rodin, Klinger, and Giovanni Segantini. Rodin's most important presentation at the Vienna Secession took place in 1901: it featured at least fourteen sculptures—some of them monumental—as well as eight drawings. The sculptor's work was shown for the last time at the Secession in 1903. Klimt and eighteen of his followers resigned from the group in 1905, after internal tensions reached an untenable level.

Also in 1905, Klimt's nomination to become a professor at the Akademie der bildenden Künste (Academy of Fine Art) in Vienna was defeated for the second and final time.[6] As it happened, Rodin received an honorary doctorate at the University of Jena in the same year. Shortly thereafter—in the wake of an exhibition at the Museum für Kunst und Kunstgewerbe (Museum of Fine and Applied Arts) in Weimar (July 6–August 15, 1904)—the French artist donated fourteen drawings to the museum, dedicating them to the Grand Duke Wilhelm Ernst of Sachsen-Weimar. Harry Graf Kessler, the museum's director and a personal friend of Rodin's, installed them in a special exhibition room at the institution in January 1906. The drawings were not met with unequivocal praise: Hermann Behmer, a painter and professor in Weimar, soon launched a smear campaign against Rodin, complaining about the "lack of morality" in these "disgusting" French drawings of partly or completely nude women.[7]

Klimt, who in March 1906 was named an honorary member of the Königliche Bayerische Akademie der bildenden Künste (Royal Bavarian Academy of Fine Art) in Munich, must certainly have heard of this affair: the scandal led to Kessler's resignation from his post as museum director and was widely covered in the German-speaking press. By that spring, matters had escalated to the point that the well-known Munich art journal *Jugend* reproduced a large drawing by Paul Rieth in which Behmer can be seen throwing the contents of a chamber pot at Rodin's sculpture *The Kiss* (*Le Baiser*, 1885–98) [Fig. 3].[8] Undoubtedly Rieth's choice to illustrate this sculpture (which had not been exhibited in Rodin's Weimar show) was due to its critical and popular success.[9]

Klimt's seminal painting *The Kiss* (*Der Kuss*, 1907–08) was also an instant hit [Fig. 4]. Begun just a year after the height of the Rodin scandal in Weimar, it was

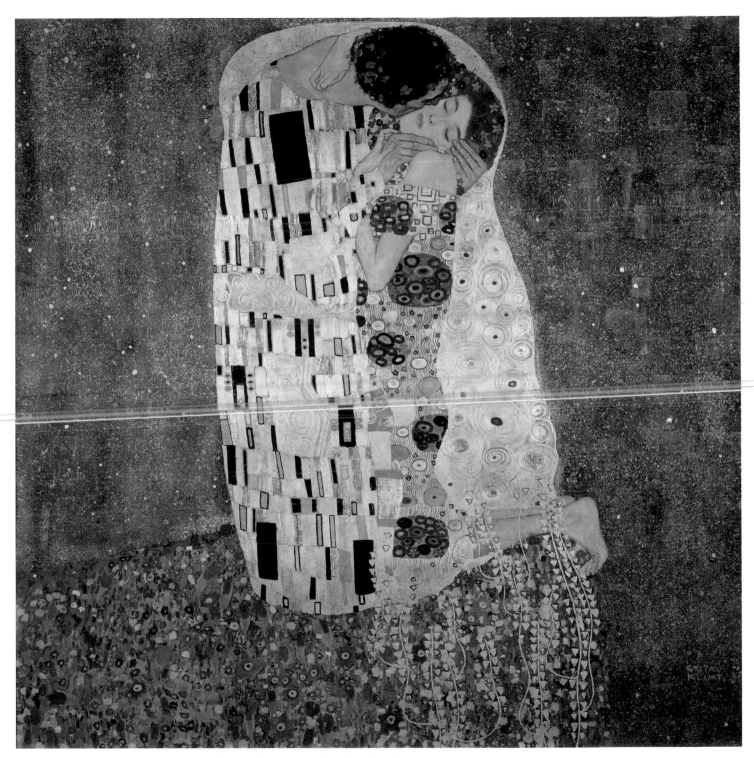

4. Gustav Klimt, *The Kiss*, 1907–08, oil on canvas. Courtesy Österreichische Galerie Belvedere, Vienna

acquired by the Österreichische Staatsgalerie after its first showing during May and June at the 1908 *Kunstschau*.

Rodin's powerful sculpture and Klimt's ethereal, golden canvas—two very different approaches to a single theme—are among the best-known works of art in the Western world, and are certainly the quintessential pieces associated by the public with each artist. The conjunctions between them are striking, and reveal a great deal about the artistic minds of these two masters.

A KISS

There are, of course, a number of formal parallels between the famous Rodin sculpture and Klimt's painting. Notably, in neither composition do the lovers actually kiss on the lips. A space of nearly four inches separates the lips of Rodin's passionate pair, and in Klimt's painting the male lover's lips are planted on the cheek of a dreaming woman's face (despite the fact that she is endowed with a full red mouth). Neither artist originally titled his work *The Kiss*. Klimt's painting was first exhibited in Room 22 at the Kunstschau as *Lovers* (*Liebespaar*); and the 1882 terracotta model that served as the basis for Rodin's monumental sculpture bore the name *Paolo and Francesca*.

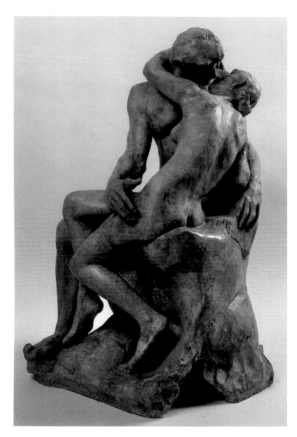

5. Auguste Rodin, *The Kiss*, ca. 1887, terracotta. Musée Rodin, Paris

Today it is seldom mentioned that not only this sculpture, but the sculptural environment for which it was originally intended—*The Gates of Hell* (*La Porte de l'Enfer*)—were inspired by Rodin's close study of Dante's *Inferno*.[10] Soon after completing *Paolo and Francesca*, however, Rodin decided to banish it from his *Gates,* replacing it with another, more tortured-looking pair. From the outset, Rodin's terracotta ca. 1887 [Fig. 5] rendering caused consternation for its exhibitors; it became, in fact, his most censored work. When the sculpture was shown for the first time, in 1887 at the Galerie Georges Petit in Paris, it brought about a wave of titillated gossip—engendered partly because it had been redubbed *The Kiss*. The only remaining indication that this was a portrayal of the tragic couple Paolo and Francesca—venerated in history and literature—is the half-opened book in Paolo's left hand at the sculpture's base. More than a few prudish viewers must have objected to this depiction of what appeared to be merely a contemporary pair of lovers.[11] *The Kiss*'s second presentation took place in 1893 at the Universal Exhibition in Chicago. There, it was hidden behind curtains like a peepshow, and only adult males were allowed to view it. It was not until 1898, when Rodin first exhibited a life-sized marble version of the work at the Société Nationale des Beaux-Arts in Paris, that *The Kiss* began to be greeted with great critical acclaim [Fig. 6].[12] Never before had the public been confronted with a rendering of such an ecstatic pair of full-sized lovers—presented naked and outdoors, seated on a rocky throne, they embrace and are just about to touch lips. The moment depicted is described by Dante in Canto V of the *Inferno*:

*On a day for dalliance we read the rhyme
Of Lancelot, how love had mastered him.
We were alone with innocence and dim time.*

*Pause after pause that high old story drew
Our eyes together while we blushed and paled;
But it was one soft passage overthrew*

*Our caution and our hearts. For when we read
How her fond smile was kissed by such a lover,
He who is one with me alive and dead*

*Breathed on my lips the tremor of his kiss.
That book, and he who wrote it, was a pander.
That day we read no further.*[13]

Although the story of Paolo and Francesca had interested artists for centuries, Rodin was the first to make the woman the initiator of their kiss.[14] Passionately pulling a hesitant Paolo toward her lips, this Francesca negates the idea of the book being to blame as "pander." But despite her hungry sensuality, this woman is no *femme fatale*. Instead, the sculpture subtly implies that the state of rapture she conveys to her more inhibited male partner is positive and simply natural. Indeed, Rodin denied that such works were erotic, stating: "I have never sought erotic motifs. I have represented two people in motion, in excitement, in battle, because I found the changing play of light and shadow on these forms beautiful."[15]

Klimt would likely have read a lengthy review of the 1899 Rodin exhibition in Amsterdam that was published in *Ver Sacrum,* the monthly journal of the Vienna Secession, in which the critic Oskar Fischel asserted: "One topic occupies [Rodin] foremost: 'the Kiss' … and his untiring fantasy for this subject."[16] This observation may have had a particular impact on the Austrian master; in his own oeuvre, the kiss motif began with the 1895 canvas with golden side panels, *Love* (*Liebe*), depicting a young couple in profile, eyes closed, in the instant before their lips join [Fig. 7]. He created a magnificent reiteration of the theme seven years later in the *Beethoven Frieze.* Here, an embracing full-figure couple enacts Friedrich Schiller's passage "Diesen Kuss der ganzen Welt" (This kiss for the whole world) from the poem "An die Freude" ("Ode to Joy"), to the music of Beethoven's Ninth Symphony, as the culminating point of the mural [Fig. 9]. The same subject reappears a final time in the stylized Palais Stoclet frieze, as *Fulfillment* (*Die Erfüllung*, 1908–10) [Fig. 8].

A VARIETY OF INFLUENCES

Like Rodin, Klimt had an abiding interest in the work of Dante. He is said to have habitually carried a copy of the *Divine Comedy* in his coat pocket, and to have

6. Exhibition of Auguste Rodin's *The Kiss*, marble, at the Salon de la Société Nationale des Beaux-Arts, Paris, 1898. Silver gelatin print by Eugène Druet

7. Gustav Klimt, *Love*, 1895, oil on canvas. Wien Museum, Vienna

8.

8. Gustav Klimt, *Fulfillment*, 1908–10, tempera, watercolor,
gold, silver, bronze, crayon, pencil, gold and silver leaf on paper.
MAK–Austrian Museum of Applied Arts/Contemporary Art, Vienna

9. Gustav Klimt, *Beethoven Frieze*, 1902, casein colors on a stucco
base with gold overlay, semiprecious stone inlay (detail). Courtesy
Österreichische Galerie Belvedere, Vienna

9.

recited lines from Dante while painting.[17] Nevertheless, apart from *The Kiss*'s
original title, *The Lovers*, nothing about Klimt's painting suggests a mutual, even
hesitant, desire to join sexually.[18]

The woman's closed eyes, the golden light, and the starlit sky point obliquely to
another literary source: the myth of Cupid and Psyche.[19] In Apuleius's *Golden Ass*,
the beautiful but unmarriageable Psyche is abandoned on a "precipitate
mountaintop" by her family; from here, as foretold, a "monster" is to take her as his
bride. Sometime thereafter, Psyche awakens to find herself "on flower-sprinkled
turf" near a palace. With a floor that is a "mosaic of gems" and "walls inlaid with
ingots of gold" the palace never grows dark, continuing instead to "exude
illumination." Cupid makes himself her husband, at first against Psyche's will.
Stealing to her bed only at night, he forbids her ever to see his face. Psyche falls
in love with him in spite of this, and describes Cupid as her "only light."[20]

Just as Rodin adapted Dante's tale to suit his own artistic purposes, Klimt seems
to have taken this part of the story of Cupid and Psyche as a starting point for his
Lovers (which would later become *The Kiss*). As in Apuleius's telling, Psyche is on
the cliff's "flower-sprinkled turf" where she has been deposited, and where she
awakes in a kind of golden shelter with Cupid—who remains invisible to her closed
eyes. Here the moment in time depicted seems to be their very first night together.

Coincidentally or not, a reproduction of Rodin's *Cupid and Psyche* (*Amour et
Psyche*, ca. 1905) appeared in 1907 in the journal *Jugend* [Fig. 10]. In Klimt's

painting, however, the couple is neither naked nor lying in bed, as they are in both Apuleius's tale and Rodin's rendering. Instead, in Klimt's painting, an immense ornamental robe completely obscures the body of the god: he seems to be all neck, cranium, and long, fine-boned fingers. The woman likewise wears a sumptuous gown, but hers is sufficiently snug to reveal the curve of her buttocks and her slender frame. Her face is tilted toward the viewer, yet it tells us nothing about her identity or her state of mind. Devoid of emotion, in the thrall of a sleep-like reverie, she seems sealed off from the world.

Although it has been argued otherwise, in this work the man neither forces the woman to her knees nor towers over her.[21] Rather, the proportions of the two figures in relation to one another suggest that both are kneeling. While the man genuflects with his body facing the viewer, the woman, kneeling against his left side, is seen with her body in profile. They may be naked beneath these robes, but the man and the woman do not seem to yearn for each other in quite the same way: the woman's apparent trance-like state indicates that she dwells in her head, not in her body; by contrast, the massive neck of the man as he leans his head toward her cheek conveys active masculine desire.

In Klimt's pair of lovers, it is thus the man rather than the woman who initiates the advance. But asleep or not, this woman—as in Rodin's sculpture—appears to be in command. She seems virtually indifferent to her partner's entreaty; like Rodin's Francesca, she is clearly stronger than her lover, who cautiously capitulates to his desire for her. Although her grasping left hand may suggest that she is teetering between accepting his embrace and resisting it, she remains firmly lodged on the flowery carpet that unfolds around her. Moreover, although she is poised on the edge of an abyss, she shows no sign of fear.

Klimt concealed the identity of both figures—but there are several indications that they may represent himself and his longtime companion, Emilie Flöge. A fashion designer and strong individualist, Flöge is said to have cultivated an intense but platonic[22] relationship with the artist, who was well known for creating hundreds of drawings of carnal depictions of women,[23] and was infamous for his many sexual conquests. As such, the painting may also connote Klimt's wish to enslave or "take possession" of this enlightened woman (as Cupid certainly does Psyche, until she finally opens her eyes). The artist himself purportedly had a thick, ox-like neck, as does the man in The Kiss,[24] and both figures are dressed in loose Reformkleider ("reform clothing"), a style designed and worn by Flöge and Klimt [Fig. 11]. Furthermore, it is known that a reproduction of The Kiss hung over Flöge's bed.[25] Ten years after beginning The Kiss, Klimt provided a scrap of possible evidence about the identity of the woman: in his 1917 notebook, he wrote the name "EMIL(I)E" along the left edge of a composition design for The Kiss [Fig. 12].[25] Encircled by an aureole of gold, amidst a blooming field of grass

10. Auguste Rodin, *Cupid and Psyche*, ca. 1905, marble, as illustrated in *Jugend*, issue no. 47, July 1907

11. Gustav Klimt and Emilie Flöge in a rowboat on the Attersee, 1910, silver gelatin print. Courtesy Asenbaum Photo Archive, Vienna

12. Gustav Klimt, 1917, sketchbook page (Strobl 3165). Private Collection

13. 14.

13. Auguste Rodin, *Man and His Thought*, ca. 1888, plaster. Rodin donation 1916, Musée Rodin, Paris

14. Auguste Rodin, *The Eternal Idol*, 1889, plaster. Rodin donation 1916, Musée Rodin, Paris

and flowers, the couple in this *Kiss* evokes a chaste love capable of bringing forth a host of higher rewards, not the least of which is the gift of art.

Rodin's *Kiss* was not the only one of his sculptures that may have had bearing on Klimt's work: the painter would have been able to consider a number of other works by the French master at many Vienna exhibitions. Rodin's desire to impart life to an inert substance is clearly seen in his sculpture *Man and His Thought* (*L'Homme et sa pensée*, ca. 1888) [Fig. 13]. Klimt was quite familiar with this piece: it had been among the five Rodin sculptures shown at the 1898 Jubilee exhibition in Vienna. In it, a kneeling man reverently places a kiss between the breasts of a young woman who is locked in the stone of a cliff. His arms cannot help him—they rest limply at his side; all of his concentration is focused on trying chastely to kiss his "thought" awake, as it is temporarily trapped in the block of stone that awaits his chisel. The same theme is seen in Rodin's *The Eternal Idol* (*L'Idol éternelle*, 1889) [Fig. 14], a work even more closely related to the iconography of Klimt's painting. Again we see a kneeling man placing a kiss on the breastbone of a female; here she, too, is on her knees—like the woman in Klimt's *Kiss*.

In both of these sculptures, the figures are posed on outcroppings of stone from which they seem to issue. The relationship of the figures to the ground in Klimt's *Kiss* is exactly the opposite: the sharp outline of their robes and the woman's legs

16.

hint that, although they are touching an earthly bed, their essence remains distinct from it; they seem on the verge of taking flight. This idea is again found in the iconography of Rodin's *Eternal Spring* (*l'Eternal Printemps*, 1884) [Fig. 15]; here, we see an agile young male kissing a kneeling woman in a natural setting. He has literally swept her off her feet. Sometimes titled *Zephyr and Earth*, or *Cupid and Psyche*, the depiction was well known by the turn of the twentieth century.

Klimt was in all likelihood very familiar with each of these sculptures. Both the 1898 and the 1901 Secession shows included photographs—a novel but practical method Rodin utilized to expand upon the exhibited works' meaning, as well as to present important pieces that were not included in the selection.[27] Even if *The Eternal Idol* and *Eternal Spring* were not among these images shown in the exhibitions, Klimt would surely have come across the former in Rainer Maria Rilke's book *Auguste Rodin*, which was first published in March 1903 and was reissued in 1907, the year Klimt began his *Kiss* [Fig. 16].

TELLING HANDS

In 1905, the art historian Paul Clemen published the first installment of a two-part article about Rodin in the widely read bimonthly journal *Die Kunst für Alle*;[28] It is very likely that Klimt saw this lavishly illustrated piece. (The same issue of the

15. Auguste Rodin, *Eternal Spring*, 1884, painted plaster, Rodin Museum, Philadelphia

16. Rainer Maria Rilke, 1906

periodical contained a review of the twenty-second Secession show, written by one of Klimt's staunchest advocates, Berta Zuckerkandl.) If he did read Clemen's article, Klimt would have discovered the most lengthy discussion yet to appear in print on Rodin's *The Kiss* and those works related to it—*The Eternal Idol, Man and His Thought, Eternal Spring, Fugitive Love* (*Fugit Amor*, 1895), and *Paolo and Francesca*. Fascinating to read, and clearly indebted to Rilke, Clemen's description of *The Eternal Idol* calls to mind several aspects of Klimt's *The Kiss*:

> There a woman stands, sunk in a dream. … This gripping sculpture has something of the sacred, of a great and chaste love; everything is suspended above the earthly. And what a deep insight into the night of love the artist allows us here to experience—even the one of the woman, who, wandering as in sleep, reveals the fervor of her devotion.[29]

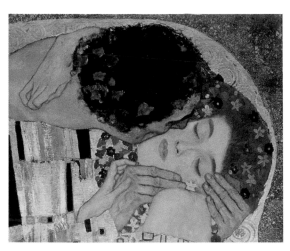

17. Gustav Klimt, *The Kiss*, 1907–08 (detail)

The closed eyes of the woman in *The Kiss* [Fig. 17] do indicate a kind of somnambulistic condition, and the artist has endeavored to evoke a glowing version of the nighttime in which love often unfolds. In both Rodin's sculpture and Klimt's painting, the two figures seem to be at once sleeping and exuding an intense energy. In Klimt's *Kiss*, the cell-like, organic shapes on the woman's robe reinforce this impression: like her charged but momentarily slumbering form, they seem just about to spring to life. Everywhere colors bloom around her; trails of golden-leafed vines are the only ties that bind her serene but vital body.

Gently, tenderly, the man holds his lover: her left hand tentatively clutches his right. Is she frightened and slightly resisting, or pulling him closer? With abandonment she allows her right arm to encircle his enormous neck. This right hand is nervously clutched: the fingers are held tightly together, concealing the fingertips.[30] The life of both figures in *The Kiss* is communicated in great part through the gestures of their hands—a fact that strongly suggests that Rodin was at the forefront of Klimt's mind as he was creating the painting.

As Rilke points out in the early pages of his text on Rodin:

> Rodin has made hands, independent, small hands which, without forming part of a body, are yet alive … hands in motion, sleeping hands and hands in the act of awakening. … Hands have a history of their own, they have indeed, their own civilization, their special beauty; we concede to them the right to have their own development, their own wishes, feelings, moods, and favorite occupations.[31]

We see all of this also in the hands of Klimt's lovers: they tell of myriad tasks and emotions, of wanting and hoping, of resisting and giving, hesitating and caressing. As a part of something greater, they also refer us back to the genesis of the theme of the embrace in Klimt's art.

THE KISS

18.

19.

20.

Klimt's earliest painting of this motif, his 1895 *Love*, owes little if anything to Rodin's oeuvre, but the French artist's influence is obvious in the pair of embracing lovers in Klimt's monumental *Philosophy* (*Philosophie*) of 1900–07 [Fig. 18]. This was one of three paintings, Klimt's largest official commission: the faculty paintings for the ceiling of the Great Hall of Vienna's new university. By the time he was conceiving these paintings and wrestling with the complexity of this commission, Klimt seems to have absorbed more than a little of the essence of Rodin's achievement. Shortly before Klimt completed the final sketches for three large works—*Philosophy*, along with *Medicine* and *Jurisprudence* (*Medizin*, 1901–07; *Jurisprudenz*, 1903–07)—the first article written in German about Rodin was published in the journal *Pan*. Penned by the renowned critic Roger Marx in 1897, it focused in part on Rodin's *Gates of Hell*, on which the artist had been toiling by then for some seventeen years. It may have been here that Klimt was reminded of Dante's importance to the French sculptor; it had been Rodin's idea to make a gate the starting point of his own *Inferno*. As Marx wrote:

> In the meanwhile nothing is more natural than the choice of such material, which corresponds to his epic inclinations and authorizes his conviction in representing human passion in its highest agitation … fists curl in on themselves, hands grapple crazily and faces are distorted; they destroy

18. Gustav Klimt, *Philosophy*, 1900–07, oil on canvas, ceiling panel created for the Great Hall of the University of Vienna; destroyed by fire in 1945

19. Rodin (right) with his study for Andrieu d'Andrès, from his 1889 *The Burghers of Calais* (with Jesse Lipscomb), 1887, albumen print. Private Collection

20. Auguste Rodin, *She Who Was Once the Helmet-Maker's Beautiful Wife*, 1889–90, bronze. Los Angeles County Museum of Art, Gift of Iris and B. Gerald Cantor

21.

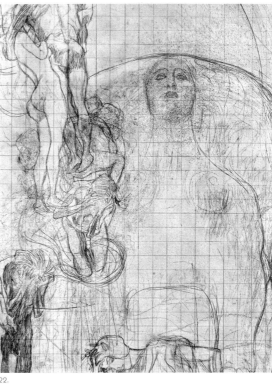

22.

21. Auguste Rodin, *Fugitive Love*, pre-1887 (this version), marble. Musée Rodin, Paris

22. Gustav Klimt, transfer-sketch study for *Philosophy*, 1898–99, black crayon and graphite. Wien Museum, Vienna

themselves, incapable of finding peace or happiness in love … and after the embrace are fed further upon the bitter rancor of their unfilled wishes.[31]

This is precisely the atmosphere that pervades Klimt's *Philosophy*. Consider the elderly naked male figure at the bottom of the composition, with his head in his hands; just above him a female, also covering her face, is caught in the grips of despair. This female's aging body calls to mind Rodin's *She Who Was Once the Helmet-Maker's Beautiful Wife* (*Celle qui fut la belle heaulmière*, 1889–90) [Fig. 20].[33] The cowering man resembles Andrieu d'Andrès in Rodin's *Burghers of Calais* (*Les Bourgeois de Calais*, 1889) [Fig. 19]. The French sculptor's characteristic genius in repeating figures, to emphasize their expressive pathos and to evoke multiple moments in time, seems to have caught Klimt's attention. In *Philosophy*, we see a similarity between the woman being embraced by the man at the painting's center and the female positioned just above her head; the coiffure of the standing figure looks very much like that of the woman who is falling. Is this not the *same* woman, seen from a variety of angles at different points in time? A tall column of twisting and turning human flesh dominates *Philosophy*; females and males come together—only to be moved apart. The image echoes the intertwined lovers of Rodin's *Fugitive Love* (*Fugit Amor*) [Fig. 21]. Exhibited at the Vienna Secession in 1898 (the same year during which Klimt was working on the preparatory sketches for the university panels), these two sculptures were surely known to Klimt. Both were conceived in connection with

The Gates of Hell, and are also related to Rodin's *Kiss*. (The female faun in *Sin*, who twines her body around the man, may in fact be the prototype for Francesca in Rodin's *Kiss*.)

Fugitive Love suggests the aftermath of that union: a pair with their backs to one another swirl endlessly in space, the man desperately stretching his arms out in a futile attempt to link up with the despairing woman.[34] Klimt seems to have at least looked closely at *Sin*, as is evident from the transfer sketch for *Philosophy* dated 1898–99 [Fig. 22]. Here, we see an interlocked couple at the center left of the composition—although in this pairing, it is not the woman who takes the initiative.

UNDER FIRE

The exhibition of Klimt's *Philosophy* at the Secession in the spring of 1900 unleashed a storm of debate. The work committed a number of heinous transgressions in the view of many: it did not include historical or literary references, and the composition contained overt nudity and depictions of imperfect bodies, along with unusual, sometimes downright strange perspectives. *Philosophy* was widely perceived as un-beautiful and non-idealized, and thus morally unacceptable. Eighty-seven professors at the University of Vienna signed a petition arguing that the work was unfit for the Great Hall.[35]

There was some vindication for Klimt: *Philosophy* was awarded the Grand Prix at the 1900 Paris World's Fair. He was thus admired abroad but sharply criticized at home. When *Medicine* was presented the next year at the Secession, an enormous fracas ensued: not just professors but now politicians condemned both paintings. Nevertheless, Klimt continued to paint, showing all three of his university paintings at the Secession between November and December of 1903 [Fig. 23]. Soon thereafter, the somewhat shell-shocked artist withdrew his application for the state commission. Not interested in having his paintings installed elsewhere, Klimt began to negotiate for their return.[36]

As all this was transpiring, Rodin's presence in German-speaking Europe reached a first high point. The opening of his large retrospective in Düsseldorf in May 1904 as part of the *Internationale Kunstausstellung* included 62 sculptures, 170 drawings, and a handful of photographs, displayed in a special pavilion devoted exclusively to Rodin's work.[37] *The Kiss* so impressed the young artist Wilhelm Lehmbruck that he wrote a long poem about it, titled "Vor Rodins *Kuss*" (Before Rodin's *Kiss*). Although Klimt would not have been familiar with the poem, he was most likely aware of the show's important catalogue. *The Kiss* was prominently featured, the first work illustrated in a section of the book titled "Die Plastik der Gegenwart" (Contemporary sculpture). The piece was described here as "a poem in marble," around which one had to walk in a circle in order to see its various perspectives in full. The catalogue's author lamented that younger artists were

23. The Secession's eighteenth exhibition,
1903–04, installation view showing the main hall, with
Klimt's *Medicine* and *Philosophy*

attempting to emulate Rodin's art without understanding its essence.[38] Reduced to a word, that "essence" is movement, a quality of Rodin's *Kiss* that Rilke had summed up just the year before:

> His point of departure is not the figures which embrace one another, he has no models, which he arranges and groups. He begins with surfaces where contact is strongest ... And so it comes about that in every part of these bodies we seem to gaze upon the ecstasy of the kiss.[39]

Interestingly, even Rilke seems to have forgotten that in Rodin's sculpture the lovers do not actually *kiss* (he seems to have relied primarily upon photographs to construct his brilliant text). It seems that no photographic angle can capture the distance between their lips. Only a firsthand look at the sculpture reveals what Francesca's shoulder denies to the camera's lens.[40]

The surfaces of such sculptures, the planes that seem almost to undulate, catching and refracting light and shade, gave several critics grist to attack Rodin's

works. In 1903, the same year in which Rilke's book first appeared, Ludwig Volkmann published one of the most enduring critiques of Rodin's sculpture in his book *Die Grenzen der Künste*. He wrote:

> Everyone is talking about Rodin today, and it takes some courage to speak about his style with anything other than unconditional approval, now that he has often been praised as if he were a prophet of a new era of sculpture. … If these works really do obtain their trembling life primarily from the atmosphere, it is by drawing on an unpredictable factor for their effect that lies outside of the artwork itself. … But these are sleights of hand that have nothing more to do with the plastic effect of the work's own form, and thus should be disdained as serious art.[41]

Paul Clemen's lengthy 1905 article was in part a retort to this critique. He argued: "[Rodin] did not want to include a rendering of the atmosphere itself, as one mistakenly has meant, but wanted to offer this atmosphere to play upon all sides of his figures. The classical example of this art is his *Kiss*."[42]

Given the mounting assault on his work in Vienna, Klimt may have been content that parallels between the iconography and style of his *Philosophy* and Rodin's work all but escaped critical notice. Indeed, the attacks against Klimt had reached such a proportion that by 1903 Fritz Waerndorfer—founder of the Wiener Werkstätte and a great champion of Klimt's work—and other Secessionists felt compelled to answer them.[43] They responded with impassioned statements—ranging from inane to hostile—collected and published as *Gegen Klimt* (*Against Klimt*) late in 1903, with a foreword by critic Hermann Bahr, one of the chief supporters of the Secession.

NEW PERSPECTIVES

Not long after, a group of twenty paintings by Edvard Munch was included in the nineteenth Secession exhibition (January–March 1904). Munch's 1897 painting *The Kiss* was not included in this exhibition (neither had it been present in his first showing with the Secession in 1901). Despite arguments to the contrary, Munch's *Kiss* seems to owe nothing to Rodin's sculpture of the same name.[44] His painted couple is standing, fully clothed, and in an interior setting—but more importantly, the image lacks any trace of the tender and protective gestures of the lovers in Rodin's sculpture. The same may be said about this painting's relationship to Klimt's *Kiss*, which seems to have no relation whatsoever with the apparent psychotic obsessiveness of Munch's couple.[45]

As it happened, in 1903 Dr. Max Linde, owner of the largest Rodin collection in Germany, commissioned Munch to make a series of engravings, the subject of which was to be his own house and sculpture garden. Klimt likely became aware

24. Edvard Munch, *Rodin's Faun*, as reproduced in
Kunst und Künstler, May 1904

of this in 1904, when a long article by Emil Heilbut about Linde's collection was published in the widely circulated artists' journal out of Berlin, *Kunst und Künstler*. Linde's Rodin collection was both illustrated and discussed in the article, which also included a reproduction of Munch's lithograph of a view into Linde's park, showing Rodin's *Kneeling Female Faun* (*Faunesse à genoux*, 1884) [Fig. 24]. This sculpture, too, would have been known to Klimt: it had been among the fourteen Rodin sculptures exhibited in 1901 at the Secession. As such, it seems likely that either this sensuous kneeling woman or those that Klimt knew from reproductions of Rodin's *Eternal Idol* or *Eternal Spring* may have served as points of departure for the genuflecting female in his *Kiss*.[46]

In 1907, the year when Klimt began to paint *The Kiss*, he also reworked his three university paintings in connection with their exhibition, first in November at the Galerie Keller und Reiner in Berlin, and subsequently at the Galerie Miethke in Vienna. That same month, Rilke traveled to Vienna, where he gave a reading of his work at the book dealer Hugo Heller's Kunstsalon on November 8. By then the writer had become something of a celebrity in Vienna; his poems had been published regularly in *Ver Sacrum* since its launch in 1898. The event at the Kunstsalon was said to be the greatest success that a living poet had ever had in Vienna. On November 13, Rilke delivered a lecture on Rodin, also at Heller's Kunstsalon.[47] Although we do not know if Klimt was part of the crowd listening to Rilke, he certainly would have read reports about these events in the newspaper.

As he worked on his painting *The Kiss*, perhaps Klimt recalled that Rilke valued *The Eternal Idol* even more highly than Rodin's *The Kiss*. Although it was not intended for the sculptor's *Gates of Hell*, Rilke nevertheless felt that *The Eternal Idol* belonged to the world of Dante's *Divine Comedy*:

> But still more marvelous is that other kiss about which is raised the statue called *The Eternal Idol*, like walls around a garden. ... A girl is kneeling ... with an expression of forbearance, majesty, and patience she gazes down ... upon the man whose face is buried in her breast as if in many flowers. He too is kneeling. ... There is something of the atmosphere of a Purgatorio in this work. A heaven is at hand but it is not yet attained: a hell is near which is not yet forgotten. Here again all the radiance emanates from contact, the contact of the two bodies and contact of the woman with herself.[48]

Klimt's painting gives such a garden another concrete form. The couple is perched high on a rocky ledge; the only remnant of a hell is the distant abyss, toward which three of the elegantly swaying toes of the woman's left foot point downward. This pair is headed, however, in the opposite direction, indicated by their proximity to the canvas' upper edge. Draped in golden robes, surrounded by a luminescent gloriole, this couple seems to generate an intensely radiant, golden

light. Here, too, a majestic woman looks inside herself, gently tolerating the man's lips, but with no intention of succumbing to them. Though her partner draws her kneeling form to his, she remains enclosed in the safe harbor of her own being. Perhaps ultimately this was Klimt's private rejoinder to his doubting critics and patrons, who had embroiled him in conflict until 1905. That year the city's ministry of education finally agreed to return the university paintings to Klimt—provided he repay the advance he had been given ten years prior. Klimt expressed his attitude during this time in these words: "I wish to remove myself from all these unedifying and supposedly supportive absurdities and regain my freedom. ... I decline every form of state assistance. I renounce all of this"[49] Klimt's patron the industrialist August Lederer lent the artist the money for these repayments, allowing Klimt at last to attain his long-desired independence.

Auguste Rodin and Gustav Klimt, both from modest backgrounds, became giants of their generation despite tremendous adversity. They followed similar paths, and both adamantly defended the mandate of artistic freedom. Despite many obstacles—both societal and aesthetic—they prevailed, and "kissed" awake two of the most significant masterpieces of twentieth-century art.

I am deeply grateful to the following friends and colleagues: Marian Bisanz-Prakken and Alessandra Comini, for their invaluable comments; Pamela Kort for sharing her insightful remarks on Auguste Rodin; Rebekka Rudin for research; and Diana C. Stoll for her sensitive editing.

All translations from German are the author's, unless otherwise noted.

NOTES

1 Kirk Varnedoe, *Vienna 1900: Art, Architecture and Design* (New York: Museum of Modern Art, 1986), p. 20.
2 The exhibition took place at Prague's Artist's Union Manes, May 10–July 15, 1902.
3 On Klimt's relations with Berta Zuckerkandl, see Emily Braun's essay in this volume.
4 Christian M. Nebehay, *Gustav Klimt: From Drawing to Painting* (New York: Abrams, 1994), pp. 112–14.
5 Christian M. Nebehay, "Gustav Klimt Biographie und Werkverzeichnis," in Toni Stoos and Christopher Doswald, eds., *Gustav Klimt*, exh. cat., Kunsthaus Zurich (Stuttgart: Hatje Cantz, 1992), p. 367.
6 The Archduke Franz Ferdinand objected to Klimt's appointment. See Fritz Novotny and Johannes Dobai, *Gustav Klimt* (Salzburg: Galerie Welz, 1967), p. 398.
7 Laird McLeod Easton, *The Red Count: The Life and Times of Harry Kessler* (Berkeley/ London: University of California Press, 2002), p. 151.
8 Claude Keisch, "Chronologie des Weimarer 'Rodin-Skandals,'" in *Auguste Rodin: Plastik, Zeichnungen, Graphik* (Berlin: Nationalgalerie, 1979), pp. 68–74.
9 In 1898, when Rodin first showed the large marble version of *The Kiss*, he signed a twenty-year contract with the Gustave Leblanc-Barbedienne foundry to make four different-sized smaller versions in bronze. By the time that contract had expired, some 329 casts had been made and sold! See Albert E. Elsen with Rosalyn Frankel Jamison, *Rodin's Art: The Rodin Collection of the Iris and B. Gerald Cantor Center for the Visual Arts at Stanford University* (New York: Oxford University Press, 2003), p. 214.
10 Paolo and Francesca, who appear in the fifth canto of Dante's *Inferno*, sealed their fate with the most famous kiss in all of medieval literature. These studious, courtly lovers were based on the historical personages Francesca da Rimini (b. ca. 1260, d. 1283/85) and Paolo Malatesta (b. 1246, d. 1283/85),

who are said to have fallen in love while reading the story of Lancelot and Guinevere. Francesca's husband, Giovanni Malatesta (Paolo's older brother), discovered their adulterous affair and murdered them in flagrante delicto.

11 Antonio Canova's sculpture *Cupid and Psyche* (1786–93), though equally erotic, passed the censors because it depicted a mythological subject. I am grateful to Alessandra Comini for drawing my attention to this.

12 Anne-Marie Bonnet, "Das Thema 'Paare' bei Rodin," in *Auguste Rodin: Der Kuss—die Paare*, ed. Bonnet, Hartwig Fischer, Christiane Lange, exh. cat. (Munich: Kunsthalle der Hypo-Kulturstifftung, 2006), pp. 22–24; and Elsen, *Rodin's Art*, pp. 211–13.

13 Dante Alighieri, *Inferno*, Canto V, trans. and with an introduction by John Ciardi (New York: Modern Library, 1996), p. 42. The Italian: "Noi leggiavamo un giorno per diletto/di Lancialotto come amor lo strinse:/soli eravamo e sanza alcun sospetto./Per più fïate le occhi ci sospinse/quella lettura, e scolorocci il viso;/ma solo un punto fu quel che ci vinse./Quando leggemmo il disïato riso/esser baciato da cotanto amante,/questi, che mai da me non fia diviso,/la bocca mi baciò tutto tremante./Galeotto fu il libro e chi lo scrisse;/quel giorno più non vi leggemmo avante."

14 Elsen, *Rodin's Art*, p. 211.

15 Otto Grautoff, "Aus Gesprächen mit Rodin," *Jugend*, no. 47, 1907, p. 1.

16 Oskar Fischel, *Ver Sacrum*, no. 2, 1899, p. 11: "Ein Thema beschäftigt ihn vor allem 'der Kuss' … seiner nicht zu ermüdeten Phantasie für dieses Sujet."

17 Alma Mahler-Werfel, *Mein Leben* (Frankfurt: Fischer, 1960), p. 91; and Nebehay, *Klimt: From Drawing to Painting*, p. 220 mentions Friederike Maria Beer-Monti's recollection of Klimt reciting Dante .

18 The author respectfully and convivially disagrees on this subject with Alessandra Comini, who describes the "drastically straightforward sexuality … in *The Kiss*." Comini, *Gustav Klimt* (New York: Braziller, 1975), p. 15.

19 The author disagrees with Laura Arici's interpretation of the relationship of Klimt's painting to the history of Cupid and Psyche (she argues that the woman in the painting is not allowed to awake, but is being kissed to sleep). See Arici, "Der Kuss," in Stoos and Doswald, *Gustav Klimt*, p. 148.

20 Apuleius, *The Golden Ass*, trans. Jack Lindsay (Bloomington: Indiana University Press, 1962).

21 See Laura Arici, "Schwanengesang in Gold 'Der Kuss': eine Deutung," in Stoos and Doswald, *Gustav Klimt*, pp. 46–47.

22 It has been suggested that Emilie Flöge and Klimt restrained from sexual relations because the artist was infected with syphilis. In an unpublished letter (collection of Alfred Weidinger, Vienna) Flöge's mother, writing to her son Hermann, expresses fear that Emilie will become infected with Klimt's terrible disease. See Susanna Partsch, "Gustav Klimt 'Als Person nicht interessant' Von der Ringstrasse zur Secession," in *Gegenwelten Gustav Klimt: Künstlerleben im Fin de Siècle* (Munich: Bayerische Veriensbank, 1996), p. 32.

23 Wolfgang Georg Fischer refers to Klimt's erotic sketches as "a *Kama Sutra* of the Viennese avant-garde." Fischer, "Gustav Klimt und Emilie Flöge; Oskar Kokoschka und Alma Mahler," in Stoos and Doswald, *Gustav Klimt*, p. 341.

24 Emil Pirchan, *Gustav Klimt: Ein Künstler aus Wien* (Vienna/Leipzig: Wallishausser, 1942), p. 74.

25 Alice Strobl, *Gustav Klimt: Die Zeichnungen*, vol. 3 (Salzburg: Galerie Welz, 1980–89), p. 8

26 Ibid., p. 241, cat. no. 3165.

27 See *Rodin Photographies*, exh. cat. (Paris: Musée Rodin, 1986), with a text by Hélène Pinet, p. 154.

28 Paul Clemen, "Auguste Rodin," in *Die Kunst für Alle* (*Die Kunst*), vol. 20, no. 3, April 1, 1905, pp. 289–307.

29 Ibid., p. 299.

30 On close inspection, this hand seems perhaps even slightly deformed. Here it should be recalled that the same year Klimt began working on *The Kiss*, the artist created his *Portrait of Adele Bloch-Bauer I* [Cat. no. P3]. This sitter, a *grande dame* of Viennese society (and rumored to have had a love affair with the artist), had a right hand that was slightly impaired; Maria Altmann, Adele Bloch-Bauer's niece, has mentioned her aunt's crippled middle finger. (Apart from this feature, however, there is nothing to hint that the female figure in *The Kiss* might be a concealed portrait of her.) See Sophie Lillie and Georg Gaugusch, *Portrait of Adele Bloch-Bauer* (New York: Neue Galerie New York, 2006), p. 59. The 1939 inventory of the estate of Ferdinand and Adele Bloch-Bauer included Rodin's bronze *Allegory of Freedom* (*Allegorie de la Liberté*). See also Sophie Lillie, *Was einmal war: Handbuch der einteigneten Kunstsammlungen Wiens* (Vienna: Czernin, 2003), p. 206.

31 Rainer Maria Rilke, "Auguste Rodin" (1903), in *Rodin and Other Prose Pieces*, with an introduction by William Tucker, trans. G. Craig Houston (London/Melbourne/New York: Quartett Books, 1986), pp. 18–19.

32 Roger Marx, "Cartons d'Artistes: Auguste Rodin," *Pan*, vol. 3, no. 3, 1897, p. 104. "Nichts ist indessen natürlicher, als die Wahl eines Stoffes, der so wie dieser seiner epischen Niegung entsprach und ihm gestattete, menschliche Leidenschaft in ihrer höchsten Erregung darzustellen … die Fäuste sich ballen, die Hände irr umhergreifen und die Gesichter sich verzerren; sie zerstört sich, unfähig in der Liebe Frieden oder Glück zu finden: das Verhängnis verfolgt die Paare, dis sich suchen, anziehen, umschlingen und nach der Umarmung doch den bitteren Groll unbefriedigten Wunsches weiter nähren."

33 Marian Bisanz-Prakken acknowledges Klimt's debt to Rodin in his honest depiction of aging bodies. See Bisanz-Prakken, "Gustav Klimt's Drawings," in *Gustav Klimt: Modernism in the Making*, ed. Colin Bailey, exh. cat. (Ottawa: National Gallery of Canada, 2001), p. 148.

34 See the groundbreaking essay by Johannes Dobai, "Zu Gustav Klimts Gemälde 'Der Kuss,'" *Mitteilungen der Österreichischen Galerie*, vol. 12, no. 56 (1968), particularly pp. 103–106. Marian Bisanz-Prakken has reiterated this comparison in *Gustav Klimt: Modernism in the Making*, p. 148.

35 See Carl E. Schorske, *Fin-de-Siècle Vienna: Politics and Culture* (New York: Knopf, 1980), pp. 231–44; and also Dora Guth, "That Is Not a Sign of the Times, It Is a Sign of Extravagance: The Scandal Surrounding Gustav Klimt's Faculty Paintings," in *Die Nackte Wahrheit: Klimt, Schiele, Kokoschka und andere Skandale*, ed. Tobias G. Natter and Max Hollein, exh. cat. (Frankfurt: Schirn Kunsthalle, 2005), pp. 68–70.

36 In April 1905 Klimt returned the thirty-thousand-kronen advance he had received for the commission. See Nebehay's Klimt chronology in Stoos and Doswald, *Gustav Klimt*, p. 368.

37 See Christina Buley-Uribe, "Chronological Landmarks," in *Auguste Rodin: Watercolors from the Collection of the Musée Rodin, Paris*, ed. Thomas Knubben and Tilman Osterwold, exh. cat. (Ravensburg: Städtische Galerie, 2004–05), p. 115.

38 Rudolf Klein, "Die Plastik der Gegenwart," in *International Kunstausstellung Düsseldorf*, exh. cat. (Düsseldorf: Verlag der Rheinlande, 1904), p. 368.

39 Rilke, *Rodin*, pp. 19–20.

40 See Elsen, *Rodin's Art*, pp. 211–21. See also Bonnet, "Das Thema 'Paare' bei Rodin," pp. 74–77.

41 Ludwig Volkmann, *Die Grenzen der Künste* (Dresden: Gerhard Kühtmann, 1900), pp. 91–90.

42 Clemen, "Auguste Rodin," p. 297.

43 Markus Neuwirth, "Hermann Bahr und Gustav Klimt: Exotismus als Fluchtpunkt," in *Hermann Bahr: Für eine andere Moderne* (Bern: Jeanne Benay, 2004), p. 264.

44 Ilka Soennecken, *Dantes Paolo und Francesca in der Kunst des 19. und 20. Jahrhunderts: Entstehung und Entwicklung eines 'romatischen' Bildthemas* (Weimar: VDG, 2002), p. 174.

45 The most recent argument for the relationship of Klimt's painting to Edvard Munch's is by Peter Vergo, "Between Modernism and Tradition: The Importance of Klimt's Murals and Figure Paintings," in *Gustav Klimt: Modernism in the Making*, pp. 32–33.

46 It has been argued (see Arici, "Der Kuss," p. 46) that Klimt's kneeling woman is based rather on the ascetic kneeling youths in George Minne's *Fountain*, a plaster model was shown in Vienna at the eighth Secession exhibition in 1900 and featured in 1901 in *Ver Sacrum*.

47 Sabine Fuchs, "Hugo Heller (1870–1923): Buchhändler und Verleger in Wien," master's thesis, University of Vienna, 2004, p. 78.

48 Rilke, *Rodin*, p. 20.

49 Alice Strobl, "Zu den Fakultätsbildern von Gustav Klimt," *Albertina-Studien*, vol. 2, no. 4, 1964, p. 161, cited in Guth, "That Is Not a Sign of the Times," p. 70.

PAINTINGS

THE TALL POPLAR TREE I, 1900

Die Grosse Pappel I

Oil on canvas, 80 x 80 cm (31½ x 31½ in.)

Unsigned, undated

CAT. NO. P1

1. Gustav Klimt, *The Tall Poplar Tree II*, 1903, oil on canvas. Private Collection

Klimt dedicated the first twenty years of his career to commissioned figurative decorations and paintings for public building interiors throughout the Hapsburg Empire. With *The Tall Poplar Tree I*, he turned his focus at last toward nature.[1]

Academic landscape painting in Austria had long been grounded in nineteenth-century Romanticism. Klimt emerged from this tradition, infused it with symbolism, and shifted it to a modernist approach. Rarely were Klimt's landscape paintings commissioned, and it often took years before they sold. Alois Riegel, a prominent Viennese art historian of the day, coined the term *Stimmungsmalerei* (mood painting) to describe such works; the critic Ludwig Hevesi wrote of Klimt's landscapes: "The atmospheric problem plays the main part."[2]

Klimt spent the first days of his 1900 summer sojourn on the Allersee, in the tranquil Salzkammergut, scouting for possible scenes with a square viewfinder.[3] He and fellow Secession artists may have been following the lead of the French Impressionists, who also often employed a square format for landscape works. "I am working here at five paintings … I hope to be able to finish"—among them "a big poplar," as he wrote in late August to Marie ("Mizzi") Zimmermann, his model and the mother of two of his sons, who remained in Vienna while he traveled. The "big poplar" of this painting dwarfs the adjacent Seewalchen chapel.

Although based on an actual scene, *The Tall Poplar Tree I* is charged with a sense of the vast heavens, experienced in this natural setting. This subject clearly interested the artist, as he repeated it three years later with *The Tall Poplar Tree II* (*Die Grosse Pappel II*, or *Aufsteigendes Gewitter*) [Fig. 1] According to Christian M. Nebehay, this enormous tree collapsed in 1928. Both paintings are unique examples in Klimt's oeuvre of clouds and sky masterfully dominating the artist's composition.[4] —RP

1 According to Christian M. Nebehay, Klimt's earliest landscape painting, *Fruit Orchard* (*Obstgarten*), was created ca. 1898.

2 "Das atmosphärische Problem spielt die Hauptrolle." See Christian M. Nebehay, *Gustav Klimt: Dokumentation* (Vienna: Galerie Christian M. Nebehay, 1969), p. 420.

3 See Klimt's letter of August 1903 to Marie ("Mizzi") Zimmermann, in Nebehay, *Gustav Klimt: From Drawing to Painting*, p. 268.

4 Nebehay, *Gustav Klimt: Dokumentation*, p. 447.

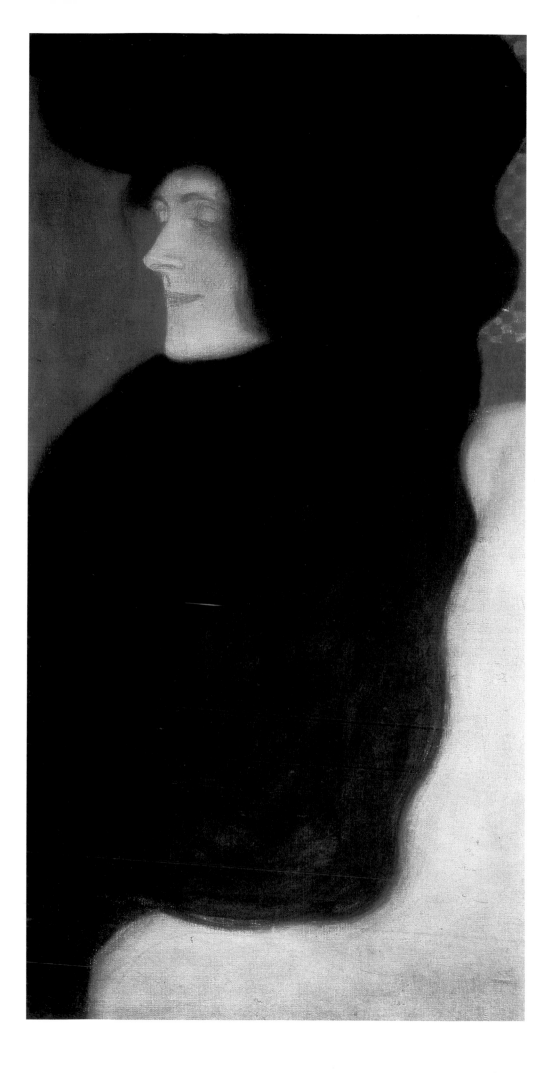

PALE FACE, 1903

Bleiches Gesicht
Oil on canvas, 80 x 40 cm (31½ x 15¾ in.)
Unsigned, undated
CAT. NO. P2

Klimt's *Pale Face* is dominated by the bright transparency of a sharply outlined female face with a distinctly pointed chin.[1] The face is veiled in the schematic, dark surfaces of the high-necked coat and broad hat. The remote female in the image does not apparently represent a particular person, but rather the embodiment of a melancholic mood.

This imaginary portrait was evidently inspired by the 1895 drawing *Nirvana* (*Nirwana*) [Fig. 1] by the Dutch Symbolist Jan Toorop (b. 1858, d. 1928), whose influence on Klimt reached its height shortly after 1902.[2] Works by Toorop were presented in Viennese exhibitions in 1899, 1900, and 1901–02. *Nirvana* was not shown in Vienna but would likely have been familiar to Klimt from reproductions. Klimt borrowed the three-quarter view and the sharp contours from the Toorop image, and similarly addressed the spiritual qualities of his subject's physiognomy. Crucial for the expression of reflection and meditation in both portraits are deep shadows around the subject's eyes and her inward-directed gaze beneath heavy, half-lowered eyelids. The two faces are strikingly similar in terms of the form of the nose. Klimt depicts the woman's head turned somewhat farther to the right, which makes the tip of her nose seem to protrude more. Both faces are framed by tendrils of wavy hair. Klimt's delicate black chalk lines in the transparent painted surface of the face are reminiscent of Toorop's overall work on a general level as well.

But Klimt's *Pale Face* differs from the visage in Toorop's *Nirvana* by the strictly linear stylization of the facial features. In this respect, Klimt may have been orienting himself around an even better-known female type by Toorop: a face characterized by an extremely pointed chin and narrow, tightly closed lips. A well-known example of this type is seen in Toorop's drawing *Souls at the Shore* (*Zielengang langs de oceaan*, 1898) [Fig. 2], which was exhibited at the Secession in 1901–02 and was illustrated in *Ver Sacrum* in 1902.

In the catalogue raisonné of Klimt's paintings, Johannes Dobai dates *Pale Face* to circa 1907–08 on the basis of its similarity, in his view, to two other vertical-format paintings by Klimt: *The Sisters* (*Die Schwestern*, 1907–08) and *Portrait of a Woman in Red and Black* (*Damenbildnis in Rot und Schwarz*, 1907–08). This similarity has been questioned by some authors in recent years.[3] There are, indeed, a number of arguments to support the assumption that *Pale Face* was painted in 1903. The obvious inspiration from Toorop is strong evidence of this dating: this was the year in which Klimt was most clearly influenced by his Dutch colleague.

1. Jan Toorop, *Nirvana*, 1895, pencil on paper. Kunsthandel Studio, Blaricum

Also typical of this transitional phase in Klimt's oeuvre is the combination of flowing contour lines and geometrical patterns seen, for example, in his drawing studies of 1903–04 for *Adele Bloch-Bauer I* (finished in 1907). The simplicity of the checkerboard pattern at the upper right in *Pale Face* recalls the ornaments in the background of the *Gorgons* (*Gorgonen*) in Klimt's 1902 *Beethoven Frieze* (*Beethovenfries*). With its cloud-like stylization, the black clothing is remarkably similar to the dark, misty backdrop in the upper left of the faculty painting *Jurisprudence* (*Jurisprudenz*, 1903–07). Last but not least, the melancholic gravity of the painting is linked to the gloomy pessimism of the allegories of 1903, among them *Jurisprudence*, *Hope I* (*Die Hoffnung I*), and *From the Realm of the Dead* (*Aus dem Reiche des Todes*). — MBP

1 See *Toorop/Klimt: Toorop in Wenen, inspiratie voor Klimt*, ed. Marian Bisanz-Prakken, with contributions by Hans Janssen and Gerard van Wezel, exh. cat., Gemeentemuseum, The Hague (Zwolle: Waanders, 2006), cat. no. 120, where *Pale Face* is compared with works by Toorop for the first time, and is dated definitely as 1903.

2 Ibid., cat. no. 65.

3 See Alice Strobl, *Gustav Klimt: Die Zeichnungen*, vol. 4 (Salzburg: Galerie Welz, 1980–89), p. 225; John Collins in *Gustav Klimt: Modernism in the Making*, ed. Colin Bailey, exh. cat. (Ottawa: National Gallery of Canada, 2001), p. 119. The catalogue of the eighteenth Secession exhibition (November 1903–January 1904), devoted to Klimt, mentions a painting titled *Bleiches Gesicht* with the year 1903 (cat. no. 34). This work was long considered to be lost, but may now be identified as our painting.

an Toorop, *Souls at the Shore*, 1898, pencil on paper. Nationalgalerie, Berlin

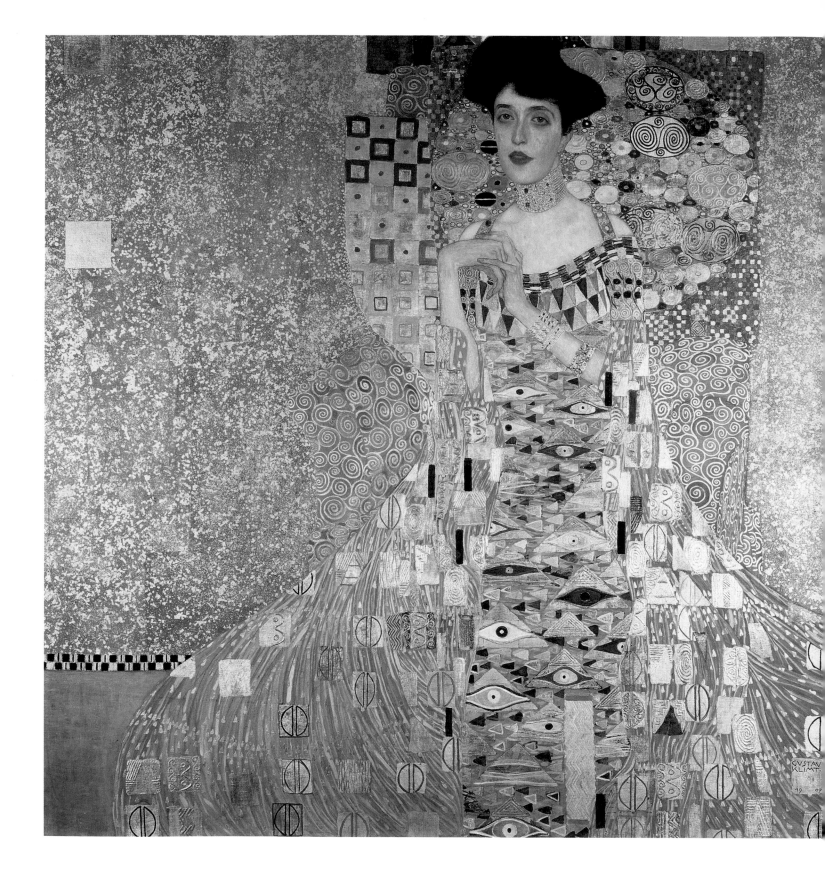

ADELE BLOCH-BAUER I, 1907

Bildnis Adele Bloch-Bauer I
Oil, silver, and gold on canvas, 140 x 140 cm (55⅛ x 55⅛ in.)
Signed and dated

CAT. NO. P3

Adele Bauer (b. 1881, d. 1925) [Fig. 1], born into a prominent Viennese Jewish banking family, was married to a wealthy industrialist seventeen years her senior, the sugar magnate Ferdinand Bloch (b. 1864, d. 1945). She was twenty-six when this portrait, originally intended as a wedding anniversary gift for her parents, was completed.[1]

Adele was a member of Viennese society and an enthusiast of contemporary art; she was cultured and intelligent, although (like most women of her day) she was denied a university education.[2] She maintained a salon that was frequented by Vienna's intellectual, political, and artistic elite. The Bloch-Bauers took a strong interest in the work of Klimt—who by the turn of the century was already very well known—which undoubtedly prompted the commission.[3] Klimt started making sketches of Adele around 1900; more than one hundred preparatory drawings survive. Rumors of a romance between the artist and the socialite abound, but no concrete evidence of a liaison has been documented.[4]

This portrait is a central masterpiece of Klimt's Golden Style. The subject and her husband were obviously pleased with the painting: the artist was given an unprecedented second commission (*Adele Bloch-Bauer II*), which he completed in 1912 [Fig. 2]. *Adele Bloch-Bauer I* was first displayed publicly in Mannheim the year it was finished, and at the 1908 *Kunstschau* in Vienna. Among its memorable reviews was one in the *Neues Wiener Tagblatt* that characterized the work cleverly as "Mehr Blech als Bloch" (More brass than Bloch).[5]

Although regally dressed and enthroned on an upholstered armchair decorated with spirals, Adele gazes out dreamily with a rather sultry air. In 1903, on two separate occasions, Klimt visited the Italian town of Ravenna, where he admired the Byzantine mosaics at the church of San Vitale [Fig. 3], especially the image of Empress Theodora, glittering before an abstract gold background— "mosaics of unprecedented splendor," as he wrote to Emilie Flöge.[6] The painter Max Lenz accompanied Klimt to Italy and remarked that the "primitives" had captivated Klimt's attention far more than the famous Italian Old Masters.[7] The sitter's flushed face, full lips, and fine-veined porcelain flesh are realistic depictions embedded in ceremonial, golden ornament—evoking not only such Byzantine mosaics, but Russian icons as well.

Adele's slender fingers join her hands: the right hand is curiously folded at the wrist, hiding her malformed middle finger.[8] A halo-shaped swirl of stylized cells and spirals surrounds the sitter's head—regally postured on her neck adorned with a diamond choker—giving Adele an almost saint-like appearance.[9] The artist, who was oriented to the applied arts through his background and training, applied gold paint over gesso for a three-dimensional textural relief on the sitter's golden bracelets and her initials, "A" and "B." The raised decorative motifs on her robe and

1. Adele Bloch-Bauer in her drawing room, ca.1910, silver gelatin print. Courtesy Österreichische Galerie Belvedere, Photo Archive

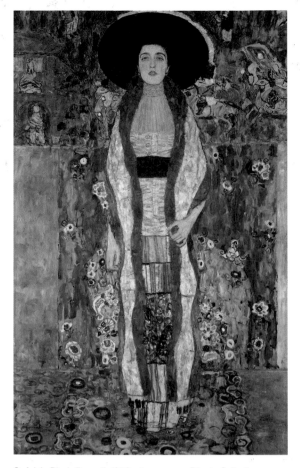

2. *Adele Bloch-Bauer II*, 1912, oil on canvas. Private Collection

coat—a kind of web of armor—add a sensuous plasticity to the work. The various ornaments indicate a symbolic content in the painting, leading to much conjecture: the "god's eye" on the sitter's strapped dress is a testament to Klimt's strong interest in Egyptian art[10]—as may be seen in the Palais Stoclet frieze designs on which he worked in 1905–11. The joining half-moon shapes may allude to female genitalia (a possible, though oblique, reference to the alleged intimate nature of the relationship between artist and sitter). Soft forms alternate with hard ones in an ongoing dialogue. The rectilinear border of black-and-white squares over the green baseboard in the lower right, the red outlined squares to the right of Adele's face, and the two silver squares over the stippled gold background counterbalance the organic shapes that are scattered throughout the composition.

This commission is a superb example of the seamless synergy that took place between the fine and applied arts in fin-de-siècle Vienna. The frame, designed by Josef Hoffmann, accentuates the boundary between the man-made image and its surrounding environment. The work is a daring investigation into the paradox of reality versus illusion. The purposeful interplay of nearly palpable flesh and abstract ornamental gold ground is a clear foray into a modernist approach, based on the "primitive" sensibilities of the past. —RP

1 As Klimt's progress in creating the painting was slow, this intention to give the portrait as a 1903 wedding anniversary gift was abandoned.
2 The University of Vienna was among the last European institutions of higher education to admit women. In 1897 the department of philosophy and in 1900 the medical school allowed women to enroll. Not until 1919 were women permitted to enter any other fields of study at the university.
3 In 1906 Adele bought a portfolio (designed by the Wiener Werkstätte) of sixteen Klimt drawings from Vienna's Galerie Miethke. These drawings were the first items to be recovered in 1998 from the collection of the Graphische Sammlung Albertina, Vienna, under Austria's new bill governing the restitution of Holocaust-era art from its federal collections.
4 Salomon Greenberg suggested artist and sitter were lovers in his article "Adele: Private Love and Public Betrayal," *Art and Antiques*, Summer 1986, p. 70.
5 Eduard Pötzl, quoted in Christian M. Nebehay, *Gustav Klimt: Dokumentation* (Vienna: Galerie Christian M. Nebehay, 1969), p. 425.
6 Postcard to Emilie Flöge, December 2, 1903, in Wolfgang Georg Fischer, *Gustav Klimt und Emilie Flöge: Genie und Talent, Freundschaft und Besessenheit* (Vienna: Christian Brandstätter, 1987), p. 171.
7 Nebehay, *Gustav Klimt: Dokumentation*, p. 496.
8 According to the sitter's niece, Maria Altmann, one of Adele's fingers was misshapen.
9 Klimt used a similar pictorial device a year earlier in his 1906 portrait of Fritza Riedler.
10 The artist was exposed to ancient Egyptian art while working on the frescoes at Vienna's Kunsthistorisches Museum in 1890–92.

3. Empress Theodora (detail of *Procession* mosaic) at the Church of San Vitale, Ravenna, 546–48 AD

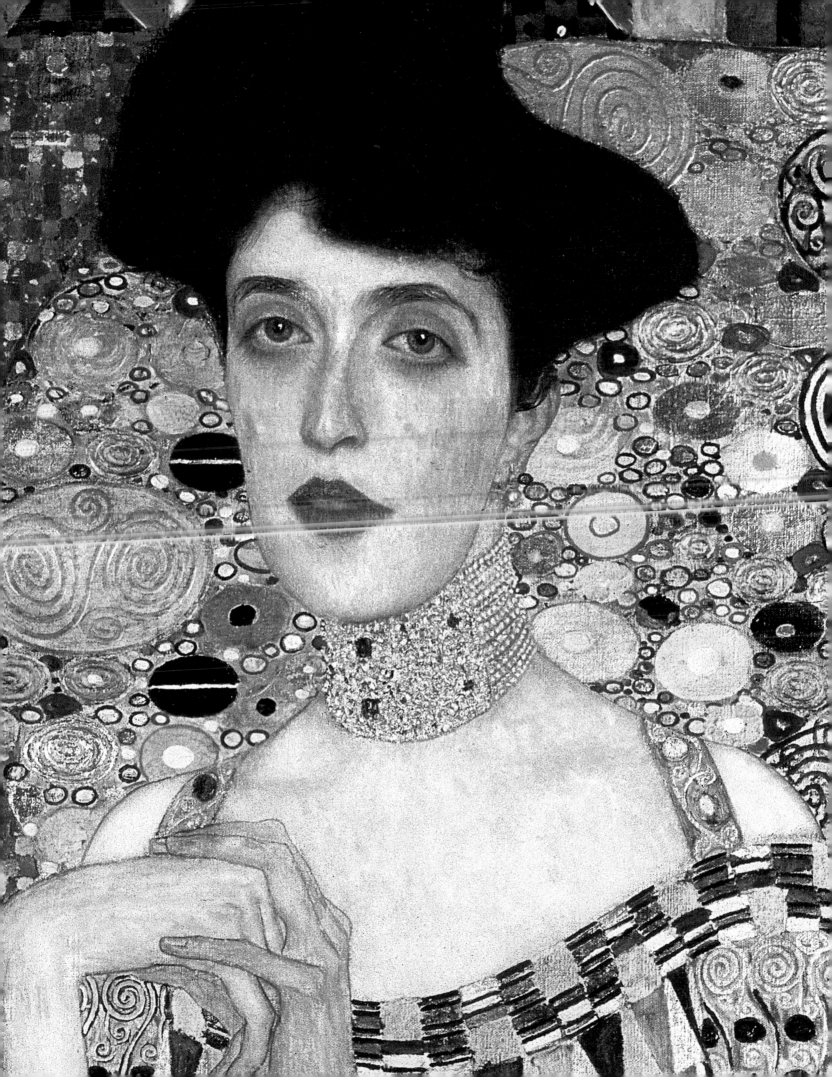

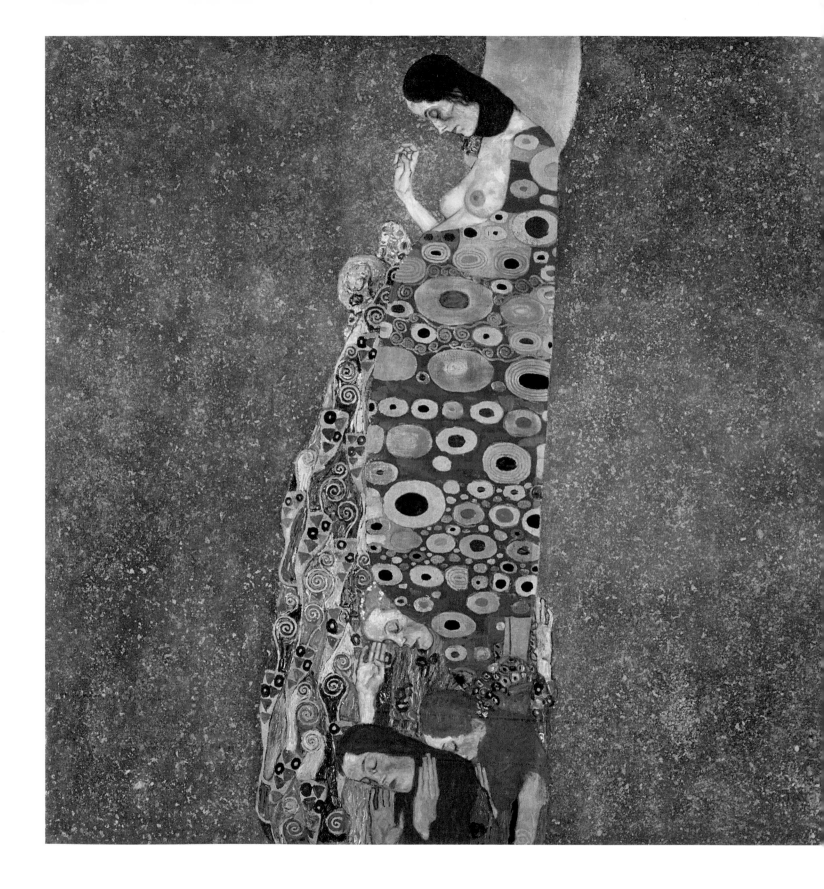

HOPE II (VISION), 1907–08

Die Hoffnung II (Vision)
Oil, gold, and platinum on canvas, 110.5 x 110.5 cm (43½ x 43½ in.)
The Museum of Modern Art, New York
Jo Carole and Ronald S. Lauder, and Helen Acheson Funds,
and Serge Sabarsky, 1978
CAT. NO. P4

Klimt returns here to the theme of the pregnant nude—which he first presented to the public in the university painting *Medicine* (*Medizin*, 1901–07), first shown at the tenth Secession exhibition in March–May 1901, then alluded to in the mythology of the *Beethoven Frieze* (*Beethovenfries*) of 1902, and again, flagrantly ennobled, in *Hope I* (*Die Hoffnung I*) of 1903. The reiteration of this theme attests to its importance in the repertoire of this artist, whom Kirk Varnedoe has described as the "avant-garde allegorist of the human condition."[1] It is, however, a baffling choice of subject, not simply because of the potential for scandal at a time when it was frowned upon for even a clothed pregnant woman to be seen in public, but also because pregnancy—seen as a medical concern—seems distant from the realm of art.

The figure of *Hope II* stands in profile, but as a concession to propriety her swollen belly is concealed from view by a crimson robe decorated with golden ellipses. As in *Hope I*, Death is present at the woman's side. Three praying female figures (derived from the work of Belgian Symbolist sculptor George Minne) rise from below, recalling the flowing tangle of unconscious human forms in *Medicine*, but here neatly compressed into an ornamental column against a nebulous cosmos of silver and gold.[2]

Hope II was first exhibited with six paintings and eight drawings in the Klimt room of the *Internationale Kunstschau* of 1909. Also making its first appearance before the Viennese public was *Hope I*, which had been withdrawn from Klimt's 1903 Secession retrospective under threat of scandal. News of the painting's return to the exhibition spaces of Vienna stirred talk in "all the coffee houses and Five o'Clocks."[3]

Although the two *Hope* paintings ostensibly represent the same subject, they are remarkably different in mood and symbolic content. *Hope II* is inspired not so much by the Wagnerian storytelling of the *Beethoven Frieze* as by a subjective exploration of the mythology of regeneration. Significantly, during his lifetime Klimt exhibited the painting under the title *Vision*, suggesting a transcendent state.[4] While the eyes of the protagonist in *Hope I* glare defiantly at the viewer, those of her counterpart in *Hope II* are closed and sunken, her cheeks pale and thin, her lips held tightly together in sullen contrast to the evident health of the rest of her body. The mass of hair on the model in *Hope I* is lush and abundant; that of the woman in *Hope II* is tucked behind her ear and falls limply about her neck. The latter model's deathly pallor is perplexing, as the various women that Klimt sketched in preparation for *Hope II* show no sign of physical weakness, but have a robust appearance.[5] Such details are at odds with the sense of romantic fecundity in *The Kiss* (*Der Kuss*, 1907–08), but share the unsettling message of Klimt's contemporaneous projects *Mother and Children* (*Mutter mit Kindern*, 1909–10) and *Death and Life* (*Tod und Leben*, 1908–15).

THE PARK OF SCHLOSS KAMMER, CA. 1910

Schlosspark Kammer
Oil on canvas , 110 x 110 cm (43¼ x 43¼ in.)
Unsigned, undated
CAT. NO. P6

Between 1908 and 1912, the years Klimt vacationed at the Villa Oleander on the Attersee, he depicted the nearby Schloss Kammer estate in seven canvases, each made from a different vantage point.[1] The series serves as a panoramic testimonial to the castle and the surrounding parklands, which in 1872 had become part of the holdings of a nearby luxury resort. A tourist guide of 1898 describes "the little paradise of Kammer … [and the] avenues, magnificent parks and gardens near the castle, a grouping of beautifully constructed villas belonging to it—Villa Oleander, Seevilla, Waldhütte, and Russvilla … these are all things uplifting to one's heart and a balm to one's health."[2]

It is difficult to imagine Klimt's Schloss Kammer views appearing in the hotel's promotional literature, however; the scenes have a hermetic quality that is hardly welcoming. With its point of view just above the water's surface and its sense of airless tranquility, *The Park of Schloss Kammer* shows the influence of such Symbolist landscapes as Fernand Khnopff's *Still Water* (*Stilles Wasser*, ca. 1895) [Fig. 1].[3] Yet Klimt refrains from imposing on his view the mood of twilight gloom that pervades Khnopff's painting. Instead, the brilliant outdoor light (achieved in part through the canvas's white underlayer), the Monet-like treatment of the pond's surface, and the robust Pointillism of the trees evoke the sensibilities of the Impressionists.

The Park of Schloss Kammer's tight framing is also reminiscent of Klimt's *The Park*. Both are composed of interwoven hues of green and blue suffused with warm yellow tones. Based upon this relationship of style and subject, Klimt's commencement on *The Park of Schloss Kammer* may be dated with *The Park* to the summer of 1909, and certainly before both canvases appeared at the Venice Esposizione Internazionale in April 1910.[4] — JC

1. Fernand Khnopff, *Still Water*, ca. 1895, oil on canvas.
Courtesy Österreichische Galerie Belvedere, Vienna

1 The Schloss Kammer landscapes are Novotny/Dobai 159, 165, 166, 167, 171, 172, and 181.
 At the time of Klimt's tenancy, the Villa Oleander belonged to Dr. Alois Scherer of nearby Vöcklabruck. Information courtesy Alfred Weidinger.
2 Leo Kegele, *Das Salzkammergut nebst angrenzenden Gebieten in Wort und Bild* (Vienna: A. Hartlebens, 1898), p. 170.
3 Khnopff's *Still Water* was included in the first Secession exhibition in March 1898, and the December 1898 issue of *Ver Sacrum* was devoted to his work. For Khnopff's influence on Klimt's figural symbolism, see Marian Bisanz-Prakken, *Toorop/Klimt: Toorop in Wenen, inspiratie voor Klimt* (The Hague: Gemeentemuseum, 2006).
4 See the exh. cat. of the 1910 Esposizione Internazionale, second edition (Venice: Carlo Ferrari, 1910), p. 58.

THE BLACK FEATHER HAT (LADY WITH FEATHER HAT), 1910

Der Schwarze Federhut
Oil on canvas, 79 x 63 cm (31 ⅛ x 24 ¾ in.)
Signed and dated
CAT. NO. P5

"After recovering from the first disappointments, bit by bit, I am discovering the interesting, better Frenchwoman; however, one should not look too closely, as much has been *done*—although well done." Klimt wrote these words to Emilie Flöge from Paris in October 1909.[1] There the artist was visiting museums, galleries, and private collections, seeking inspiration from both French art and the women's fashions of Paris.

That summer the *Internationale Kunstschau* had opened in Vienna, presenting the Austrian public with a wide selection of French modernist art. Vienna's Galerie Miethke[2] held a large Henri de Toulouse-Lautrec exhibition in the fall of 1909 [Fig. 1]. Toulouse-Lautrec's work had been displayed in Vienna as early as 1899, and was well represented at the 1909 *Kunstschau*. A year after that exhibition, Klimt would capture the spirit of the French artist, and definitively turn away from his ornamental Golden Style.

The Black Feather Hat, painted with a restricted palette of black, brown, and white and broad, expressive brushstrokes, was not a commissioned portrait. The unidentified subject leans forward apprehensively on her sharp elbow, with averted gaze, hand cupping her face, a slender finger resting on her lower lip. Two thin strands of hair have come undone from her upswept coiffure. This is an unselfconscious, private moment—reminiscent of an Edgar Degas ballet dancer, waiting backstage for her cue.

Large hats provided a chic and urbane "halo" for artistic play in Klimt's compositions of women. He had painted women with headwear before the turn of the century [Figs. 2, 3], but here pushes the level of drama with this extraordinary feathered confection. The imposing hat and hair balance and contrast with the svelte, pale face and torso of the model. The artist is clearly focused on the formal qualities of this image, rather than the emotional state of his model.

The Black Feather Hat was first exhibited in 1910 at the Venice Biennale, in the Klimt Room, along with nineteen other paintings. It was shown again in November of that year at the Galerie Miethke, and was sold shortly thereafter to Rudolf Kahler for five thousand kronen.[3] Klimt's portrayal of this very modern Viennese woman wearing a hat, and exuding worldly flair, was as "well done" as any of the Parisian products Klimt had admired. —RP

1. Poster for exhibition of the work of Henri de Toulouse-Lautrec at the Galerie Miethke, 1900. Wien Museum, Vienna

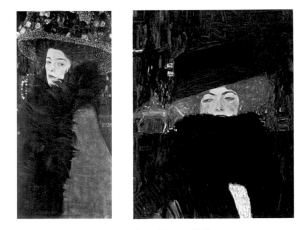

2. Gustav Klimt, *Woman with Rose Hat*, ca. 1910, oil on canvas. Whereabouts unknown

3. Gustav Klimt, *Lady with Hat and Feather Boa,* 1909, oil on canvas. Private Collection

1 Quoted in Wolfgang Georg Fischer, *Gustav Klimt und Emilie Flöge: Genie und Talent, Freundschaft und Besessenheit* (Vienna: Christian Brandstätter, 1987), p. 177.
2 According to Tobias G. Natter, as of 1904 the Galerie Miethke was Klimt's exclusive dealer (although no formal contract has surfaced). Klimt was known to attend openings there. See Natter, *Die Galerie Miethke: Eine Kunsthandlung im Zentrum der Moderne* (Vienna: Jüdisches Museum der Stadt Wien, 2003), p. 82.
3 Ibid., p. 254.

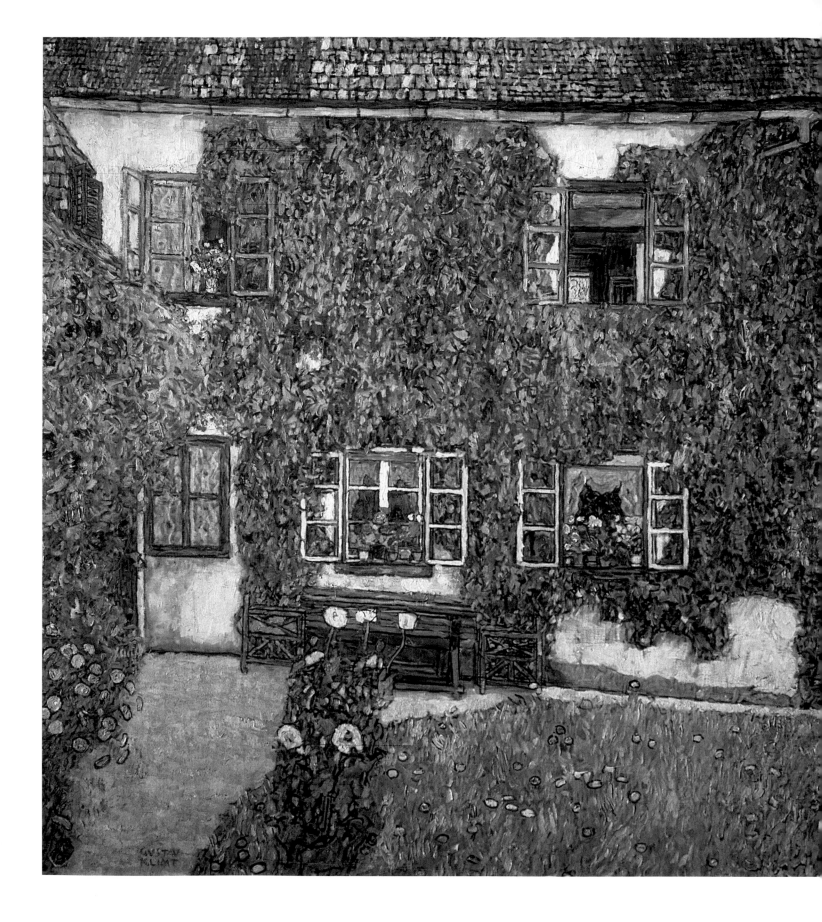

FORESTER HOUSE IN WEISSENBACH ON THE ATTERSEE, 1914 [1]

Forsthaus in Weissenbach am Attersee
Oil on canvas, 110 x 110 cm (43¼ x 43¼ in.)
Signed
CAT. NO. P7

Emilie Flöge was the first to identify the site of this painting[2] as the Forester House in Weissenbach, in a letter of 1949.[3] It was at this rather commodious home on the southern shore of the Attersee that Klimt spent the summers from 1914 to 1916, while Emilie and her family lodged separately.[4]

Emilie also mentions in her letter a variant of the painting, now accepted as *Villa on the Attersee* (*Landhaus am Attersee*, 1914) [Fig. 1].[5] These two views of the Forester House are pendants of sorts, not only in how they manifest the near and far contrasts that so delighted Klimt, but also in the way they complement one another, like opposing axes on a graph. Klimt has left further clues about the relationship between these two paintings in the architectural details—the gutter, the roofline, the doors and in his allusion to the surrounding landscape. In *Forester House*, he has created an intriguing optical puzzle, in which distant mountain vistas are contained within fragmentary details, while the familiar and everyday constitute the focus of the image.

This cognitive teaser has little bearing on Egon Schiele's *Façade of a House* (*Windows*) (*Hauswand [Fenster]*, 1914) [Fig. 2], to which *Forester House* is often compared.[6] Schiele's depiction is far more somber, showing not a luxurious summer residence, but a plain, decrepit wall of what might be a washhouse or tenement; Klimt's *Forester House* embodies the opposite of Schiele's restless style. Klimt was an artist who dwelled relentlessly on questions of death, yet these summer landscapes stand as an affirmation of the sensual delights of life. —JC

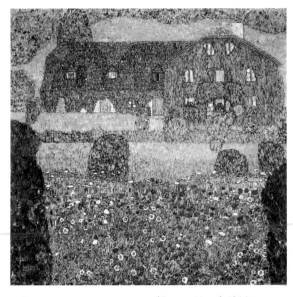

1. Gustav Klimt, *Villa on the Attersee (Forester House)*, 1914, oil on canvas. Private Collection

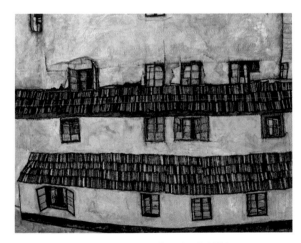

2. Egon Schiele, *Façade of a House (Windows)*, 1914, oil on canvas. Courtesy Österreichische Galerie Belvedere, Vienna

1 Recently Stephan Koja has dated this work as 1914, coinciding with Klimt's documented summer residence in Weissenbach (Koja, ed., *Gustav Klimt: Landschaften* [Munich: Prestel, 2002], pp. 126–129). However, the painting is reproduced in the 1994 monograph of Christian M. Nebehay with the date 1912 (*Gustav Klimt: From Drawing to Painting* [New York: Abrams, 1994], p. 214), following a proposed dating by Fritz Novotny and Johannes Dobai (*Gustav Klimt: With a Catalogue Raisonné of His Paintings* [London/New York: Thames and Hudson; Praeger, 1968], p. 357), which they in turn picked up, I believe, from the recollections of Emilie Flöge contained in Marie-José Liechtenstein, "Gustav Klimt und seine oberösterreichischen Salzkammergutlandschaften," *Oberösterreichische Heimatblätter*, vol. 5, nos. 3–4, 1951, p. 314, n. 39. A 1912 date is inconsistent with the chronology in Nebehay's *Gustav Klimt: Dokumentation* (Vienna: Galerie Christian M. Nebehay, 1969), p. 501–502, which indicates that Klimt did not stay in Weissenbach in the summer of 1912, but in Kammer. The 1914 date is confirmed by Alfred Weidinger, who is preparing the revision of the Novotny-Dobai *catalogue raisonné*.

2 *Forester House* was first reproduced with Franz Servaes's review "Wiener Kunstschau in Berlin," *Deutsche Kunst und Dekoration*, vol. 38, no. 4, April 1916, pp. 41–54; the painting was reproduced on p. 58.

3 Liechtenstein, op. cit.; Emilie Flöge's letter to the author (p. 317) is dated March 24, 1949.

4 Koja, *Gustav Klimt: Landschaften*, p. 126.

5 Ibid., p. 131, plate no. 49 (Novotny/Dobai 189).

6 Most recently in ibid., p. 126.

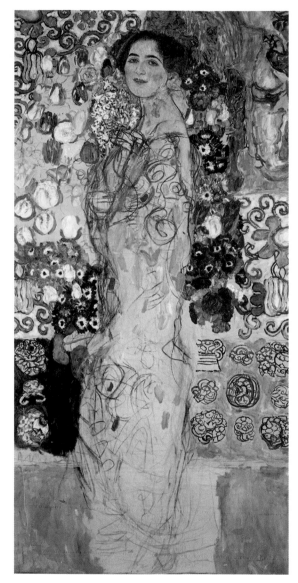

2. Gustav Klimt, *Portrait of Ria Munk III*, 1917–18, oil on canvas.
Lentos Kunstmuseum, Linz

1 "Das Munkportrait wird schon ein wunder schmerzhafter Punkt—bring'es nicht zusammen! Wird einfach nicht ähnlich!" Postcard dated February 28, 1913; see Wolfgang Georg Fischer, *Gustav Klimt und Emilie Flöge: Genie und Talent, Freundshaft und Besessenheit* (Vienna: Christian Brandstätter, 1987), p. 182.
2 Alice Strobl, *Gustav Klimt: Die Zeichnungen, 1912–1918*, vol. 3 (Salzburg: Galerie Welz, 1980–89), p. 111.
3 Marian Bisanz-Prakken, in "Im Antlitz des Todes," *Belvedere Magazin*, Vienna, 1996, vol. 1, describes Klimt's use of a deathbed photograph for his painting *Old Man on His Deathbed (Alter Mann auf dem Totenbett*, 1900). Bisanz-Prakken has kindly confirmed that Klimt must have painted Ria Munk after a deathbed photograph.
4 Arthur Schnitzler, *Tagebuch 1909–1912*, ed. Peter Michael Braunwarth, et al. (Vienna: Österreichische Akademie der Wissenschaften, 1981). See entries for January 1 and 14, 1912, pp. 294 and 296.
5 On Johanna Jusl (b. 1890, d. 1969), see Hansjörg Krug's essay in this volume.

3. Atelier D'Ora, *Dancer*, ca. 1923, silver-gelatin print.
Private Collection, Vienna

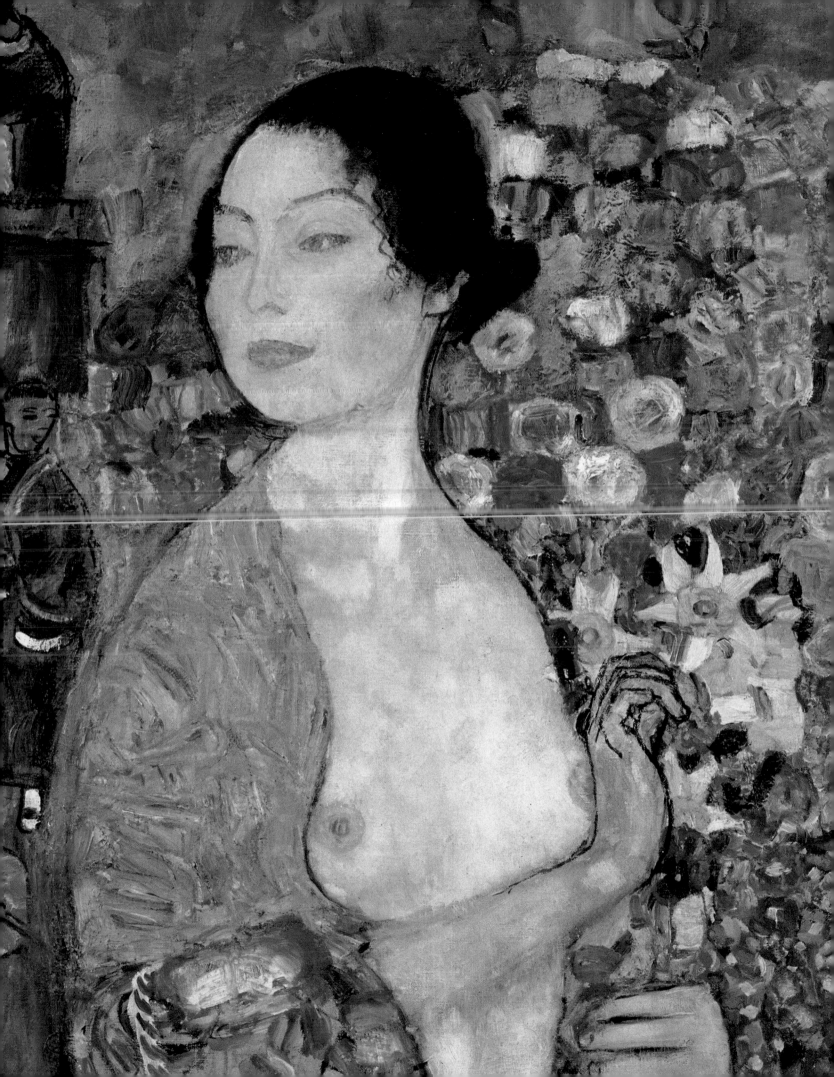

DRAWINGS

PORTRAIT OF A BEARDED MAN, 1879 CAT. NO. D1

HEAD OF A BEARDED MAN, FACING RIGHT, 1879 CAT. NO. D2

GUSTAV KLIMT

PORTRAIT OF A GIRL, HEAD SLIGHTLY TURNED LEFT, 1879 CAT. NO. D3

RECLINING MALE NUDE, 1880 CAT. NO. D5

SEATED MALE NUDE WITH STAFF, 1880 CAT. NO. D4

BOOT STUDY FOR STANDING MAN, 1883–84 CAT. NO. D6

STUDY OF A YOUNG WOMAN IN PROFILE FACING LEFT, CA. 1885 CAT. NO. D8

TWO STUDIES OF A YOUNG WOMAN SEATED AT A TABLE, 1885 CAT. NO. D7

TWO DRESSES, 1885–88 CAT. NO. D9

PORTRAIT OF A CHILD, 1885–86 CAT. NO. D10

SEATED WOMAN RESTING CHIN IN RIGHT HAND, 1895 CAT. NO. D16

PORTRAIT OF A GIRL WITH LOWERED HEAD, FACING RIGHT, 1895
CAT. NO. D17

PORTRAIT OF YOUNG GIRL, 1890–95 CAT. NO. D15

PREPARATORY DRAWING FOR JUNIUS, 1896

CAT. NO. D19

STANDING WOMAN WITH CAPE, CA. 1896 CAT. NO. D20

PORTRAIT OF A SMILING GIRL, 1896 CAT. NO. D18

**WALL DESIGN FOR THE DUMBA MUSIC SALON,
1896–97** CAT. NO. D21

**TWO STANDING WOMEN HOLDING SHEET MUSIC,
1899** CAT. NO. D23

SEATED MAN FACING LEFT, CA. 1896 CAT. NO. D22

PORTRAIT OF AN OLD MAN IN PROFILE FACING LEFT, 1896–98 CAT. NO. D24

HEAD OF AN OLD WOMAN FACING LEFT, HANDS ON TEMPLE, CA. 1903 CAT. NO. D36

PORTRAIT OF AN OLD WOMAN FACING RIGHT, CA. 1903 CAT. NO. D34

STANDING NUDE OLD WOMAN IN PROFILE FACING RIGHT; LEG STUDY, CA. 1903 CAT. NO. D35

GUSTAV KLIMT

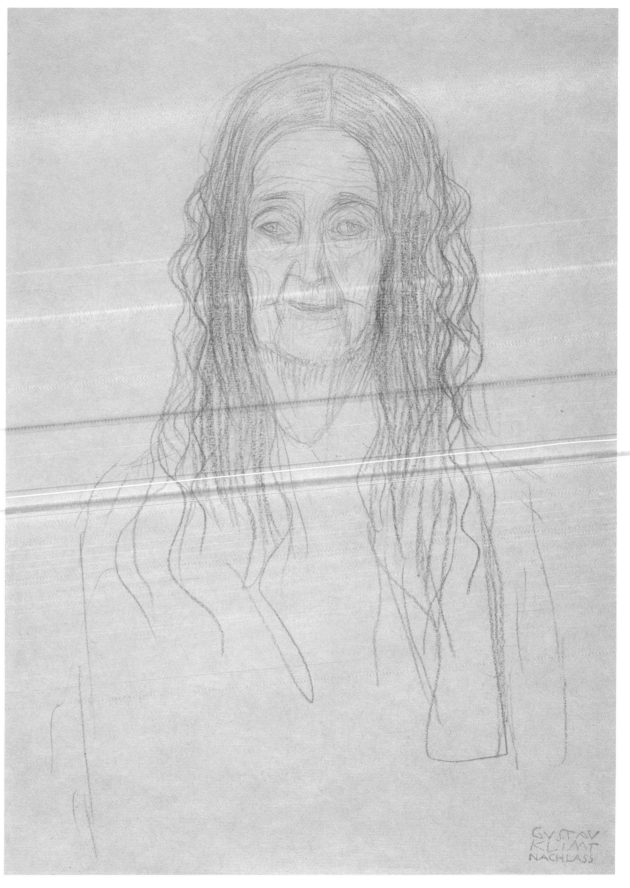

PORTRAIT OF AN OLD WOMAN, CA. 1901 CAT. NO. D33

SEATED WOMAN RESTING, 1902 CAT. NO. D45

RECLINING SEMI-NUDE FACING RIGHT, CA. 1904 CAT. NO. D67

RECLINING NUDE FACING RIGHT, 1905–06 CAT. NO. D68

RECLINING HALF-NUDE WITH RAISED RIGHT LEG, 1904 CAT. NO. D64

ADELE BLOCH-BAUER SEATED, 1903 CAT. NO. D55

ADELE BLOCH-BAUER STANDING IN THREE-QUARTER PROFILE FACING LEFT, 1903–04 CAT. NO. D59

ADELE BLOCH-BAUER SEATED, LEFT ARM ON ARMREST, 1903 CAT. NO. D56

ADELE BLOCH-BAUER

**SEATED IN THREE-QUARTER PROFILE FACING RIGHT,
1903–04** CAT. NO. D57

**WITH HAT AND HANDBAG, TO THE RIGHT A REPEATED
FIGURE, 1911** CAT. NO. D63

**STANDING FACING LEFT, FACE TURNED FORWARD,
1903–04** CAT. NO. D60

ADELE BLOCH-BAUER SEATED IN AN ARMCHAIR FACING FORWARD, RESTING HER TEMPLE ON HER RIGHT HAND, 1903
CAT. NO. D58

PORTRAIT OF AN OLD MAN FACING FRONT, 1908–11 CAT. NO. D62

SEATED OLD WOMAN IN PROFILE FACING LEFT, CA. 1904 AT. NO. D61

STRIDING WOMAN WITH DANGLING RIGHT ARM AND HORIZONTAL LEFT ARM, 1907–08 CAT. NO. D73

STANDING FEMALE NUDE IN PROFILE FACING LEFT, HEAD LOWERED TO THE BACK, 1906–07 CAT. NO. D74

STANDING FEMALE NUDE WITH LONG HAIR AND RAISED LEFT LEG, 1906–07 CAT. NO. D75

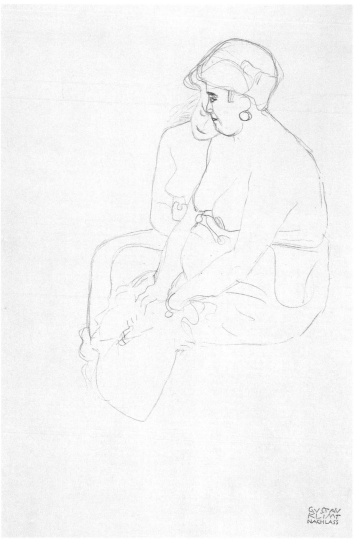

FEMALE NUDE, HER ARMS WRAPPED AROUND THE NECK
OF A HEAVY WOMAN, CA. 1908 CAT. NO. D79

GIRL CUDDLING WITH HEAVY WOMAN, CA. 1908 CAT. NO. D80

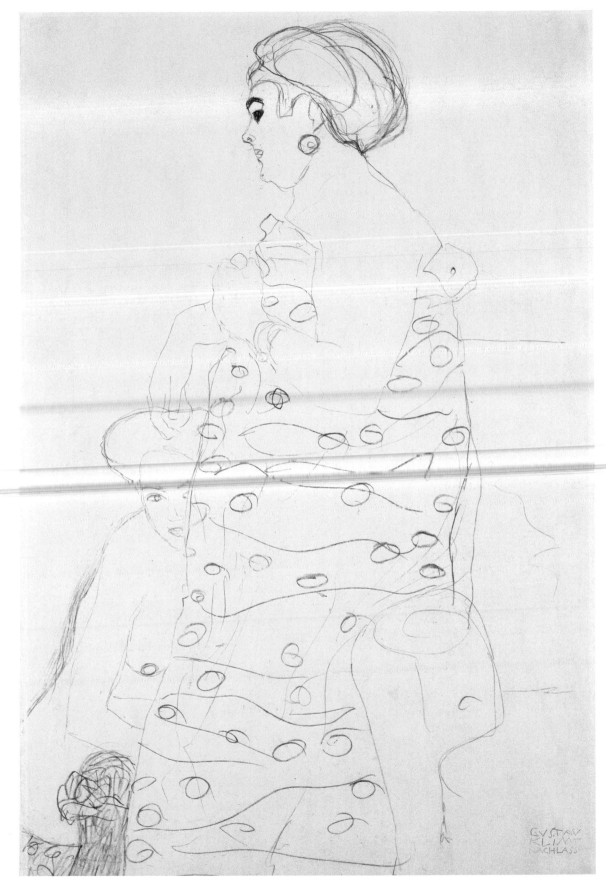

HEAVY, CLOTHED WOMAN IN FOREGROUND, FEMALE NUDE, HALF-HIDDEN AT HER FEET, CA. 1908 CAT. NO. D78

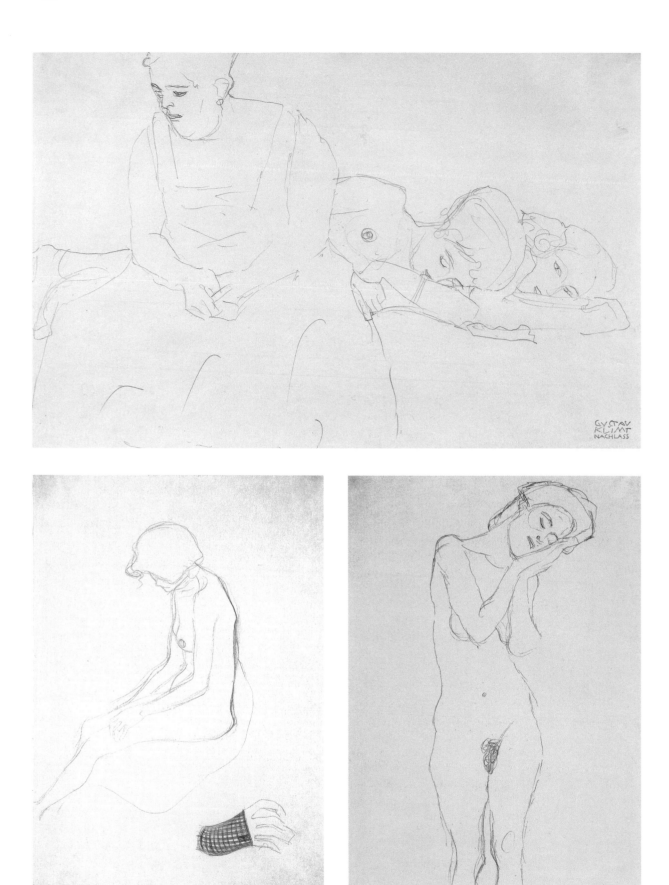

TWO RECLINING NUDES WITH SEATED HEAVY WOMAN, CA. 1908 CAT. NO. D81

SEATED FEMALE NUDE FACING LEFT, FACE COVERED BY HAIR, HAND STUDY, 1908–09 CAT. NO. D82

FEMALE NUDE FACING FRONT, HANDS HELD TO CHEEK, 1908–09 CAT. NO. D83

SEATED NUDE FACING FRONT, 1908–09 CAT. NO. D84

CROUCHING SEATED NUDE, 1908 CAT. NO. D85

NUDE LEANING ON ELBOW FACING RIGHT; CATS, 1910 CAT. NO. D91

SEMI-NUDE RECLINING ON HER BACK, 1910 CAT. NO. D92

WOMAN IN KIMONO FACING LEFT, 1910 CAT. NO. D90

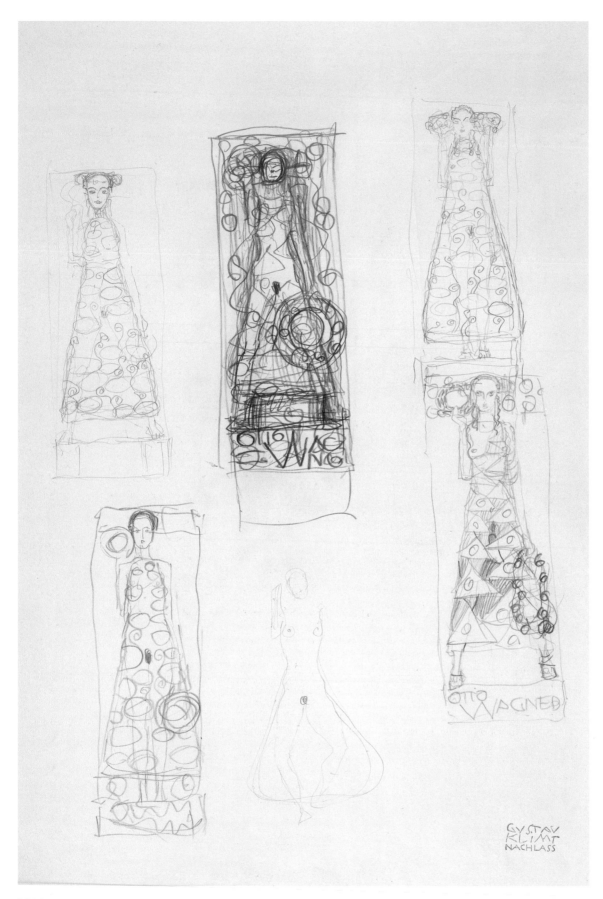

SIX SKETCHES OF A NIKE, 1911 CAT. NO. D94

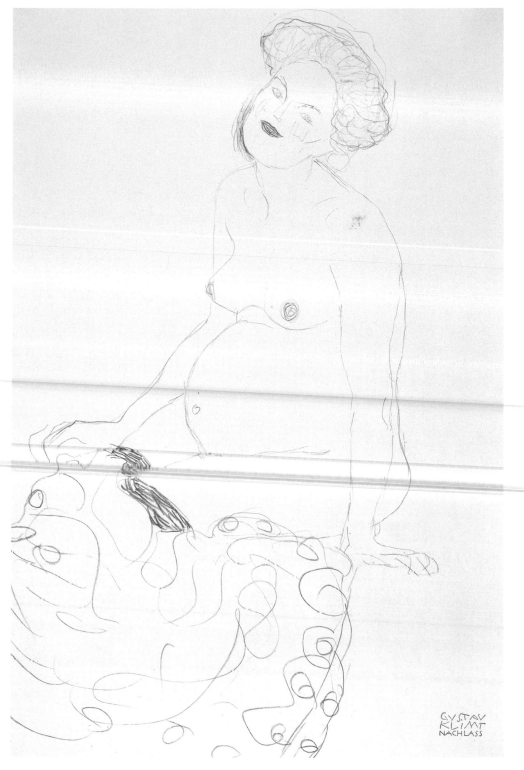

PREGNANT SEMI-NUDE SEATED FACING LEFT, 1910 CAT. NO. D93

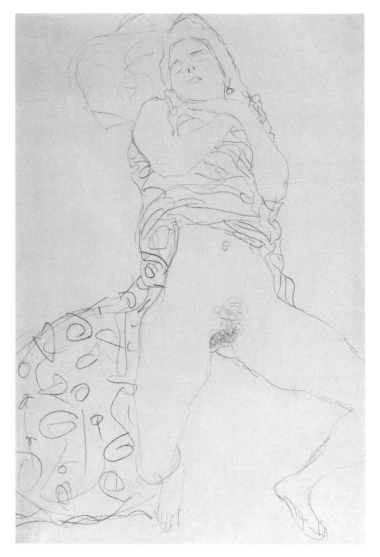

SEMI-NUDE, 1913 CAT. NO. D97

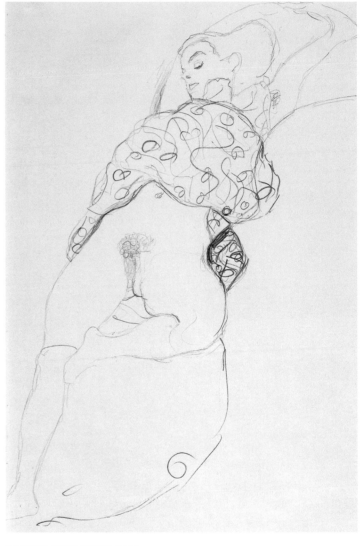

SEATED SEMI-NUDE, 1913 CAT. NO. D98

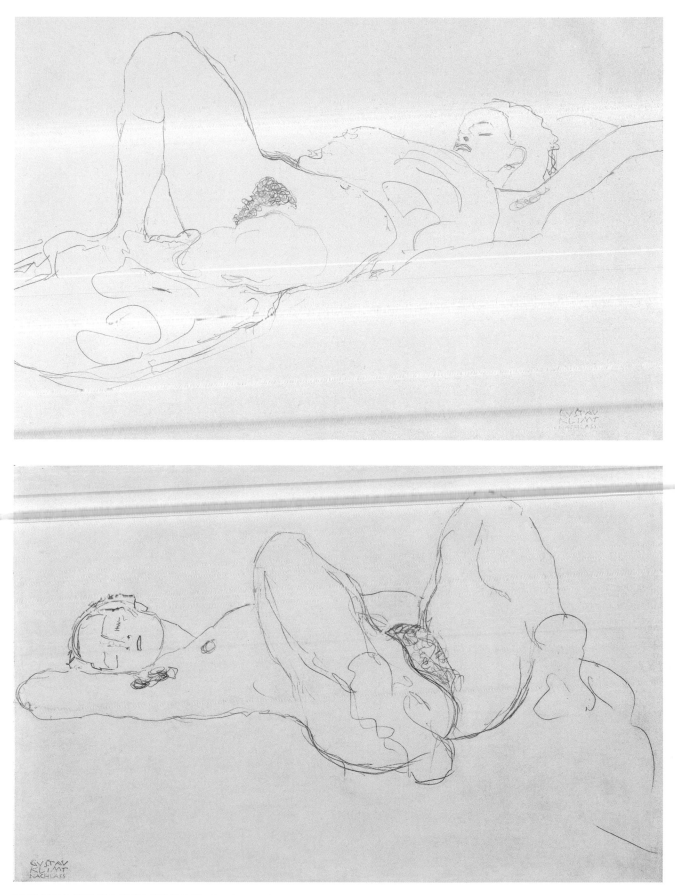

RECLINING FEMALE SEMI-NUDE WITH RAISED RIGHT LEG, 1913 CAT. NO. D100

RECLINING NUDE FACING LEFT WITH RAISED LEGS, 1912–13 CAT. NO. D95

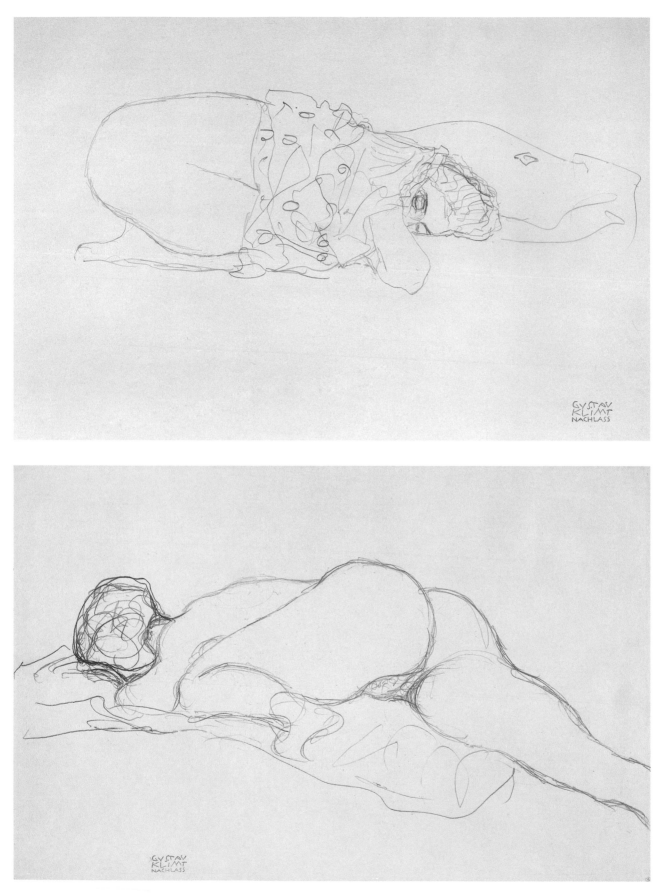

CROUCHING SEMI-NUDE FACING RIGHT, 1913–14 CAT. NO. D102

RECLINING FEMALE NUDE FACING LEFT, 1913–14 CAT. NO. D103

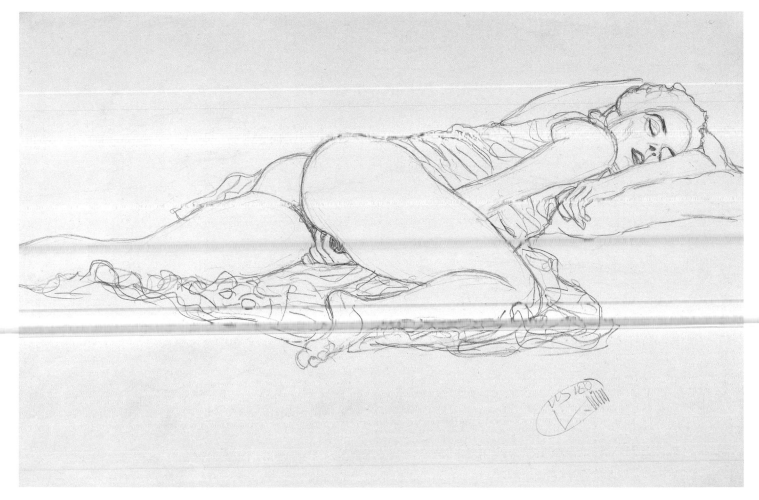

RECLINING NUDE FACING RIGHT, 1912–13 CAT. NO. D96

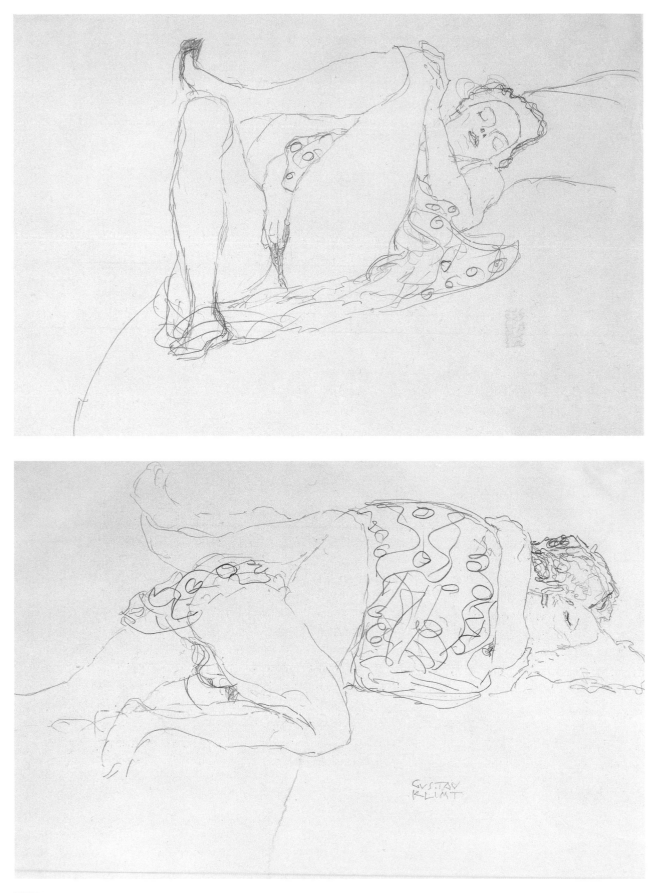

RECLINING FEMALE SEMI-NUDE FACING RIGHT, 1914–15 CAT. NO. D105

LOVERS FACING RIGHT, 1914 CAT. NO. D104

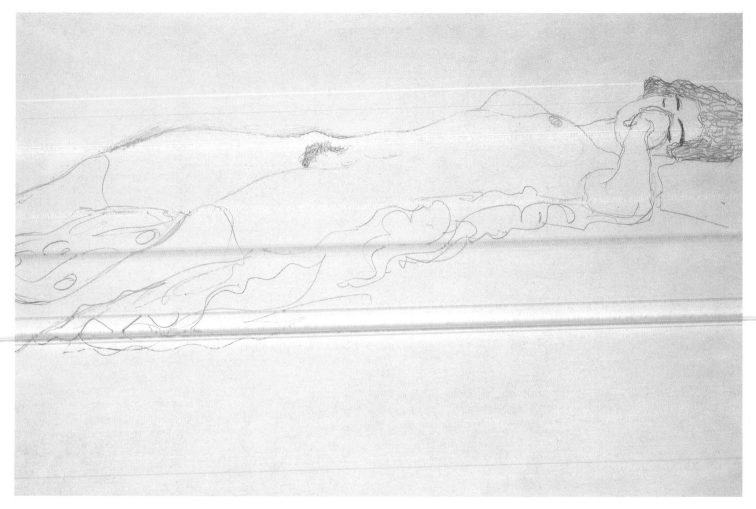

RECLINING FEMALE NUDE FACING RIGHT, 1914–15 CAT. NO. D106

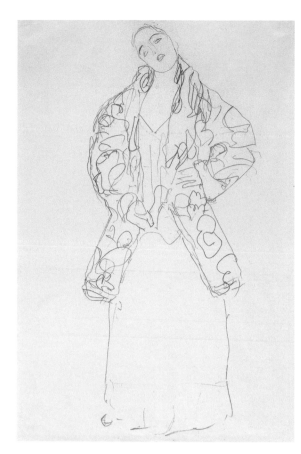

FRIEDERIKE MARIA BEER STANDING FACING FRONT, 1916 CAT. NO. D109

STUDY OF LEFT HAND, LEFT HAND WITH SHAWL, SHOE, 1916 CAT. NO. D108

FRIEDERIKE MARIA BEER HEAD STUDY FACING FRONT, 1916 CAT. NO. D110

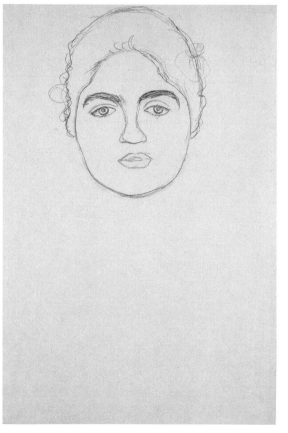

gezeichnet v. Gustav Klimt Trudl Flöge

TRUDL FLÖGE FACING FRONT, CA. 1915 CAT. NO. D107

FRÄULEIN LIESER FACING FRONT, 1917–18 CAT. NO. D119

CHARLOTTE PULITZER FACING FRONT, 1917 CAT. NO. D118

SEATED WOMAN WITH SPREAD THIGHS, 1916–17 CAT. NO. D116

MALE HEAD IN PROFILE FACING LEFT, SKETCH ABOVE, 1917–18 CAT. NO. D126

TWO MALE HEADS FACING LEFT, 1917–18 CAT. NO. D124

HEAD STUDY IN THREE-QUARTER PROFILE FACING RIGHT, 1917–18 CAT. NO. D127

TWO STUDIES OF A MAN, 1917–18 CAT. NO. D125

GUSTAV KLIMT

BABY, 1917–18 CAT. NO. D128

LADY IN

WOMAN RECLINING ON A SOFA WEARING FUR, 1917 CAT. NO. D117

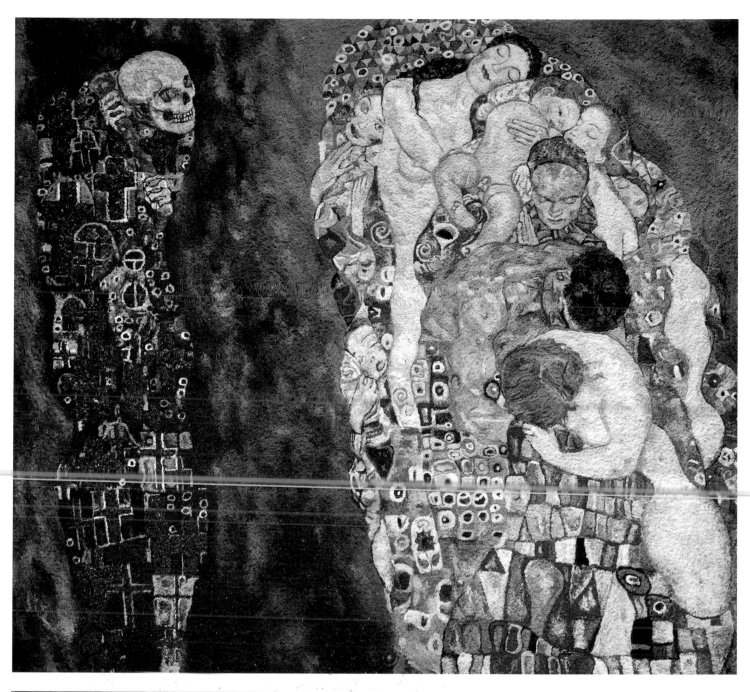

Vik Muniz, *Death and Life, after Gustav Klimt*
(*Pictures of Pigment*), 2006, chromogenic print.
Courtesy Sikkema Jenkins and Co., New York

Gustav Klimt, *Death and Life*, 1908–15, oil on canvas.
Leopold Museum, Vienna.

Vik Muniz, *Ria Munk on her Deathbed, after Gustav Klimt*
(*Pictures of Pigment*), 2006, chromogenic print. Courtesy
Sikkema Jenkins and Co., New York, and Galerie Xippas, Paris

Gustav Klimt, *Ria Munk on her Deathbed*, 1912, oil on canvas.
Private Collection, Courtesy Richard Nagy, London

EVA SCHLEGEL (B. 1960)

I appreciate the work of Gustav Klimt, especially his drawings. With very limited means, only pencil lines, he forms the body in terms of space, volume, and content. While he develops the drawing on the paper, the body itself remains isolated. To me, one of his most impressive works is the *Beethoven Frieze*. Here again he treats his figures like drawings, but they are monumentally isolated. It is also very interesting that he uses ornamentation to abstract the body, to flatten it out—juxtaposing ornament with the highly elaborated faces and hands.

Eva Schlegel, *O.T. 063*, 2005, screenprint on lead.
Courtesy Galerie Krinzinger, Vienna

Gustav Klimt, *Moving Water*, 1898, oil on canvas.
Private Collection

Suzanne Scherer and Pavel Ouporov, *Talking Tree*, 2006, egg tempera and gold leaf on poplar panel. Private Collection, Courtesy the artists

Gustav Klimt, *Tree of Life*, sketch for the dining-room, Palais Stoclet frieze, 1905–11, tempera, watercolor, gold, silver, bronze, chalk, pencil, gold and silver leaf on paper. MAK—Austrian Museum of Applied Arts/Contemporary Art, Vienna

SUZANNE SCHERER (B. 1964) & PAVEL OUPOROV (B. 1966)

Long before I met Pavel Ouporov, we were both inspired by the work of Klimt, though from opposite sides of the globe. Our collaborative work shares with him the use of symbolic and dream imagery, recurring themes of life, death, and rebirth, as well as the influence of Byzantine art and contemporary photography. As in the work of Klimt, the spatial relationships in our paintings alternate between flat and illusionistic space with areas of pattern and motif, in our case, rendered in egg tempera, gold leaf, and other media.

The spiral motif in Klimt's Palais Stoclet frieze was the basis for our 2006 works *Tree of Life* and *Talking Tree*. *Tree of Life*, inspired by our son Nicolas's dream of a talking tree filled with animals, is a reinterpretation of Klimt's frieze—but transformed into a digitally drawn, machine-cut gold vinyl form that is adhered to the wall. Small, interchangeable circular panels, rendered in egg tempera and gold leaf, fill twelve of the spirals. It is an ever-expanding tree that cites quotations from various historical literary figures such as Blake, Chekhov, Dostoevsky, Goethe, and Lao-Tzu—and that can grow new panels with time.

IRIS VAN DONGEN (B. 1975)

Klimt plays with phantasmagoric fatalistic women in his subtle yet powerful although decorative paintings as a leitmotiv of: fin-de-siècle and Secession-inspired idealism; aesthetically formed cultural assurance; *Grunderzeit*; psychosexuality; the male fatal clash of passion; repressed thoughts of weak, virtuous longings; conspicuous fulfillment of death; atmospheric conjuring of the past; ethical ennobled seduction of aggression; harmonies and love; cultural lies; and the *Nuda Veritas* in flesh and blood. This I recognize.

Iris van Dongen, *Pink Roses*, 2005, oil on wood.
Courtesy the artist and Salon 94, New York

Gustav Klimt, *Portrait of Sonja Knips*, 1898, oil on canvas (detail).
Österreichische Galerie Belvedere, Vienna

GABRIEL VORMSTEIN (B. 1974)

My interest in Gustav Klimt's *The Kiss* lies in the juxtaposition of the abstract and the figurative. The work seems to indicate a certain fear of losing the human in the abstract form (a consequence of modernism). In all its formal varieties, the icon of the "kiss" has a ageless quality due to its intimate, emotive quality. With slightly altered patterns and the shape of the figures, you can transfer the "kiss" to the present. Clothing may change in style, but kissing will always remain a timeless and beautiful thing.

Gabriel Vormstein, *La morte non trapasso*, 2003, watercolor on paper. Nathan A. Bernstein and Katharina Otto-Bernstein, New York. Courtesy Meyer Riegger Gallery, Karlsruhe, and Casey Kaplan, New York

Gustav Klimt, *The Kiss*, 1907–08, oil on canvas. Courtesy Österreichische Galerie Belvedere, Vienna

KLIMT AND CONTEMPORARY CULTURE

Klimt and Fashion

ROBERTO CAVALLI

Opposite: Roberto Cavalli dress, worn by Jacquetta Wheeler, originally published in *Vogue*, November 2005.
Photograph by Jonathan Becker

ALEXANDER MCQUEEN

Alexander McQueen, Spring/Summer 2007 ready-to-wear collection

Gustav Klimt, *The Black Feather Hat (Lady with Feather Hat)*, 1910, oil on canvas. Private Collection, courtesy Neue Galerie New York

ANNA SUI

Anna Sui, Spring/Summer 2006 ready-to-wear collection

Gustav Klimt, *Water Serpents II*, 1904–07, oil on canvas.
Private Collection

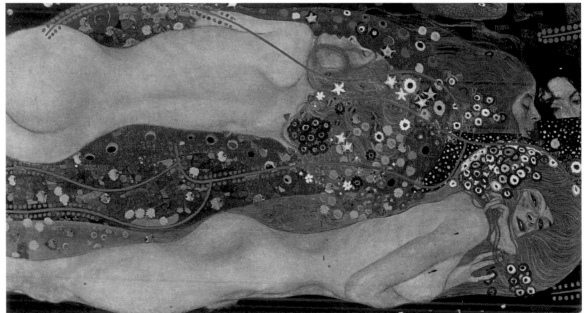

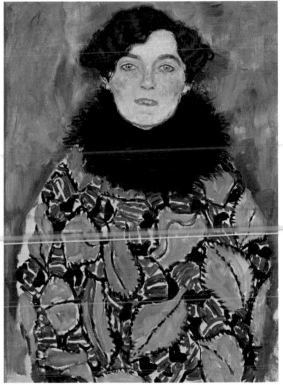

CAROLINA HERRERA

Carolina Herrera, Spring/Summer 2006 ready-to-wear collection

Gustav Klimt, *Portrait of Johanna Staude*, 1917–18 (unfinished), oil on canvas. Courtesy Österreichische Galerie Belvedere, Vienna

CHRISTIAN DIOR

Christian Dior, Fall 2006 couture collection

Gustav Klimt, *Pallas Athena*, 1898, oil on canvas. Wien Museum

CHRISTIAN LACROIX

Christian Lacroix, Spring 2006 couture collection

Gustav Klimt, *Expectation*, sketch for the Palais Stoclet frieze, 1905–11, tempera, watercolor, gold, silver, bronze, chalk, pencil, gold and silver leaf on paper. MAK—Austrian Museum of Applied Arts/Contemporary Arts, Vienna

CHRISTIAN LACROIX

Christian Lacroix, Fall 2006 couture collection

Gustav Klimt, *Portrait of Marie Henneberg*, 1901–02, oil on canvas. Stiftung Moritzburg, Halle

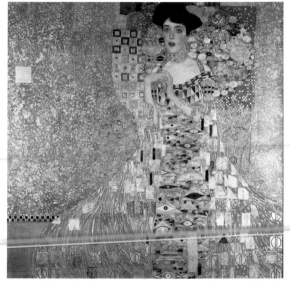

DRIES VAN NOTEN

Dries van Noten, Fall/Winter 2006 ready-to-wear collection

Gustav Klimt, *Adele Bloch-Bauer I*, 1907,
oil on canvas. Neue Galerie New York. This acquisition made
available in part through the heirs of the Estates of Ferdinand
and Adele Bloch-Bauer

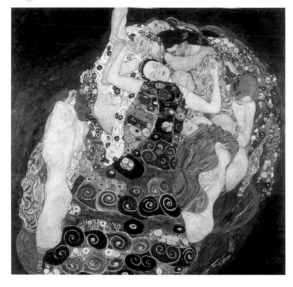

ETRO

Etro, Spring/Summer 2007 ready-to-wear collection

Gustav Klimt, *The Virgin*, 1913. National Gallery, Prague

ETRO

Etro, Spring/Summer 2007 ready-to wear collection

Gustav Klimt, *Baby (Cradle)*, 1917–18, oil and tempera on canvas. National Gallery of Art, Washington, D.C.

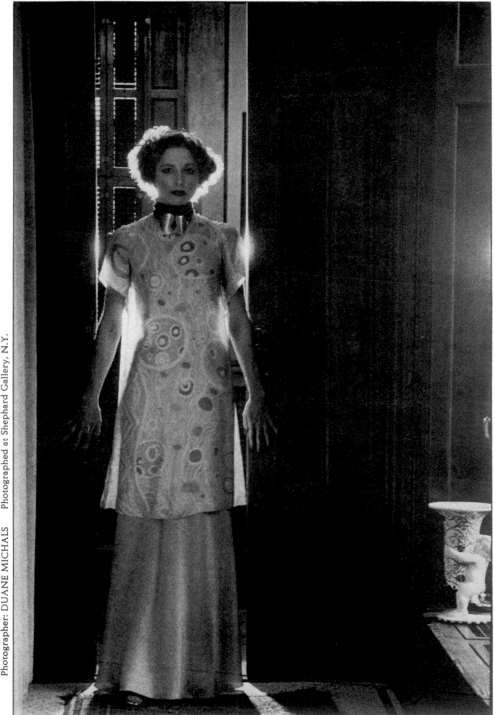

Photographer: DUANE MICHALS Photographed at Shephard Gallery, N.Y.

MARY MCFADDEN

Mary McFadden advertisement, originally published in *Vogue*,
February 1976. Photograph by Duane Michals

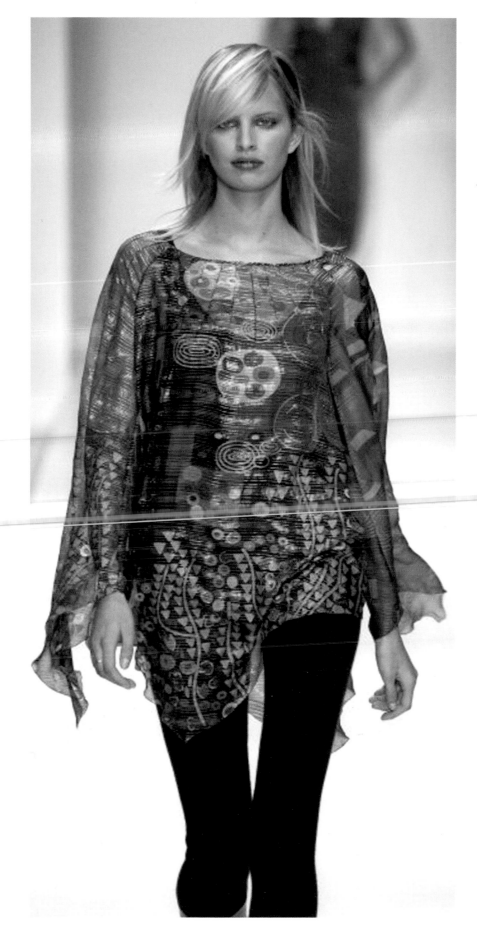

MAX MARA

Max Mara, Fall/Winter 2002 ready-to-wear collection

Bush from the *Tree of Life* (detail), study for the Palais Stoclet frieze, 1905–11, tempera, watercolor, gold, silver, bronze, chalk, pencil, gold and silver leaf on paper. MAK—Austrian Museum of Applied Arts/Contemporary Arts, Vienna

MAX MARA

Max Mara, Fall/Winter 2002 ready-to-wear collection

Gustav Klimt, *Fulfillment*, study for the Palais Stoclet frieze, 1908–10, tempera, watercolor, gold, silver-bronze, crayon, pencil, gold and silver leaf on paper. MAK—Austrian Museum of Applied Arts/Contemporary Arts, Vienna

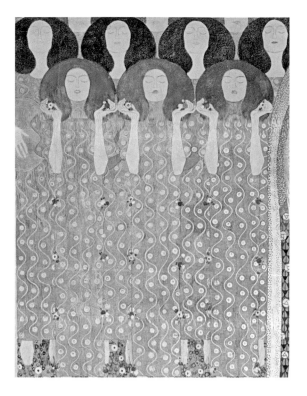

MISSONI

Missoni, Spring/Summer 2006 ready-to-wear collection

Gustav Klimt, *Joy* (detail), from the *Beethoven Frieze*, 1902,
casein colors and semiprecious stone inlay.
Courtesy Österreichische Galerie Belvedere, Vienna

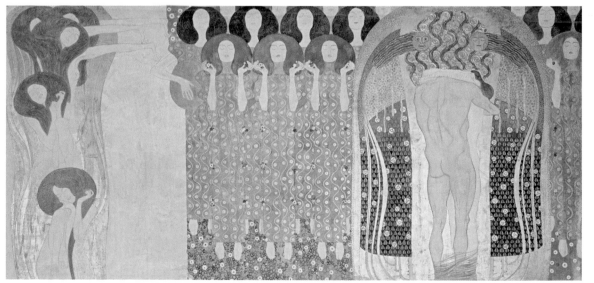

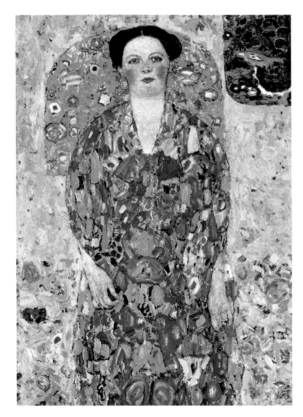

3.1 PHILLIP LIM

3.1 Phillip Lim, Spring 2007 ready-to-wear collection

Gustav Klimt, *Eugenia (Mäda) Primavesi*, 1913–14.
Toyota Municipal Museum of Art, Aichi

ROBERTO CAVALLI

Roberto Cavalli, Spring/Summer 2006 ready-to-wear collection

Gustav Klimt, *The Park*, ca. 1910. The Museum of Modern Art, New York

VALENTINO

Valentino, Fall 2006 couture collection

Gustav Klimt, *Portrait of Margarethe Stonborough-Wittgenstein*, 1905.
Neue Pinakothek, Munich

ZAC POSEN

Zac Posen, Spring/Summer 2007 ready-to-wear collection

Gustav Klimt, *Portrait of Fritza Riedler*, 1906, oil on canvas. Courtesy Österreichische Galerie Belvedere, Vienna

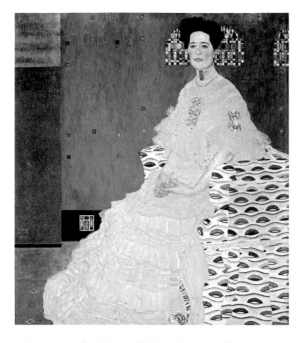

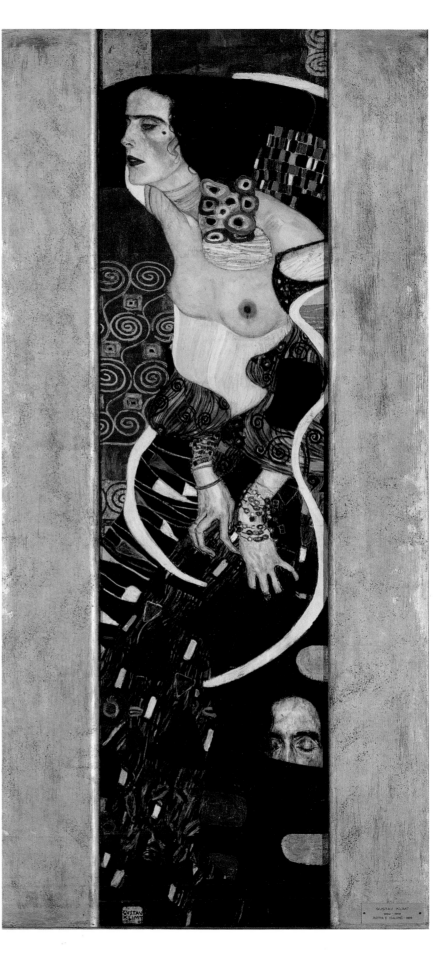

TODD REED

Gustav Klimt, *Portrait of Fritza Riedler*, 1906, oil on canvas.
Courtesy Österreichische Galerie Belvedere, Vienna

Todd Reed cuff bracelet, 2002, gold, silver, brilliant cut diamonds,
raw diamond cubes, rubies, garnets, and iolites

Todd Reed cuff bracelet, 2006, gold, natural diamond macles,
raw diamond cubes, rough cut rubies

Gustav Klimt, *Judith II (Salome)*, 1909, oil on canvas.
Galleria d'Arte Moderna di Ca'Pesaro, Venice

KLIMT AND CONTEMPORARY CULTURE

Klimt-Inspired Jewelry

FREY WILLE

Gustav Klimt, *Portrait of Emilie Flöge*, 1902 (detail)

Todd Reed bracelet, 2005, gold, princess cut diamonds and
raw diamond cubes

Frey Wille, enamel bracelet, set in 24 carat gold, 2007

Frey Wille, silk scarf, 2007

Frey Wille, enamel rings, set in 24 carat gold, 2007

KLIMT AND CONTEMPORARY CULTURE

Klimt in the Popular Sphere

"I know Beth from the days when 'Christina's World' was
up where the Klimt is now."

Captions for images on pp. 388–93 are listed on p. 477

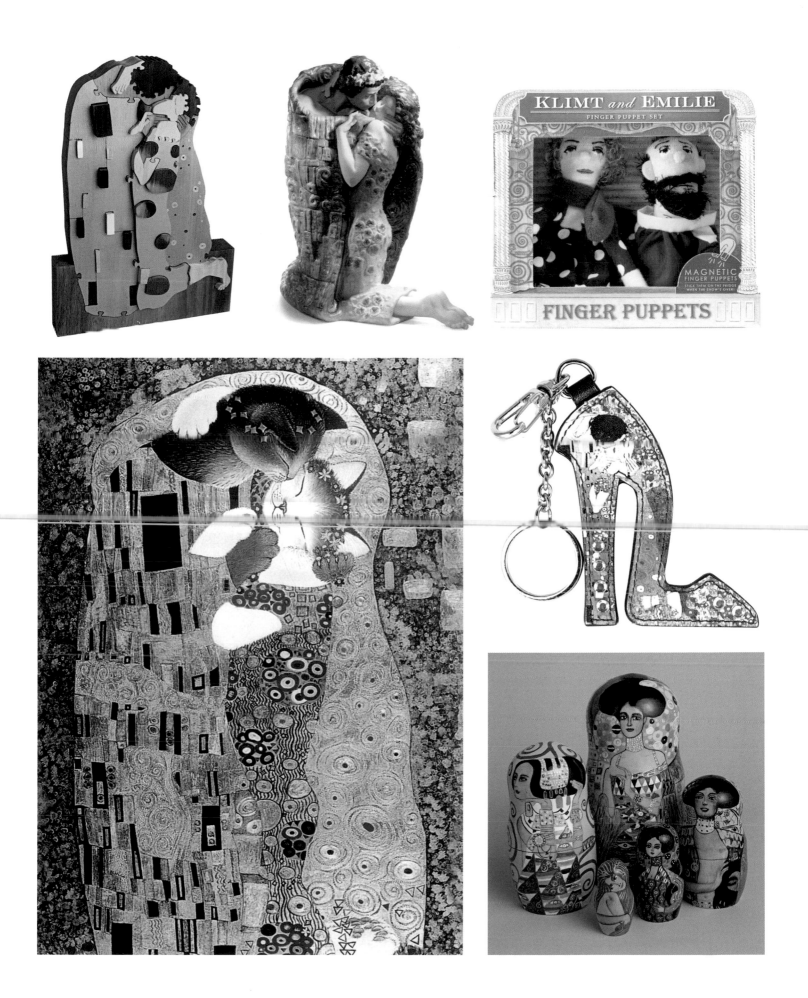

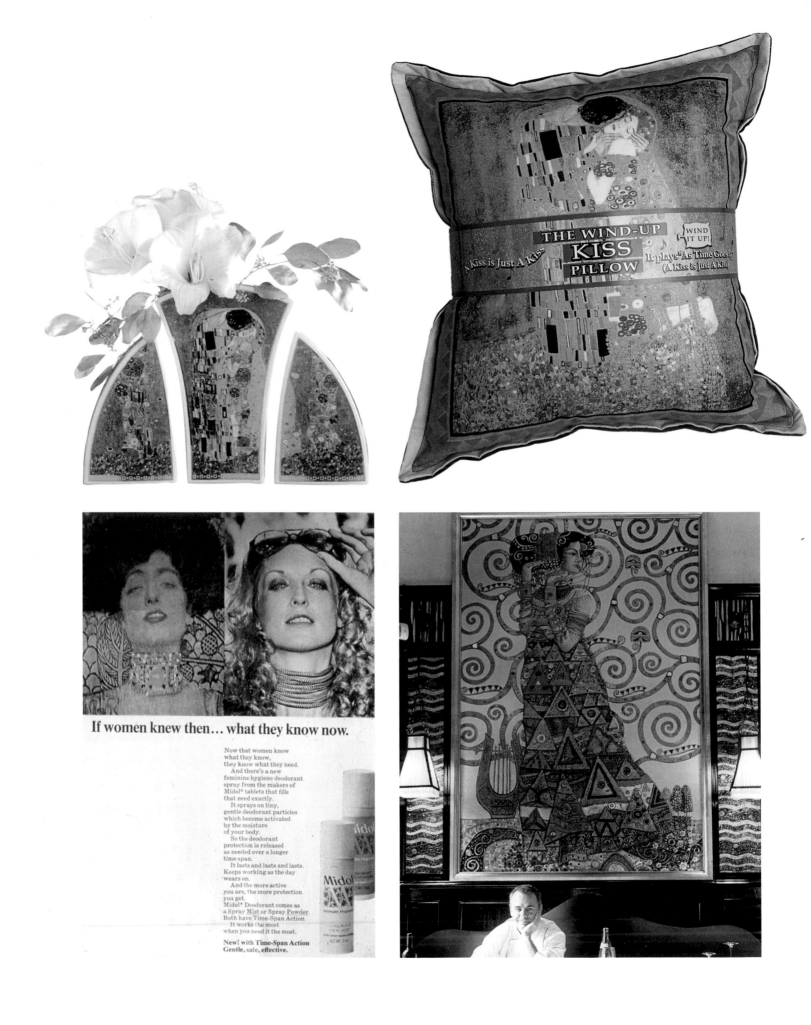

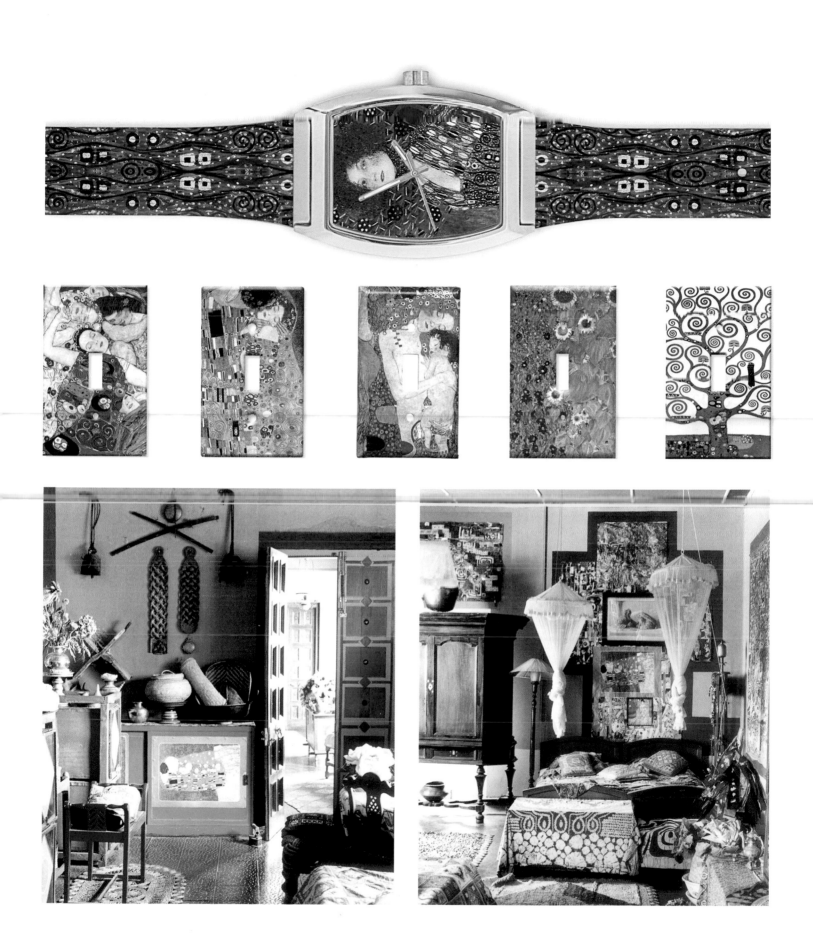

Gustav Klimt

g K
1887

G. K
1897

GVSTAV
KLIMT

GVSTAV
KLIMT

GVSTAV
KLIMT

GVSTAV
KLIMT

GVSTAV
KLIMT

GVSTAV
KLIMT

GVSTAV
KLIMT

CHECKLIST

Neue Galerie New York is committed to researching provenance histories of its holdings and to making this information available to the public in accordance with guidelines established by the American Association of Museums. In the preparation of this catalogue, Neue Galerie New York has endeavored to establish the provenance histories of the exhibited works as fully as possible. All references to previous ownership based on primary sources and publications, such as inscriptions and stamps, exhibition catalogues, sale catalogues, gallery records, and/or inventories of private collections, have been included in this catalogue.

The work of Gustav Klimt has been well documented. The original *catalogue raisonné* for his paintings was published by Fritz Novotny and Johannes Dobai in 1967 (second edition 1975); an English translation appeared in 1968 entitled *Gustav Klimt: With a Catalogue Raisonné of His Paintings*. A revised *catalogue raisonné* of the Klimt paintings by Alfred Weidinger is due to appear in fall 2007. The four-volume *catalogue raisonné* of his drawings was published from 1980–89 by Alice Strobl: *Gustav Klimt: Die Zeichnungen*. A fifth supplemental volume on the drawings is in preparation by Marian Bisanz-Prakken. For more details on these publications refer to the Bibliography in this catalogue.

PAINTINGS

CAT. NO. P1
THE TALL POPLAR TREE I
(Die Grosse Pappel I) 1900
Oil on canvas
80 x 80 cm (31 ½ x 31 ½ in.)
Unsigned, undated; stamped on verso four times, illegible;
inscription on stretcher, illegible

Provenance:
Magda Mautner Markhof, Vienna
European Private Collector, by descent
Sotheby's, London
Private Collection, New York

Literature:
Novotny/Dobai 111
Weidinger 143

CAT. NO. P2
PALE FACE
(Bleiches Gesicht) 1903
Oil on canvas
80 x 40 cm (31 ½ x 15 ¾ in.)
Unsigned, undated

Provenance:
Galerie Neumann, Vienna
Private Collection, United States
Bruce Goff, Kansas City, Missouri
Galerie St. Etienne, New York
Private Collection, New York

Literature:
Novotny/Dobai 156 (dated 1907–08)
Weidinger 170

CAT. NO. P3
ADELE BLOCH-BAUER I
(Bildnis Adele Bloch-Bauer I) 1907
Oil, silver, and gold on canvas
140 x 140 cm (55 ⅛ x 55 ⅛ in.)
Inscribed l. r.: GUSTAV/KLIMT/1907

Provenance:
Adele and Ferdinand Bloch-Bauer,
Vienna, acquired from the artist
Seized by the Viennese Magistrate (following the Nazi
Anschluss, March 1938)
Dr. Erich Führer, Vienna (state-appointed administrator
for Ferdinand Bloch-Bauer)
Österreichische Galerie Belvedere, Vienna, no. 3830
The heirs of Adele and Ferdinand Bloch-Bauer, by

restitution from the Republic of Austria
Neue Galerie New York. This acquisition made available
in part through the generosity of the heirs of the Estates
of Ferdinand and Adele Bloch-Bauer

Literature:
Novotny/Dobai 150
Weidinger 184

CAT. NO. P4
HOPE II
(Die Hoffnung II) 1907–08
Oil, gold, and platinum on canvas
110.5 x 110.5 cm (43 ½ x 43 ½ in.)
Signed l. r.: GUSTAV/KLIMT

Provenance:
Gustav Klimt, Vienna
Eugenia Primavesi, Vienna
Neue Galerie (Dr. Otto Kallir), Vienna
Private Collection
Private Collection, Vienna
Hans Barnas, Vienna
Galerie Beyeler, Basel
The Museum of Modern Art, New York.
Jo Carole and Ronald S. Lauder, and Helen Acheson
Funds, and Serge Sabarsky

Literature:
Novotny/Dobai 155
Weidinger 188

CAT. NO. P5
THE BLACK FEATHER HAT
(LADY WITH FEATHER HAT)
(Der Schwarze Federhut) 1910
Oil on canvas
79 x 63 cm (31 ⅛ x 24 ¾ in.)
Signed and dated l. r.: GUSTAV/KLIMT/1910

Provenance:
Galerie Miethke, Vienna
Rudolf Kahler, Vienna
Beran Collection, Brno and Prague
Private Collection, Graz
Aberbach Gallery, New York
Private Collection, New York

Literature:
Novotny/Dobai 168
Weidinger 200

CAT. NO. P6
THE PARK OF SCHLOSS KAMMER
(Schlosspark Kammer) ca. 1910
Oil on canvas
110 x 110 cm (43 ¼ x 43 ¼ in.)
Unsigned, undated

Provenance:
Galerie Miethke, Vienna
Heinrich Böhler, Vienna
Galerie Welz, Salzburg
Galerie Neumann, Vienna
Bruce Goff, Kansas City, Missouri
Galerie St. Etienne, New York
Private Collection, New York

Literature:
Novotny/Dobai 167
Weidinger 197

CAT. NO. P7
FORESTER HOUSE IN WEISSENBACH
ON THE ATTERSEE
(Forsthaus in Weissenbach am Attersee) 1914
Oil on canvas
110 x 110 cm (43 ¼ x 43 ¼ in.)
Signed l. l.: GUSTAV/KLIMT

Provenance:
Viktor Zuckerkandl, Vienna
Hans Böhler, Vienna
Serge Sabarsky Gallery, New York
Private Collection, New York

Literature:
Novotny/Dobai 182
Weidinger 220

CAT. NO. P8
THE DANCER
(Die Tänzerin) 1916-18
Oil on canvas
180 x 90 cm (71 ¹¹⁄₁₆ x 35 ⅜ in.)
Unsigned, undated

Provenance:
Richard Lányi, Vienna
Galerie Gustav Nebehay, Vienna
Joseph Urban, Vienna and New York
Private Collection, Paris
Private Collection, New York

Literature:
Novotny/Dobai 208
Weidinger 238

DRAWINGS

Klimt's drawings and sketches are preliminary studies in preparation for his paintings. The drawings here are organized chronologically and grouped by project, as annotated in the literature at the end of each caption.

CAT. NO. D1
PORTRAIT OF A BEARDED MAN
(Brustbild eines bärtigen Mannes von vorne) 1879
Charcoal with white heightening
40.3 x 26.7 cm (15⁷/₈ x 10¹/₂ in.)
Signed and dated l. r.: Gustav Klimt/1879

Provenance:
Betty Richard Matsch
Serge Sabarsky Collection, New York

Literature:
Strobl 3185

CAT. NO. D2
HEAD OF A BEARDED MAN, FACING RIGHT
(Kopf eines bärtigen Mannes im Dreiviertelprofil nach rechts) 1879
Charcoal with white heightening
40.5 x 25 cm (16 x 9⁷/₈ in.)
Signed and dated l. l.: G. Klimt (underlined)/24/1/1879

Provenance:
Rudolf Zimpel, Vienna
Galerie Welz, Salzburg
Serge Sabarsky Collection, New York

Literature:
Strobl 27

CAT. NO. D3
PORTRAIT OF A GIRL, HEAD SLIGHTLY TURNED LEFT
(Brustbild eines kleinen Mädchens mit leichter Wendung des Kopfes nach links) 1879
Charcoal with white heightening
36.5 x 26.5 cm (14³/₈ x 10³/₈ in.)
Signed and dated l. r.: Gustav Klimt (underlined)/1879

Provenance:
C. G. Boerner, Düsseldorf
Serge Sabarsky Collection, New York

Literature:
Strobl 30

CAT. NO. D4
SEATED MALE NUDE WITH STAFF
(Sitzender Männerakt mit Stab) 1880
Pencil
38.9 x 27 cm (15³/₈ x 10⁵/₈ in.)
Signed and dated l. r.: Gustav Klimt/den 19/5/1880

Provenance:
Erich Lederer, Geneva
Serge Sabarsky Gallery, New York
José Martinez
Serge Sabarsky Collection, New York

Literature
Strobl 3178

CAT. NO. D5
RECLINING MALE NUDE
(Liegender Männerakt) 1880
Pencil
28.9 x 43.2 cm (11³/₈ x 17 in.)
Signed and dated l. r.: Gustav Klimt (underlined)/den 13 [sic] Februar/1880

Provenance:
Erich Lederer, Geneva
Serge Sabarsky Collection, New York

Literature:
Strobl 16

CAT. NO. D6
BOOT STUDY FOR STANDING MAN
(Stiefelstudien für einen Stehenden) 1883–84
Pencil with white heightening
45 x 31.5 cm (17³/₄ x 12³/₈ in.)
Stamped l. l. corner on verso in ink: NACHLASS/GUSTAV/KLIMT/SAMMLUNG/R. ZIMPEL

Provenance:
Estate of Gustav Klimt, as per stamp
Rudolf Zimpel, Vienna, as per stamp
Christian M. Nebehay, Vienna
Scott Elliot, New York
Serge Sabarsky Collection, New York

Literature:
Strobl 100

CAT. NO. D7
TWO STUDIES OF A YOUNG WOMAN SEATED AT A TABLE
(Zwei Studien einer an einem Tisch sitzenden jungen Frau, Wiederholung der rechten Schulterlinie) 1885
Pencil with white heightening
35 x 31.5 cm (13³/₄ x 12³/₈ in.)
Stamped l. r. in ink: GUSTAV/KLIMT/NACHLASS

Provenance:
Estate of Gustav Klimt, as per stamp
Serge Sabarsky Collection, New York

Literature:
Strobl 123
Study for the ceiling of the Stadttheater Karlsbad (Karlovy Vary, Czech Republic)

CAT. NO. D8
STUDY OF A YOUNG WOMAN IN PROFILE FACING LEFT
(Mädchenstudie im Profil nach links) ca. 1885
Pencil and black chalk with white heightening
45 x 31.5 cm (17³/₄ x 12³/₈ in.)
Stamped l. r. corner in ink: GUSTAV/KLIMT/NACHLASS

Provenance:
Estate of Gustav Klimt, as per stamp
Serge Sabarsky Collection, New York

Literature:
(Not in Strobl)
Study for the ceiling of the Stadttheater Karlsbad (Karlovy Vary, Czech Republic)

CAT. NO. D9
TWO DRESSES
(Zwei Kleider) 1885–88
Pencil heightened with white chalk
45 x 31.1 cm (17³/₄ x 12¹/₄ in.)
Stamped l. r. corner in ink: GUSTAV/KLIMT/NACHLASS

Provenance:
Estate of Gustav Klimt, as per stamp
Erich Lederer, Geneva
Elisabeth Lederer, Geneva
Estate of Erich and Elisabeth Lederer, Vienna
de Pury & Luxembourg Art, Geneva
Private Collection, New York

Literature:
(Not in Strobl)
Study for the ceiling of the Stadttheater Karlsbad (Karlovy Vary, Czech Republic)

CAT. NO. D10
PORTRAIT OF A CHILD
(Porträt eines Kindes) 1885–86
Charcoal and pencil with white heightening
45 x 31.3 cm (17³/₄ x 12³/₈ in.)
Inscribed l. r. corner on verso: DR R L Dec 80 AS 60
Inscribed near center of l. edge on verso: HR

Provenance:
Rudolf Leopold, Vienna, as per inscription
Serge Sabarsky Collection, New York

Literature:
(Not in Strobl)
Study for the staircase ceiling of the Burgtheater, Vienna

CAT. NO. D11

STANDING BEARDED MAN IN PROFILE FACING LEFT; TWO HAND STUDIES

(Stehender, bärtiger Mann im verlorenen Profil nach links, Zwei Wiederholungen der rechten Hand) 1886–88
Charcoal with white heightening
44.8 x 31.1 cm (17 5/8 x 12 1/4 in.)
Inscribed in center on verso: gezeichnet von Gustav Klimt/(um 1887)/Georg Klimt

Provenance:
Estate of Gustav Klimt, Vienna, probably, as per inscription
Georg Klimt, probably, as per inscription
Serge Sabarsky Collection, New York

Literature:
Strobl 150
Study for the staircase ceiling of the Burgtheater, Vienna

CAT. NO. D12

BEARDED YOUNG MAN WITH CAP IN PROFILE FACING LEFT

(Bärtiger jüngerer Mann mit Kappe im verlorenen Profil nach links) 1886–88
Charcoal with white heightening
45.1 x 31.7 cm (17 3/4 x 12 1/2 in.)
Stamped l. r. corner in ink: GUSTAV/KLIMT/NACHLASS

Provenance:
Estate of Gustav Klimt, as per stamp
Serge Sabarsky Collection, New York

Literature:
Strobl 155
Study for the staircase ceiling of the Burgtheater, Vienna

CAT. NO. D13

JAPANESE AND NUBIAN WOMEN

(Japanerin und Nubierin) 1887–88
Pen and ink and pencil
19.3 x 23.8 cm (7 5/8 x 9 3/8 in.)
Stamped l. l. corner on verso in ink:
NACHLASS/GUSTAV/KLIMT/SAMMLUNG/R. ZIMPEL
Extensive inscription on verso

Provenance:
Estate of Gustav Klimt, as per stamp
Rudolf Zimpel, Vienna, as per stamp
Christian M. Nebehay, Vienna
Prince Sadruddin Aga Khan
Sotheby Parke Bernet Inc., New York
Serge Sabarsky Collection, New York

Literature:
Strobl 189

CAT. NO. D14

STANDING YOUNG WOMAN PUTTING ON HEADSCARF

(Stehende junge Frau, ein Kopftuch umlegend) 1888–89
Black chalk with white heightening
45.2 x 31.6 cm (17 3/4 x 12 1/2 in.)
Stamped l. r. in ink: GUSTAV/KLIMT/NACHLASS

Provenance:
Estate of Gustav Klimt, as per stamp
Klipstein und Kornfeld, Bern
Grace Borgenicht Gallery, New York
Serge Sabarsky Collection, New York

Literature:
Strobl 215
Study for Auditorium of the Old Burgtheater
(Zuschauerraum des Alten Burgtheaters), 1888

CAT. NO. D15

PORTRAIT OF YOUNG GIRL

(Brustbild eines Mädchens von vorne) 1890–95
Black chalk with white heightening
43.8 x 30.8 cm (17 1/4 x 12 1/8 in.)

Provenance:
Galerie Hassfurther, Vienna
Galerie Michael Pabst, Munich
Serge Sabarsky Collection, New York

Literature:
Strobl 249

CAT. NO. D16

SEATED WOMAN RESTING CHIN IN RIGHT HAND

(Sitzende von vorne, das Kinn auf die rechte Hand gestützt) 1895
Black chalk
44.5 x 31.7 cm (17 1/2 x 12 1/2 in.)
Stamped l. r. in ink: GUSTAV/KLIMT/NACHLASS

Provenance:
Estate of Gustav Klimt, as per stamp
Serge Sabarsky Collection, New York

Literature:
Strobl 297
Study for the Music Salon at the Palais Dumba, Vienna

CAT. NO. D17

PORTRAIT OF A GIRL WITH LOWERED HEAD, FACING RIGHT

(Brustbild eines Mädchens mit gesenktem Kopf nach rechts) 1895
Charcoal
45.4 x 32.4 cm (17 7/8 x 12 3/4 in.)
Stamped l. r. in ink: GUSTAV/KLIMT/NACHLASS

Provenance:
Estate of Gustav Klimt, as per stamp
Serge Sabarsky Collection, New York

Literature:
Strobl 3296
Study for the Music Salon at the Palais Dumba, Vienna

CAT. NO. D18

PORTRAIT OF A SMILING GIRL

(Brustbild eines lachenden Mädchens von vorne) 1896
Charcoal
44.8 x 31.7 cm (17 5/8 x 12 1/2 in.)
Stamped l. r. in ink: GUSTAV/KLIMT/NACHLASS

Provenance:
Estate of Gustav Klimt, as per stamp
Erich Lederer, Geneva
Serge Sabarsky Collection, New York

Literature:
Strobl 274

CAT. NO. D19

PREPARATORY DRAWING FOR JUNIUS

(Vorzeichnung für Junius) 1896
Watercolor, gouache, pencil, and gold paint
44.4 x 31.1 cm (17 1/2 x 12 1/4 in.)
Inscribed along l. center: JUNI
Erased and illegible inscription l. l.
Stamped l. r. corner in ink: GUSTAV/KLIMT/NACHLASS

Provenance:
Estate of Gustav Klimt, as per stamp
Erich Lederer, Geneva
Elisabeth Lederer, Geneva
Estate of Erich and Elisabeth Lederer, Vienna
de Pury & Luxembourg Art, Geneva
Private Collection, New York

Literature:
Strobl 271
Study for *Junius*, 1896

CAT. NO. D20

STANDING WOMAN WITH CAPE

(Stehende Dame mit Cape von vorne) ca. 1896
Pencil with white heightening
44.1 x 29.8 cm (17 3/8 x 11 3/4 in.)
Signed l. r. in charcoal below image: GUSTAV KLIMT

Provenance:
August Lederer, Vienna
Estate of Gustav Klimt, as per stamp
Erich Lederer, Geneva
Elisabeth Lederer, Geneva
Estate of Erich and Elisabeth Lederer, Vienna
de Pury & Luxembourg Art, Geneva
Private Collection, New York

Literature:
Strobl 270
Possibly a study for *Portrait of Sonja Knips*

CAT. NO. D21
WALL DESIGN FOR THE DUMBA MUSIC SALON
(Entwurf einer Wand mit Tür und Supraporte des
Musiksalons Dumba) 1896–97
Watercolor, gouache, and pencil
33 x 43.4 cm (13 x 17 1/8 in.)
Stamped l. r. corner in ink: GUSTAV KLIMT NACHLASS
Inscribed l. r. near l. edge in pencil: 1 METER

Provenance:
Estate of Gustav Klimt, as per stamp
Erich Lederer, Geneva
Elisabeth Lederer, Geneva
Estate of Erich and Elisabeth Lederer, Vienna
de Pury & Luxembourg Art, Geneva
Private Collection, New York

Literature:
Strobl 319

CAT. NO. D22
SEATED MAN FACING LEFT
(Sitzender Mann nach links) ca. 1896
Pencil
45.1 x 31.4 cm (17 5/8 x 12 3/8 in.)
Stamped l. r. corner in ink: GUSTAV/KLIMT/NACHLASS
Inscribed in center near lower edge in pencil on verso:
SKIZZE ZUM ("DUMBA- SUPRAPORT"/"SCHUBERT AM
KLAVIER" (sic!)

Provenance:
Estate of Gustav Klimt, as per stamp and "Z. Nr."
Erich Lederer, Geneva
Elisabeth Lederer, Geneva
Estate of Erich and Elisabeth Lederer, Vienna
de Pury & Luxembourg Art, Geneva
Private Collection, New York

Literature:
Strobl 312
Study for Palais Dumba, Vienna, *Schubert at the Piano*
(*Schubert am Klavier*), 1898–99

CAT. NO. D23
TWO STANDING WOMEN HOLDING SHEET MUSIC
(Zwei nebeneinanderstehende Mädchen nach links,
Blätter in den Händen haltend) 1899
Black crayon
45 x 31 cm (17 3/4 x 12 1/4 in.)

Provenance:
L'Art Ancien, Zurich
Estelle M. Konheim, New York
Galerie St. Etienne, New York
Neue Galerie New York

Literature:
Strobl 310
Study for Palais Dumba, Vienna, *Schubert at the Piano*
(*Schubert am Klavier*), 1898–99

CAT. NO. D24
PORTRAIT OF AN
OLD MAN IN PROFILE FACING LEFT
(Brustbild eines Greises im Profil nach links) 1896–98
Pencil with white heightening
45.5 x 30.5 cm (17 7/8 x 12 in.)
Stamped l. r. in ink: GUSTAV/KLIMT/NACHLASS

Provenance:
Estate of Gustav Klimt, as per stamp
Galerie Michael Pabst, Munich
Serge Sabarsky Collection, New York

Literature:
Strobl 380

CAT. NO. D25
PORTRAIT OF A MAN IN PROFILE FACING LEFT
(Brustbild eines Mannes im Profil nach links) 1897–98
Black chalk
45.4 x 31.1 cm (17 7/8 x 12 1/4 in.)

Provenance:
Erich Lederer, Geveva
Serge Sabarsky Collection, New York

Literature:
Strobl 3317A

CAT. NO. D26
FLOATING FEMALE NUDE IN FRONT OF DARK
BACKGROUND
(Schwebender vor dunklem Hintergrund) 1897–98
Pencil with white heightening
45.1 x 32 cm (17 3/4 x 12 5/8 in.)
Stamped l. r. in ink: GUSTAV/KLIMT/NACHLASS

Provenance:
Estate of Gustav Klimt, as per stamp
Serge Sabarsky Collection, New York

Literature:
Strobl 530
Study for *Medicine* (*Medizin*), 1901–07

CAT. NO. D27
DESIGN FOR THE FIRST SECESSION POSTER
(Entwurf des ersten Secessionsplakates) 1898
Black chalk
63 x 45.1 cm (24 3/4 x 17 3/4 in.)
Stamped l. r. in ink: GUSTAV/KLIMT/NACHLASS
Sketch with *Ver Sacrum* inscription on verso
Inscription upper l. in image: VER/SACRUM
Inscription lower center in image on recto: INTERNATIONALE
KUNST =/AUSSTELLUNG DER VEREINIGUNG/BILDENDER
KÜNSTLER ÖSTERREICHs/VON ENDE MÄRZ BIS 1. JUNI
1898/PARKRING 12 GARTENBAU
GESELLSCHAFT/GEÖFFNET VON 9H .../EINTRITT 1 KRONE

Provenance:
Estate of Gustav Klimt, as per stamp and "Z. Nr."
Erich Lederer, Geneva

Elisabeth Lederer, Geneva
Estate of Erich and Elisabeth Lederer, Vienna
de Pury & Luxembourg Art, Geneva
Private Collection, New York

Literature:
Strobl 329

CAT. NO. D28
COMPOSITION SKETCH FOR "ARCHITECTURE,"
AND SKETCH FOR VER SACRUM CAT. NO. 367
(Kompositionsskizze für "Architektur" und Skizze der
Randleiste für *Ver Sacrum* Kat. Nr. 367) 1897–98
Black chalk
45 x 31.7 cm (17 3/4 x 12 1/2 in.)
Stamped l. l. corner in ink: GUSTAV/KLIMT/NACHLASS
Inscribed along lower portion of sketch for architecture in
charcoal: ARCHITECT

Provenance:
Estate of Gustav Klimt, as per stamp
Erich Lederer, Geneva
Private Collection, Brussels
Erich Lederer, Geneva
Elisabeth Lederer, Geneva
Estate of Erich and Elisabeth Lederer, Vienna
de Pury & Luxembourg Art, Geneva
Private Collection, New York

Literature:
Strobl 333

CAT. NO. D29
DESIGN FOR TRAGODIE [TRAGEDY]
(Entwurf für die "Tragödie") 1897–98
Pencil and black chalk
45.7 x 31.5 cm (18 x 12 3/8 in.)
Stamped l. r. in ink: GUSTAV/KLIMT/NACHLASS

Provenance:
Estate of Gustav Klimt, as per stamp
Erich Lederer, Geneva
Serge Sabarsky Collection, New York

Literature:
Strobl 337
Design for *Ver Sacrum*, 1897–98

CAT. NO. D30
FEMALE NUDE WITH MIRROR IN RIGHT HAND
(Weiblicher Akt mit Spiegel in der rechten Hand) 1898
Black chalk
45 x 32 cm (17 3/4 x 12 5/8 in.)
Stamped l. r. corner in ink: GUSTAV/KLIMT/NACHLASS

Provenance:
Estate of Gustav Klimt, Vienna, as per inscription
Collection Gustav Zimpel, Vienna, as per inscription
C. G. Boerner, Düsseldorf
Serge Sabarsky Collection, New York

Literature:
Strobl 2676

CAT. NO. D113
PORTRAIT, LOWERED GLANCE, FACING LEFT
(Brustbild mit gesenktem Blick nach links) ca. 1916
Pencil
57 x 37.5 cm (22 1/2 x 14 3/4 in.)
Inscribed l. r. corner on verso: Nachlass/Gustav
Klimt/Zimpel Gustav

Provenance:
Estate of Gustav Klimt, Vienna, as per inscription
Gustav Zimpel, Vienna, as per inscription
C. G. Boerner, Düsseldorf
Serge Sabarsky Collection, New York

Literature:
Strobl 2689

CAT. NO. D114
PORTRAIT FACING FRONT
(Brustbild von vorne) ca. 1916
Pencil
55.6 x 35.8 cm (21 7/8 x 14 1/8 in.)
Signed l. r. corner: GUSTAV/KLIMT

Provenance:
Serge Sabarsky Collection, New York

Literature:
Strobl 2702

CAT. NO. D115
PORTRAIT IN PROFILE FACING LEFT
(Brustbild im Profil nach links) ca. 1916
Pencil
56 x 36.5 cm (22 x 14 3/8 in.)
Stamped l. l. in ink: GUSTAV/KLIMT/NACHLASS

Provenance:
Estate of Gustav Klimt, as per stamp
Serge Sabarsky Collection, New York

Literature:
Strobl 2713

CAT. NO. D116
SEATED WOMAN WITH SPREAD THIGHS
(Sitzende Frau mit gespreizten Schenkeln) 1916–17
Pencil and red pencil and white chalk
37.4 x 55.8 cm (14 1/2 x 22 in.)
Signed l. r. in pencil: Gustav/Klimt (encircled)

Provenance:
Erich Lederer, Geneva
Elisabeth Lederer, Geneva

Estate of Erich and Elisabeth Lederer, Vienna
de Pury & Luxembourg Art, Geneva
Private Collection, New York

Literature:
Strobl 2967

CAT. NO. D117
WOMAN RECLINING ON A SOFA WEARING FUR
(Auf Sofa liegende Dame im Pelz) 1917
Pencil and white chalk
50 x 32.4 cm (19 5/8 x 12 3/4 in.)
Stamped l. l. in ink: GUSTAV/KLIMT/NACHLASS
Inscribed center lower edge: Füsse/mehr senkrecht
Numerous color inscriptions throughout composition

Provenance:
Estate of Gustav Klimt, Vienna, as per stamp
Erich Lederer, Geneva
Elisabeth Lederer, Geneva
Estate of Erich and Elisabeth Lederer, Vienna
de Pury & Luxembourg, Geneva
Private Collection, New York

Literature:
Strobl 2571
Study for *The Polecat Fur* (*Der Iltispelz*), 1917

CAT. NO. 118
PORTRAIT OF AN OLD LADY FACING FRONT
(Brustbild einer alten Dame von vorne) 1917
Pencil
50 x 32.5 cm (19 5/8 x 12 3/4 in.)
Stamped l. r. corner on verso in ink: JOHANNA ZIMPEL

Provenance:
Johanna Zimpel, Vienna, as per stamp
Private Collection, Graz
Erich Lederer, Geneva
Elisabeth Lederer, Geneva
Estate of Erich and Elisabeth Lederer, Vienna
de Pury & Luxembourg Art, Geneva
Private Collection, New York

Literature:
Strobl 2750
Study for *The Portrait of Charlotte Pulitzer*, ca. 1917

CAT. NO. D119
HEAD STUDY FACING FRONT
(Kopfstudie von vorne) 1917–18
Pencil
50.2 x 32.5 cm (19 3/4 x 12 3/4 in.)

Provenance:
F. Klimt, Vienna
Historisches Museum der Stadt, Vienna, as per stamp
Serge Sabarsky Collection, New York

Literature:
Strobl 2597
Study for the *Portrait of Fräulein Lieser*, 1917–18
(unfinished)

CAT. NO. D120
BACK VIEW OF A STANDING WOMAN WITH PATTERNED SKIRT
(Rückenansicht einer stehenden Frau mit gemustertem
Rock, rechts Wiederholung) 1917–18
Pencil
49.5 x 29.8 cm (19 1/2 x 11 3/4 in.)

Provenance:
Galerie Arnoldi-Livie, Munich
Private Collection, Munich
Serge Sabarsky Collection, New York

Literature:
Strobl 2606
Study for the *Portrait of Ria Munk III*, 1917–18
(unfinished)

CAT. NO. D121
LADY IN A KIMONO, BARING RIGHT SHOULDER
(Dame im Kimono, die rechte Schulter entblösst)
1917–18
Pencil and red and blue pencil with heightening
50.1 x 32.4 cm (19 3/4 x 12 3/4 in.)
Signed l. r.: GUSTAV/KLIMT

Provenance:
Clara Mertens, New York
Serge Sabarsky Collection, New York

Literature:
Strobl 2616
Study for the *Portrait of Ria Munk III*, 1917–18
(unfinished)

CAT. NO. D122
SEATED WOMAN FACING FRONT
(Sitzende von vorne) 1917–18
Pencil
57 x 37.5 cm (22 3/8 x 14 3/4 in.)
Signed l. l.: Gustav Klimt

Provenance:
Dorotheum, Vienna
Serge Sabarsky Collection, New York

Literature:
Strobl 2665
Study for *Portrait of a Woman* (*Damenbildnis en Face*),
1917–18 (unfinished)

CAT. NO. D123
PORTRAIT FACING FRONT
(Halbbild von vorne) 1917–18
Pencil
50.1 x 32.5 cm (19 3/4 x 12 3/4 in.)
Signed l. l.: GUSTAV/KLIMT

Inscribed on lower portion of secondary support: Gustav
Klimt, den Idealen der Natur bist Du, fast
eigentlich/unbewusst, nahegerückt, und selbst Deine
einfachen, eigentlich adeligen/Bauerngärten mit
Sonnenblumen und Unkraut enthielten/einen Hauch der
Poesie des Schöpfers! So hieltest Du Dich auch
allmälig/abseits von den Menschen, die dafür keinerlei
Verständnis haben!/Gustav Klimt, Du warst ein
Mensch!!!/Peter Altenberg/21./2./1918

Provenance:
Johanna Staude, Vienna
Serge Sabarsky Collection, New York

Literature:
Strobl 2726
Study for the *Portrait of Johanna Staude*, 1917–18
(unfinished)

CAT. NO. D124
TWO MALE HEADS FACING LEFT
(*Zwei Männerköpfe nach links*) 1917–18
Pencil
56.2 x 36.8 cm (22 1/8 x 14 1/2 in.)
Stamped l. l. in ink: GUSTAV/KLIMT/NACHLASS

Provenance:
Estate of Gustav Klimt, as per stamp
Serge Sabarsky Collection, New York

Literature:
Strobl 2873
Study for *Adam and Eve* (*Adam und Eva*), 1917–18
(unfinished)

CAT. NO. D125
TWO STUDIES OF A MAN
(*Zwei Studien eines Mannes*) 1917–18
Pencil
55.8 x 36.5 cm (22 x 14 3/8 in.)
Stamped l. l. corner on verso in ink:
NACHLASS/GUSTAV/KLIMT/SAMMLUNG/R. ZIMPEL

Provenance:
Estate of Gustav Klimt, as per stamp
Collection of Rudolf Zimpel, Vienna, as per inscription
Galerie Nebehay, Vienna
Francis C. Reif, Vancouver
Amides Arts, Ltd., Vancouver
Serge Sabarsky Collection, New York

Literature:
Strobl 2877
Study for *Adam and Eve* (*Adam und Eva*), 1917–18
(unfinished)

CAT. NO. D126
MALE HEAD IN PROFILE FACING LEFT,
SKETCH ABOVE
(*Männerkopf im Profil nach links, oberhalb begonnene
Skizze*) 1917–18
Pencil
56.5 x 37 cm (22 1/4 x 14 5/8 in.)
Stamped l. l. corner on verso in ink:
NACHLASS/GUSTAV/KLIMT/SAMMLUNG/R. ZIMPEL

Provenance:
Estate of Gustav Klimt, as per stamp
Estate of Rudolf Zimpel, as per stamp
Sotheby's, Los Angeles
Fred Elghanayan, New York
Serge Sabarsky Collection, New York

Literature:
Strobl 2879
Study for *Adam and Eve* (*Adam und Eva*), 1917–18
(unfinished)

CAT. NO. D127
HEAD STUDY IN THREE-QUARTER PROFILE
FACING RIGHT
(*Kopfstudie im Dreiviertelprofil nach rechts*) 1917–18
Pencil
56.5 x 37.5 cm (22 1/4 x 14 3/4 in.)
Stamped l. r. in ink: GUSTAV/KLIMT/NACHLASS

Provenance:
Estate of Gustav Klimt, as per stamp
Rudolf Leopold, Vienna
Serge Sabarsky Collection, New York

Literature:
Strobl 2890
Study for *Adam and Eve* (*Adam und Eva*), 1917–18
(unfinished)

CAT. NO. D128
BABY (CRADLE)
(*Baby* [*Wiegel*]), 1917–18
Pencil and red and blue pencil and white chalk
56.3 x 37.3 cm (22 1/8 x 14 5/8 in.)
Signed l. l.: GUSTAV/KLIMT

Provenance:
Erich Lederer, Geneva
Elisabeth Lederer, Geneva
Estate of Erich and Elisabeth Lederer, Vienna
de Pury & Luxembourg Art, Geneva
Private Collection, New York

Literature:
Strobl 3037
Study for *Das Baby* (*The Baby*), 1917–18; and/or
The Bride (*Die Braut*), 1917–18 (both unfinished)

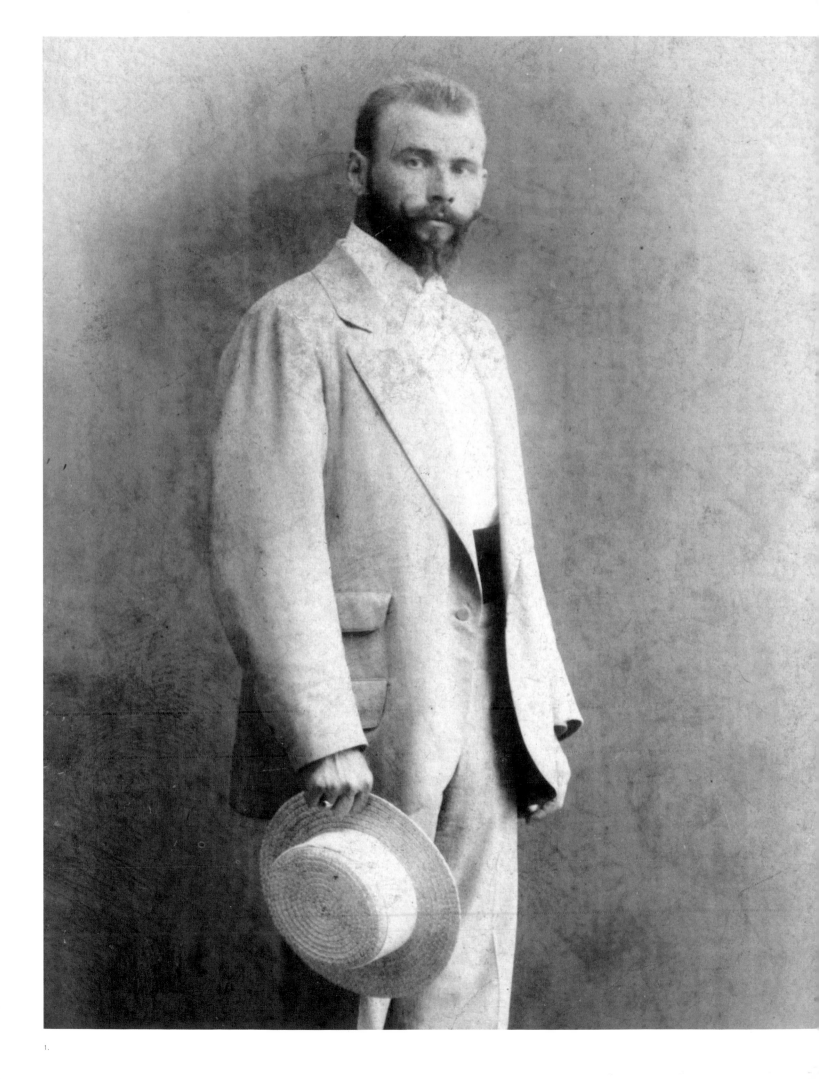

BIOGRAPHY

1. Gustav Klimt, ca. 1890. Photograph by Carl Schuster, Vienna.
Courtesy Asenbaum Photo Archive, Vienna

2. Gustav Klimt's birthplace at Linzerstrasse 247, Vienna, ca. 1900.
The house was demolished in 1967. Courtesy Asenbaum Photo Archive, Vienna

3. Ernst Klimt, ca. 1890. Photograph by Carl Schuster, Vienna.
Courtesy Asenbaum Photo Archive, Vienna

1862 Gustav Klimt is born July 14, at Linzerstrasse 247, in Baumgarten [Fig. 2], on the outskirts of Vienna (today the city's fourteenth district), the second child of metal engraver Ernst Klimt (1834–1892, from Northern Bohemia) [Fig. 3] and Anna Klimt (née Finster; 1836–1915, from Vienna). Anna and Ernst Klimt have seven children in all: Klara (1862–1937), Gustav (1862–1918), Ernst (1864–1892), Hermine (1865–1938), Georg (1867–1931), Anna (1869–1874), and Johanna (1873–1950).

1867–73 The Klimt family moves to Vienna's seventh district. They live initially on Lerchenfelderstrasse, but move later that year to Neubaugasse 51. Gustav attends the Bügerschule, an elementary school in Vienna.[1] The financial crisis in Vienna places the Klimt family under strain. They move to Märzstrasse in the fifteenth district. According to Gustav's sister Hermine, the family has no bread at Christmas, let alone gifts.[2]

1876 In October, Gustav is accepted at the Kunstgewerbeschule (School of Applied Art, founded 1867), established by the Österreichisches Museum für Kunst und Industrie (Austrian Museum of Art and Industry, today the MAK-Austrian Museum of Applied Arts/Contemporary Art, Vienna). Gustav begins a two year course of preparatory classes under Professors Michael Rieser, Ludwig Minnigerode, and Karl Hrachowina.

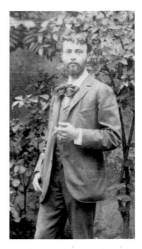

1877 Gustav's brother Ernst begins attending the Kunstgewerbeschule. The brothers undertake coursework with the intention of becoming drawing teachers. Gustav and Ernst help support their family by painting miniature watercolor portraits from photographs. They also prepare technical drawings for Adam Pollitzer, an ear specialist. Their brother, Georg Klimt, will also later attend the Kunstgewerbeschule. He becomes a sculptor and engraver and creates frames for a number of Gustav's paintings.

1878–79 Gustav, his brother Ernst, and Franz Matsch (1861–1942) are accepted as students in the Fachschule für Zeichnen und Malerei

(Technical School for Drawing and Painting) under Ferdinand Laufberger (1829–1881). [Fig. 4] After his death, they study under Julius Victor Berger (1850–1902). Gustav attends the Kunstgewerbeschule until 1883.

Ferdinand Laufberger gives Gustav, Ernst, and Franz Matsch a share of his commission for the decoration of the courtyards of the Kunsthistorisches Museum in Vienna.[3]

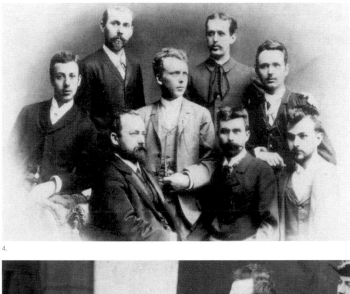

4.

5.

4. Professor Ferdinand Laufberger's class at Vienna's Kunstgewerbeschule (School of Applied Arts), ca. 1880. Front row, from left: Ferdinand Laufberger, Gustav Klimt, Ernst Klimt. Back row, left: Franz Matsch. Neue Galerie New York, Gift of C. M. Nebehay Antiquariat, Vienna

5. Ernst Klimt (seated) and Franz Matsch, ca. 1886, as models for the spectators in Klimt's ceiling painting, *Shakespeare's Theater*, for the right staircase of the Burgtheater, Vienna. Courtesy Asenbaum Photo Archive, Vienna

Gustav, Ernst and Franz are invited to participate in the preparations for the procession celebrating the silver wedding anniversary of the Emperor Franz Joseph I and the Empress Elisabeth, directed by the painter Hans Makart (1840–1884).

1880 The Klimt family moves to Vienna's sixth district, Mariahilferstrasse 75, and live in a former cloister. With the help of income from Gustav and Ernst, the family's financial situation improves. They remain at this address until 1884 when the building is demolished.

The architect Johann Sturany commissions the Klimt brothers and Matsch to paint decorative scenes for his Palais at Schottenring 21 in the first district in Vienna on the subjects *Poetry, Music, Dance*, and *Theater*.[4]

1881 Gustav Klimt is invited by Martin Gerlach, a printer based in Vienna, to submit work for the forthcoming serial publication *Allegorien und Embleme* (Allegories and Emblems). This is Klimt's first commissioned work and he appears in the company of well-known artists of the day including Max Klinger (1857–1920), Franz von Stuck (1863–1929), and his Professor Julius Victor Berger (1850–1902). Ernst Klimt and Franz Matsch also contribute designs to the publication. *Allegorien und Embleme* is published between 1882–84 and 1895–1900. Gustav provides eleven full-page illustrations, with reproductions of paintings and drawings, for the series.

1883–85 Having completed their studies, Gustav, Ernst, and Franz Matsch move into their own studio in the sixth district of Vienna on Sandwirthgasse 8. They join together to form the Künstler-Compagnie (Artists' Company), agreeing to work in the Historicist style, without stylistic differences, and with the allowance that one will take over another's work should they be unable to complete it. The group quickly attracts significant commissions. The Künstler-Compagnie receives commissions from the Viennese theater architects Ferdinand Fellner (1847–1916) and Hermann Helmer (1849–1919) to design curtains, ceiling paintings and other theatrical elements. They are installed in cities including Reichenberg, Karlsbad (Karlovy Vary, Czech Republic), Fiume (Rijeka, Croatia), and others throughout the Austro-Hungarian Empire, Germany, Switzerland, and the Balkans.

The King of Romania commissions the Künstler-Compagnie to design tapestries and old master copies.

6.

6. Gustav Klimt, *Hanswurst: Improvised Comedy in Rothenburg*, 1886–88, oil on stucco ground. Ceiling painting in the staircase of the Burgtheater, Vienna

7. The Klimt family residence at Westbahnstrasse 36, Vienna, ca. 1890

8. Klara Klimt, as a model for *Shakespeare's Theater*, ca. 1879. Courtesy Asenbaum Photo Archive, Vienna

9. Hermine Klimt modeling for *Shakespeare's Theater*, ca. 1879. Courtesy Asenbaum Photo Archive, Vienna

Gustav Klimt moves to Stuckgasse 6 in the seventh district of Vienna. He lives at this address until 1890. The Künstler-Compagnie completes the paintings for the State Theater in Karlsbad.

After the death of Hans Makart, the Künstler Compagnie executes his sketches for the ceiling painting in the Hermesvilla on the outskirts of Vienna in the suburb of Lainz.

1886 The Künstler-Compagnie receives its first significant commission to produce the ceiling and lunette paintings for the two staircases of Vienna's newly constructed Burgtheater, completed by Karl von Hasenauer after the resignation of Gottfried Semper. The history of theater is specified as the theme of the decoration. The contract is awarded by the Hof-Bau-Comité (Imperial Building Commission). Emperor Franz Joseph I is evidently pleased with the work of the Künstler-Compagnie and Gustav Klimt is dubbed the "heir" to Hans Makart.

1888 The paintings for the Burgtheater staircase are completed. The Künstler-Compagnie receives the Golden Order of Merit. Commissioned by the City of Vienna, Gustav Klimt and Franz Matsch

7. 8. 9.

both paint watercolor views of the interior of the old Burgtheater from different perspectives. Klimt shows a view from the stage towards the entrance, containing numerous portraits of members of Viennese society. Both artists achieve social prominence.

In August, Gustav and Ernst travel to Innsbruck, Salzburg, and the Königsee.[5]

1889 Gustav and Ernst travel to the Salzkammergut region for the first time.

1890 Klimt receives the *Kaiserpreis* (Imperial Prize) in April worth 400 ducats (about $11,000 today) in recognition for his watercolor painting *The Auditorium of the Old Burgtheater*.

In June, Gustav and Ernst travel to Venice and Carinthia, using the money Gustav had earned with the Imperial Prize.[6]

Gustav moves to Westbahnhofstrasse 36, in Vienna's seventh district. He resides here for the rest of his life with his sisters Klara, Hermine, and his mother Anna. [Figs. 7, 8, 9, 28]

1891 Ernst marries Helene Flöge (1871–1936). Gustav paints his first portrait of her seventeen-year-old sister Emilie (1874–1952). The Künstler-Compagnie receives a commission to decorate the staircase of the Kunsthistorisches Museum, its second Imperial commission. While Ernst Klimt and Franz Matsch remain faithful to the academic style, in Gustav's painting *Art of Ancient Greece II* a stylistic change is apparent. Glycera, his personification of the Antique era, is shown as a modern woman in contemporary clothing [Fig. 10]. The Klimt brothers and Franz Matsch join the Künstlerhaus-genossenschaft (Vienna Artists' Association).

1892 The Künstler-Compagnie moves into a studio in the Josefstädter Strasse 21, in Vienna's eighth district. This remains Klimt's studio until 1912.

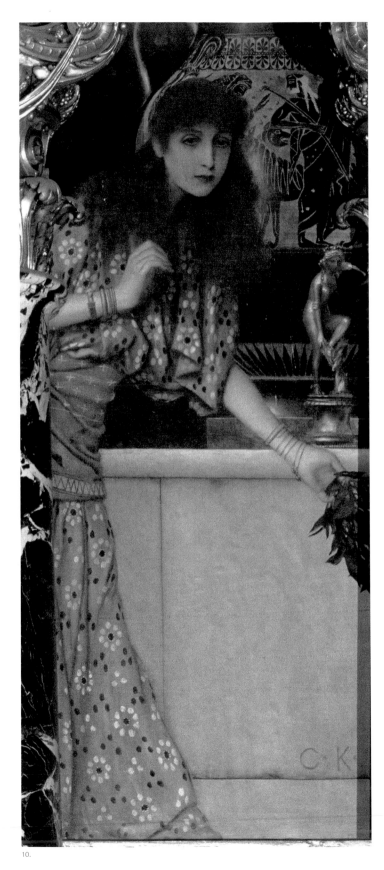

On July 13, Gustav's father Ernst dies.

The daughter of Ernst and Helene Klimt (née Flöge) is born: Helene Luise Klimt (married Donner, 1892–1980).

Gustav's brother Ernst dies on December 9, and Gustav is appointed guardian to his niece Helene.

The Künstler-Compagnie gradually dissolves due in part to the death of Ernst and to the stylistic evolution of Gustav.

1893 In preparation of a ceiling painting for the Burgtheater, Klimt paints his second portrait of Emilie Flöge.

In January, Klimt travels to Totis (Tata), Hungary to paint *The Auditorium of the Schloss Esterházy Theater* which wins the silver medal at the Künstlerhaus Exhibition in March.

Klimt is nominated for a professorship at the Akademie der bildenden Künste (Academy of Fine Arts) in Vienna; Spezialschule für Historienmalerei (School of Historical Painting). He handwrites his *Curriculum vitae*, but is not accepted for the position.[7]

Gustav takes up rowing and other sports activities.

1894 Klimt and Franz Matsch receive a commission to prepare sketches for the ceiling paintings of the Great Hall of the University of Vienna.

In December, the Munich Secession exhibits in the Vienna Künstlerhaus.

1895 Klimt works on the designs for a new series of *Allegories and Emblems*.

During a ceremony unveiling a monument for Emil Jakob Schindler (1842–1892), Klimt meets Alma Schindler (1879–1964, first married to Gustav Mahler, then Walter Gropius, and last to Franz Werfel).

Nikolaus Dumba commissions Klimt to undertake the decorations for the music room in his Palais on Vienna's Parkring. Hans Makart was selected to design the panels for the study and Franz Matsch was also employed in the decoration of the Dumba Palais.

Klimt's painting *The Auditorium of the Schloss Esterházy Theater* is awarded first prize at the Antwerp Grand Prix.

10. Gustav Klimt, *Art of Ancient Greece II* (*Girl from Tanagra*) (*Griechische Antike*), 1890–91, oil on stucco ground. Intercolumnar panel in the staircase of the Kunsthistorisches Museum, Vienna

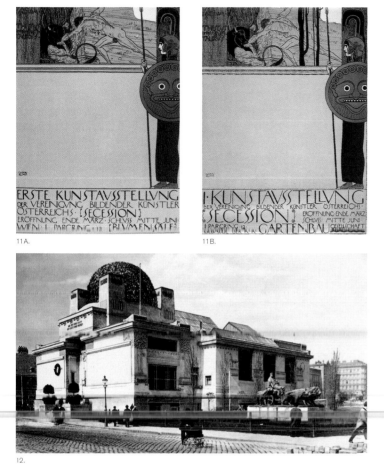

11A. 11B.

11. Gustav Klimt, poster for the first Secession exhibition, 11A. uncensored version; 11B. censored version, 1898, lithograph. Neue Galerie New York

12. The Vienna Secession, Karlsplatz, Vienna, ca. 1900, designed by Joseph Maria Olbrich

13. Marie Zimmermann, ca. 1910

1896 Although their work is no longer stylistically unified, Klimt and Matsch are commissioned to produce the allegorical paintings of the university faculties for the University's Great Hall. Klimt is assigned *Medicine*, *Philosophy*, and *Jurisprudence*.

1897 Along with twenty other artists, Klimt resigns from the Künstlerhausgenossenschaft. The Vienna Secession (Vereinigung bildender Künstler Österreichs), following the examples set in 1892 in Munich and 1893 in Berlin, is founded. Klimt is named its first president.

April marks the beginning of the correspondence between Klimt and Emilie Flöge.

Klimt spends the summer with the Flöge family in Fieberbrunn in Tyrol.[8] He begins painting landscapes.

1898 In January, the first issue of the Secession's magazine *Ver Sacrum* is published, Hermann Bahr and Max Burghardt are literary advisors. The first Secession exhibition (Klimt designs and must alter the poster to pass the censors [Figs. 11A, 11B]) includes works by its members and by Arnold Böcklin, Walter Crane, Max Klinger, Max Liebermann, Auguste Rodin, Giovanni Segantini, Franz von Stuck, and Hans von Thoma. The exhibition is held at the Gartenbaugesellschaft (Horticultural Society) (March 26–June 15), attracting more than 56,000 visitors and 218 works of art are sold, enabling the Secession to construct its own building. Joseph Maria Olbrich (1867–1908), a student of Otto Wagner, is the chosen architect. Klimt influences the design of the building, and is responsible for the exhibition programming (with Josef Hoffmann and Carl Moll) until 1905.

Klimt rents an additional studio with high ceilings in the eighth district at Florianigasse 54 to work on the three university faculty paintings.[9]

When Klimt presents his sketches for the faculty paintings in the Great Hall, they are met with sharp criticism and specific conditions are imposed for their execution.

He spends the summer with the Flöge family in St. Agatha on Hallstättersee where he paints landscapes.

On November 12, the second Secession exhibition opens in the new Secession building.

1899 Klimt completes work on the interior decorations for the music room in the Palais Dumba, for which Klimt produced the painting *Schubert at the Piano* among other works. The painting is greeted with lavish praise. Critic Hermann Bahr writes: "Klimt's *Schubert* is the finest painting every done by an Austrian…. I know of no modern that has struck me as so great and pure as this one…"[10]

13.

In spring, Klimt travels around Italy visiting Florence, Genoa, Verona, and Venice with Carl Moll (1861–1945), his wife Anna (formerly Anna Schindler), and Moll's stepdaughter Alma Schindler. During the summer, he stays with the Flöge family in Golling near Salzburg. In August a son named Gustav is born to Klimt and Marie (Mizzi) Zimmermann, one of his models [Fig. 13]. Klimt completes the *Portrait of Serena Pulitzer*, one of his most important patrons.

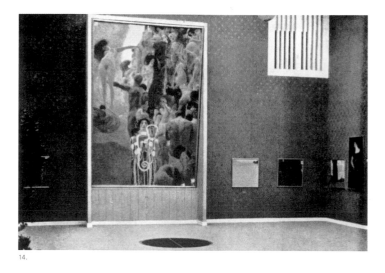

14.

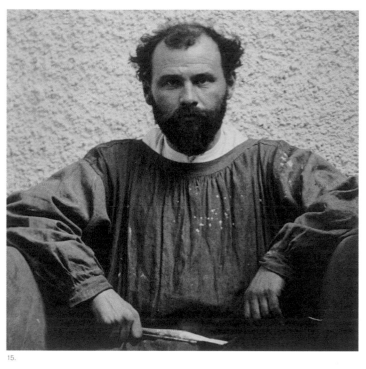

15.

16.

1900 At the Seventh Secessionist exhibition (March 8 – June 6) Klimt presents his painting *Philosophy*. The painting draws 35,000 visitors and creates a scandal. Eighty-seven professors sign a petition requesting that it should not be installed in the University's Great Hall. Another twelve professors issue a counterstatement. The petition of the professors is finally turned down at a meeting of the artistic commission of the Ministry of Education.

At the *Exposition Universelle* in Paris, Klimt is awarded the Gold Medal for the painting. Emilie Flöge and Klimt spend their first summer holiday in the Brauhof (brewery) Litzlberg on the Attersee.

1901 At the Tenth Vienna Secession exhibition, Klimt presents the second faculty painting *Medicine* [Fig. 14], which causes renewed protests, principally because of its nude depiction of a pregnant woman.

A proposal by the Vienna Academy of Fine Arts that Klimt should be appointed professor is rejected by the Ministry of Education.

In August, Klimt vacations on the Attersee with the Flöge family, residing at the Brauhof Litzlberg.

1902 For the Fourteenth Vienna Secession exhibition mounted in honor of Max Klinger's sculpture *Beethoven*, Klimt creates the *Beethoven Frieze*. It is greeted with enthusiasm and protests. In June Auguste Rodin (1840–1917) visits the Secession and meets Klimt.

Klimt paints his third and last portrait of Emilie Flöge. He summers with the Flöge family in Litzlberg on the Attersee.

On June 22, Marie (Mizzi) Zimmermann gives birth to Otto, her second child with Klimt. Otto dies on September 11.[11]

14. Gustav Klimt, *Medicine* (*Medizin*), installed in the tenth Vienna Secession exhibition, 1901

15. Gustav Klimt at the Vienna Secession (detail), 1902. Photograph by Moritz Nähr. Courtesy Asenbaum Photo Archive, Vienna

16. Postcard from Gustav Klimt to his mother, Anna Klimt, showing the Litzlbergkeller, 1902. Private Collection

1903 Klimt visits Venice and Ravenna. The early Byzantine mosaics of San Vitale make a lasting impression on him, and their influence is reflected in the development of his Golden Style.[12]

Ferdinand Hodler (1853–1918) visits Vienna, befriends Klimt, and acquires *Judith I*.

In May, the artists Josef Hoffmann (1870–1956) and Koloman Moser (1868–1918) and the industrialist Fritz Waerndorfer found the Wiener Werkstätte (Vienna Workshops). Several Klimt paintings are on permanent display there.

During the summer, Klimt visits the Flöge family in Litzlberg on the Attersee.

Publication of an anthology of hostile articles entitled *Gegen Klimt* (Against Klimt), edited by Hermann Bahr.

17.

On November 11, the artistic commission of the Ministry of Education approves Klimt's faculty paintings. Due to the differences in quality between Klimt's and Matsch's works, however, it is suggested that Klimt's paintings should not be displayed at the University's Great Hall but in the Moderne Galerie, Vienna.

In the fall, the Secession shows the largest Klimt exhibition yet (*Klimt-Kollektive*), presenting eighty works, including the faculty paintings that are presented together for the first time. The *Beethoven Frieze* is left in place for the exhibition.[13]

At the end of the year, *Ver Sacrum* ceases publication.

1904 Josef Hoffmann and the Wiener Werkstätte are entrusted to build and furnish a villa in Brussels for the industrialist Adolphe Stoclet. Klimt is asked to produce a design for the marble frieze in the dining room.

Paul Bacher (d. 1908) acquires the Galerie Miethke for which Carl Moll acts as artistic director. The gallery becomes Klimt's future representative in Vienna.

Klimt participates in the *Grosse Kunstschau* (Great Art Exhibition) in Dresden and in the First Exhibition of the German Artists' Society in Munich.

On July 1, the Flöge sisters, Pauline, Helene and Emilie, open their fashion salon Schwestern Flöge in Casa Piccola on Mariahilferstrasse 1b.

In the summer, Klimt returns to the Attersee, staying with the Flöge family in Litzlberg.

1905 In early April, Klimt officially withdraws from the University of Vienna faculty commission. Following a lively public debate, the paintings are returned to him at the end of the month and he returns his fee with the assistance of his patron August Lederer.

Klimt exhibits fifteen of his paintings in Berlin at the Deutscher Künstlerbund in May.

The Vienna Secession splits into two stylistic groupings after prolonged differences of opinion among the members. One group rallies around Josef Engelhart and wishes to present purely pictorial exhibitions is known as the "Impressionists." A second group, dubbed the *Klimt-Gruppe* or the "Stylists" affirm the importance of the decorative arts. They leave the association in June.

Fifteen Klimt paintings are shown in Berlin in the Exhibition of the Deutscher Künstlerbund. He participates in the International Art Exhibition in Munich.

Klimt's appointment as professor at the Academy of Fine Arts is definitively refused.

1906 On March 12, Klimt is named an honorary member of the Königlich Bayerische Akademie der bildenden Künste (Royal Bavarian Academy of Fine Arts) in Munich.

Klimt travels to Brussels to see Stoclet, to London, and to Florence.

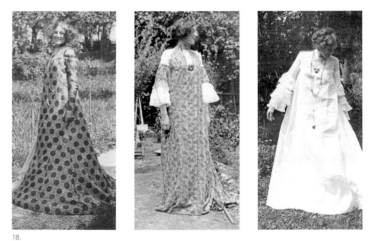

18.

17. Postcard from Gustav Klimt to his mother, 1904

18. Emilie Flöge in reform dresses from the Salon Schwestern Flöge and jewelry from the Wiener Werkstätte, 1907. Photographs by Gustav Klimt. Neue Galerie New York; middle and right: Courtesy Asenbaum Photo Archive, Vienna

19.

20.

19. Gustav Klimt, *Farm Garden with Sunflowers*, ca. 1907.
Courtesy Österreichische Galerie Belvedere, Vienna

20. Klimt with Emilie Flöge (wearing hat) and friends walking at the Attersee, 1907.
Photographer unknown. Neue Galerie New York

Klimt becomes the president of the newly founded Künstlerbund (League of Artists).

In the summer, Klimt is once again in Litzlberg with the Flöge family. During their summer stay on the Attersee, Klimt takes a series of fashion photographs of Emilie in her own reform dresses [Fig. 18].

1907 *Die Hetärengespräche des Lukian* (*Lucian's Dialogues of the Courtesans*), translated by Franz Blei, is published in May with reproductions of Klimt drawings.

Klimt travels and exhibits the faculty paintings in Berlin at Galerie Keller und Reiner. He also takes part in the Viennese art exhibition at the Galerie Arnold, Dresden, and the International Art Exhibition in Mannheim.

He meets Egon Schiele during the summer.

July 13 to September 8 he spends with the Flöge family in Litzlberg, Attersee.

For the October 19 opening of the Cabaret Fledermaus, Klimt designs costumes for Peter Altenberg's play *Masken* (Masks).[14]

1908 The *Klimt-Gruppe* artists organize the *Kunstschau* (Art Show) in Vienna, presenting their work in an improvised exhibition hall designed by Josef Hoffmann. The center of the exhibition is the Klimt Room, with sixteen paintings, including *The Kiss*, which is acquired by the Moderne Galerie, and *Adele Bloch-Bauer I*.

Thanks to Klimt's intervention, the rebellious young Oskar Kokoschka (1886–1980) participates in the show.

With Klimt's supervision, the Galerie Miethke begins publication of *Das Werk Gustav Klimts*, a subscription portfolio of reproductions.

The Historisches Museum der Stadt Wien (Historical Museum of the City of Vienna) acquires the *Portrait of Emilie Flöge*.

Klimt and the Flöge family spend their first summer in the Villa Oleander in Kammer on the Attersee.

1909 At the *Internationale Kunstschau*, a survey of contemporary European painting is presented. Klimt's *Hope I* and *Hope II* are shown publicly for the first time. Works of Kokoschka and Egon Schiele are included. It is the last time that Klimt is to work as an exhibition organizer.

Klimt takes part in the Tenth International Art Exhibition in Munich and in the Eighteenth Exhibition of the Berlin Secession. In the fall, he travels to Paris where he sees the Musée Guimet collection, and to Spain with Carl Moll.

End of Klimt's Golden Style phase.

Second summer with the Flöge family in the Villa Oleander.

1910 Klimt shows twenty-two paintings at the Ninth Biennale in Venice [Fig. 21]. *Judith II* is acquired by the Galleria d'Arte Moderna, Venice.

21.

21. Installation view of Klimt's paintings in room 10 of the 1910 Venice Biennale. Courtesy Archivio Storico delle Arti Contemporanee la Biennale di Venezia

22. Klimt rowing on the Attersee, ca. 1910. Photograph by Richard Teschner. Neue Galerie New York

23. Schloss Kammer on the Attersee, picture postcard sent by Klimt to his mother, ca. 1908. Private Collection

24. Schönbrunn, Vienna, postcard by the Wiener Werkstätte, no. 137, sent by Klimt on February 27, 1909. Private Collection

22.

23.

24.

Klimt participates in the exhibition of the *Deutscher Künstlerbund* in Prague. In addition, he is represented at the exhibition *Zeichnende Künste* (Drawing Arts) in the Berlin Secession. The Galerie Miethke displays drawings by Klimt.

He completes the designs for the Palais Stoclet frieze, which is executed by the Wiener Werkstätte. Klimt summers with the Flöge family in Villa Oleander on the Attersee.

1911 Klimt completes the Palais Stoclet frieze. Participates in the *Esposizione internazionale* (International Art Exhibition) in Rome, in the Austrian pavilion designed by Hoffmann, receives the first prize for his painting: *Death and Life*.[15] Travels with Fritz Waerndorfer to Brussels, London, and Madrid.

Much of his summer is spent with the Flöge family on the Attersee.

1912 The Galleria Nazionale d'Arte Moderna, Rome, acquires *The Three Ages of Woman*, 1905.

Klimt participates in the *Grosse Kunstausstellung* in Dresden. Klimt becomes president of the Österreichischer Künstlerbund.

Adele Bloch-Bauer II is completed, showing influence of Henri Matisse's palette.

Klimt and Emilie Flöge vacation together in Bad Gastein and in the Villa Oleander in Kammerl on the Attersee.

25.

26A.

26B.

25. Gustav Klimt, Emilie Flöge, and her mother Barbara in their garden at the Villa Oleander in Kammer on the Attersee, 1910. Neue Galerie New York, Gift of C. M. Nebehay Antiquariat, Vienna

26A. and 26B. The Flöge summer house in Weissenbach on the Attersee, ca. 1914. Courtesy Wolfgang Georg Fischer Archive, Vienna

27. Klimt and his niece Trude Floge on the dock of Villa Paulick in Seewalchen on the Attersee, 1912. Courtesy Wolfgang Georg Fischer Archive, Vienna

28. Anna Klimt, Gustav's mother, in 1905. Courtesy Asenbaum Photo Archive, Vienna

27.

28.

Klimt moves into a new studio in the Feldmühlgasse 11, in Vienna's thirteenth district.[16]

1913 Klimt takes part in exhibitions in Budapest, Munich, and Mannheim. In the summer, Klimt returns to Bad Gastein, on the Gardasee. He also spends time at the Villa Paulick in Seewalchen on the Attersee. As usual, he joins the Flöge family.

1914 Klimt shows at the exhibition of the *Deutscher Künstlerbund* in Prague. The city's Národní Galerie (National Gallery) acquires *The Virgin,* the second Klimt painting to enter the collection. Klimt's portrait of *Mäda Primavesi* is shown at the Second Secession in Rome.

Klimt travels to Brussels to see the completed Palais Stoclet frieze in place. He visits the Brussels Musée du Congo, and is deeply impressed by the sculptures displayed.

Klimt spends the summer in Weissenbach on the Attersee, residing at the Forester's house.

1915 In early February, Klimt's mother Anna dies [Fig. 28]. Klimt spends the summer with the Flöge family in Weissenbach.

Three paintings and twenty-two drawings are shown at the Viennese Artists exhibition in the Kunsthaus Zürich. With Schiele,

Kokoschka, and Faistauer, Klimt takes part in the Society of Austrian Artists show in the Berlin Secession.

1916 Klimt participates in the exhibition of the Bund Österreichischer Künstler (League of Austrian Artists) at the Berlin Secession, together with Schiele, Kokoschka, and Faistauer. Klimt is named member of the Sächsische Akademie der Bildenden Künste in Dresden (Saxon Academy of Fine Arts)

Last summer stay on the Attersee.

29.

29. Apartment of Julius Zimpel, Mollardgasse 11, with Hermine Klimt, Julius and Rudolf Zimpel, Gustav Klimt, Julius Zimpel Sr. (standing), Johanna, Eleonora, and Gustav Zimpel, December 1916. Neue Galerie New York, Gift of C. M. Nebehay Antiquariat, Vienna

30. Klimt's last passport, dated 24 May, 1917.
Photograph Gift of C. M. Nebehay Antiquariat, Vienna

1917 Journey to Romania [Fig. 30].

Schiele lists Klimt as a co-founder of the Kunsthalle, an exhibition and work group of artists, writers, and musicians.

In early July, Klimt composes a poem, perhaps inspired by the tragedy of World War I: "The water lily grows in the lake/It is in flower/Its soul is sad/Mourning for the handsome man."[17]

In late July, Klimt visits the thermal baths in Bad Gastein. He participates in the show *Österrikiska Konstutställingen* (Exhibition of Austrian Art) in Stockholm. Klimt is elected an honorary member of the Academies of Fine Art in Munich and Vienna.

Die Identität der auf obiger Photographie abgebildeten Person mit dem Paßinhaber

Herrn ~~Otto~~ Klimt Gustav.

Frau

und die eigenhändige Beisetzung der Namens- unterschrift werden hiemit amtlich bestätigt.

K. k. Polizeidirektion in Wien.

Wien, am **24. Mai** 191**7**.

30.

31.

32.

33.

1918 On January 11, Klimt suffers a stroke at his home, at Westbahnhofstrasse 36, which leaves him paralyzed on one side. He is admitted to the Fürth Sanatorium and later moved to the Allgemeine Krankenhaus (General Hospital). Schiele closely follows Klimt's state of health.[18] Klimt dies there on February 6 at 6 am. following a lung infection. On February 9, Klimt is buried in the cemetery in Hietzing. The family refuses an honorary grave. In the periodical *Der Anbruch*, February 15, 1918 Schiele eulogized: Gustav Klimt/an artist of unbelievable completion/a human with rare depth/his work is sacred." Klimt's grave is marked with an unadorned marble slab bearing his name [Fig. 34].

The Kunsthaus Zurich presents *Ein Jahrhundert Wiener Malerie* (One Century of Viennese Painting) in May and June including fifteen Klimt paintings, *The Tall Poplar Tree I, Adele Bloch-Bauer I,* and *Death and Life,* among them.

"…there is always hope, as long as the canvases are empty."

Gustav Klimt,
letter from August 1903 to Marie ("Mizzi") Zimmermann

34.

31. Egon Schiele, *The Dead Gustav Klimt* (detail), 1918, black crayon. Serge Sabarsky Collection, New York

32. Photograph of Gustav Klimt's death mask, 1918. Neue Galerie New York, Gift of C. M. Nebehay Antiquariat, Vienna

33. Death notice for Gustav Klimt, issued by the Association of Austrian Artists, 1918

34. Klimt grave site at Hietzinger Friedhof cemetery, Vienna. Photograph by Alessandra Comini

35.

35. Klimt's painting smock, linen and embroidery. Wien Museum, Vienna

36A. Josef Hoffmann, cufflinks owned by Gustav Klimt, 1906, executed by the Wiener Werkstätte in silver and opal. Private Collection

37B. Eduard Josef Wimmer-Wisgrill (probably), tie pin for Gustav Klimt, 1912, executed by the Wiener Werkstätte in gold and turquoise. Private Collection

NOTES

1 This information was included in the *Curriculum vitae* prepared by Klimt in December 1893 when he applied for the job of professor at the Academy of Fine Arts, Spezialschule für Historienmalerie (Special School for Historical Painting) in Vienna. See Nebehay, *Gustav Klimt: From Drawing to Painting*, 1994, p. 274.
2 Nebehay, 1969, p. 26, note 6.
3 Partsch, 108.
4 Koja and Bailey
5 Nebehay, 1969, p. 491
6 Nebehay, 1969, p. 492
7 For a reproduction of the *Curriculum vitae*, see Nebehay, 1994, p. 274.
8 Nebehay, 1969, p. 494
9 Nebehay, 1994, p.278
10 Nebehay, 1994, p. 46.
11 Strobl, 1980-89, vol. I, p.274
12 Nebehay, 1969, p. 495
13 It was bought by Carl Reininghaus (1857-1929), important patron of Austrian modernism, until it became part of the August Lederer Collection. Today it is once again installed in the Secession building.
14 "Kabarett Fledermaus", *Neue Wiener Journal*, October 20, 1907, p.12
15 Novotny and Dobai, p. 391
16 See Ernst Ploil essay in these pages.
17 Novotny and Dobai, p. 392 (translated in Bailey p. 210). See also Fischer, 1992, p. 134.
18 In a letter to Anton Peschka, dated January 30, 1918, Schiele wrote: "Klimt is faring no better, I pity him enormously, especially since his studio was burglarized two days after his stroke. That is the gratitude of the world." See Price, ed., *Egon Schiele: The Ronald S. Lauder and Serge Sabarsky Collections* (New York: Neue Galerie New York, 2005) p. 423.

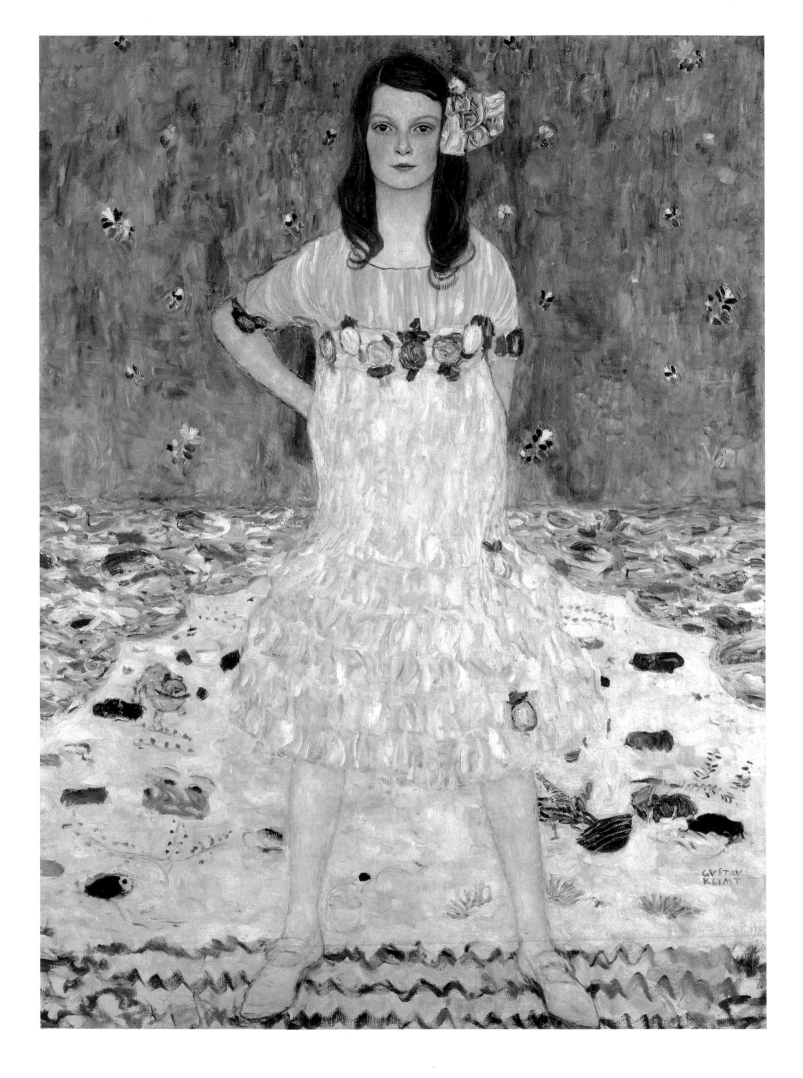

KLIMT IN U.S. PUBLIC COLLECTIONS

**ALLEN MEMORIAL ART
MUSEUM, OBERLIN COLLEGE**

OBERLIN, OHIO

Portrait of a Lady, ca. 1897
[Novotny/Dobai 82]
Pastel on paper
R. T. Miller, Jr. Fund
Acquired 1958

Study of a Male Nude, ca. 1910
Pencil and white chalk heightening
on paper
Gift of an anonymous donor in
memory of Jessie B. Trefethen
Acquired 1982

Reclining Girl, ca. 1912–14
Pencil on paper
Friends of Art Fund
Acquired 1958

**THE ART INSTITUTE OF
CHICAGO**

CHICAGO, ILLINOIS

*Male Nude with Left Foot on a
Pedestal*, 1879
[Strobl 3175]
Pencil and white chalk heightening
on paper
Gift of Shin'enKan, Inc., Bruce Goff
Archives
Acquired 2000

Male Nude, 1880
[Strobl 3176]
Various pencils on paper
Promised gift of Dorothy Braude
Edinburg to the Harry B. and Bessie
K. Braude Memorial Collection

Portrait of a Lady in a High Hat, ca.
1907–08
[Strobl 1927]
Pencil on Japan paper
Wentworth Greene Field Fund
Acquired 1962

*Seated Woman from the Front with
Hat, Face Hooded*, 1910
[Strobl 2006]
Pencil with red, blue, and white
colored pencils on paper
Promised gift of Francey and Dr.
Martin L. Gecht

Reclining Girl, 1912–14
[Strobl 1969]
Blue pencil on Japan paper
Wentworth Greene Field Fund
Acquired 1967

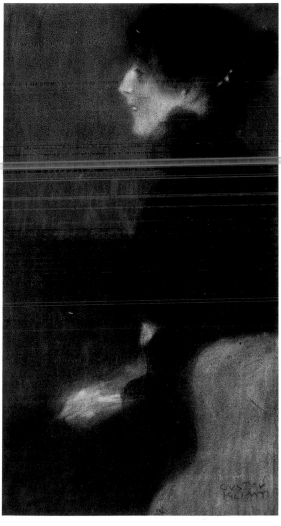

Opposite: *Mäda Primavesi*, 1912, oil on canvas.
The Metropolitan Museum of Art, New York

Portrait of a Lady, ca. 1897, pastel on paper.
Allen Memorial Art Museum, Oberlin College, Ohio

Male Nude, 1880, various pencils on paper.
The Art Institute of Chicago

Study for a Satyr Carrying Drum, ca. 1886–88,
pencil and white chalk on paper. Collection of the UCLA Grunwald
Center for the Graphic Arts, Hammer Museum, Los Angeles

BALTIMORE MUSEUM OF ART

BALTIMORE, MARYLAND

Reclining Nude (*Study for Water
Serpents*), ca. 1904–07
Pencil on paper
Board of Trustees Fund
Acquired 1958

Portrait, ca. 1916
Pencil on paper
Gift of Cory and Stanford Z.
Rothschild, Baltimore
Acquired 1993

BERKELEY ART MUSEUM, UNIVERSITY OF CALIFORNIA, BERKELEY

BERKELEY, CALIFORNIA

Recto: *Study of a Head*, verso: *Nude*,
1881–91
[*Strobl 129*]
Recto: pastel on paper, verso: pencil
on paper
Gift of Mrs. Ansley Salz
Acquired 1969

BROOKLYN MUSEUM

BROOKLYN, NEW YORK

*Study for the Portrait of Hermine
Gallia*, 1903–04
[*Strobl 1024*]
Colored pencil on paper
Bequest in the name of Chaim Abba
Gitlin and Feiga Leah Gitlin from the
estate of Samuel Zachery Gitlin by
exchange and the Caroline A. L. Pratt
Fund
Acquired 1989

BUSCH-REISINGER MUSEUM, HARVARD UNIVERSITY

CAMBRIDGE, MASSACHUSETTS

Untitled (*Three Male Figure Studies*), 1886–88
[*Strobl 3289*]
Pencil and white chalk heightening on paper
Gift of Lucia Titgemeyer and the Acquisitions Committee of the Friends of the Busch-Reisinger Museum
Acquired 2004

Pear Tree, 1903 (later reworked)
[*Novotny/Dobai 134*]
Oil and casein on canvas
Gift of Otto Kallir
Acquired 1956

Lady with a Fan, ca. 1908
[*Strobl 3311*]
Charcoal on paper
Purchase in memory of Louis W. Black
Acquired 1959

CANTOR CENTER FOR VISUAL ARTS, STANFORD UNIVERSITY

STANFORD, CALIFORNIA

Profile Head of a Woman, ca. 1904
Pencil on paper
Russell J. Miedel Fund
Acquired 1968

Reclining Nude, ca. 1912–17
[*Strobl 2998*]
Pencil on paper
Gift of Ramona C. and Nathan Oliveira
Acquired 1991

CARNEGIE MUSEUM OF ART

PITTSBURGH, PENNSYLVANIA

Orchard, 1905
[*Novotny/Dobai 164*]
Oil on canvas
Patrons Art Fund
Acquired 1960

Drawing, ca. 1906
Crayon on paper
Lillian Claster Memorial Fund
Acquired 1960

Standing Woman (*Study for the painting Portrait of Paula Zuckerkandl*), 1911
[*Strobl 2066*]
Pencil on paper
Gift of Gertrud A. Mellon in memory of Mrs. Margaret M. Hitchcock
Acquired 1999

Drawing, ca. 1915
[*Strobl 2227*]
Pencil on paper
Carnegie Museum of Art, Pittsburgh; Gift of Mr. and Mrs. J. Alfred Wilner
Acquired 2002

CLEVELAND MUSEUM OF ART

CLEVELAND, OHIO

Hermine Gallia, ca. 1903–04
[*Strobl 1051*]
Pencil on paper
Gift of Henry H. Hawley
Acquired 1972

Pear Tree, 1903 (later reworked), oil and casein on canvas. Harvard University Art Museums, Busch-Reisinger Museum, Cambridge, Massachusetts.

Lady with a Fan, ca. 1908, charcoal on paper. Harvard University Art Museums, Busch-Reisinger Museum, Cambridge, Massachusetts

Orchard, 1905, oil on canvas.
Carnegie Museum of Art, Pittsburgh, PA

**DAVIS MUSEUM AND CULTURAL
CENTER, WELLESLEY COLLEGE**

WELLESLEY, MASSACHUSETTS

Study of a Male Figure, n.d.
Charcoal on Japan paper
Gift of Professor John McAndrew
Acquired 1957

Reclining Nude, n.d.
[*Strobl 3716*]
Pencil on paper
Gift of Mrs. Sarah d'Harnoncourt
(Sarah Carr, Class of 1925)
Acquired 1984

DES MOINES ART CENTER

DES MOINES, IOWA

Untitled (*Portrait of Bearded Man
Facing Right*), 1895
[*Strobl 3293a*]
Charcoal and chalk on paper
Director's Discretionary Fund from
the John Brady Foundation
Acquired 1983

DETROIT INSTITUTE OF ARTS

DETROIT, MICHIGAN

Sleeping Child, ca. 1905–07
[*Strobl 1306*]
Pencil on paper
Founders Society Purchase, John S.
Newberry Fund
Acquired 1967

**FINE ARTS MUSEUM
OF SAN FRANCISCO**

SAN FRANCISCO, CALIFORNIA

*Study for Portrait of Adele Bloch
Bauer*, n.d.
Purple-red crayon on paper
Gift of the Thiebaud Family
Acquired 1994

**FOGG ART MUSEUM, HARVARD
UNIVERSITY**

CAMBRIDGE, MASSACHUSETTS

Standing Woman (*Study for Portrait of
Dora Breisach*), 1917–18
[*Strobl 2735*]
Pencil on paper
Anonymous Gift in memory of Marilyn
Monroe
Acquired 1962

**SOLOMON R. GUGGENHEIM
MUSEUM**

NEW YORK, NEW YORK

Two Female Nudes Standing, ca. 1900
[*Strobl 612*]
Charcoal on paper
Acquired 1967

Girl Seated in a Chair, 1904
[*Strobl 1440*]
Charcoal on Japan paper
Acquired 1967

Standing Female Nude, Frontal, 1911
[*Strobl 2042*]
Pencil on paper
Acquired 1967

ARMAND HAMMER MUSEUM OF ART AND CULTURAL CENTER, UNIVERSITY OF CALIFORNIA, LOS ANGELES

LOS ANGELES, CALIFORNIA

Study for a Satyr Carrying Drum,
ca. 1886–88
[*Strobl 174*]
Pencil and white chalk heightening
on paper
Collection of the UCLA Grunwald
Center for the Graphic Arts, Hammer
Museum. Partial and Promised Gift of
Eunice and Hal David. The Eunice
and Hal David Collection of 19th and
20th Century Works on Paper
Acquired 2001

Three Studies of a Cherub, ca.
1870–85
Pencil and white chalk heightening
on paper
Collection Grunwald Center for the
Graphic Arts, Hammer Museum.
Purchase
Acquired 1967

*Study for the Portrait of Frau Adele
Bloch-Bauer*, ca. 1900
[*Strobl 1093*]
Charcoal on paper
Collection Grunwald Center for the
Graphic Arts, Hammer Museum. The
Fred Grunwald Collection
Acquired 1965

Standing Woman Reading a Letter, n.d.
Pencil on paper
Collection Grunwald Center for the
Graphic Arts, Hammer Museum.
Rudolf L. Baumfeld Bequest
Acquired 1988

HECKSCHER MUSEUM OF ART

HUNTINGTON, NEW YORK

Head of a Woman, 1897–98
[*Strobl 391*]
Charcoal on paper
Gift of Dr. and Mrs. Milton M. Gardner
Acquired 1982

INDIANA UNIVERSITY ART MUSEUM

BLOOMINGTON, INDIANA

Sitting Nude, n.d.
Pencil on paper
Acquired 1975

Nude (*Study for Medicine*),
1898–1900
Pencil on paper
Jane and Roger Wolcott Memorial,
Gift of Thomas T. Solley
Acquired 1969

Standing Nude, ca. 1900
[*Strobl 794*]
Black chalk on paper
Gift of Serge Sabarsky
Acquired 1979

Seated Nude Leaning Forward, 1902
[*Strobl 808*]
Black chalk on paper
Gift of Serge Sabarsky
Acquired 1979

Standing Nude with Inclined Head,
1903
[*Strobl 889*]
Blue crayon on paper
Gift of Serge Sabarsky
Acquired 1979

Seated Nude Leaning Forward, 1902, black chalk on paper.
Indiana University Art Museum, Bloomington

Standing Nude with Inclined Head, 1903, blue crayon on paper.
Indiana University Art Museum, Bloomington

Study for Portrait of Adele Bloch-Bauer I, 1903, charcoal on paper. The Jewish Museum, New York

Serena Pulitzer Lederer, 1899, oil on canvas. The Metropolitan Museum of Art, New York

THE JEWISH MUSEUM

NEW YORK, NEW YORK

Study for Portrait of Adele Bloch-Bauer I, 1903
[*Strobl 1069*]
Charcoal on paper
Gift of the Muriel and William Rand Collection
Acquired 1997

THE METROPOLITAN MUSEUM OF ART

NEW YORK, NEW YORK

Serena Pulitzer Lederer, 1899
[*Novotny/Dobai 103*]
Oil on canvas
Purchase, Wolfe Fund, and Rogers and Munsey Funds, Gift of Henry Walters, and Bequests of Catharine Lorillard Wolfe and Collis P. Huntington, by exchange
Acquired 1980

Reclining Nude with Outstretched Left Arm, 1903–04
[*Strobl 1383*]
Pencil on paper
Bequest of Scofield Thayer
Acquired 1982

Two Women Friends Reclining, 1904–07
[*Strobl 3575*]
Pencil on paper
Bequest of Scofield Thayer
Acquired 1982

Two Reclining Nudes, 1905–06
[*Strobl 1443a*]
Pencil on paper
Bequest of Scofield Thayer
Acquired 1982

Standing Nude, 1906–07
[*Strobl 1583*]
Pencil on paper
Bequest of Scofield Thayer
Acquired 1982

Mäda Primavesi, 1912
[*Novotny/Dobai 179*]
Oil on canvas
Gift of André and Clara Mertens, in memory of her mother, Jenny Pulitzer Steiner
Acquired 1964

Reclining Nude with Drapery, 1913
[*Strobl 3665*]
Pencil on paper
Bequest of Scofield Thayer
Acquired 1982

Reclining Nude, 1913
[*Strobl 3664*]
Pencil on paper
Bequest of Scofield Thayer
Acquired 1982

The Lovers, ca. 1914
[*Strobl 3681*]
Pencil on paper
Bequest of Scofield Thayer
Acquired 1982

Two Studies for a Crouching Woman, 1914–15
[*Strobl 2377*]
Pencil on paper
Bequest of Scofield Thayer
Acquired 1982

Reclining Nude with Drapery, Back View, 1917–18
[Strobl 3018]
Pencil on paper
Bequest of Scofield Thayer
Acquired 1982

Half-Figure of a Young Woman, 1918
Pencil on paper
Gift of Sir John Pope-Hennessy
Acquired 1982

MILWAUKEE ART MUSEUM

MILWAUKEE, WISCONSIN

Young Girl with Baggy Trousers, ca.
1917
[Strobl 2578]
Pencil on paper
Maurice and Esther Leah Ritz
Collection
Acquired 2004

THE MORGAN LIBRARY
AND MUSEUM

NEW YORK, NEW YORK

Seated Nude, ca. 1907
[Strobl 1618]
Blue pencil on Japan paper
Bequest of Fred Ebb
Acquired 2005

Seated Nude, Chin on Hand, ca.
1909–10
[Strobl 1948]
Pencil on paper
Bequest of Fred Ebb
Acquired 2005

Portrait Studies of Two Women, ca.
1916
Red-orange pencil on paper
Gift of Otto Manley
Acquired 1981

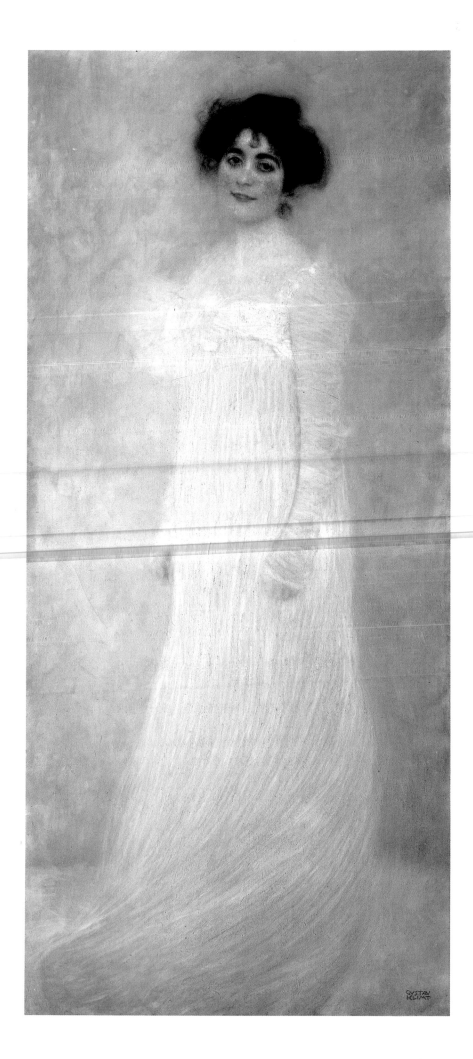

MUSEUM OF FINE ARTS

BOSTON, MASSACHUSETTS

Reclining Woman, ca. 1901–02
[*Strobl 3447*]
Black chalk on paper
Mary L. Smith Fund
Acquired 1964

Portrait of a Young Woman, ca. 1914
[*Strobl 2644*]
Pencil on paper
Sophie M. Friedman Fund
Acquired 1985

*Woman in Kimono, Left Shoulder
Bare*, 1917–18
[*Strobl 2608*]
Pencil on Japan paper
Gift of Hanna Friedenstein
Acquired 2006

THE MUSEUM OF MODERN ART

NEW YORK, NEW YORK

Kunstausstellung Secession, 1898
Lithograph
Gift of Bates Lowry
Acquired 1968

Woman in Profile, 1898–99
[*Strobl 432*]
Blue pencil on paper
The Joan and Lester Avnet Collection
Acquired 1979

Standing Woman, ca. 1904–05
[*Strobl 1765*]
Pencil on paper
Gift of Mrs. Anneli Arms
Acquired 1966

Hope II, 1907–08
[*Novotny/Dobai 155*]
Oil, gold, and platinum on canvas
Jo Carole and Ronald S. Lauder, and

Helen Acheson Funds,
and Serge Sabarsky
Acquired 1978

Three Courtesans, ca. 1908
[*Strobl 1713*]
Pencil on paper
Mr. and Mrs. William B. Jaffe Fund
Acquired 1957

The Park, 1910
[*Novotny/Dobai 165*]
Oil on canvas
Gertrud A. Mellon Fund
Acquired 1957

Reclining Woman, 1912–13
[*Strobl 2271*]
Crayon on paper
Gift of Mrs. Gertrud A. Mellon
Acquired 1969

Seated Woman, ca. 1915
[*Strobl 2599*]
Pencil on paper
Gift of J. B. Neumann
Acquired 1964

Woman with Scarf, ca. 1915
[*Strobl 1984*]
Red pencil on paper
W. Alton Jones Foundation Fund
Acquired 1955

Reclining Woman, ca. 1917
[*Strobl 2381*]
Pencil on paper
Gift of Dr. Christopher Tietze
Acquired 1964

Standing Woman in Kimono,
1917–18
[*Strobl 2614*]
Pencil on paper
Gift of Galerie St. Etienne
Acquired 1961

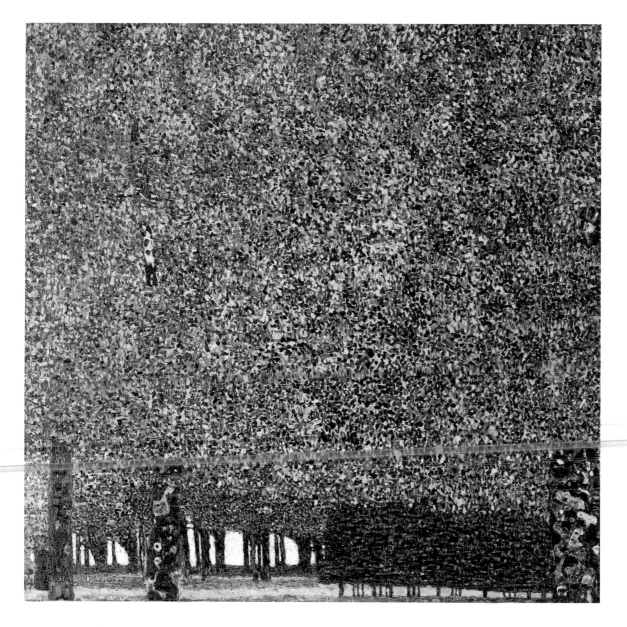

NATIONAL GALLERY OF ART

WASHINGTON, D.C.

*Study of a Nude Old Woman
Clenching Her Fists, and Two
Decorative Objects*, ca. 1901
[*Strobl 592*]
Black and blue crayon on paper
Gift of Dr. Otto Kallir
Acquired 1973

Reclining Woman, ca. 1909
[*Strobl 1507*]
Red crayon on Japan paper
Ailsa Mellon Bruce Fund
Acquired 1973

Portrait of a Woman, ca. 1910
[*Strobl 2522*]
Pencil on paper
Rosenwald Collection
Acquired 1964

Reclining Nude, 1913, pencil on paper.
The Metropolitan Museum of Art, New York

Reclining Nude with Drapery, 1913, pencil on paper.
The Metropolitan Museum of Art, New York

Portrait of a Young Woman, ca. 1914, pencil on paper.
Museum of Fine Arts, Boston

The Park, 1910, oil on canvas.
The Museum of Modern Art, New York

Three Courtesans, ca. 1908, pencil on paper.
The Museum of Modern Art, New York

Woman with Scarf, ca. 1915, red pencil on paper.
The Museum of Modern Art, New York

Curled up Girl on Bed, 1916–17
[*Strobl 2978*]
Pencil on paper
Ailsa Mellon Bruce Fund
Acquired 1974

Baby (*Cradle*), 1917–18
[*Novotny/Dobai 221*]
Oil and tempera on canvas
Gift of Otto and Franziska Kallir with
the Carol and Edwin Gaines
Fullinwider Fund
Acquired 1978

NATIONAL GALLERY OF CANADA

OTTAWA, CANADA

Hope I, 1903
[*Novotny/Dobai 129*]
Oil on canvas
Acquired 1970

*Study for Portrait of Adele Bloch-
Bauer*, 1903
Black chalk on paper
Acquired 1965

*Study for Portrait of Adele Bloch-
Bauer I*, ca. 1904–06
[*Strobl 1137*]
Black crayon on paper
Acquired 2000

*Study for Portrait of Adele Bloch-
Bauer I*, ca. 1904–06
[*Strobl 1118*]
Black crayon on paper
Acquired 2000

NEW ORLEANS MUSEUM OF ART

NEW ORLEANS, LOUISIANA

*Duchess Thyra of Cumberland
Standing in a Box at the Old
Burgtheater, Vienna*, n.d.
[*Strobl 3288*]
Black chalk with white gouache
heightening on paper
Gift of Mrs. P. R. Norman
Acquired 1991

PRINCETON UNIVERSITY ART MUSEUM

PRINCETON, NEW JERSEY

*Standing Pregnant Woman with a
Man* (*Study for Hope I*), 1903–04
[*Strobl 3497*]
Black chalk and charcoal on paper
Museum purchase
Acquired 1985

Head of a Girl, n.d.
Pencil on paper
Museum Purchase (Laura P. Hall
Memorial Fund)
Acquired 1968

RHODE ISLAND SCHOOL OF DESIGN

PROVIDENCE, RHODE ISLAND

Nude, n.d.
Pencil on paper
Museum Works of Art Fund
Acquired 1960

Nude, n.d.
Brown chalk on paper
Edgar J. Lownes Fund
Acquired 1957

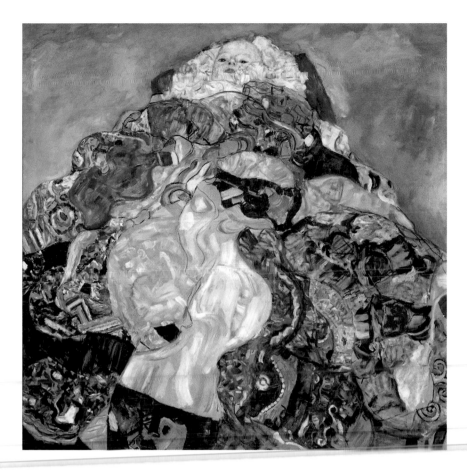

Baby (Cradle), 1917–18, oil and tempera on canvas. National Gallery of Art, Washington, D.C.

Study for Portrait of Adele Bloch-Bauer, 1903, black chalk on paper. National Gallery of Canada, Ottawa

ST. LOUIS ART MUSEUM

ST. LOUIS, MISSOURI

Seated from the Front, ca. 1907
[*Strobl 1070*]
Pencil on paper
Gift of Vincent Price
Acquired 1995

THE SNITE MUSEUM OF ART, UNIVERSITY OF NOTRE DAME

NOTRE DAME, INDIANA

Seated Nude, 1908
[*Strobl 1821*]
Pencil on paper
Purchase Fund
Acquired 1960

TOLEDO MUSEUM OF ART

TOLEDO, OHIO

Female Nude Bending Down, ca. 1914–17
[*Strobl 2360*]
Pencil on paper
Gift of an Anonymous Donor
Acquired 1974

UNIVERSITY OF IOWA MUSEUM OF ART

IOWA CITY, IOWA

Seated Nude with Arms Crossed, 1910–12
[*Strobl 1823*]
Pencil on paper
Museum purchase, the University of Iowa Museum of Art
Acquired 1977

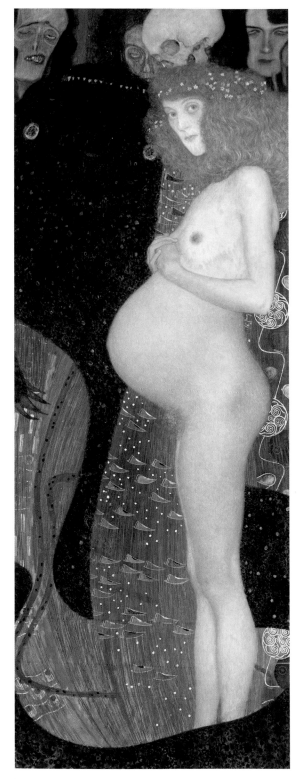

Hope I, 1903, oil on canvas. National Gallery of Canada, Ottawa

Seated Nude, 1908, pencil on paper. The Snite Museum of Art,
University of Notre Dame, IA

WADSWORTH ATHENEUM
MUSEUM OF ART

HARTFORD, CONNECTICUT

Two Girls with Oleander, ca. 1890–92
[*Novotny/Dobai 59*]
Oil on canvas
The Douglas Tracy Smith and
Dorothy Potter Smith Fund and The
Ella Gallup Sumner and Mary Catlin
Sumner Collection Fund
Acquired 1993

Study for Adele Bloch-Bauer Seated,
ca. 1904–06
Black chalk on paper
Purchased through the gift of Henry
and Walter Keney
Acquired 2002

WORCESTER ART MUSEUM

WORCESTER, MASSACHUSETTS

Nude Study, 1903
Pencil on paper
From the Estate of Mrs. Manuel
Berman, as a gift of Mr. and Mrs.
Manuel Berman
Acquired 2003

YALE UNIVERSITY ART
GALLERY

NEW HAVEN, CONNECTICUT

Two Studies of Female Nude (*for the
Beethoven Frieze*), ca. 1898–1903
[*Strobl 694*]
Black chalk on paper
Everett V. Meeks Fund
Acquired 1963

Sleeping Woman, 1904
[*Strobl 1399*]
Pencil on paper
Gift of John Goelet
Acquired 1967

*Woman Lying on Her Back, Partly
Dressed*, 1916–17
[*Strobl 2962*]
Pencil on paper
Gift of John Goelet
Acquired 1967

Four Portrait Studies of Women, n.d.
Pencil and white chalk on paper
Gift of John Goelet
Acquired 1967

Untitled (*Nude*), n.d.
Pencil on paper
Gift of Molly and Walter Bareiss
Acquired 1999

Two Girls with Oleander, ca. 1890–92, oil on canvas.
Wadsworth Atheneum Museum of Art, Hartford, CT

Standing Female Nude, Frontal, 1911, pencil on wove paper.
Courtesy Solomon R. Guggenheim Museum, New York

Woman Lying on Her Back, Partly Dressed, 1916–17, pencil on paper.
Yale University Art Gallery, New Haven, CT

KLIMT EXHIBITIONS IN THE UNITED STATES

1922 ■ The Wiener Werkstaette of America is established in New York City at 581 Fifth Avenue by Joseph Urban (gallery opens June 8)

■ *Modern Austrian Art Exhibited by the Wiener Werkstaette of America*, Art Institute of Chicago, September–October

1940 ■ *Saved from Europe: Masterpieces of European Art*, Galerie St. Etienne, New York City, Summer

1945 ■ *Vienna Through Four Centuries*, Galerie St. Etienne, New York City, March

■ *Austrian Paintings: 1818–1918*, American British Art Center, New York City, June 19–July 7

1950 ■ *Austrian Art of the Nineteenth Century: From Waldmuller to Klimt*, Galerie St. Etienne, New York City, April 1–29

1955 ■ *Austrian Drawings and Prints*, National Gallery of Art, Washington, D.C., February 20–March 20; Minneapolis Institute of Arts, Minnesota, April 3–24; J. B. Speed Art Museum, Louisville, Kentucky, May 8–31; Los Angeles County Museum of Art, July 29–August 28; William Rockhill Nelson Gallery of Art, Kansas City, Missouri, September 11–October 2; Seattle Art Museum, Washington, October 12–November 6; Marion Koogler McNay Art Institute, San Antonio, Texas, November 20–December 18; George Thomas Hunter Gallery of Art, Chattanooga, Tennessee, February 5–26, 1956

1956 ■ *Expressionism 1900–1955*, Walker Art Center, Minneapolis, Minnesota, January 22–March 11

1957 ■ *Recent Acquisitions*, Museum of Modern Art, New York City, January 1–December 31

JUNE NINETEENTH TO JULY SEVENTH 1945

AUSTRIAN PAINTINGS

Gustav Klimt No. 28, Castle Kammer on the Attersee

1818 — 1918

THE AMERICAN BRITISH ART CENTER, INC.
44 WEST 56th STREET, NEW YORK 19, N. Y.

Exhibition catalogue for *Austrian Paintings: 1818–1918*, American British Art Center, 1945. Courtesy Frick Art Reference Library, New York

Opposite: Entrance to the Wiener Werkstaette of America showroom, New York, 1922

Installation view of *Klimt, Schiele, Kokoschka* exhibition, Institute of Contemporary Art, Boston, 1957.
Courtesy Institute of Contemporary Art, Boston

The Fine Arts Department
of
Barnard College
presents
"MODERN ART FROM AUSTRIA"
Catalogue

GUSTAV KURT BECK FOUR FIGURES, 1951 (Linoleum-cut)*
(1902-) TWO FORMS IN RED, 1956 (Linoleum-cut)*
 SYMPHONY OF A TOWN, 1956 (Linoleum-cut)*

JOSEPH FLOCH INTERIOR (Mixed Technique)
(1894-) *Lent by Erica Tietze-Conrat*

JOHANN FRUHMANN COMPOSITION, 1952 (Watercolor)*
(1929-)

ANTON HANAK TWO FIGURES (Drawing)
(1875-1934) *Lent by Erica Tietze-Conrat*

WOLFGANG HOLLEGHA STANDING FIGURE (Aquatint)*
(1929-) SITTING FIGURE (Etching)*

FRITZ HUNDERTWASSER . THREE TALL BUILDINGS, 1953 (Linoleum-cut)*
(1928-)

LUDWIG HEINRICH JUNGNICKEL WILD BOAR, 1918 (Drawing
(1881-) *Lent by Erica Tietze-Conrat*

GUSTAV KLIMT NUDE (Drawing)
(1862-1918) PORTRAIT OF A LADY
 Lent by the Gallery St. Etienne

OSKAR KOKOSCHKA . STUDY FOR "DIE TRAEUMENDEN KNABEN," 1907
(1886) (Drawing)
 Lent by Erica Tietze-Conrat
 SITTING GIRL (Watercolor)
 Lent by Mrs. A. Knize
 TWO SHEETS FROM THE "BACHKANTATE," 1914
 a) SELFPORTRAIT (Lithograph)
 b) "WOHLAN, SOLL ICH VON NUN AN SELIG SEIN"
 Lent by Julius S. Held

ALFRED KUBIN ON THE LAKE OF ZELL
(1877-) THE HOLD-UP
 Lent by the Gallery St. Etienne

ANTON LEHMDEN ROTTING FISH, 1954 (Drawing)*
(1929-) BURSTING LANDSCAPE, 1956 (Watercolor)*
 LANDSCAPE IN FLIGHT, 1956 (Watercolor)*

JOSEPH MIKL HEAD I, 1956 (Etching)*
(1929-) HEAD II, 1956 (Etching)*

KURT MOLDOVAN BUTTERFLY, 1953 (Lithograph)*
(1918-) END OF CARNEVAL, 1957 (Drawing)*

ARNULF RAINER PERMANENT EXPLOSION, 1951 (Drawing)*
(1929-) TABERNACLE, 1956 (Etching)*

EGON SCHIELE LYING WOMAN (Watercolor)
(1890-1918) STANDING WOMAN (Watercolor)
 STANDING WOMAN (Drawing)
 Lent by Mrs. A. Knize

SLAVI SOUCEK FRAGMENTS, 1952 (Linoleum-cut)*
(1898-) COMPOSITION IN BLUE AND RED, 1952 (Linoleum-cut)*

All items with an asterisk are lent by the artist and are for sale.

APRIL 24 TO MAY 17, 1957
JAMES ROOM, BARNARD HALL

Brochure for *Modern Art from Austria*, Barnard College, New York,
1957. Courtesy Barnard College Archives, Columbia University,
New York

Installation view of *Recent Acquisitions* exhibition,
The Museum of Modern Art, New York, 1957

■ *Modern Art from Austria*, Barnard College, New York City,
April 24–May 17
■ *Klimt, Schiele, Kokoschka*, Institute of Contemporary Art, Boston,
August 10–September 22; Allen Memorial Art Museum, Oberlin
College, Ohio, November 1–26

1958 ■ *Paintings, Sculpture, and Graphic Arts from the Museum Collection*,
Museum of Modern Art, New York City, March 23–April 7

1959 ■ *Gustav Klimt*, Galerie St. Etienne, New York City, April 1–May 2
(first American solo exhibition)
■ *The Dial and The Dial Collection*, Worcester Art Museum,
Massachusetts, April 30–September 8
■ *European and American Expressionists*, Galerie St. Etienne, New York
City, September 22–October 17

1960 ■ *Sixth Annual Exhibition of Master Drawings from Five Centuries*,
Este Gallery, New York City, April 15–May 30
■ *Watercolors and Drawings by Austrian Artists from The Dial Collection*,
Galerie St. Etienne, New York City, May 2–28
■ *Art Nouveau*, Museum of Modern Art, New York City, June
6–September 6; Museum of Art, Carnegie Institute, Pittsburgh,
Pennsylvania; Los Angeles County Museum of Art; Baltimore Museum
of Art, Maryland

- *Paintings, Drawings and Prints of the Nineteenth and Twentieth Centuries: The Collection of Dr. and Mrs. Otto Fleischman*, University of Kansas Museum of Art, Lawrence, December 4–January 28, 1961

1961
- *Klimt, Schiele, Dolbin*, Este Gallery, New York City, February 1–28
- *Exhibition 1961: Paintings from the Galleries' Collection*, E. and A. Silberman Galleries, New York City, March 1–April 1
- *Klimt, Schiele, Kokoschka, Kubin*, Galerie St. Etienne, New York City, March 14–April 8
- *Recent Accessions*, Museum of Art, Rhode Island School of Design, Providence, April 23–May 28

1962
- *Master Drawings from Five Centuries*, Este Gallery, New York City, May 14–June 30
- *A Selection of Nineteenth Century Paintings, Sculpture and Prints from the Milwaukee Art Center and the Layton Art Gallery Permanent Collections*, Milwaukee, Wisconsin, May 17–Summer
- *Watercolors, Drawings and Graphic Works by Schiele, Klimt, Kokoschka, Kubin, Kollwitz*, Galerie St. Etienne, New York City, October 15–November 7
- *Paintings, Sculpture, and Graphic Art from the Museum Collection,* Museum of Modern Art, New York City, October 27–November 3, 1963

1963
- *Viennese Expressionism 1910–1924*, University Art Gallery, University of California, Berkeley, February 5–March 10; Pasadena Art Museum, California, March 19–April 21
- *Twentieth Century Master Drawings*, Fogg Art Museum, Harvard University, Cambridge, Massachusetts, January 9–February 10; Solomon R. Guggenheim Museum, New York City, November 6–January 5, 1964; University of Minnesota, Minneapolis, February 3–March 15, 1964
- *Paintings from the Museum of Modern Art, New York*, National Gallery of Art, Washington, D.C., December 16–March 1, 1964

1964
- *Austrian Expressionists: Watercolors, Drawings, Prints*, Galerie St. Etienne, New York City, January 6–25; Sarasota Art Association, Florida, February 2–14; Fort Worth Art Center, Texas, March
- *Paintings and Sculpture from the Museum Collection*, Museum of Modern Art, New York City, May 27–January 1965
- *1914: An Exhibition of Paintings, Drawings and Sculpture*, Baltimore Museum of Art, Maryland, October 6–November 15
- *Twenty-Fifth Anniversary Exhibition*, Galerie St. Etienne, New York City, October 14–November 14

1965
- *Gustav Klimt and Egon Schiele*, Solomon R. Guggenheim Museum, New York City, February 5–April 25

Invitation for *Gustav Klimt* exhibition, Galerie St. Etienne, New York, 1959. Courtesy Galerie St. Etienne

Catalogue for *Klimt, Schiele, Dolbin*, Este Gallery, New York, 1961. Courtesy New York Public Library

Exhibition catalogue for *Gustav Klimt, 1862–1918: Drawings*, Galerie St. Etienne, New York, 1970. Neue Galerie New York

Review of *Gustav Klimt, 1862–1918: Drawings*, Galerie St. Etienne, New York, 1970

Exhibition catalogue for *Art and Design in Vienna: 1900–1930*, La Boetie in association with Robert K. Brown, New York, 1972. Neue Galerie New York; Gift of Reinhold Brown Gallery

Gustav Klimt, *Pregnant Woman*, charcoal. Courtesy Galerie St. Etienne.

ARTS — April 1970

GUSTAV KLIMT AT ST. ETIENNE

Fabulous creator of the Viennese *fin de siècle* period, setting up fresh patterns of portraiture and of oil-on-canvas landscapes, Klimt is most memorable for his countless unpretentious pencil or charcoal drawings on Japan paper.

The present show gives weight to these delicate sensitive expressions of an artist's sheer joy in depicting feeling with masterly technique. The Austrian art world considers this show a major event, at last rounding out American recognition of one of Europe's most influential art forces from 1898 to his death, supplementing the Guggenheim showing of his oils a couple of years ago.

Leader of the Secession movement beginning in 1898, Klimt inspired Schiele and Kokoschka. Portraits of the beautiful women of Vienna, at a period of the city's exuberant prosperity, decked in dramatic extremes of dress hold suggestions of Beardsley; and Klimt's love of bejeweled mosaic effects might recall Gustave Moreau —all this in oils not shown in the present exhibit. But those who have known the lushly colorful Klimt can fully appreciate the "graphic process of spiritualization" in playful, musical pencil jottings of the same beautiful women freed from all worldly decor and covering. Where clothing is present, it blends with bodies, adding touches of virtuoso line but not covering up the innocent lovely natural forms. Klimt here is as close to creating feeling without letting technique show as an artist can get. (Mar. 20-Apr. 25)—W.D.A.

1975
- *German and Austrian Expressionism,* New Orleans Museum of Art, Louisiana, November 22–January 18, 1976
- *The Kondon Collection*, La Jolla Museum of Contemporary Art, California, December 19–February 1, 1976

1976
- *The Lyon Collection: Modern and Contemporary Works on Paper*, The Art Galleries, California State University, Long Beach, March 29–May 2
- *Neue Galerie–Galerie St. Etienne: A Documentary Exhibition*, Galerie St. Etienne, New York City, May
- *Austrian and German Drawings in the Held Collection*, Clark Institute, Williamstown, Massachusetts, October 19–December 5
- *European Master Paintings from Swiss Collections: Post-Impressionism to World War II*, Museum of Modern Art, New York City, December 17–March 1, 1977

1977
- *Austrian Art,* Birmingham Museum of Art, Alabama, April 15–May 22
- *Works on Paper 1900–1960 From Southern California Collections,* Montgomery Art Gallery, Pomona College, Claremont, California, September 18–October 27; M. H. de Young Memorial Museum, San Francisco, California, November 11–December 31

1978
- *Aspects of Twentieth-Century Art*, National Gallery of Art, Washington, D.C., June 1–July 30, 1979
- *Recent Acquisitions: Painting and Sculpture*, Museum of Modern Art, New York City, September 22–November 26
- *Vienna Moderne: 1898–1918: An Early Encounter Between Taste and Utility*, Cooper-Hewitt Museum, New York City, November 27–February 4, 1979; Sarah Campbell Blaffer Gallery, University of Houston, Texas, March 2–April 29, 1979; Portland Art Museum, Oregon, June–July, 1979; David and Alfred Smart Gallery, University of Chicago, January 9–February 24, 1980

1979
- *German Expressionism from Milwaukee Collections: An Exhibition of Painting, Drawings, Prints and Sculpture*, The Fine Art Galleries, University of Wisconsin–Milwaukee, January 22–March 11
- *Beauties*, Cantor Arts Center, Stanford University, Palo Alto, California, January 23–March 18
- *Thirty-two Drawings by Gustav Klimt from the Collection of His Highness Prince Sadruddin Aga Khan*, Sotheby's, New York City, public viewing May 11–15 (auction on May 16)
- *Fortieth Anniversary Exhibition*, Galerie St. Etienne, New York City, November 13–December 28
- *An Exhibition of Drawings by Gustav Klimt*, Serge Sabarsky Gallery, New York City, November–December
- *Master Drawings and Watercolors of the Nineteenth and Twentieth Centuries*, Solomon R. Guggenheim Museum, New York City, August

Exhibition catalogue for *Gustav Klimt*, Spencer A. Samuels and Co., New York, 1974. Neue Galerie New York

Addendum to the exhibition catalogue for *Gustav Klimt*, Spencer A. Samuels and Co., New York 1974. Neue Galerie New York

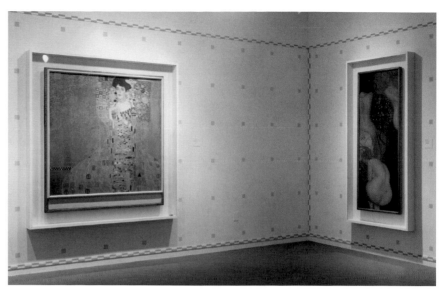

Installation view of *Vienna 1900*, featuring Klimt's *Adele Bloch-Bauer I* and *Goldfish*, The Museum of Modern Art, New York

Invitation interior for *Gustav Klimt: Drawings and Selected Paintings*, Galerie St. Etienne, New York, 1983. Courtesy The Jean-Noël Herlin Archive Project, New York, 1986

November 12, 1986–November 20, 1991; June 21, 1989–April 4, 1992; April 22–August 4, 1992

- *Art Around 1900*, Cantor Arts Center, Stanford University, Palo Alto, California, October 16–December 1
- *Arnold Schoenberg's Vienna,* Galerie St. Etienne, New York City, November 13–January 5, 1985

1985
- *Drawings from the Indiana University Art Museum Collection*, Indiana University Art Museum, Bloomington, January 16–March 3
- *Vienna 1900–Prints, Drawings, Watercolors and Paintings 1897–1918*, Shepherd Gallery, New York City, April 9–May 18
- *Drawings in Austria and Germany*, Museum of Modern Art, New York City, May 25–November 19
- *European and American Landscapes,* Galerie St. Etienne, New York City, June 4–September 13
- *Great Drawings from The Art Institute of Chicago: The Harold Joachim Years*, Art Institute of Chicago, July–September
- *Expressionists on Paper*, Galerie St. Etienne, New York City, October 8–November 23
- *The Art of Giving*, Galerie St. Etienne, New York City, December 3–January 18, 1986
- *The Vienna Secession*, Allen Memorial Art Museum, Oberlin College, Ohio, November 19–January 31, 1986

1986
- *Expressionist Painters*, Galerie St. Etienne, New York City, March 25–May 10
- *Gustav Klimt, Egon Schiele, and Oskar Kokoschka*, Galerie St. Etienne, New York City, May 27–September 13
- *Vienna 1900–Art, Architecture and Design*, Museum of Modern Art, New York City, July 3–October 21

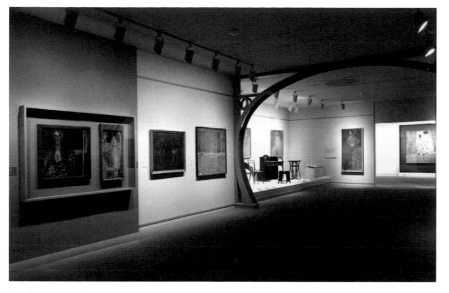

Installation view of *Vienna 1900*, featuring works by Klimt, The Museum of Modern Art, New York, 1986

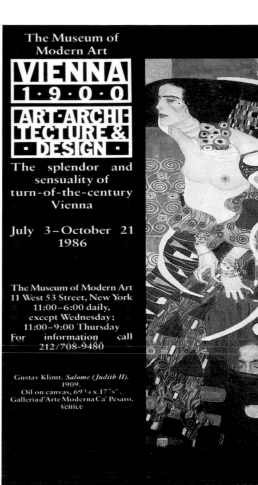

The splendor and
sensuality of
turn-of-the-century
Vienna

Invitation for *Vienna 1900: Art, Architecture and Design*,
The Museum of Modern Art, New York, 1986

- *The Expressive Figure from Rousseau to Bacon*, Solomon R. Guggenheim Museum, New York City, July 18–September 21
- *Saving Face: The Portrait*, Ripin Print Gallery, Allen Memorial Art Museum, Oberlin College, Ohio, August 8–September 9
- *Viennese Design and Wiener Werkstätte,* Galerie St. Etienne, New York City, September 23–November 8
- *Drawing the Fine Line: Discovering European Drawings in Long Island Private Collections,* Hillwood Art Gallery, C. W. Post Art Gallery, C. W. Post Center of Long Island University, Greenvale, New York, November 2–28
- *The Expressionist Figure*, Lafayette Parke Gallery, New York City, November–December 20
- *Oskar Kokoschka and His Time,* Galerie St. Etienne, New York City, November 25–January 31, 1987

1987 ■ *Recent Acquisitions and Works from the Collection*, Galerie St. Etienne, New York City, April 7–October 31
- *Pre-Modern Art of Vienna, 1848–1898*, IBM Gallery of Science and Art, New York City, May 12–July 11; Edith C. Blum Art Institute of Bard College, Annandale-on-Hudson, New York, July 20–September 18; De Pree Art Gallery of Hope College, Holland, Michigan, October 2–November 29; Bass Museum of Art, Miami Beach, Florida, December 15–January 30, 1988
- *Drawing the Figure*, University Art Gallery, University of Pittsburgh, Pennsylvania, September 13–November 8

1988 ■ *From Art Nouveau to Expressionism,* Galerie St. Etienne, New York City, April 12–May 27
- *Recent Acquisitions and Works from the Collection*, Galerie St. Etienne, New York City, June 14–September 16

Exhibition catalogue for *Vienna 1900—Art, Architecture and Design*, The Museum of Modern Art, New York, 1986. Neue Galerie New York

449

Exhibition catalogue for *Gustav Klimt: Landscapes*, Sterling and Francine Clark Art Institute, Williamstown, MA, 2002. Neue Galerie New York

Exhibition catalogue for *Gustav Klimt: Modernism in the Making,* National Gallery of Canada, Ottawa, 2001. Neue Galerie New York.

Exhibition ticket for *Gustav Klimt: Landscapes*, Sterling and Francine Clark Art Institute, Williamstown, MA, 2002. Courtesy Clark Art Institute

- *1900–Art at the Crossroads*, Solomon R. Guggenheim Museum, New York City, May 19–September 10
- *Art Nouveau, 1890–1914*, National Gallery of Art, Washington, D.C., October 8–January 28, 2001

2001
- *The Global Guggenheim: Selections from the Extended Collection*, Solomon R. Guggenheim Museum, New York City, February 1–April 22
- *Corot to Picasso: Masterworks of the Detroit Institute of Arts Nineteenth and Early Twentieth Century Collections,* Detroit Institute of Arts, Michigan, April 7–November 25
- *A Legacy for Learning: Gifts to Stanford from Mona and Nathan Oliveira*, Cantor Arts Center, Stanford University, Palo Alto, California, April 18–July 29
- *Portrait/Self-Portrait: Prints and Drawings from the Museum's Collections*, Carnegie Museum of Art, Pittsburgh, Pennsylvania, May 5–December 9
- *Gustav Klimt: Modernism in the Making,* National Gallery of Canada, Ottawa, June 15–September 16
- *Recent Acquisitions (And Some Thoughts on the Current Art Market),* Galerie St. Etienne, New York City, June 26–September 7
- *New Worlds: German and Austrian Art, 1890–1940,* Neue Galerie New York, November 1–February 18, 2002 (Neue Galerie's inaugural exhibition)
- *Portraits on Paper: A Sampling from the Collection*, Jewish Museum, New York City, November 18–February 10, 2002
- *Gustav Klimt, Egon Schiele, Oskar Kokoschka: From Art Nouveau to Expressionism*, Galerie St. Etienne, New York City, November 23–January 5, 2002
- *Treasure Hunt: A Decade of Collecting Works on Paper*, Carnegie Museum of Art, Pittsburgh, Pennsylvania, December 15–June 2, 2002

2002
- *Gustav Klimt: Landscapes*, Sterling and Francine Clark Art Institute, Williamstown, Massachusetts, June 16–September 2
- *Recent Acquisitions*, Galerie St. Etienne, New York City, June 25–September 20

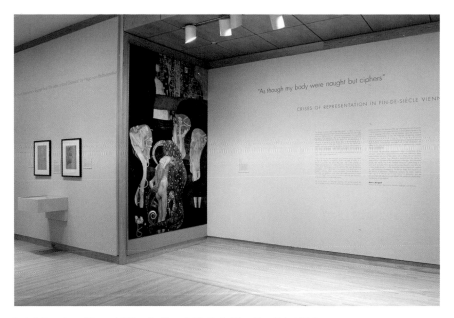

Installation view of the exhibition *As Though My Body Were Naught but Ciphers:*
Crises of Representation in Fin-de-Siècle Vienna, The Busch-Reisinger Museum, Cambridge, MA, 2005.
Harvard University Art Museums Archive

- *To Be Looked At: Painting and Sculpture from the Collection*,
 Museum of Modern Art, New York City, June 29–September 13
- *Prelude to a Nightmare*, Museum of Art, Williams College,
 Northampton, Massachusetts, July 13–October 27
- *European Master Drawings from the Allen Memorial Art Museum*,
 Ripin Gallery, Allen Memorial Art Museum, Oberlin College, Ohio,
 October 8–March 9, 2003

2003 ■ *In Search of the "Total Artwork": Viennese Art and Design,*
 1897–1952, Galerie St. Etienne, New York City, April 8–June 14
- *Recent Acquisitions*, Galerie St. Etienne, New York City, June
 24–September 12
- *The Heroic Century: The Museum of Modern Art's Masterpieces,*
 200 Paintings and Sculptures, Museum of Fine Arts, Houston, Texas,
 September 21–January 4, 2004
- *Interiors*, exhibition of the permanent collection, Solomon R.
 Guggenheim Museum, New York City, October 20–April 15, 2004
- *The Eunice and Hal David Collection of Nineteenth and Twentieth*
 Century Works on Paper, Armand Hammer Museum of Art and
 Cultural Center, University of California, Los Angeles,
 November 14–February 8, 2004; Portland Art Museum, Oregon,
 May 1–July 25, 2004

2004 ■ *Fernand Khnopff: A Retrospective*, McMullen Museum of Art, Boston
 College, Chestnut Hill, Massachusetts, September 19–December 5
- *65th Anniversary Exhibition Part I: Austrian and German Expressionism*,
 Galerie St. Etienne, New York City, October 28–January 8, 2005

Exhibition catalogue for *Prelude to a Nightmare*,
Museum of Art, Williams College, Northampton, MA, 2002.
Courtesy Williams College

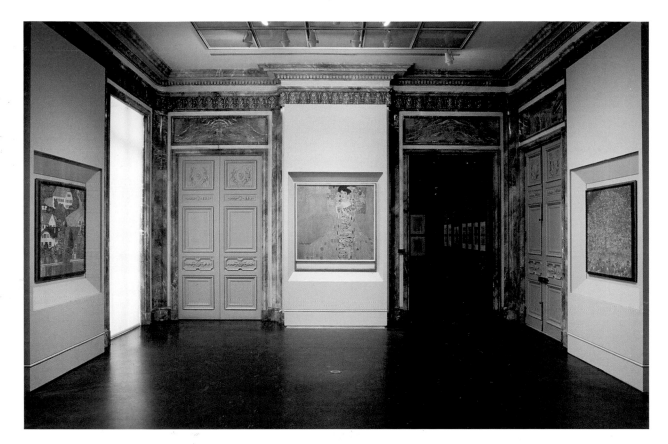

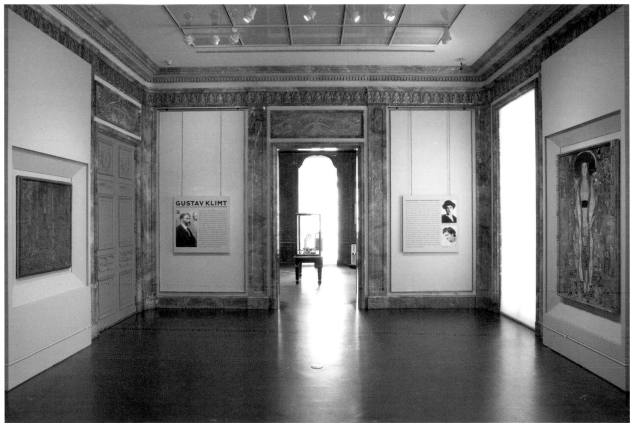

Installation views of the exhibition *Gustav Klimt: Five Paintings from the Collection of Ferdinand and Adele Bloch-Bauer*, Neue Galerie New York, 2006. Neue Galerie New York

- *Painting and Sculpture: Inaugural Installation*, Museum of Modern Art, New York City, November 20–February 2, 2005
- *Drawing from the Modern: 1880–1945*, Museum of Modern Art, New York City, November 20–March 7, 2005

2005
- *Reflections and Shadows: Impressionism and 19th-Century Style*, Wadsworth Atheneum, Hartford, Connecticut, January 1–December 31, 2006
- *As Though My Body were Naught but Ciphers: Crises of Representation in Fin-de-Siècle Vienna*, The Busch-Reisinger Museum, Harvard University, Cambridge, Massachusetts, February 12–June 12
- *Jewish Women and Their Salons: The Power of Conversation*, Jewish Museum, New York City, March 4–July 10
- *Every Picture Tells a Story*, Galerie St. Etienne, New York City, April 5–May 27
- *Ronald Lauder Installation*, Museum of Modern Art, New York City, May 10–ongoing
- *Recent Acquisitions*, Galerie St. Etienne, New York City, June 7–September 9
- *Old Masters/New Directions: A Decade of Collecting*, Wadsworth Atheneum, Hartford, Connecticut, August 8–August 2008
- *Coming of Age*, Galerie St. Etienne, New York City, November 15–January 7, 2006

2006
- *Rediscovering Portfolio Prints: Prints by Gustav Klimt and Egon Schiele*, Jason Jacques Gallery, New York City, March 31–May 31

Exhibition brochure for *Gustav Klimt: Five Paintings from the Collection Ferdinand and Adele Bloch-Bauer*, Neue Galerie New York, 2006.

- *Gustav Klimt: Five Paintings from the Collection of Ferdinand and Adele Bloch-Bauer*, Los Angeles County Museum of Art, April 4–June 30
- *Drawings in Dialogue: Old Master through Modern*, Art Institute of Chicago, June 3–July 30
- *Recent Acquisitions*, Galerie St. Etienne, New York City, June 6–September 8
- *Gustav Klimt: Five Paintings from the Collection of Ferdinand and Adele Bloch-Bauer*, Neue Galerie New York, July 13–October 9
- *More than Coffee was Served: Café Culture in Fin-de-Siècle Vienna and Weimar Germany*, Galerie St. Etienne, New York City, September 19–November 25

2007
- *Gustav Klimt: Ten Drawings,* Patrick Derom's Selection at Shepherd & Derom Galleries, New York City, Spring 2007

Exhibition catalogue for *Gustav Klimt: Ten Drawings*, Shepherd & Derom Galleries, New York, 2007. Neue Galerie New York

APPENDIX I

The Klimt Affair
Berta Zuckerkandl on Gustav Klimt

Klimt's 1896 commission from Austria's Ministry of Education to depict three of the university faculties—Philosophy, Medicine, and Jurisprudence—for the ceiling of the Great Hall of the University of Vienna turned into an unmitigated fiasco. Klimt's depictions were deemed scandalous, and the three works were rejected by the Minister of Education. In April 1905, with the financial aide of his patron, August Lederer, Klimt finally withdrew the commissioned works, and refunded his advance fee of thirty thousand kronen. Critic Berta Zuckerkandl, the artist's friend and champion, interviewed Klimt and summarized his statements as follows:

April 12, 1905

The main reason I took back the ceiling paintings commissioned by the Ministry of Education … is not that I was disgruntled by the diverse attacks on myself made by a wide range of authorities. At the time, that did not really affect me, and would not have caused me to lose my enthusiasm for the commission.

In general, I am not sensitive to attacks. I do, however, become very sensitive if I feel that the person who commissioned my work is not satisfied with it, as was the case with the ceiling paintings. Throughout his attacks, the minister presented only the legal grounds for his standpoint, and barely touched on the artistic aspects of the work, which should have been the primary issue, after all. Indeed, the overall impression was that the ministry rejected the work on artistic grounds. In countless insinuations, the ministry gave me to understand that I had become an embarrassment to them. For an artist—naturally I apply that term quite broadly—there is no more embarrassing situation than creating specially commissioned works for someone who does not fully support, with heart and mind, the artist's work. I find that to be absolutely intolerable.

For a long time I looked for all the possible ways to extract myself from this situation, which I found deeply demeaning. Eight years ago, when the art commission presented my sketches for the ceiling paintings, I felt the same way. At

KLIMT'S LETTER TO THE MINISTRY OF EDUCATION

To the Imperial and Royal Ministry for Culture and Education:

When I received the commission for the Great Hall of the university more than ten years ago, I approached this weighty task with enthusiasm. Years of serious effort on my part brought me, as is well known, an abundance of insults that, considering the sources, at first did little to cool my enthusiasm. That changed over time, however. His Excellency Minister Dr. Hartel made it clear to me in a series of particulars that my work had become an embarrassment to those who had commissioned it. If my work, which has consumed years, is ever to be completed, I will first have to regain my pleasure in it, which is utterly lacking given the present circumstances and as long as I have to view it as a state commission. I am thus confronted with the impossibility of completing this commission, which has dragged on so long. I have already disclaimed a part of it—the paintings for the pendentives—which the ministry has granted. I hereby follow that by disclaiming the entire commission, and will return the advances I have received over the years. I kindly request information regarding the account to which I should pay the money.

Respectfully yours,

Klimt

From: Berta Zuckerkandl, *Zeitkunst: Wien, 1901–1907*
(Vienna: Hugo Heller, 1908), pp. 163–67.

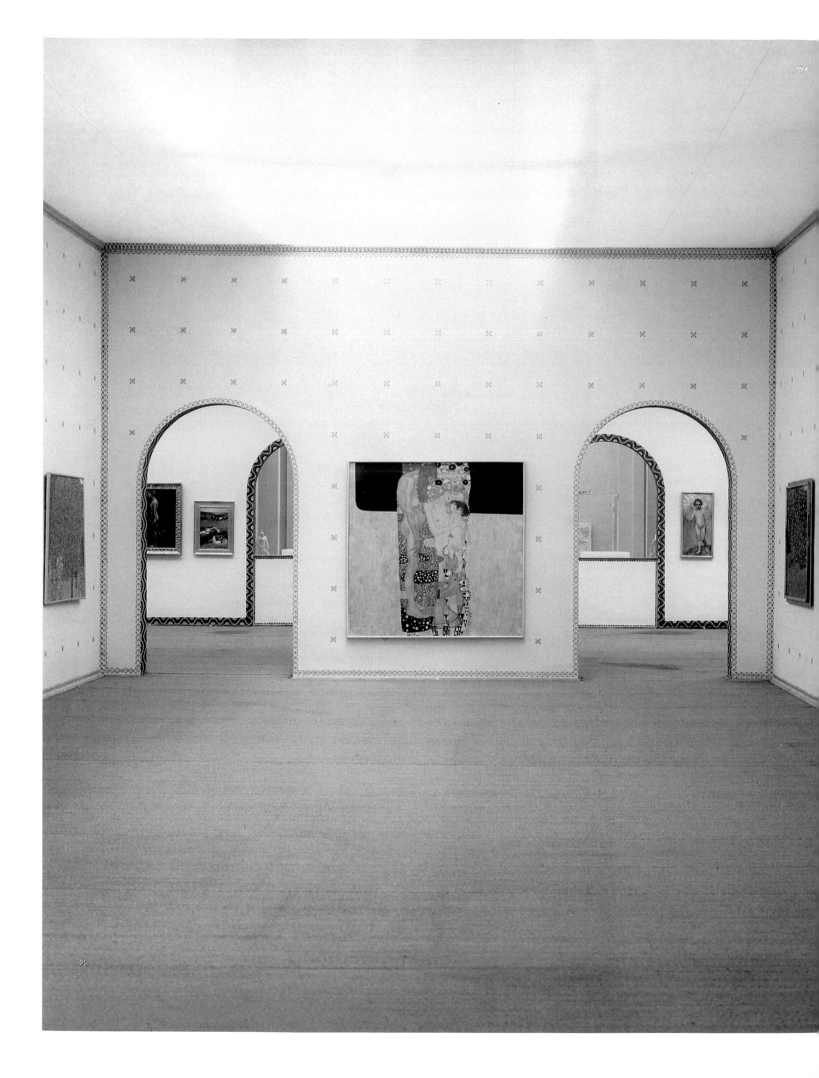

APPENDIX II

Gustav Klimt Speech at the 1908 *Kunstschau*

Ladies and Gentlemen,

It has been four years since we last presented our work to you in an exhibition.

View of the Klimt Hall (room 22), designed by Koloman Moser, at the 1908 *Kunstschau*, Vienna

It is, after all, well known that we do not consider an exhibition the ideal forum for establishing contact between artist and public; large public art commissions would be incomparably superior, in our view. But as long as public life is primarily concerned with economic and political matters, the exhibition is the only path available to us. Therefore we must be extremely grateful for all the public and private factors that have made it possible for us to pursue this path, and show you that we have not been idle during these four years, but rather—perhaps precisely because we were not worrying about exhibitions—have been all the more industrious and fervent in developing our ideas.

We are not a cooperative, not an association, not a league. We have come together in a loose form for the sole purpose of this exhibition, united only by the conviction that no realm of human life is too insignificant and small to offer room for artistic efforts; that—in [William] Morris's words—even the most unprepossessing thing, if it is perfectly executed, can help increase the beauty of this earth, and that the progress of culture is founded solely in the ever-increasing permeation of all life with artistic intentions.

Accordingly, this exhibition does not present a summation of our artistic careers. Rather, it is a review of the efforts of Austria's artists, a faithful report of the present state of culture in our empire.

Just as broadly as we conceive the term "work of art," we conceive the term "artist." We apply that name not only to those who create but to those who enjoy, who are capable of belief and who appreciate emotionally what has been created. For us, the "community of artists" is all those who create and enjoy. The fact that this community exists, that it is strong and powerful—thanks to its youth and

Courtyard to the *Kunstschau*, Vienna, at its opening, 1908. Writing on photograph identifies Klimt, with back to camera, with three other men; and Emilie Flöge, composer Julius Bittner and Kolomon Moser's wife near the rear wall. Courtesy Asenbaum Photo Archive, Vienna

Berthold Löffler, *Kunstschau Wien 1908*, lithograph. Serge Sabarsky Collection, New York

Opposite: Gustav Klimt, ca. 1908. Photograph by Moritz Nähr. Courtesy Asenbaum Photo Archive, Vienna

energy and the purity of its convictions—is proven by the fact that this building was built and that this exhibition can now open.

Hence it is utterly futile for our adversaries to declare this modern art movement dead, or to try to combat it, because such a battle goes against growing and developing—against life itself. We—who have now worked together for weeks on this exhibition—will, once it has opened, separate and each go his own way. But perhaps we will find ourselves together again in the foreseeable future, in a completely different grouping, for other goals. In any case, let us rely on one another.

Finally, I thank all those who participated in this exhibition, for their diligence, their enthusiastic willingness to make sacrifices, and their fidelity. And I also wish to thank all our patrons and supporters, who have made it possible for us to realize this exhibition. Ladies and gentlemen, by inviting you to a tour through the exhibition spaces, I declare the *Kunstschau* Wien 1908 to be open.

From: Christian M. Nebehay, *Gustav Klimt: Dokumentation* (Vienna: Galerie Christian M. Nebehay, 1969), p. 394

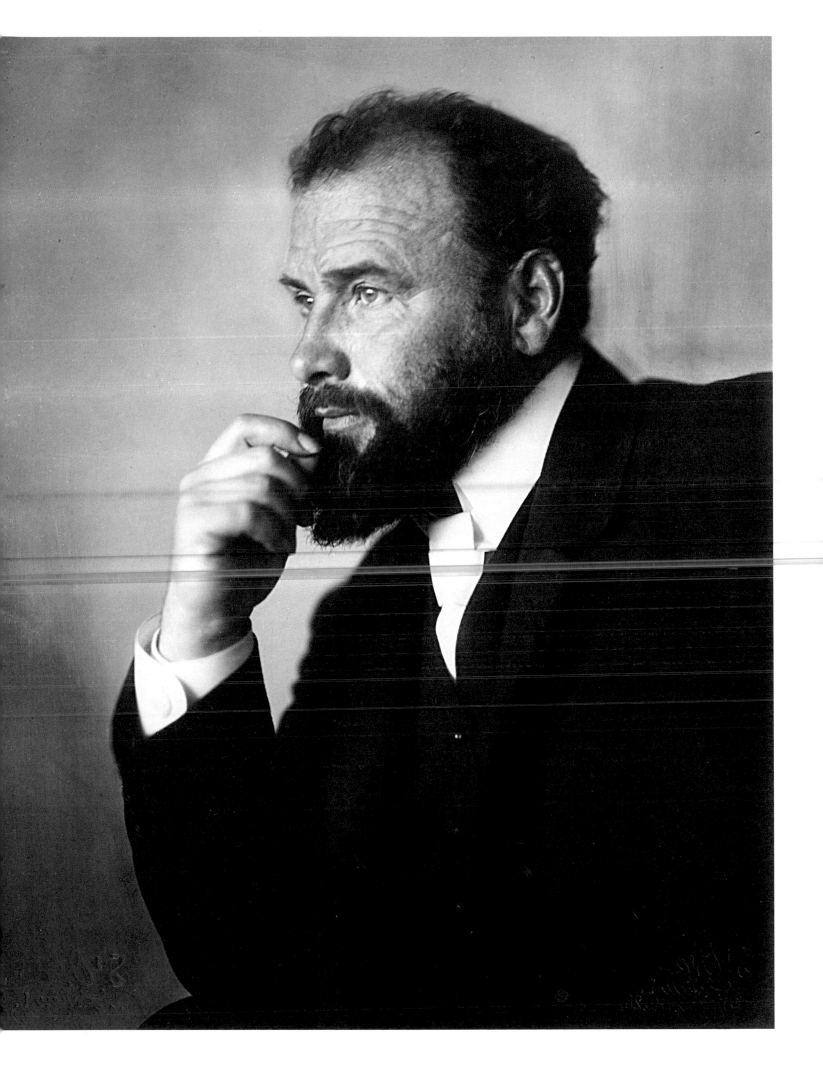

SELECT BIBLIOGRAPHY

Bailey, Colin B., ed. *Gustav Klimt: Modernism in the Making.* Ottawa: National Gallery of Canada, 2001.

Bisanz-Prakken, Marian. *Gustav Klimt, der Beethovenfries: Geschichte, Funktion und Bedeutung.* Salzburg: Residenz, in association with the Graphische Sammlung Albertina, 1977 (unabridged edition 1980).

———. *Heiliger Frühling: Gustav Klimt und die Anfänge der Wiener Secession, 1895–1900.* Vienna: Graphische Sammlung Albertina/Christian Brandstätter, 1998.

Brandstätter, Christian. *Klimt and Fashion.* New York: Assouline, 1998.

Breicha, Otto, ed. *Gustav Klimt, die goldene Pforte: Werke, Wesen, Wirkung: Bilder und Schriften zu Leben und Werk.* Salzburg: Galerie Welz, 1978.

Comini, Alessandra. *Gustav Klimt.* New York: George Braziller, 1975 (reprinted 1980).

Czernin, Hubertus. *Die Fälschung: Der Fall Bloch Bauer* and *Die Fälschung: Der Fall Bloch-Bauer und das Werk Gustav Klimts.* 2 vols. Vienna: Czernin, 1999.

Eisler, Max. *Gustav Klimt.* Vienna: Österreichische Staatsdruckerei, 1920.

Fischer, Wolfgang Georg. *Gustav Klimt und Emilie Flöge: Genie und Talent, Freundschaft und Besessenheit.* Vienna: Verlag Christian Brandstätter, 1987. Published in a somewhat abridged form in English as *Gustav Klimt and Emilie Flöge: An Artist and His Muse.* Woodstock, NY: Overlook, 1992.

Frodl, Gerbert. *Klimt.* Translated by Alexandra Campbell. New York: Konecky and Konecky, 1992.

Hofmann, Werner. *Gustav Klimt.* Translated by Inge Goodwin. Greenwich, CT: New York Graphic Society, 1971.

Kallir, Jane. *Saved from Europe: Otto Kallir and the History of the Galerie St. Etienne.* New York: Galerie St. Etienne, 1999.

Koja, Stephan, ed. *Gustav Klimt: Landschaften.* Munich: Prestel, 2002.

Metzger, Rainer. *Gustav Klimt: Drawings and Watercolors.* Vienna and London: Christian Brandstätter/Thames and Hudson, 2006.

Miller, Manu von. *Sonja Knips und die Wiener Moderne: Gustav Klimt,*

Josef Hoffmann und die Wiener Werkstätte gestalten eine Lebenswelt.

Vienna: Christian Brandstätter, 2004.

Natter, Tobias G., and Gerbert Frodl, eds., *Klimt und die Frauen.* Vienna and Cologne: Österreichische Galerie Belvedere/DuMont, 2000. Published in English as *Klimt's Women.* New Haven, CT: Yale University Press, 2001.

Nebehay, Christian M. *Gustav Klimt: Dokumentation.* Vienna: Galerie Christian M. Nebehay, 1969.

———. *Gustav Klimt: Das Skizzenbuch aus dem Besitz von Sonja Knips.* Vienna: Tusch, 1987.

———. *Gustav Klimt, Egon Schiele und die Familie Lederer.* Bern: Galerie Kornfeld, 1987.

———. *Gustav Klimt: From Drawing to Painting.* New York: Harry N. Abrams, 1994.

Novotny, Fritz, and Johannes Dobai. *Gustav Klimt: With a Catalogue Raisonné of His Paintings.* London and New York: Thames and Hudson/Frederick A. Praeger, 1968.

———. *Gustav Klimt.* Salzburg: Galerie Welz, 1967 (revised 1975).

Partsch, Susanna. *Klimt: Life and Work.* London: Bracken, 1989.

———. *Gustav Klimt: Painter of Women.* Munich: Prestel, 1994 (reprinted 2006).

Pirchan, Emil. *Gustav Klimt: Ein Künstler aus Wien.* Vienna: Bergland, 1942.

Powell, Nicolas. *The Sacred Spring: The Arts in Vienna, 1898–1918.* Greenwich, CT: New York Graphic Society, 1974.

Sabarsky, Serge, ed. *Gustav Klimt: Drawings.* London: Gordon Fraser, 1984.

Sármány-Parsons, Ilona. *Gustav Klimt.* New York: Crown, 1987.

Schorske, Carl E. *Fin-de-siècle Vienna: Politics and Culture.* New York: Alfred A. Knopf, 1980.

Stooss, Toni, and Christoph Doswald, eds. *Gustav Klimt.* Kunsthaus Zürich, 1992.

Strobl, Alice. *Gustav Klimt: Die Zeichnungen.* 4 vols. Salzburg: Galerie Welz, 1980–89.

Vergo, Peter. *Art in Vienna 1898–1918: Klimt, Kokoschka, Schiele and Their Contemporaries.* Third rev. ed. London: Phaidon, 1993 (first edition 1975).

Weidinger, Alfred. *Klimt.* Munich: Prestel, 2007.

Zuckerkandl, Berta. *Zeitkunst Wien 1901–1907.* Vienna and Leipzig: Hugo Heller, 1908.

INDEX

This catalogue has been published in conjunction
with the exhibition

GUSTAV KLIMT
THE RONALD S. LAUDER AND SERGE SABARSKY COLLECTIONS

Neue Galerie New York
October 18, 2007–June 30, 2008

Edited on behalf of Neue Galerie New York
by Renée Price

Director of Publications
Scott Gutterman

Text Editors
Diana C. Stoll
Audrey Walen

Editorial
Janis Staggs

Photo Research
Sharon Jordan

Translations
Steven Lindberg

Design
Tsang Seymour Design, Inc.
Laura Howell

Project Coordination
Victoria Salley
Anja Besserer

Production
Florian Tutte

Image Origination
Repro Ludwig, Zell am See, Austria

Printing and Binding
Druckerei Uhl GmbH & Co. KG, Radolfzell, Germany

Printed in Germany on acid-free paper

Exhibition Curator
Renée Price

Exhibition Design
Peter de Kimpe

Klimt Atelier Reconstruction
John Vinci
Christian Witt-Dörring

Exhibition Coordination
Geoffrey Burns
Sefa Saglam

Library of Congress Control Number: 2007933349

ISBN 978-3-7913-3834-7

Prestel Verlag
Königinstrasse 9, 80539 Munich
Tel. +49 (89) 38 17 09-0, Fax +49 (89) 38 17 09-35

Prestel Publishing Ltd.
4, Bloomsbury Place, London WC1 2QA
Tel. +44 (020) 7323-5004, Fax 44 (020) 7636-8004

Prestel Publishing
900 Broadway, Suite 603, New York, NY, 10003
Tel. +1 (212) 995-2720, Fax +1 (212) 995-2733

www.prestel.com